# American
# Impressionism

Essay and Selection by

## William H. Gerdts

Professor of Art History
City University of New York

Published by
The Henry Art Gallery,
University of Washington, Seattle

Copyright © 1980 The Henry Gallery Association
All rights reserved.

This volume has been prepared in conjunction with an exhibition organized by
the Henry Art Gallery.

Henry Art Gallery, University of Washington, Seattle
January 3-March 2, 1980
The Frederick S. Wight Gallery, University of California at Los Angeles
March 9-May 4, 1980
The Terra Museum of American Art, Evanston, Illinois
May 16-June 22, 1980
The Institute of Contemporary Art, Boston
July 1-August 31, 1980

This project has been supported by grants from the National Endowment for the
Arts, Washington, D.C., a Federal Agency, and the Henry Gallery Association
Publication Fund.

**Library of Congress Cataloging in Publication Data**

Gerdts, William H
 American impressionism.

 Prepared in conjunction with an exhibition
organized by the Henry Art Gallery, held at the
gallery, Jan. 3-March 2, 1980 and at other
institutions between March 9 and Aug. 31, 1980.
 Bibliography: p.
 Includes index.
 1. Impressionism (Art) — United States.
 2. Painting, American — United States.
 3. Painting, Modern — 19th century — United States.
 I. Henry Art Gallery. II. Title.
 ND210.5.I4G47 1980   759.13'074'019777   79-25157
 ISBN 0-935558-00-4
 ISBN 0-935558-01-2 pbk.

Front Cover:
Ernest Lawson, *Spring Thaw*
The Daniel J. Terra Collection

Back Cover:
William Glackens, *Breezy Day,
Tugboats, New York Harbor*
Milwaukee Art Center Collection

# Table of Contents

# Lenders to the Exhibition

Addison Gallery of American Art, Phillips Academy, Andover, Massachusetts

Mr. Arthur G. Altschul

Amon Carter Museum, Fort Worth, Texas

Mr. and Mrs. Richard Anawalt

Ball State University Art Gallery, Muncie, Indiana

Mr. and Mrs. Thomas W. Barwick

Bentley-Sellars Collection

Berry-Hill Galleries, New York, New York

Brigham Young University, Provo, Utah

The Brooklyn Museum, Brooklyn, New York

Mrs. Charles Burlingham

The Butler Institute of American Art, Youngstown, Ohio

California Historical Society, San Francisco, California

Canajoharie Library and Art Galley, Canajoharie, New York

Cincinnati Art Museum, Cincinnati, Ohio

Cleveland Museum of Art, Cleveland, Ohio

The Coggins Collection of American Art

Columbus Museum of Art, Columbus, Ohio

Corcoran Gallery of Art, Washington, D.C.

The Detroit Institute of Arts, Detroit, Michigan

DeVille Galleries, Los Angeles, California

El Paso Museum of Art, El Paso, Texas

Mr. and Mrs. William M. Fuller

Mr. Thomas R. Gallander

The Merrill J. Gross Collection

Gulf States Paper Corporation, Tuscaloosa, Alabama

Henry Art Gallery, University of Washington, Seattle, Washington

Hirshhorn Museum and Sculpture Garden, Smithsonian Institution, Washington, D.C.

Mr. and Mrs. Raymond J. Horowitz

Mrs. Robert Douglas Hunter

The Hyde Collection, Glens Falls, New York

Indianapolis Museum of Art, Indianapolis, Indiana

IBM Corporation, Armonk, New York

Joslyn Art Museum, Omaha, Nebraska

Messrs. James and Timothy Keny

Mr. and Mrs. Clarence W. Long

The Metropolitan Museum of Art, New York, New York

Milwaukee Art Center, Milwaukee, Wisconsin

Museum of Art, Rhode Island School of Design, Providence, Rhode Island

Museum of Fine Arts, Boston, Massachusetts

National Collection of Fine Arts, Smithsonian Institution, Washington, D.C.

The New Britain Museum of American Art, New Britain, Connecticut

The Newark Museum, Newark, New Jersey

Norton Gallery and School of Art, West Palm Beach, Florida

The Oakland Museum, Oakland, California

The Parrish Art Museum, Southampton, New York

The Pennsylvania Academy of the Fine Arts, Philadelphia, Pennsylvania

The Phillips Collection, Washington, D.C.

Portland Art Museum, Portland, Oregon

Mr. and Mrs. Meyer P. Potamkin

Randolph-Macon Woman's College Art Gallery, Lynchburg, Virginia

The Reading Public Museum and Art Gallery, Reading, Pennsylvania

Mr. Laurent Redfield

Rose Art Museum, Brandeis University, Waltham, Massachusetts

The St. Louis Art Museum, St. Louis, Missouri

Santa Barbara Museum of Art, Santa Barbara, California

Scripps College, Claremont, California

Drs. Ben and A. Jess Shenson

Helen Foresman Spencer Museum of Art, The University of Kansas, Lawrence, Kansas

Mr. and Mrs. Ralph Spencer

The Daniel J. Terra Collection

University Art Gallery, University of Minnesota, Minneapolis, Minnesota

University of California, Los Angeles, California

University of Nebraska Art Galleries, Lincoln, Nebraska

Wadsworth Atheneum, Hartford, Connecticut

Washington University Gallery of Art, St. Louis, Missouri

The Westmoreland County Museum of Art, Greensburg, Pennsylvania

Worcester Art Museum, Worcester, Massachusetts

Private Collections

# Acknowledgements

On behalf of the University of Washington, it gives me a great deal of pleasure to express my appreciation to the Henry Gallery Association for their financial support of this publication. Without funding by these patrons, the University art gallery would not be able to publish Professor Gerdts' text or to organize this exhibit for our University, and for the University of California at Los Angeles, the Terra Museum of American Art, Evanston, Illinois, and the Institute of Contemporary Art, Boston.

The Association's commitment to our Art Gallery enriches and invigorates the intellectual and artistic life of this University. We are deeply indebted to all who have made this significant project possible.

William P. Gerberding
President,
University of Washington

This American Impressionism exhibition and publication could not have happened at this time without William H. Gerdts. His thorough scholarship, painting connoisseurship, and punctuality made the curatorial concept a reality. For that, I am deeply grateful to him.

I want to join Dr. Gerberding in thanking the Henry Gallery Association Board of Trustees and members for their contributions to the project. I must express my gratitude to Mr. James E. Hussey, President of the Board of Trustees, Mr. Robert J. Behnke, Chairman of the Development Committee, Mrs. John E.Z. Caner, Director of the Association, and to the donors to the publication fund.

During the past year I have enjoyed many opportunities to work with individuals at the other institutions that are hosting the exhibition. At the Frederick S. Wight Art Gallery, Jack Carter, the Acting Director, Mrs. Franklin Murphy, President of the UCLA Arts Council, and Mrs. Julian Ganz, a distinguished American art collector and active member of the UCLA Arts Council, have been a joy and pleasure to work with; I thank each of them for their early and unwavering support for this project. Stephen Prokopoff, Director of the Institute of Contemporary Art, and Theodore Stebbins, Curator of American Art at the Museum of Fine Arts, Boston, have given graciously of their time and expertise in planning the exhibition's visit to the Institute of Contemporary Art. Dr. Stebbins has made special, and successful, arrangements for the loan of some of the Museum's masterworks to the exhibition. To both of them I am indebted.

The exhibition's visit to the Terra Museum of American Art, Evanston, has been one of the most unexpected and pleasing events of the two-year project. The exhibition —with John I.H. Baur acting as consulting director — inaugurates the first museum devoted to 19th-century American art in the Chicago area, a most significant event for the region and for scholars of American art history. Furthermore, Mr. Terra has played a leading role in expanding the format of this book by his early suggestion that, because of the exhibition's importance, the publication should not be modest; he gave generously of his finances to that end. His willingness to lend a number of works from his distinguished collection for the required ten-month period is another indication of his support for and belief in this project. I have enjoyed to no end his advice, and the establishment of a warm friendship.

The project could not have been realized without the cooperation of the institutions and individuals who have agreed to lend priceless objects which represent an important part of our cultural heritage. A special note of thanks goes to Directors and staffs of The Brooklyn Museum, the Corcoran Gallery of Arts, the Museum of Fine Arts, Boston, The National Collection of Fine Arts, the Pennsylvania Academy of the Fine Arts, and to Mr. Arthur G. Altschul, Mr. and Mrs. Raymond J. Horowitz, Mr. and Mrs. Meyer P. Potamkin, Mr. and Mrs. Ralph Spencer, and Mr. and Mrs. Daniel J. Terra.

The staff of the Henry Art Gallery has given much time, talent, and dedication to this project. I am grateful to each member of an outstanding gallery staff. Vickie Ross, Project Administrator, Frederick Dunagan, Curator of Collections, and Joseph Newland, Editor of Publications, have been responsible for major portions of the project's administration. Carole Sabatini, Mona Nagai, Paula Wolf, Joan Watkins, and Dorothy Guiwits performed indispensible tasks. Each has played an important role in the success of this project.

Harvey West
Director,
Henry Art Gallery

Photograph taken in 1903 on the occasion of William Merritt Chase replacing the deceased John Henry Twachtman. The signed photograph was presented to Albert Milch by the artists as a gesture of their friendship. Courtesy Harold Milch.

Seated (l. to r.): Edward Simmons, Willard Leroy Metcalf, Childe Hassam, J. Alden Weir and Robert Reid. Standing: William Merritt Chase, Frank Benson, Edmund Tarbell, Thomas Dewing and Joseph De Camp.

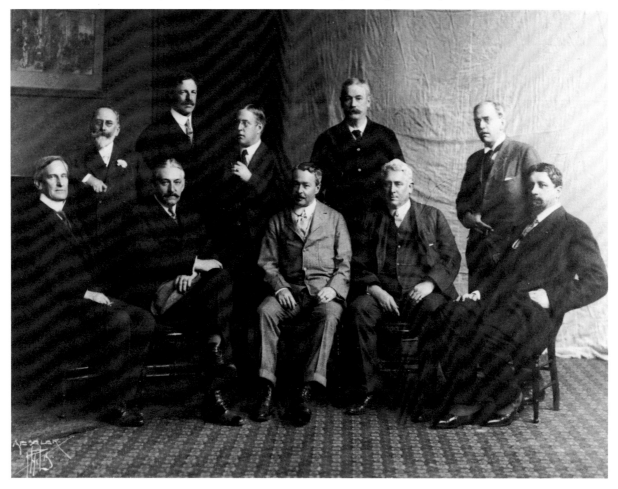

Two years ago, in 1978, William H. Gerdts agreed to be the Henry Art Gallery's guest curator for an American Impressionism project. With that the success of the project was assured for Seattle's, Los Angeles', Chicago's and Boston's museum public. Yet even with high expectations, the actual visual impact of 140 of the finest American Impressionist paintings on exhibit was not fully anticipated by anyone. The excitement, yes, but not their incredible collective beauty. An equally exciting event has been the publication of this book by the Henry Gallery Association. A fully illustrated volume with Dr. Gerdts' superbly researched essay and extensive bibliography on the subject is an exceptional preface to new art history scholarship on American Impressionism and related subjects for the 1980s and beyond.

Dr. Gerdts' text is a study of the impact of French Impressionism on this nation's art history, the significance and distinction of the principal American practitioners, the critics' interpretation of the movement since its beginnings in America, and the relationship of Impressionism to Modernist aesthetic developments of the early 20th century. The publication is intended as a scholarly companion to the exhibition of American Impressionist painting.

The paintings selected by Dr. Gerdts for the exhibition and which are illustrated here present the results of international, primarily French, Impressionism joining with the nature of American art in the 19th and early 20th century. The nucleus of the paintings consists of works by five artists: Mary Cassatt, Theodore Robinson, Childe Hassam, J. Alden Weir, and John Twachtman. Their canvases and those of the other painters included were chosen to reveal the thematic as well as aesthetic concerns of the Impressionist artists: the urban scene, the figure, plein-air landscape painting, the high horizon, square canvases, *alla prima* painting techniques, draftsmanship. And color. And light. The investigation into the character of Nature's light in America before the Impressionist triumph is represented by Winslow Homer's Luminism and George Inness' Tonalism. Mark Fisher, Dennis Bunker, and John Singer Sargent represent those artists who performed seminal roles in introducing Impressionist aesthetics to American artists and patrons. In addition to the five core painters, Impressionists from the Northeast, Midwest, and West are represented by works from various groups and schools identified with those regions.

The purpose behind the book, touring exhibition, and the related symposia and other special education events is the stimulation of new scholarly inquiry into our country's art history. At this time, in the majority of our universities, 19th century and 20th century American art and criticism are conspicuously absent from art and art history curricula. The fact that this exhibition is the first such showing of American Impressionist paintings on the West Coast indicates that significant events which have been overlooked or not properly researched have had a decided influence on the dynamic quality and character of the contemporary American art community. Moreover, the task of better knowing our art history is made most agreeable since so many yet unstudied, or perhaps even unknown, artists have given us — as is evidenced by the American Impressionists — magnificent art objects of lasting value and beauty to use as the touchstone in our assessment of their contributions.

Harvey West

**Theodore Robinson**

*The Wedding March.* 1892
Oil on canvas
22 x 26 in. (55.9 x 66.1 cm)
The Daniel J. Terra Collection

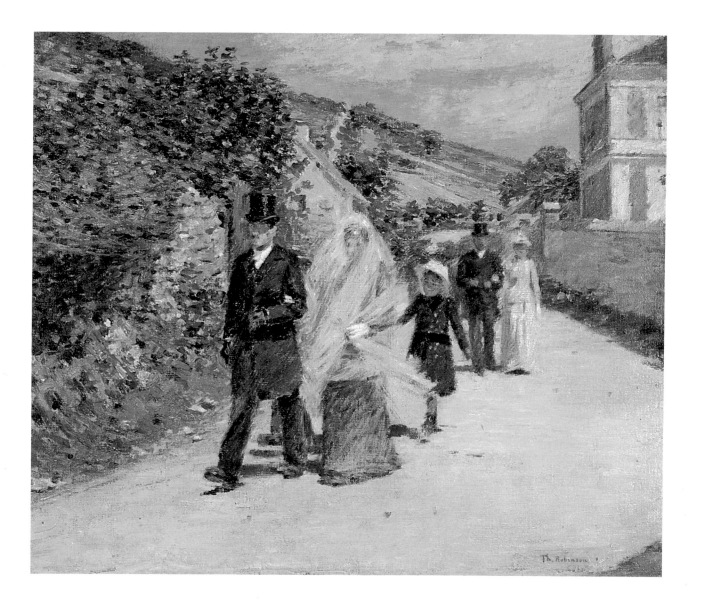

The notes for this chapter will be found on page 15.

# American Impressionism

# In Context

As recently as fifteen years ago, the mounting of a major exhibition devoted to the subject of American Impressionism would have elicited much derision, even on the part of scholars in American art and cognoscenti among collectors and critics. Only a handful of the artists here represented would have been familiar to any but a few specialists; even those would have been imperfectly known and generally derided, with the exception of a few major artists—primarily expatriates really better known for the international ramifications of their art, painters such as Mary Cassatt, James Whistler and John Singer Sargent. After the heyday of American Impressionism in the last decade of the last century and the first of the present one, the work of most of the other artists seen here had fallen into disrepute, and even the best-remembered of them, such as Childe Hassam, were imperfectly known.

This is, of course, no longer true. We have witnessed in fewer than twenty years a tremendous upsurge of interest in the field, which is manifest in many areas. Two major studies have been published on the subject, by Donelson Hoopes in 1972 and Richard Boyle in 1974, and a volume on the "core" group of American Impressionism—The Ten American Artists—was written by Patricia Jobe Pierce, in 1977. Kenneth Haley completed a dissertation on the last-named subject in 1975 for the State University of New York at Binghampton.[1]

Even more impressive is the swelling number of museum and commercial gallery exhibitions which have preceded the present one, a number of them of true significance. It is not the purpose here to enumerate and describe all of them; they are listed in the bibliography following this essay. But before 1965, there are recorded only half a dozen such shows, the majority of which were exhibitions of Impressionist painting which, however, generally made deference to the existence of American participation in the aesthetic. The earliest of these took place at The Brooklyn Museum in the 1930s, one show in 1932 and another in 1937. The latter was *Leaders of American Impressionism,* organized by John I. H. Baur, who has been, in this area as in so many other aspects of American art history, one of the most perceptive and innovative figures in museum scholarship. It was with Baur, too, and the Theodore Robinson Show at the Brooklyn Museum in 1946 that major museum exhibitions began to be devoted to single figures among the American Impressionists, perhaps because Robinson was the most important artist omitted from the previous exhibition. Here again, however, the number of exhibitions devoted to individual artists has increased tremendously in recent years, reaching new levels of scholarship not only in the treatment of traditionally recognized figures such as Mary Cassatt but in the reappraisal of such marvelous but heretofore neglected painters as Dennis Bunker and William Paxton.

The burgeoning of publications and exhibitions devoted to our subject tells only part of the story. Concomitantly, collecting in this area is also witnessing a tremendous increase, among both public institutions and private collectors, and there are some patrons of the arts who have concentrated almost exclusively upon this area, among them Arthur Altschul, the Raymond Horowitzes, the Meyer Potamkins, the Ralph Spencers and the Daniel Terras, all of whom have graciously lent major examples from their collections to the present exhibition. The Horowitz collection may be the best known in this field because of the superlative exhibition of a large part of their holdings at The Metropolitan Museum in New York City in 1973.

What, then, accounts for the relatively sudden upsurge of interest in American Impressionism? The answer must lie, in part at least, in the very beauty of the finest of the examples of this art movement, in which great competency of craftsmanship is wedded to luminosity, beautifully variegated color and cheerful, easily perceived and recognized subject matter. The artists involved with the movement, following the lead of the French originators of Impressionism, banished not only the drab, dark tones of much earlier painting or even contemporary Munich Realism, but often the soulful, frequently gloomy and depressing subject matter that went along with those art movements. One cannot overlook also the more frankly commercial aspect of the rise of interest in American Impressionism. With the acceleration of the long-standing interest in French Impressionism among American collectors and museums, prices for masterworks of that movement moved into realms so astronomical that alternatives that had not yet achieved such popularity were investigated, and some of the work of the Americans allied to that movement seemed sufficiently similar so that they became, in a sense, substitutes of often equal, or almost equal appeal, and obtainable at considerably lower cost.

This is not necessarily demeaning to American Impressionism, since it resulted in intense study of the American movement and an investigation of its relationship to its French counterpart, with recognition of distinct differences as well. For if the popularity of American Impressionism is bound up, on the one hand, with the appeal of Impressionism generally, on the other it must be part of the increasing awareness of and interest in the myriad aspects of *American* culture. This is not to isolate American Impressionism as exclusive of Western (European) and indeed world cultural expression but rather to recognize the place of American Impressionism within a global context, at the same time appreciating individual and national distinctions and aspirations.

The denigration of American Impressionism among historians and critics of the previous generation stemmed from one of two (mis)conceptions. Either the work of these artists was judged as totally imitative of their French peers (and superiors), and was thus not deemed an original art form, or it was felt that the art was too inhibited by the tradition of American Realism (a dubiously postulated tradition in any event!) to allow for full comprehension and expression of the Impressionist aesthetic. Furthermore, American Impressionism seemed to fall between the more powerful and always appreciated art of Winslow Homer and Thomas Eakins, who until recently have been interpreted in a narrowly provincial context of "truly American" painters (and therefore "better" artists!), and the more exciting directions of the early 20th century: the urban realism of The Ashcan School, or "The Eight" (again interpreted as distinctly American), or the more radical work of the American Modernists—followers of Picasso and Matisse—who were involved with the formative years of Cubism and Fauvism.

There is no denying, of course, the primacy of France in the development of Impressionism, but with the growing emphasis upon national foci in cultural, historical and sociological study, individual national manifestations of it are coming more clearly into view. This is not limited to the scholarship of our own nation; Impressionism and related art movements have been the subject of extensive investigation and exhibition around the world, with books and exhibition catalogues revealing the beauty and characteristics of British Impressionism, Canadian Impressionism, Australian Impressionism,

Spanish Impressionism and the like. Many of these exhibit individual qualities quite distinct from French Impressionism, though all of them share to some degree a broadened interest in light and color over the forms of art previously or contemporaneously practiced in those countries. Some of those national manifestations, often taking place contemporaneously with American Impressionist activities, reveal close similarities to the American movement in either a general approach to the painting of colored light and atmosphere or parallel artist-to-artist expression, oceans apart.

With such individual national interpretations of the Impressionist aesthetic currently subject to study and research, usually investigated by scholars of those specific nations, it would be folly to attempt a summation in the course of only a few lines, for the primary purpose of this essay — as of the exhibition which it serves — is to present the many aspects of American Impressionism. Nevertheless, the primacy of France in the histories of Impressionist art is deservedly such that, in this country still, little is known of other national manifestations, thus making the introduction of some comparative material desirable.

Receptivity to French Impressionism and native adaptation of it varied tremendously from nation to nation. Impressionism came late to British art for instance, due not only to a resistance to French cultural domination but also to the prevailing Pre-Raphaelite aesthetic and its allied moral component, a philosophical purposefulness to art lacking in Impressionism.[2] The French Impressionist artists and their dealers had high hopes for a positive reception in England. Durand-Ruel opened a gallery in London in 1870 to show the work of French artists, including pictures by Edouard Manet, Claude Monet and Camille Pissarro, but the attempt failed and the gallery closed in 1875. In the 1880s, the New English Art Club represented a progressive and French-influenced force in British painting, but it was still a vanguard of primarily Barbizon-inspired or at best plein-air painting, in the manner of Jules Bastien-Lepage. Whistler was the primary force in the introduction of French Impressionism into Britain, inviting Monet to show with the Society of British Artists in 1887, but he was voted out of the presidency of that body the following year and turned his efforts to the New English Art Club.

The exhibition of London Impressionists — a group of artists primarily connected with the New English Art Club — at Goupil's London Gallery in December of 1889 marks the public emergence of a native manifestation of Impressionism. Still, the one artist of the period who truly accepted the tenets of Impressionism was Philip Wilson Steer, who turned from the academic practice he had learned in France under William Bouguereau and Alexander Cabanel to the new art after seeing the exhibition of French Impressionism in London in 1883 at the Dowdeswell Gallery, and the Manet memorial in Paris the next year. Steer's series of paintings of figures, usually of young girls, on the beaches at Boulogne in France and Walberswick in England, of the late 1880s and early 1890s represent the major manifestation of Impressionism in Britain, but it was of short duration, and by the late 1890s he had turned to a recapitulation of Constable-like landscape and then French rococo-inspired portraiture, with his ventures into Impressionism only a distant memory.

English Colonial artistic developments are of particular interest to the study of American art for the obvious similarities that they offer, as well as for the divergencies dictated by historic, geographic, economic and sociological considerations. In Canada, as in the United States, the late 19th century witnessed new aesthetic investigations coinciding with an increasing emphasis upon European, and particularly French, training and the influence of Whistler and the Art-for-Art's-Sake movement.[3] Yet, most Canadian painters of the 1890s and after practiced at most a modified version of Impressionism, and the emphasis upon the Canadian landscape of the foremost group of Canadian artists, The Group of Seven, though certainly influenced by Impressionist color and brushwork, turned Canadian art away from the full exploration of the French-inspired aesthetic. Perhaps it is not coincidental that the most fully developed Canadian Impressionist was a Quebecois, well trained in Paris at the Académie Julian and the École des Beaux-Arts, Marc Aurele de Foy Suzor-Coté, who adopted the Impressionist approach and applied it primarily to one subject back in Canada, landscapes depicting a stream between snowy banks flowing toward the viewer, paintings with an overall glistening atmosphere and utilizing a heavy impasto. The secretary of the Royal Canadian Academy could write as late as 1913 that:

*No French Canadian painter fortunately has dreamed of following in their folly those despisers of art who have undertaken the mission of denying beauty and proscribing truth. Cubists and Futurists may go by. Our country is too young not to be attracted by novelty, but it has enough native good sense not to allow itself to be made a fool of, or to take the grin of a monkey for the smile of a woman.* [!][4]

One of the most fascinating, and most isolated, manifestations of a new approach to the painting of colored light occurred in Australia.[5] Australian landscape painting until the 1880s was dominated by Barbizon-inspired aesthetics, until the young art student Tom Roberts returned from Europe in 1885. In 1883 he had met some Spanish followers of Bastien-Lepage on a walking tour through Spain, and through them he became imbued with the concept of plein-air painting and adopted a new colorism, inspired by the Southern sun and the Spanish landscape, which he took back to Australia. There, in 1888, he was joined by Charles Conder and Arthur Streeton in Melbourne, and together they founded the Heidelberg School — named after an artists' camp established outside the city. They painted together and exhibited the following year, devoting their talents to creating a distinctly Australian art, based upon the painting of the light and color peculiar to Australian atmosphere and vegetation, painting both the Australian landscape and the urban scene. This was the first distinctly Australian school, and therefore was viewed as other than a foreign import. The concern with light, the image of the sun, was very much a part of Australian cultural expression, to be found also in literature and in the general mystique of Australian nationalism.

The most vital years of the Australian movement occurred from the mid-1880s to about 1893, closely paralleling American developments. The Australian painters were familiar with the art of the French Impressionists, and became more so after Charles Conder departed for Europe in 1890 and sent back news from France of European developments, terming Monet the greatest of all landscape painters. But Australian paintings differed still from their French counterparts. Colors tended to be paler and often opalescent, with rosy pinks and dusty yellow tones predominating. Drawing remained a paramount consideration and neutral tones were often not omitted. Furthermore, subject matter, specifically native, was still emphasized, yet

criticism of this challenge to prevailing taste sharpened. Predictably, the works of Roberts, Streeton and Conder were condemned as lazy, or creating a "pain in the eye." The artists were satirized as small boys apprenticed to a housepainter, or as painting scenes seen through thick gauze. Parenthetically, it should be noted that Impressionism made no headway in New Zealand where strong hostility toward even a broader technique precluded success even for the subdued modernism of the landscapes of James McLaghan Nairn, the Glasgow-school inspired Scotsman who arrived in Wellington in 1890.[6]

Given both geographic proximity and cultural affiliation, it is not surprising that Belgium was almost the only European country in which Impressionism was welcomed for its progressive tendencies and quickly became identified with modern art. Modernism was formally taken cognizance of in the organization of the Group of XX in Brussels in January of 1884, with its purpose to aid and diffuse modern art and to organize international expositions of the work of members and invited artists. Through their publication, *L'Art Moderne,* the group set about an active campaign to further French art and emphasized the painting of light and color. In 1884, the Group of XX invited Whistler, Sargent and Chase to show with them; in 1886, Monet, Renoir, and Redon were invited along with Whistler and Chase. Impressionism came to Belgium not in the 1870s but in the 1880s however, and in that decade, Impressionism was superseded by Post-Impressionism as the most progressive art movement, one which also reached Belgium quickly, so that in the shows of 1887 and after, there was a strong and dominant emphasis upon Pointillism. Seurat's *La Grande Jatte* was shown in 1887, along with works by Pissarro, Berthe Morisot and the Englishman, Walter Sickert, and in 1888, Henri Cross and Paul Signac exhibited Divisionist works there.

This emphasis was reflected in turn in native Belgian art. Emil Claus became, about 1888, the foremost representative of standard application of Impressionist technique, flecked, broken brushwork and sparkling color applied to bucolic subjects often on canvases of heroic scale; in 1904 he became the leader of the group, "Vie et Lumière." But more significant was Theo Van Rijsselberghe, whose portrait of 1885 of Octave Maus—the major writer and organizer of the Group of XX—contrasts in its strong chiaroscuro and rich, dark painterly realism with the completely Divisionist depiction of Mme. Charles Maus of 1890. In between, in 1888, Van Rijsselberghe had seen Seurat's work and had become a friend of Cross and Signac. By the middle of the next decade, however, his work became more decorative and his forms more simplified, and by about 1900 Van Rijsselberghe had abandoned the strict tenets of Pointillist Post-Impressionism. By 1886-87, Jan Toorop, also a member of the XX, shared the current enthusiasm for Divisionism, and Georges Lemmen was producing Divisionist landscapes by 1889 in Belgium.

In Germany, the absorption of and reaction to Impressionism took a different form than elsewhere in Europe, and indeed, one might question the existence of such an art form as "German Impressionism."[7] One might also say that there was little true English, or Spanish, or Italian Impressionism, due to innate conservatism, adverse reaction to things French, and the substitution of a form of "academic tonalism" which will be discussed shortly. However, those German artists of a more progressive and sometimes more inventive cast, seem instead to have bypassed Impressionism and

veered toward a more expressive use of color and brushwork, almost pre- or proto-Fauve, which culminated in German Expressionism in the 20th century—often a stronger, more dramatic art form than much French painting of similar emotional force.

The dramatic use of color and paint adopted by younger German painters in the 1870s, tied to a Realist imagery, suggests the work of Gustave Courbet and, indeed, Courbet was a pivotal figure in the development of German art. His work was known in Germany as early as 1858, and his influence increased greatly with his visit to Munich in 1869, when he was met by the young painter Wilhelm Leibl. Some artists in Leibl's circle, particularly those concerned with landscape painting such as Hans Thoma, adopted a modified Impressionism, but Impressionism was often considered anti-German. It was a French import inimicable to the spirit of national unity which prevailed after 1870, one that developed in conjunction with a war against France.

The most significant German painter related to the Impressionist movement was Max Liebermann. His visit to Paris in 1873 brought him in contact with the peasant tradition of Millet as modified by the monumentality and plein-airism of the following generation, and visits to Holland allied him to the kindred painting of Josef Israels. Gradually, during the 1880s, in works such as *The Bleaching Ground* of 1882, his palette lightened, his paint was applied more freely, and light was investigated both for naturalistic and decorative effects, but it was only with his work done after the turn of the century, when he was president of the Berlin Sezession, the organization which attracted modernist artists from all over Germany, that Liebermann's art adopted a full colorism more allied to Impressionism. His most casual and brightest oils were depictions of outdoor restaurants, hotel terraces and the zoological gardens in Berlin, reflecting the subject matter of much earlier French Impressionist painting. The Sezession, the private galleries in Berlin, and the newly established periodical *Kunst und Künstler* focused upon modernism and French art, but by then Impressionism had been superseded by newer developments. The younger artists Lovis Corinth and Max Slevogt, though allied to the Berlin Sezession and their art related to Impressionism, are really more Expressionist painters. It might be argued in fact, that the most completely Impressionist paintings done by a German artist were the informal studies of his daughters in the family garden painted by Fritz von Uhde in the first decade of the 20th century, so diametrically opposite to the updated religious themes in which Christ appears to contemporary German peasants for which von Uhde was internationally known. Other German artists to investigate the light, space and broken color of Impressionism included Gotthard Kuehl and Leopold Graf von Kalckreuth. With the exception of the small handful of paintings by von Uhde, however, none of the German artists attempted to capture the scintillating vibrations of sunlight.

Among Spanish artists, two especially must be considered in relationship to Impressionism.[8] The earlier was the short-lived Mario Fortuny, an extraordinarily influential painter in his day, and the leader of the so-called "Hispano-Roman School." He was famous in the 1860s for his sparkling light and radiant atmospheric effects, first introduced in his art as the result of his stay in Morocco in 1860 to record the war there between Spain and that nation. He subsequently worked in Paris and in Rome, where his influence became international in scope. He was a key figure in the artistic

**Dennis Miller Bunker** (above)          **Thomas Wilmer Dewing**

*Wild Asters.* 1889                        *The Hermit Thrush.* ca. 1893

Oil on canvas                              Oil on canvas
25 x 30 in. (63.5 x 76.2 cm)               34¾ x 46⅛ in. (86.4 x 116.9 cm)
Private Collection                         National Collection of Fine Arts,
                                           Smithsonian Institution, Gift of John Gellatly

development of the Italian painter, Giovanni Boldini, an important influence on such Americans as Robert Blum (who was referred to as "Blumtuny"), and Fortuny's work in watercolor culled a group of French followers who, in 1878, formed the Society of Painters in Watercolors in Paris. In Fortuny's last years his palette brightened considerably, but even at its freest was applied flatly with strong chiaroscuro. Yet, the Spanish artist's relationship to Impressionism was recognized by Edward Prescott when he wrote in *Harper's* in 1888:

*The peculiar technique of many of the modern Spanish painters and their loose manner of handling color must in a great measure be ascribed to Fortuny, who accomplished a revolution in the Spanish school as sweeping and iconoclastic as that which Gericault led in France against the so-called classic school of David. Many of the Impressionist painters of the present day owe their inspiration to Fortuny...*[9]

Fortuny died just as French Impressionism found complete expression. The leading Spanish artist of the next generation was Joaquin Sorolla y Bastida, who began in an academic manner, painting historical works.[10] In the 1880s he fell under the influence of the French plein-air painters such as Bastien-Lepage and of Fortuny, and turned to themes of social realism, but in 1899 he vowed he had painted his last "sad" picture and began painting what has become known as "typical" Sorolla themes, figures—often children—and animals in the open air, bathed in brilliant, colored sunlight, along the shore near Valencia. Sorolla painted shimmering wetness with swift, spontaneous strokes, in a distinctive manner referred to as "Istantismo" and "Sorolloismo" rather than Impressionism. His fame was international, and he was nowhere more popular than in the United States, where an enormous show of 357 of his works took place at the Hispanic Society in New York City in 1909.

Artistic expression in Italy was no more unified than the fragmented political structure of that country during most of the 19th century, though tentative approaches toward Impressionist interests can be identified among artists of the Schools of Posillipo and Resina near Naples, the Scapigliatura of Milan, and especially the best-known mid-century movement, the Macchiaioli of Florence. The last-named prefigured the French Impressionists in their interest in outdoor light during the 1850s, but to identify them with that movement is a distortion of later art history and criticism. The works of that group which appear to be the most advanced were studies not meant for public exhibition or viewing, and it was their more complex and finished pictures of direct observations of everyday life—paralleling contemporary pictures in America by Winslow Homer and Eastman Johnson—that drew critical complaints of slovenliness, and of sacrificing form to effect. In none of their work, however, did the Macchiaioli abandon dark tones and blacks, juxtapose complementary colors, or resort to the broken colorism of true Impressionism.[11]

A number of Italian painters worked in Paris with the French Impressionists, and the works of such artists as Federico Zandomeneghi reflect a more complete influence of the new movement. In Italy itself, a mixture of Impressionist techniques with Divisionist art theory influenced the painting of Vittore Grubicy and, through him, his protégé Giovanni Segantini.[12] Segantini worked in a variety of styles, but many of his works depicting pastoral scenes in his native Alpine region are painted with long, thick colored brushstrokes that have come to be identified as the "Segantini

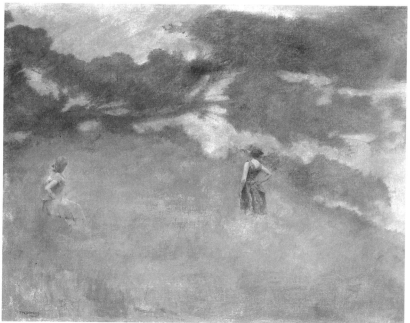

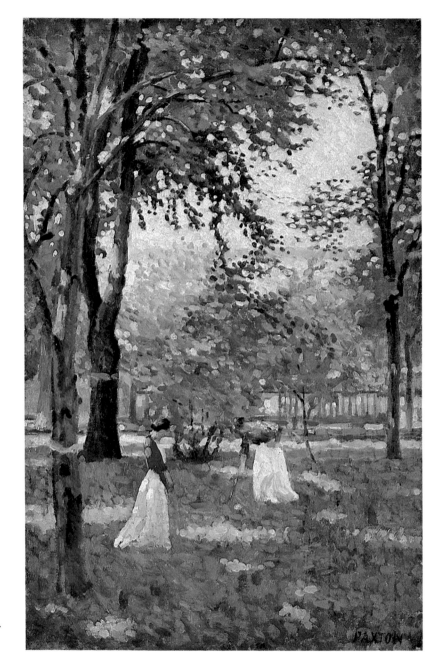

*The Croquet Players.* ca. 1898
Oil on canvas
32 x 21 in. (81.3 x 53.3 cm)
Collection of Mrs. Robert Douglas Hunter

stitch." This quite peculiar and distinctive stylistic manner was shared also by Gaetano Previati, and both artists utilized this technique in large allegorical and religious paintings Segantini exploring a pantheistic symbolism and Previati sharing in a revival of Catholic mysticism. This mystical turn to Impressionist and Divisionist aesthetics, first visible in 1891 at the Triennale Exhibition at the Brera Gallery in Milan, is the most distinctive quality of Italian painting of the period. The dynamic nature of this interpretation was to characterize the work of the Italian Futurists, a number of whom began their careers with paintings vitally concerned with the pictorialization of colored light, though in very non-naturalistic terms.

In general, Scandinavia was not deeply touched by Impressionism, though the impact of the movement varied among the separate nations. Denmark may have been least affected, though a modified interest in light and color can be seen in the works of some members of the Skagen school, especially Anna Ancher and Peder Krøger. There was little Impressionist painting in Norway, but several Norwegian artists working in Paris were affected by the Impressionist aesthetic. In his own time, Fritz Thaulow was the most famous Norwegian artist who practiced a very modified, almost "academic" Impressionism, a strongly structured landscape art which made him internationally acceptable — and famous. The great Expressionist painter Edvard Munch briefly experimented with Impressionist techniques during his Paris years of 1889-92, applying those techniques to street scenes in Paris and Oslo.

Swedish art was more sympathetic to French developments, continuing the historic cultural affinities developed centuries earlier. Bruno Liljefors was a bird and animal painter interested in the instantaneous movement of his subjects and in the air and light of outdoors; he may be the one (near-) Impressionist animal painter! But the best-known Scandinavian artist of his day was the Swede, Anders Zorn, famous both as an international portraitist and as a figure painter, particularly of the nude. His subjects, often seen bathing, were treated with great pictorial boldness, and the artist reveled in the rosy tints of flesh and reflections of light upon them; the women he painted often were depicted in the brilliant, clear light of Northern Sweden. Zorn was not truly an Impressionist, but Impressionism had a strong impact upon his art.

Even in Eastern Europe, Impressionism made its mark. Its effect may have been greatest in Romania where, like Sweden, there was a tradition of French cultural presence; Nicolae Grigorescu turned from a Barbizon-inspired manner to greater colorism and painterly freedom by the end of the century. In Hungary, Pal Szinyei Merse's art hovered comfortably between solid construction and vibrant light and color, and his quite triumphant *Picnic in May* of 1873 seems prescient in its chromatic brilliance.

The situation was more complicated in Russia.[13] Strident nationalism during the Impressionist generation favored the Peredvizhniki, the "Wanderers." These, the men of the sixties, had been young rebels seeking liberal expression and freedom in their choice of subject matter, opposing the dictates of the academy. But by the 1880s, these Realist painters who emphasized purely Russian themes, often of or relating to social oppression, were themselves dictating against newer themes and forms, particularly as these were of foreign — usually French — origin. The greatest of the late 19th-century Russian artists, Ilya Repin, shocked and discomforted his Peredvizhnik colleagues when he wrote from Paris in 1874 that he felt there

was something to the Impressionists. His teacher Ivan Kramskoy reproached him for having forgotten his native land, but on his return in 1876, Repin's first painting was an Impressionist outdoor family scene, *On a Turf Bench.* However it met no success, and by the end of the year Repin had returned to the fold as a painter of powerful national types and scenes, in a Realist manner with little conscious concern for experimental technique.[14]

Nevertheless, French Impressionist techniques and concerns did filter into late 19th-century Russian paintings at least occasionally, receiving the support of collectors from the new wealthy bourgeoisie, above all Pavel Mikhailovich Tretiakov. Tretiakov patronized art of all forms and schools within Russia and in 1889 acquired the *Girl in Sunlight* painted by Valentin Serov, the greatest Russian portrait painter of the period. Serov worked in a broad, free manner and in his more informal works particularly, Impressionist techniques can be seen. Likewise, Arkhip Kundzhi painted large landscapes with dappled colorism not unlike the early Impressionist works of Monet and his colleagues of the late 1860s and early 70s.

Isaac Levitan's work is enlightening in this regard, and bears comparison with American developments. A landscape painter, his work nominally sought to depict the distinctive character of the Russian scene, although landscapes were not valued as highly as were figure paintings during that period, precisely because they were more universal and less nationally distinctive. His *Golden Autumn, Village* of 1889 is a gentle, loosely painted work in a Barbizon manner, but by the mid-nineties, in such pictures as the *Tolling of the Evening Bells* of 1892 and his *Fresh Wind — Volga* of 1895, his work has a crisp clarity, open-ended breadth and even panoramic horizontality of much American Luminist painting of a generation earlier. Finally, with *The Lake* of 1899-1900, Levitan's art had acquired a scintillation, colorism and concern for light and reflection that marks it as Impressionist, in which any specific national character of the scene seems quite secondary. Unfortunately, Levitan died in the last mentioned year, 1900, at the age of 40.

A study of Impressionist art is concerned with both technique and subject matter. Too often, emphasis has been placed only upon the experimental and radical techniques of the Impressionists, slighting their subject matter, which, though consciously casual, was nevertheless consciously chosen. This is just as true of American Impressionism as it is of the work of the French painters who developed the movement. Much Impressionist painting in all nations was naturally landscape, since the movement was concerned with the expression of outdoor light and atmosphere, but a surprising number of the American Impressionists were figure painters, and some specialized in the painting of figures in interiors. These interiors are often peopled by women, especially women reading or playing the piano. Sometimes the women are veiled, and Impressionist artists investigated transparent and openwork materials such as veiling, or hammock webbing. Nude figures—perhaps surprisingly—are found in a number of Impressionist canvases, and, at the other extreme of tradition and propriety, the theme of the Mother and Child was popular, not only with Mary Cassatt. Interior screens appear often in Impressionist interiors, and a number of the artists even painted such screens for actual use. Still lifes were also not unpopular among the American Impressionists, most of whom at least painted a number of fruit and flower pictures.

Among the landscapes, park scenes were especially popular, and beach scenes abound also. A great many of the landscapes are really "cityscapes," urban views, often clothed in the snow and cold of winter, or depicted at night, or both. The Impressionist painters rarely ventured out into raw, unexplored or uncultivated nature, and the concern with wilderness and unbounded space was minimal.

The present exhibition is a show primarily of oil paintings, but the American Impressionists investigated all media, and as they were in the forefront of progressive art, they took up the new and newly popular media of the day. Most of them were avid watercolorists, and a number of them, particularly Childe Hassam, J. Alden Weir and John Twachtman, were significant printmakers, working in lithography and taking part in the renaissance of etching. A number of the finest works of some of these artists are illustrations in books and magazines; Hassam's illustrations to William Dean Howell's 1891 *Venetian Life,* and Celia Thaxter's 1894 *An Island Garden* are deservedly famous. Occasionally, some of the artists also essayed the poster. They were important pastelists, and the significance of pastel in the 1880s, both for itself and in paving the way for the freedom and colorism of Impressionist oil painting, is just beginning to be recognized, thanks to the contributions of Dianne H. Pilgrim. Many of the artists considered here also entered with enthusiasm into the revival of mural painting which assumed full strength with the art work involved in the Columbian Exposition in Chicago in 1893, in which a number of the American Impressionists participated.

Certain geographic centers, at home and abroad, are particularly associated with the Impressionists. Most of the artists were trained in Paris of course, but some in Munich, and almost all of them went to Venice, which proved something of an international artistic mecca in the years before and after 1880. In France, Monet's village of Giverny was a center for Impressionist painting for many decades, while Broadway in England was an Anglo-American artists' and writers' colony where developments having an impact upon Impressionist art occurred. Back in America, Celia Thaxter's home on Appledore in the Isles of Shoals off the New Hampshire coast was an informal salon attracting artists, notably Childe Hassam, who later was one of the most distinguished of the many painters, often working in an Impressionist aesthetic, who stayed at Old Lyme, Connecticut. Cos Cob in that state also was a center for Impressionist painting. There was a recognized Boston school, a Pennsylvania group centering around New Hope, and a "Hoosier Group" that held sway in Indiana.

The Impressionist artists quite early became dominant forces in the American art world through their association with such bodies as the more conservative National Academy of Design and the younger, more liberal Society of American Artists, both in New York City, though they founded their own organization, "The Ten American Painters," in 1898. Impressionist artists were important members of such New York clubs as the Lotos and the Players. Many of the Impressionists in this country were prominent teachers, working at such organizations as the Art Students' League in New York or the Pennsylvania Academy of the Fine Arts, in addition to teaching private classes. They trained further generations, often of younger Impressionists. Through their associations and their teaching, Impressionism was widely diffused in this country; through the mounting numbers of exhibitions in the older academies, the burgeoning museums and

## John Henry Twachtman

*Bark and Schooner (Italian Salt Barks).* ca. 1900
Oil on canvas
25 x 25 in. (63.5 x 63.5 cm)
University of Nebraska Art Galleries,
F. M. Hall Collection

the growing numbers of commercial galleries, Impressionist pictures were constantly on view. In addition to the increasing fluidity of the art scene and the rapidly changing and mobile nature of artistic expression, the almost complete dominance and acceptance of Impressionism by the early years of the 20th century may, in turn, have been responsible for the reaction against the work of the American Impressionists among younger artists, critics and new patrons of the following generation. Only in recent years has this work been reassessed and revalued; the present exhibition and this text attest to those developments.

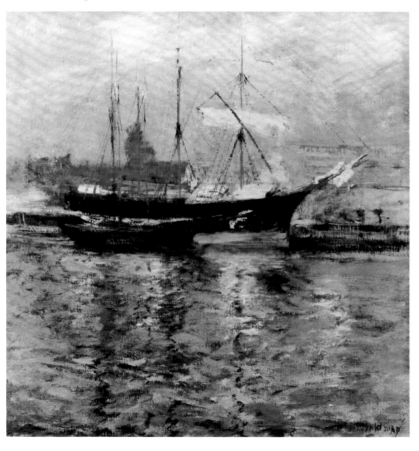

1.  Donelson F. Hoopes, *American Impressionism,* New York, Watson-Guptill, 1972; Richard J. Boyle, *American Impressionism,* Boston, New York Graphic Society, 1974; Patricia Jobe Pierce, *The Ten,* Concord, New Hampshire, Rumsford Press, distributed by Pierce Galleries, North Abington, Massachusetts, 1976; Kenneth Haley, "The Ten American Painters; Definition and Reassessment," unpublished Ph.D. dissertation, State University of New York at Binghamton, 1975.

2.  For a good summation of Impressionism in England, or the lack of it, see the catalogue of the show *Impressionism: Its Masters, Its Precursors, and Its Influence in Britain,* The Royal Academy of Arts, London, 1974. Neither that exhibition nor the present essay deals with the interesting relationship of the Impressionist movement to the Glasgow School in Scotland. That late 19th century artistic manifestation is discussed in all the books on Scottish art and was interestingly and well summed up in the article by W. G. Blaikie Murdoch, "The Scottish Impressionists," *The American Magazine of Art,* Vol. 7, no. 6 (April, 1916), 218-23.

3.  See the essay by Joan Murray in the catalogue *Impressionism in Canada 1895-1935,* Art Gallery of Ontario, Toronto, 1973.

4.  J. Russell Harper, *Painting in Canada: A History,* Toronto, University of Toronto Press, 1966, 280.

5.  The impact of Impressionism in Australia is discussed extensively in all histories of Australian art; in addition to these, see Brian Finemore, *Australian Impressionists,* Victoria, Longmans, 1968, part of The Arts in Australia series.

6.  See Gil Docking, *Two Hundred Years of New Zealand Painting,* Wellington, A. H. & A. W. Reed, 1971, 76-80.

7.  The literature in this area is immense. See especially Siegfried Wichmann, *Realismus und Impressionismus in Deutschland,* Stuttgart, Schuler Verlagsgesellschaft, 1964, and Hans Platte, *Deutsche Impressionisten,* Gütersloh, Bertelsmann Kunstverlag, 1971.

8.  See the exhibition catalogue *El Impresionismo en España,* Museo de Arte Moderno, Barcelona, 1974.

9.  Edward Bowen Prescott, "Modern Spanish Painting," *Harper's New Monthly Magazine,* Vol. 77 (March, 1888), 491.

10.  There is a great deal written on Sorolla by both Spanish and American writers. For a good, useful summation of his career and his impact in America, see Priscilla Muller, "Sorolla in America," *American Artist,* Vol. 38, Issue 381 (April, 1974), 22-29, 68-71.

11.  See Norma Freedman Broude, "The Macchiaioli: Academicism and Modernism in Nineteenth Century Italian Painting," unpublished Ph.D. dissertation, Columbia University, 1967.

12.  See Fortunato Bellonzi, *Il divisionismo nella pittura Italiana,* Milan, Fratelli Fabbri, 1967; this is No. 13 in the Mensili d'Arte series. Also useful in this context is No. 17, Anna Marie Damigella, *L'Impressionismo fuori di Francia,* 1967.

13.  See Rudolf Zeitler, *Die Kunst des 19. Jahrhunderts,* Band 11, Berlin, Propyläen Verlag, 1966, 122-28.

14.  Elizabeth Valkenier, *Russian Realist Art,* Ann Arbor, Ardis, 1977, 59-61, 117.

*An Adirondack Lake.* 1870

Oil on canvas
24¼ x 38¼ in. (61.6 x 97.2 cm)

Henry Art Gallery, University of Washington,
Seattle, Horace C. Henry Collection

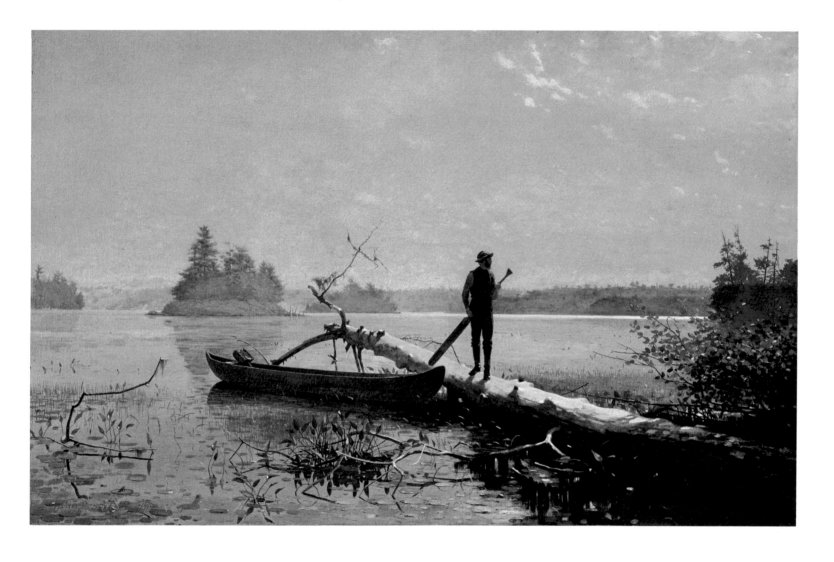

The notes for this chapter will be
found on page 19.

# 2 An Alternate Aesthetic of Light

It should be pointed out that the pictorial concern with the depiction of light in the late 19th century was not necessarily synonymous with the development of Impressionism. Critics, artists and collectors were certainly conscious of a lightening of the palette in the exhibitions of the period, over the predominantly dark or muted tones of earlier shows. This was, indeed, one of the most striking, because it was obvious, impressions that exhibitions made upon their audiences year after year. Whereas the work of one artist might seem to develop little or not at all from show to show, the overall reaction elicited in the galleries was that of progressive lightening and brightening. This phenomenon occurred not only abroad, but in America as well. When Hamlin Garland published in 1894 his reaction to the "dazzling sun-light effects" seen the previous year at the Columbian Exposition in Chicago as compared to the art shown at the International Exposition in Paris in 1889, he was beginning to formulate the most succinct and perceptive rationale for Impressionism to be written by an American,[1] but his essay was concerned not only with Impressionist painting but with the effects wrought by plein-air painting in general, as developed by artists —particularly but not exclusively landscape painters —of the late 19th century. Critics on both sides of the Atlantic increasingly remarked about the elimination of the "brown sauce," the dark tones and "old master" aesthetic metaphors previously sought after and introduced by artists in annual exhibitions in Munich, at the Paris Salon, at the Society of American Artists in New York City and in international expositions.

The increasing interest in recording the phenomenon of light led, perhaps inevitably, to Impressionism, but that was only one of several directions it took. Writers, critics and the artists themselves readily recognized that the Impressionist concern with light and color led to the sacrifice of solid form and well-defined space; this led in turn to the several directions taken by progressive French artists from the mid-1880s on, the developments which we recognize as Post-Impressionism.

However, even during the formative years of Impressionism in France itself, there were other artists who wished to maintain the characteristics of academic formal rendering yet saw the necessity of yielding to the increasing interest in outdoor visual phenomena, beyond the attraction of plein-airism as such. These were painters who wished to record sunlight, and effect brighter, more colorful and engaging natural effects, thus appearing more modern. This last was not, necessarily, a matter of faddism. These artists were consciously rejecting the more academically traditional appearance of painting and alliances with or references to old masters' work, similarities they were often rejecting in not only formal but thematic ways, too. It is not coincidence that these changes — "progressive" if you will —allied a new, brighter palette with the new subject matter of the peasantry, contemporary social concerns or the painting of landscapes associated with the common man and often of national, but surprisingly unheroic, physical character and dimensions.

Yet they have been viewed as artists of compromise, according to the more 20th-century, post-Meier-Graefean conception of inexorable Modernist progression, itself now seen as rather myopic and suspect. These painters were not willing to jettison "significant" subject matter any more than they were willing to throw overboard the accumulated skills and knowledge of their own immediate academic training, so dearly achieved, and the totality of still-respected if no longer revered tradition. In fact, part

of their attractiveness and very possibly a sound measure of their skill and achievement lies in the balanced ratio of Modernism and tradition in their explicit concern with the contemporaniety and significance of their subject matter.

These artists of the "juste-milieu" —to use the accepted French term which, while applicable to these painters, must take on wider import and international usage —can be found in all nations. What they share aesthetically —at least what one large and perhaps the most significant group of them share —is what I shall term here the "Glare" aesthetic.[2] These artists were interested in the effects of intense daylight, portrayed in strong tonal contrasts, often achieving the powerful effect of glare from reflecting surfaces. Thus flat, or near-flat, areas and surfaces are often significant spatial forms in their paintings. These may appear as broad areas of background or horizontal "support" areas on which figures, merchandise and buildings stand, but they function more significantly than only in such a passive manner. They are mirrors from which dazzling sunlight is reflected back toward the spectator and upon which strong silhouettes of still clearly rendered forms may be cast, allowing for the intensification of color and light without dissolution of form.

Barbara Novak, in her very significant *American Painting of the Nineteenth Century,* deals essentially with this phenomenon as a distinctively national one, but it is precisely *not* that. It may be found in the art of all Western nations. For example, Ford Madox Brown's marvelous *Pretty Baa Lambs* of 1852 is a quintessential Pre-Raphaelite canvas. It is known to have been painted in the intense heat of the summer completely out-of-doors (much to the artist's extreme discomfort), but despite the extra-ordinary intensity of color it is totally lacking in any suggestion of proto-Impressionist divisionism. Moreover, not only are forms precisely rendered, but they reflect light, rather than absorb it. In the same decade, the great German artist Franz von Lenbach painted peasant boys resting in the Italian Campagna in brilliant sunlight, but the rendering here is again based upon tonal contrast and the effects of glare, which Lenbach heightens by the introduction of colored umbrellas or parasols which are not only centralizing formal, compositional accents but act as large reflective surfaces for colored light, where the natural settings provide no broad expanses of pavement or wall. The Austrian artist, Ferdinand Waldmüller, in his joyful peasant scenes, intensified his light in a similar manner, but it is used to render form and detail *more* exactly, not to submerge them. Tonal glare effects can be found in the works of the aforementioned Spanish artist, Mario Fortuny, particularly in such informal works as his *Nude on the Beach at Porticini* or his watercolor *Faithful Friends* of 1869, where the wall behind the old man and his dog functions as a brilliant reflective surface.

Reference to the work of Lenbach and Fortuny painted in Italy suggests that Italy was a center for the development of this alternative light aesthetic and perhaps even suggests a peculiar characteristic of Southern, Italian light that led to such development. The latter is at best only partially true, though it is inevitable that given the partial or complete interest in outdoor Nature painting which developed from the mid-century on, artists concerned with the rendition of intense sunlight effects would be drawn more toward regions where they were more manifest —Italy more than the greyer climes of Norway or Scotland for instance —but it should be recalled after all that Impressionism developed in Northern France.

Even so, much of the Glare aesthetic in Europe can be seen in the work of artists active in Italy, whether foreign or native-born. Many of the smaller paintings of the Macchiaioli are Glare pictures; Fattori's *White Wall* indeed might be considered a quintessential example. In the late 1870s and early 80s—contemporary with fully Impressionist painting in France—Venice was an extremely important center for artistic development, and painters from all over Europe and also from America gravitated there, exchanging ideas and influencing one another. The beautiful outdoor market scenes by the outstanding Venetian painter Giacomo Favretto function as effectively as they do, in part at least, because of light reflected off the broad expanse of pavement which acts as a foil for the intense color and activity of the milling peasant figures who dominate the scenes. A decade or more earlier, in his landscapes and canal scenes, Guglielmo Ciardi was investing his views with intense sunlight, reflected off village paths, building walls and the still waters of Venice. (Ciardi's later Venetian scenes involve more broken brushwork and mottled colors and find strong parallels in the work of the local American expatriate-in-residence there, William Gedney Bunce.)

Foreign artists in Venice in the eighties shared the Glare aesthetic with the local painters. Fortuny's follower Martin Rico, in his multitude of Venetian canal scenes, combined the scintillating, flickering brushwork of his Spanish mentor with a passion for flat reflective surfaces—building walls, canal waters, and sky. One of the features of Frank Duveneck's immensely complex art of the 1880s, much of it painted in Venice, is its relationship to the painting of Favretto and other Europeans working there, Italian and otherwise. Compared to his Leibl-influenced figures of the previous decade done in Munich, it appears more "academic," but it is also brighter and more light-filled, and while the intensity of the light-reflecting planes of architecture is not as great as Favretto's, it is certainly related. This reflective, Glare aesthetic, again on a more muted level, also can be found in the park scenes done at the end of the 1880s and in the early 1890s in New York by Duveneck's former Munich colleague, William Merritt Chase.

What has been termed the "Glare" aesthetic here had, in fact, affected American art earlier. If recognized in natural, rather than architectural, components of paintings, it is, in effect, a major aspect of the movement which, since its identification by John I. H. Baur in 1954 and its characterization by him earlier, in 1948, has been termed "Luminism"—the keystone to Novak's thesis of a peculiar identification of American light and its pictorialization. But Luminist landscapes, those emphasizing tonal light reflecting from flat, usually watery, surfaces, can be found from John Brett's English seascapes from the 1860s on, to Gregor Soroka's and Alexander Ivanov's lake and marsh scenes painted in Russia in the mid-19th century.[3] They are contemporary too with the long, Luminist landscapes of the Macchiaioli and Ciardi's Venetian canal scenes, and the work of the men of the Etruscan School active in Italy in the 1850s and 60s, including the Italian, Giovanni Costa, and the Englishmen, George Heming Mason and Frederick, later Lord, Leighton.[4]

The distinction between the American Luminists, at their creative peak in the 1850s and 60s, and the subsequent generation which participated at times in the Glare aesthetic is one more of chronology, training and subject matter than of primary aesthetic orientation. The Luminists were earlier artists, still concerned with an almost religious celebration of Nature—usually, though not always, American Nature—in which they recognized and experienced

the hand of the Almighty. The later artists utilized light in a more purely phenomenological way. Transitional to this group is a small body of paintings by Winslow Homer, perhaps above all *An Adirondack Lake* of 1870, which supply a convenient date between the earlier and later phases of this particular investigation of light. Though the atmosphere has not entirely lost the palpableness of Luminism, Homer conceives of the broad expanses of lake and sky in more completely planar terms, and the foreground forms of boat, log and the guide with the oar are strongly lit and silhouetted against those flat planes, all of which are tonal.

Tonal light and glare are manifest in major works painted by Americans on both sides of the Atlantic during the next decade, more a matter of international aesthetic continuum and *Zeitgeist* than of individual influence or specific common sources. They are noteworthy in the outdoor paintings by Thomas Eakins, done in and around Philadelphia during the first half of the 1870s, where light is used in a manner quite different from that found in his indoor figure and genre scenes of the same period. It is especially characteristic of the earliest and greatest of his Schuylkill sculling scenes, *Max Schmitt in a Single Scull* of 1871, conceived in large, tonal areas, where light clarifies and particularizes, and reflects strongly off of the surfaces not only of sky and water, but of bridge, scull, and Schmitt himself.

Eakins' principal Parisian master, Jean-Léon Gérôme, was not an artist primarily concerned with the recording and interpretation of natural phenomena and certainly not one of the major practitioners of the Glare aesthetic. Yet, art historians should be cautious in over-simplifying categorizations, and some of Gérôme's Egyptian scenes in particular not only display an interest in the appearance of tonal light but offer precedents for Eakins' sculling pictures in compositional components as well. This seems to be especially true of the earlier Egyptian scenes done after Gérôme's first trip to Egypt in 1856 and before the second of 1867, though some of his non-anecdotal, pure landscape subjects of Egyptian villages and caravans are characterized by the Glare aesthetic. Flat, reflective areas of sky and water figure prominently in such pictures of the early sixties as his *Excursion of the Harem* of 1862, *The Prisoner* of 1863, and *Prayer on the Rooftops* of 1865, all painted in the years just prior to Eakins' study with the master.[5]

The most complete expression of the Glare aesthetic by an American artist is found in the art of another pupil of Gérôme's, William Lamb Picknell. Picknell, an artist of the first rank who died tragically young,[6] studied landscape in Rome with George Inness in 1874 and in 1876 began to work with Gérôme. This was the source of his technical proficiency, but his expressive powers manifested themselves when he joined the international colony of artists at Pont-Aven in Brittany, which contained a large American group under the leadership of Robert Wylie. Many of Picknell's subsequent landscapes are moving, poetic pictures emphasizing diffuse light, grey against an overcast sky, but his fame was established, and continued to rest, upon a series of "road" pictures, beginning with his most renowned work, *Road to Concarneau* of 1880, including *On the Banks of the Loing,* and concluding with his *Road to Nice* of 1896. The *Concarneau* and *Nice* pictures, particularly, are brilliant studies of strong sunlight, reflected in dazzling planes of light from deeply receding roadways, a late 19th-century spatial emphasis which is again a concern internationally and which can be identified in the works of such diverse painters as the Italian Giuseppe

## William Lamb Picknell

*Road to Concarneau.* 1880

Oil on canvas
42-⅜ x 79¾ in. (106.8 x 202 cm)
Corcoran Gallery of Art

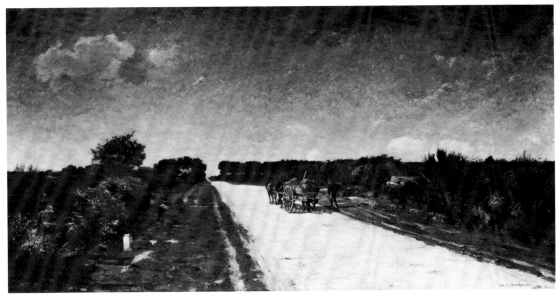

1. Hamlin Garland, "Impressionism," *Crumbling Idols: 12 Essays on Art,* 1894, new edition, Cambridge, Massachusetts, Harvard University, Belknap Press, 1960, 97-110.

2. My formulation of the Glare aesthetic derives from my discussion with Michael Quick in 1973; I would like to acknowledge my gratitude to Quick, now curator of American Painting and Sculpture at the Los Angeles County Museum of Art.

3. For the international implications of Luminism see my *American Luminism,* Coe Kerr Gallery, New York City, 1978, and Theodore E. Stebbins, Jr., "Luminism in Context: The Work of Ivan Konstantinovich Aivazovsky and Other Considerations," for a show concerned with the pictorialization of American light to be held at the National Gallery of Art in Washington, D.C., in 1980.

4. *The Etruscan School,* exhibition held at The Fine Art Society Limited, London, 1976.

5. Historians are beginning to recognize Eakins' close aesthetic links with his Parisian teachers as well as with contemporary European art in general. The most pertinent article here is Gerald M. Ackerman, "Thomas Eakins and His Parisian Masters Gérôme and Bonnat," *Gazette des Beaux-Arts,* n.s. 6, Vol. 73 (April, 1969), 235-56.

6. See Edward Waldo Emerson, "An American Landscape-Painter: William L. Picknell," *The Century Monthly Magazine* [hereinafter *Century*], Vol. 62, no. 5 (September, 1901), 710-13.

7. Otto Stark, "The Evolution of Impressionism," *Modern Art,* Vol. 3, no. 2 (Spring, 1895), 54. The article has been reprinted in Leland G. Howard, *Otto Stark, 1859-1926,* Indianapolis Museum of Art, 1977, 58-60.

de Nittis, the American Childe Hassam, the Frenchman Gustave Caillebotte and the Dutchman Vincent Van Gogh.

The existence and significance of the Glare aesthetic did not go unnoticed by American critics. The most interesting discussion of it can be found in the article by the Indiana painter Otto Stark that appeared in *Modern Art* in 1895 on "The Evolution of Impressionism." Discussing American pictorial development since the Philadelphia Centennial in 1876, Stark oversimplified that development defining a series of coloristic approaches which he called the "black movement," the art of the Munich school; the "gray movement," the American followers of Bastien-Lepage and French plein-airism; the "high-key movement," attempts to approach pure white in the palette; and concluding, of course, with the "color movement" of Impressionism.

Stark saw each of these phenomena, in reality often concurrent and overlapping, as leading one into the other. Yet, he recognized the aesthetic preoccupations of many of America's foremost artists and saw a development that did, to some extent, occur sequentially. Picknell's "road" pictures, introduced to great acclaim in 1880, would, of course, correctly occupy the premier position of advanced landscape painting before the introduction of Impressionism, the "high key" in painting as Stark termed it, "which meant to paint as light and as near white as the palette would allow, and well do I remember walking through exhibitions where a large percentage of canvases looked like white-washed fences, the paint being plastered on in a manner which reminded one of mortar put on with trowel of a stone mason." [7]

For Stark however, and for countless other American artists, "still, it was not sunlight." The French Impressionists created a theory and a system which, precisely because it offered a unified approach to the interpretation of colored light, became internationally the dominant aesthetic in that investigation. The manifestation of the "Glare" aesthetic, which was in no way a prior stage or an example of "Proto-Impressionism," was submerged in the history of the investigation of light in later 19th-century painting by the Impressionist triumph.

*Morning, Catskill Valley.* 1894
Oil on canvas
33⅜ x 54 in. (84 x 137.2 cm)
Santa Barbara Museum of Art, Preston
Morton Collection

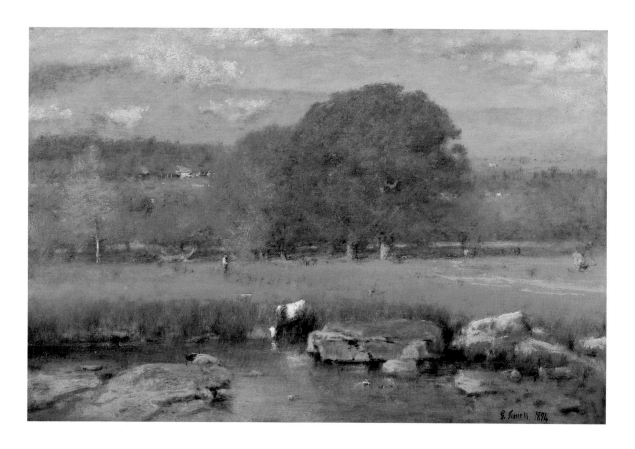

The notes for this chapter will be
found on page 25.

*The Olive Grove.* ca. 1910
Oil on panel
23¼ x 33¼ in. (58.4 x 83.9 cm)
The Daniel J. Terra Collection

# 3 Landscape and Light in American Painting of the 1880s

When America — her artists, critics and collectors — first became aware of the various manifestations of Impressionism, during the 1880s, the then-dominant trend in American landscape painting was an inheritance from French Barbizon traditions. One of the two major proponents of Barbizon aesthetics, the Bostonian William Morris Hunt, had lately died, in 1879; his was the more direct and more frankly acknowledged espousal of French leadership, and, as a figure painter primarily, he was more an admirer of Jean François Millet than of the French landscape specialists. He was not the only one; perhaps no 19th-century French artist was written about and extolled in American periodical literature as much as Millet.

George Inness, however, was very much alive and was, by 1880, recognized as the foremost American landscape painter then active, and seen as the greatest one the nation had produced. His landscape aesthetic, akin to that of the French Barbizon painters, emphasized broad masses of form, richer and increasingly loosely handled paint qualities, and a concern with elements of weather and time of day, and with Nature's moods and character, all infused with a quasi-religious, Swedenborgian spirituality. The dissolution of natural forms in his later works — those done after he settled in Montclair, New Jersey in 1878 — and the increasing lack of topographical references, were, and were interpreted as, a reaction against the microcosmic detail of the Hudson River School and the concern with spectacle of such still active masters as Frederic Church and Albert Bierstadt.

Inness' position in regard to Barbizon aesthetics is easily understood and appreciated, but the issue of his influence upon his American contemporaries is more complex, for original works by Corot and his French contemporaries were being brought to America in increasing numbers, both by the wealthy collectors themselves after the Civil War and by the new phenomenon of the commercial art establishment.[1] The nationalistic "buy and paint American" of the 1840s and 50s was replaced by the patronage of European culture, perhaps of French art and *objets de vertu* especially.

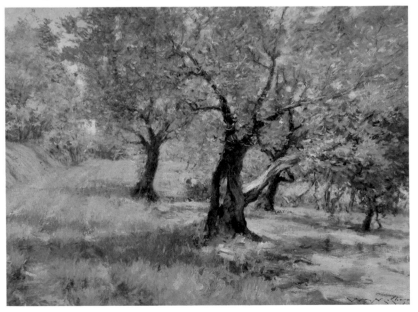

A new artistic climate was created when this radical change in American cultural orientation interacted with the establishment of art galleries and art advisors, and the mass exodus of young American art students, primarily to the ateliers of Paris where they could hope to learn the technical rudiments necessary to allow them to compete with the foreign academic masters whose works were enjoying tremendous American patronage. Inness was, of course, the antithesis of the academic painter, but the espousal of things French or French-related by the new patron class in search of an instant cache of culture is a factor that must be considered in the success both of Inness and Barbizon painting, and of the next generation of American Impressionists also.

Inness' later work, that of the late 1880s and the early 1890s is, indeed, close to Impressionism, especially in its emphasis upon thick, colored atmosphere in which forms are all but completely dissolved. It would be difficult, in fact, to believe that Inness' painting was not affected by the growing number of examples of Impressionistic painting that were appearing in American exhibitions and collections at exactly that time, but the artist's own reaction to the identification of his work as Impressionistic was not only negative but hostile. As early as 1879, Inness was aware of the new movement and wrote thusly about it:

*Impressionism has now become a watchword, and represents the opposite extreme to Pre-Raphaelitism. It arises from the same skeptical scientific tendency to ignore the reality of the unseen. The mistake in each case is the same, namely, that the material is the real. It was supposed by the founder of the Impressionist school that the aesthetic sense could be satisfied by what the eye is impressed with. The Paris Impressionists a few years ago had so nearly succeeded in expressing their idea of truth, that only flat surfaces, the bounds of which represented, at some points, defined forms, appeared on their canvases. Everything was flat. But God's truth is only made more evident by such error, and the exhibition failing serves to restrain further attempts. Science now teaches that it is the inexperienced eye that sees only surfaces, and the efforts of Manet and others to reduce their aesthetic culture to zero was wonderfully attained.*[2]

Inness was to repeat his strong objections to Impressionism and to continue to compare it, equally negatively, to Pre-Raphaelitism in a letter to the editor of the Tarpon Springs, Florida *Ledger* and in his famous letter written in 1884 from Goochland, Virginia, to the art writer and critic, Ripley Hitchcock, where he said:

*While PreRaphaelitism is like a measure worm trying to compass the infinite circumference, Impressionism is the sloth enrapt in its own eternal dullness. Angularity, rotundity involving solidity, air and light involving transparency, space and color involving distances, these constitute the appearances which the creative mind produces to the individualized eye and which the organized mind endorses as reality. A representation which ignores any one of these elements is weak in its subjective and lacking in its objective force and so far fails as giving a true impression of nature.*[3]

Inness' objections to Impressionism were taken up by many critics: they objected on the one hand to the elimination of traditional naturalistic elements and, on the other, to the lack of spiritual undertones. Inness' earlier statement suggests also that he had seen the first Impressionist show in Paris in 1874, illustrating curiosity and perspicacity rare in Americans of the period; even a decade later most American artists in Paris seemed almost

oblivious to newer artistic trends.

Inness' later paintings represent also the most eloquent expression of what has been defined as Tonalist landscape painting. This subject, so perceptively studied in recent years by Wanda Corn, was a recognized art movement in its own time; it was also interpreted around the turn of the century as a distinctively national school of art by critics still searching for Americanisms which seemed so remote from the French-dominated aesthetics of Barbizon painting and Impressionism.[4]

Tonalism may be seen as an artistic descendant of Barbizon art, and was contemporary with Impressionism, but the Tonalists held that Impressionism was generally too realistic, and that their own alternative interpretation of Nature allowed for the introduction of heightened spiritual values. Tonalism meant the prevalence of one single tone or color over all others, though it also came to mean the creation of an envelope of atmosphere filling the canvas, creating blurred edges and a lack of definiteness. Such characteristics were shared by many Impressionist works, though the Tonalists made far greater use of neutral tones. They preferred to exploit evocative half lights, emphasizing fog and mist, and locating the scene temporally at dawn or at dusk. Tonalist landscapes emanated reverie, nostalgia and longing, and if figures were introduced they were depersonalized, inactive or even dissolved.

Today, the major Tonalist landscape painters are usually identified as J. Francis Murphy and Dwight Tryon, both of whom enjoyed tremendous popularity and patronage during their own lifetimes. Their works, too, are quite similar: rather empty landscapes, "peopled" usually with frail, wispy trees somewhat akin to those that appear in the late landscapes of Camille Corot. The typical Murphy landscape depicts a clump of delicate trees on one side of a hazy, flat, marshy scene, and a smaller, more tentative group further back on the other side; that is all. Tryon preferred to range his tenuous, spindly trees in a row, parallel to the picture plane, in the middle distance, creating a screen that blocks the viewer's eye from traveling further back, not so much because of the density of the foliage but the implied emptiness beyond. Tryon occasionally employed a slightly more lively somewhat more prismatic palette than did Murphy, adopting a modified Impressionist chromatic scheme. He was also attracted by the subtleties of Japanese art, and the more geometric nature of his compositions as well as the silence of his empty landscapes suggest his admiration for the murals of Puvis de Chavannes.

In 1906, however, when Clara Ruge wrote about Tonalism, it was Henry Ward Ranger, not Murphy or Tryon, who was identified as the head of the movement. He was a slightly younger man, and the first, in 1899, to go to Old Lyme, Connecticut, which became an art colony of late Barbizon, or Tonalist, aesthetic persuasion, centering around the Florence Griswold house. The 1914 *Art-Talks with Ranger* became the official statement of Tonalist method and purpose, where the artists' goal was the fusion of all elements of Nature's lyric beauty, achieved through the depiction of colored light broken by the emergence of colored surfaces.[5] Ranger described as Tonalists almost all the major American landscape painters of the late 19th and early 20th centuries, including the Impressionists J. Alden Weir and John Twachtman. Twachtman was generally the one exception to the Tonalists' rejection of Impressionism as too spiritually vacuous. By the time Ranger's talks appeared, however, Tonalism was already in decline. It was

gradually displaced, first by Impressionism and then by more vigorous aspects of 20th-century Modernism, and criticized as being too much allied with Aestheticism, not bold or adventuresome enough. To attain greater force and to infuse it with a sense of life, Tonalism had in fact, both in painting and photography, moved into the city, particularly in the urban nocturnes of Birge Harrison. These interpretations of the avenues and skyscrapers of New York seen in enveloping nocturnal darkness reveal more clearly than the landscapes of Murphy, Tryon and Ranger the other primary source of Tonalism: the well-known and much admired painting of the American expatriate James McNeill Whistler. Harrison was often a subtle painter, capable of achieving beautiful effects. He was also one of the leading painter-writers on art at that time, and among the landscapists assumed a significant critical position along with Arthur Hoeber. Harrison also conducted the Art Students' League summer school at Woodstock, New York at its founding in 1912.

Even the rejuvenating force of the city, however, could not prevent Tonalism from paling before the urban vitality of The Ashcan School. Yet the Tonalist movement numbered among its adherents one of the finest American painters of the late 19th and early 20th centuries, and one of the artists equally associated with American Impressionism. This was Thomas Wilmer Dewing. Dewing was one of the members of The Ten American Painters and thus qualified in contemporary critical estimation as a "certified" Impressionist, but his aesthetic was basically Tonalist. Nevertheless, he was distinct among the artists of the school listed by Ranger and, in fact, unique in his approach. He was *the* Tonalist figure painter.[6]

Dewing grew up in Boston. Like the vast majority of his fellow American art aspirants, he went to Paris and there he studied with Jules Lefebvre, learning those elements of correct academic method — the structure of the human form, the drawing of precise outline, the ability to render movement by the understanding of body locomotion — which always underlay his figure painting, even when he might seem to have abandoned those qualities. His earliest mature work, done in the late 1870s, is tightly structured and suggests artistic sympathies actually more English than French: aesthetic and stylized women, boys and animals that bear a kinship with Albert Moore's, and especially those of Lawrence Alma-Tadema. The classical setting, the precision and the rendering of highly polished marble suggest such a relationship, but even this early, the emphasis upon things feminine and ethereal, a concern with suggestion rather than realization in the activities and motivations of the figures, and the elegant elongation of forms suggest the direction of Dewing's later art. The change in his aesthetic appears to have taken place in the late 1880s; in his 1886 *Wood Nymph* (painted by Dewing and his wife, Maria Oakey), and *The Days* of 1887 forms are still tightly, meticulously rendered; by 1891, in *The Recitation,* a diffuse, light-filled atmosphere envelopes the figures. It is probably not coincidence that this shift occurred after the work of Jan Vermeer, first brought to public attention in 1866 by Theophile Thorè, was further presented by Henry Harvard, first in the *Gazette des Beaux-Arts* in 1883 and then in a monograph in 1888.

Dewing's art was to retain a kinship with English painting, with later Pre-Raphaelitism and the Aesthetic movement. Though a figure painter and draftsman — indeed one of the finest and most subtle yet precise of

*Connecticut Woods.* 1899

Oil on canvas
28¼ x 36¼ in. (71.7 x 91.9 cm)
National Collection of Fine Arts,
Smithsonian Institution, Gift of William T.
Evans

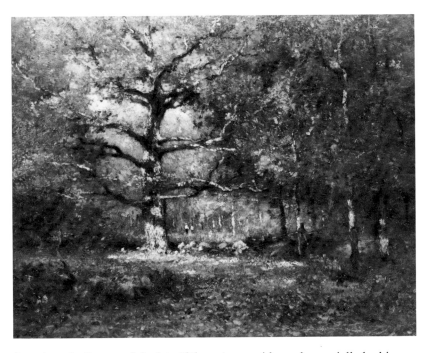

American draftsmen of the late 19th century, evidenced especially by his pastels and silverpoint drawings — his art is totally removed from anecdote. His subject is Woman. He painted her almost always clothed though he drew her nude, occasionally in groups but more often alone, and sometimes in outdoor settings though usually indoors. Her activity is nearly always *inactivity.* His women often are seated, though those depicted in the out-of-doors occasionally stand; they do not stride. They may hold a book, but seldom read it. They may hold a lute or sit at a spinet, and the instruments of music are themselves of great delicacy and fineness, paralleling the extreme elegance of the figures. The spectator can almost conjure the music itself, delicate and faint echoes that would merge with the very palpable atmosphere which envelops the scene.

The sense of harmony that dominates Dewing's paintings is at once one of form and of interpretation. These are Tonalist pictures, in which one color is ascendant, describing the gown of the woman or women depicted, reflected in her flesh and infusing the atmosphere of the whole. That color is often stated in the titles of his paintings: *Lady in Gold, Lady in White,* etc. The colors themselves are never dark, never strident; indoors they tend often toward the golds, russets or violets, harmonious with indoor light; outdoors, they are, naturally, more often an overall green.

While Dewing's figures are frequently depicted alone, they never suggest distress or really even ennui. They are too much transfixed in a state of timeless reverie and this, together with the simple but elegant, long, flowing gowns they invariably wear, suggest a relationship with the later 19th-century renewal of the classical spirit, so beautifully stated in England by Albert Moore, and for a short while enthusiastically adopted by Moore's friend Whistler, who was also an influence upon Dewing. It is in fact extremely fitting that the greatest collector of the works of Whistler and Dewing was Charles Freer, and that their works now hang together in the Gallery he endowed in Washington, D.C.[7]

In their slender, aristocratic, thin-boned physical development and their attenuation, Dewing's women are also similar to the figures that appear in the upper-class social dramas — extremely popular on both sides of the Atlantic — that were painted in England by Sir William Quiller Orchardson, who was, significantly, a close friend of Whistler's. Likewise, the spatial sparseness, the vast caverns of emptiness populated only by thin-boned ladies and a few fine pieces of furniture, glass and pottery, is similar to the works of both these artists, but Dewing eschews the socially dramatic situations which motivate Orchardson's figures for concentration upon poetic expression, enigmatic in a quasi-Symbolist manner, but never with morbid or even hallucinatory overtones. Only Sadakichi Hartmann found a slight touch of the Parisian demi-monde in Dewing's works, suggesting that the women he depicted were reading Swinburne.

Beauty, subtle and delicate, was Dewing's artistic motivation. He criticized a still life of his friend, Abbott Thayer, in stating, "Beautiful roses, Thayer, but why did you put them in an ash barrel?"[8] A harmony of refinement characterizes his work completely: refinement not only of figures, but of their costume, their setting and the manner in which all is rendered — form, light and atmosphere. Certainly he received an impetus toward that refinement in the contemporary enthusiasm for Oriental art, but perhaps the major influence upon his mature style was that of the newly-rediscovered Vermeer. It is natural enough that Dewing would gravitate toward the Dutch little masters rather than the monumental imagery of Rembrandt or the vivacious bravura of Frans Hals which so attracted his Munich-trained colleagues, and the reemergence of Vermeer from almost complete obscurity at the end of the 19th century afforded Dewing a model for both the infinitely subtle effects of light-filled atmosphere in sparse interiors and the painting of elegant women quietly depicted without anecdotal drama. It is this last quality and kinship which differentiates Dewing's paintings from those of his Boston contemporaries such as Edmund Tarbell, Frank Benson and William Paxton, in which a sense of the specific in both individual definition and their activity of the moment is far more pronounced, but then, the figures in the work of these Boston artists exist in real and specific settings. Dewing's environments seem purposefully vague and often endless, particularly when he depicted his women in at least nominally outdoor settings.

Dewing was primarily an artist of easel paintings though his graphic work is also outstanding. He painted some works in concert with his wife, Maria Oakey Dewing, one of the finest flower painters of the period, in which Thomas depicted the figure and Maria added the still-life and nature elements. His works of the 1880s were more purely decorative than those of the last decade of the 19th century and thereafter, and he painted a number of multi-paneled screens in the decorative manner also. In these he combined the contemporary concern with fine products of art and craft with the vogue for things Japanese. He occasionally painted a fine portrait, as that of the architect Joseph M. Wells, and was involved in mural decoration in New York's Hotel Imperial at Broadway and 31st Street. But once the dominant subject and form of his art was determined, about 1890, little change or development seems discernable, at least until more in-depth scholarly study is made of this intriguing artist and his extremely beautiful works.

The other progressive group of artists that developed in the 1870s and

emerged as a dominant force in American painting at the end of that decade were those painters who studied in Munich. All of them, and several even in the preceding decade, had gone to Munich to study at the Royal Academy there, a viable alternative to Paris, cheaper and in some ways easier of access, particularly for the many young art students of Germanic heritage, who often came from the Midwest. Most of these young men had come under the influence of Wilhelm Leibl and his circle, who had abandoned the emphasis upon the traditional academic manner of painting and traditional subject matter also, for vivid, dark and dramatic compositions harking back aesthetically to Rembrandt and Frans Hals, and reflecting the heroic realism of peasant imagery found in the work of the contemporary French painter, Gustave Courbet, who himself had been Leibl's principal inspiration.

The dominant figure among this group of young Americans was the Cincinnati painter, Frank Duveneck, who in turn gathered many American art students around him, first in Munich and in the late 1870s in Italy, where he took the "Duveneck Boys" to Florence and Venice. Among the other figures active in this group were William Merritt Chase, J. Frank Currier and Walter Shirlaw. These young painters were instrumental in the founding of the progressive Society of American Artists in New York City in 1877, which challenged the conservatism of the National Academy of Design. The earlier exhibitions of the Society, which began in 1878, were noticed by the critics for the predominance of Munich inspiration, with dramatic chiaroscuro and a vivid use of paint, though many works in their exhibitions were American Barbizon. Gradually, however, the Society's shows became more and more Impressionist and lost the dark palette of Munich.

Duveneck's own art is fascinating and complex, and his Venetian pictures of the 1880s differ markedly from the slashing, painterly dark tones of his Munich residence. But they are not Impressionist. They do reflect a general artistic concern with light, and may well relate also to the work of contemporary Venetian painters such as Favretto with whom they share both similar subject matter and elements of the Glare aesthetic. Much later, in the early years of the 20th century, Duveneck painted some landscapes at Gloucester in which he utilized a full prismatic palette, but even here strong outline and structural emphasis still dominated.

The most influential of the Duveneck Boys, William Merritt Chase, was also one of the painters whose style later became allied to Impressionism.[9] In the 1880s, Chase also abandoned the dark tones of Munich for a blond palette which, combined with the more scintillating brushwork of Munich, became the basis for his later painting, both figure and landscape work. The outdoor park pictures begun when he first moved to Brooklyn in 1887, depicting Prospect Park and then Central Park, are vivid renderings of light and reflection in the open. The park scene became a staple of Impressionist work in America, and Chase precedes Maurice Prendergast in his concentration upon the subject. In many of these pictures of *circa* 1890, Chase emphasizes a vivid rush back into space, with long perspective lines meeting abruptly in the rear. In such works, Chase parallels the interest in spatial distortion of the period which can be found among such diverse artists as Van Gogh and De Nittis, previously mentioned. Such spatial manipulation is fascinating and lends great vitality to these little pictures; it also counteracts the flatness implicit in much Impressionist art and may in part be a Modernist reaction against Impressionist limitations.

In 1890, Chase first visited Shinnecock, on Long Island, and favorably received the suggestion of opening a school there, which he did the following year. His Art Village was the first organized school in America where painting was taught in the open air. The school went on for eleven years, and in 1892 Chase built a house at Shinnecock. Some of his finest landscape painting was done at Shinnecock during these years, colorful pictures filled with the light of day and a sense of air and great expan-

siveness. The horizon is often very low and the compositions are invariably open-ended, so that even the smaller canvases achieve panoramic breadth, while the brushwork applied both to the dunes and scrub foliage, and the brightly-garbed figures often sparkles. Chase seldom employed the full, prismatic color scale, however, and his skies are often clear and tonal. He did not, perhaps, fully commit himself to the precepts or practices of Impressionism at this time; rather, in his Shinnecock paintings he approaches the aesthetic stance of Eugene Boudin, Monet's teacher.

Chase, however, became a member of The Ten American Painters, although he was not one of the original group; he took the place of John Twachtman when the latter died in 1902. In 1907 he began having summer classes in Florence, Italy, and the technique in some of the work produced during those years, *The Olive Grove,* for example, is handled in a more conventional Impressionist manner than that of the earlier Shinnecock pictures, the later ones exhibiting strongly impastoed paint and short, comma-shaped flecked brushwork. Throughout Chase's career, the Munich concerns of the 1870s continued, not the dark and dramatic method, which he practiced further only in his later still lifes, but the concern with technical expression and virtuosity. The *practise* of his art was its own *raison-d' etre,* this, rather than the interpretation of nature, of air, light and atmosphere. But these same factors which qualify so much of his near-Impressionist painting made him the most significant teacher in America of his time — at Shinnecock, at the Art Students' League, at the Chase School in New York which he founded in the last decade of the century, and with the classes of students he took abroad.

One of the more significant artists among the Duveneck Boys was Otto Bacher, but his achievements and his fame are far better recognized in the graphic arts than in painting.[10] Bacher was born in Cleveland, Ohio, and studied there with De Scott Evans; he went to Munich in 1878 where he continued to paint but also began to work in etching. He was in Venice in 1880 with Duveneck, along with Chase, and met Whistler, whose engagement to produce a series of prints of Venice for London's Fine Art Society was seminal to Bacher's later art. Bacher returned to America in 1883, but like many Munich-trained painters — John Twachtman was another — he went for further study to Paris. He was there from 1885-88; when he came back to this country, he settled in New York City and was active with the Society of American Artists. Bacher continued to paint and also was a significant practitioner of pastel painting, but he established his reputation as an etcher. Few of his oil paintings have so far come to light, but these, such as his *Nude Outdoors* of 1893, reveal him totally committed to the aesthetic of Impressionism at just the time when the dominance of that movement was recognized. It is totally Impressionist, that is, while still not abnegating the sense of form and firm contour, the heritage of Bacher's academic training. But the interest in light and color and an emphasis upon bright sunshine is quite dazzling, the artist attempting not unsuccessfully to interpret the quintessential academic subject in the most modern aesthetic. His purpose is enhanced by the sloping, colored landscape background which engulfs the nude figure and pushes her forward against the picture plane.

1. The now-classic study of American art and its relationship to the Barbizon School is the essay by Peter Bermingham in the catalogue *American Art in the Barbizon Mood,* National Collection of Fine Arts, Washington, D.C., 1975, which is drawn in part from the same author's "Barbizon Art in America," unpublished Ph.D. dissertation, University of Michigan, 1972. In America the number of volumes and periodicals written on French art in the 19th century, usually Barbizon painting, was enormous. Among the major studies that should be mentioned are Arthur Hoeber, *The Barbizon Painters: Being the Story of the Men of Thirty,* New York, Frederick A. Stokes, 1915; John La Farge, *The Higher Life in Art,* New York, McClure, 1908; and Charles S. Smith, *Barbizon Days: Millet-Corot-Rousseau-Barye,* New York, A. Wessels, 1903.

2. "Mr. Inness on Art-Matters," *The Art Journal* (New York), Vol. 5 (1879), 377.

3. The letter is reproduced in the catalogue *George Inness of Montclair,* Montclair Art Museum, Montclair, New Jersey, 1964, unpaginated.

4. Wanda M. Corn, *The Color of Mood: American Tonalism 1880-1910,* M. H. de Young Memorial Museum and the California Palace of the Legion of Honor, San Francisco, 1972. For an earlier estimation, see Clara Ruge, "The Tonal School of America," *International Studio,* Vol. 27, no. 107 (January, 1906), lvii-lxvi.

5. Ralcy Husted Bell, *Art-Talks with Ranger,* New York, G. P. Putnam's Sons, 1914. A study of the art colony at Old Lyme can be found in Grace L. Slocum, "Old Lyme," *American Magazine of Art,* Vol. 15, no. 12 (November, 1924), 635-43.

6. The bibliography on Dewing is, to date, surprisingly sparse. Articles by Charles H. Caffin, Royal Cortissoz, Catherine Beach Ely, Sadakichi Hartmann, Homer Saint-Gaudens, Ezra Tharp, and Nelson C. White will be found in the bibliography following this essay; White more recently wrote the short essay in the catalogue *Thomas W. Dewing* for the exhibition of Dewing's work at the Durlacher Brothers Gallery, New York, 1973.

7. See Royal Cortissoz, "American Artist Canonized in the Freer Gallery," *Scribner's Magazine,* Vol. 74, no. 5 (November, 1923), 539-46, and Leila Mechlin, "The Freer Collection of Art, *Century,* Vol. 73, no. 3 (January, 1907), 357-70.

8. White, *Thomas W. Dewing,* unpaginated.

9. The standard study of Chase has been by his pupil Katherine Metcalf Roof, *The Life and Art of William Merritt Chase,* New York, Scribner's, 1917. Ronald G. Pisano recently published, too late to review here, a major study, *William Merritt Chase,* New York, Watson-Guptill, 1979. See also the exhibition catalogues for which Pisano wrote essays: *The Students of William Merritt Chase,* Heckscher Museum, Huntington, New York, 1973; *William Merritt Chase (1848-1916),* M. Knoedler & Co., New York City, 1976; and *William Merritt Chase in the Company of Friends,* Parrish Art Museum, Southampton, New York, 1979.

10. The substantial monograph by William W. Andrew, *Otto H. Bacher,* Madison, Education Industries, 1973, is concerned almost totally with Bacher as a graphic artist.

**Edgar Degas**

*Ballet Rehearsal (A Ballet).* **1874**

Gouache and pastel on paper
21¾ x 26¾ in. (55.3 x 68 cm)
Nelson Gallery — Atkins Museum, Kenneth
A. and Helen F. Spencer Foundation Fund

The notes for this chapter will be
found on page 31.

# 4 Impressionism in America: Its Reception and Terminology

A discussion of the introduction of Impressionism into America inevitably owes a debt to the superb article by Hans Huth, "Impressionism Comes to America," which appeared in the *Gazette des Beaux-Arts* in April, 1946.[1] Such a discussion must also take into account the roles played during the crucial years of the 1880s and early 1890s by the dealers and commercial galleries and also by the contemporary periodicals. Both these factors of American artistic life, particularly strong, then as now, in New York City, had been on the rise during the post-Civil War decades. Before those years of conflict, dealers were few and of limited significance; artists tended to sell from their studios or from public exhibition, or painted works on commission. Commercial outlets were few, outside of occasional exhibition in frame shops, bookstores and the like, and what few true commercial galleries were established functioned primarily to merchandise European art. Only a few magazines devoted solely to the world of art existed, and with the exception of the pioneering publication, *The Crayon,* of 1855-60, those magazines were literary organs of art organizations, functioning as promotional mouthpieces and succumbing with the associations themselves.

The situation changed dramatically in the years after the Civil War. Dealers continued to promote works by European artists but gradually took on the art of Americans, particularly those who reflected contemporaneous European art currents, whether academic or more radical; some of these galleries are still in operation today. Specialized art magazines began to appear in ever-increasing numbers, themselves reflecting aesthetic preferences and prejudices either as policy or as personal editorial attitudes. *Art Interchange, The Collector,* and perhaps most significant, the *Art Amateur,* were influential critical organs of the period, while *Modern Art* appeared in 1893, created as a result of new artistic development and reflecting the most advanced aesthetic taste. In addition, the general periodical press continued to devote large selections of their monthly magazines to developments in the arts, and were thorough and persuasive, such magazines as *Atlantic Monthly, Scribner's Monthly* (later *The Century Monthly Magazine,* hereinafter *Century*) and *Scribner's Magazine* especially. Among the critics and writers specially concerned with the Fine Arts and often involved with the considerations of the pros and cons of Impressionist art were William C. Brownell and Clarence Cook in *Scribner's Monthly,* Alfred Trumble in *The Collector,* Russell Sturgis in the *Art Interchange,* and Theodore Child, Roger Riordan and the editor, Montague Marks, in the *Art Amateur.* It should be emphasized, however, that the above-named writers were not the only ones whose opinions could be found in those magazines, and conversely, the writings of those critics also appeared in many other magazines and newspapers.

It would appear that American critics, in their concern with contemporary art and their evaluation of the work of American painters, were aware of Impressionism quite early, but that appearance, is, in fact, somewhat deceptive. The terms "impressionism" and "impressionist" appear relatively early in the critical writing of the period. Henry James, in *The Nation* for May 31, 1877, reviewing a show at the Grosvenor Gallery in London, commented on some paintings of Whistler's that they were not pictures but nocturnes, arrangements and harmonies; he found them uninteresting but labeled the artist an "Impressionist." A writer in *The Critic* for July 30, 1881 wrote some "Notes on a Young 'Impressionist,'" concerning the art of J. Frank Currier, and the *National Academy Notes* for 1883 noted a *Marine* by John Twachtman and *A Sail in Grey* by William Gedney Bunce as "examples of the impressionist school."

It is evident that these critics did not mean in their use of the term the aesthetic of prismatic color, broken brushwork and primary concern with light and color which we associate with Impressionism. Twachtman might be considered a true Impressionist only later in his career, and a grey marine by Bunce would be precisely the kind of picture which would not exhibit his usual preference for bright sunlight. This use of the term "Impressionist" is probably best understood by the reference to Currier; the writer "F. W." was actually speaking of a combination of non-traditional and non-ideal subject matter, and especially Currier's concern with and belief in brushwork: vivid, spontaneous, and "unfinished" application of the medium. Loose, vivid brushwork is certainly a characteristic of Impressionism, but it is only one aspect of that aesthetic. The critic, in fact, was responding to a major tenet of progressive Munich painting, of which Currier was a major practitioner and one of the artists most loyal to that style. It was also a characteristic of much of the painting shown in New York at the newly formed Society of American Artists, distinguishing the painting there from the more conservative work seen at the older National Academy.

Terminology, therefore, is an important factor in our understanding of the critical reaction to and against Impressionism. If "Impressionism" was host to a variety of interpretations early in its appearance in America and to American critics and artists, other terms were also introduced to mean what has come to be accepted as Impressionism. Another term that enjoyed at least sporadic use was "luminarist." Cecilia Waern, in an important article in the *Atlantic Monthly* for April, 1892, attempted to define Impressionism as an art concerned with unity, citing the work of Jean-Charles Cazin, Jean François Raffaelli and Whistler.[2] This she perceptively divided into two factions, the *"synthetistes"* who emphasized form, and the *"luminaristes"* who emphasized light. And the latter, in turn, she subdivided into two groups, acknowledging the scientific faction of *"pointilistes."* The term was used again much later, by the influential critic and landscapist Birge Harrison in his important book, *Landscape Painting,* published in 1909.[3] Harrison insisted there, as he did in his article "The True Impressionism in Art," which appeared in *Scribner's Magazine* in October of the same year, that *all* artists were Impressionists. He proposed the term "luminarists" for those painters concerned with light and color, and spoke of the "pulsating, vibrating effects" of this art. "Vibration" in fact was the key word in much of the critical terminology concerning Impressionism in America.

A related term was introduced by the Tonalist artist, Henry Ward Ranger, in his 1914 *Art-Talks* when he spoke of the "Luminist movement" which had captured the world, using that term not in the present reference to the earlier art of Martin Heade, Sanford Gifford and other mid-century landscape painters, but referring rather to what is now known as Impressionism.[4] The important Midwestern painter, Theodore Steele, used the alternate term, "Impressionalism" in a significant article that appeared in the magazine *Modern Art,* which was first published in his native city of Indianapolis in 1893.[5] A hostile critic in the Minneapolis *Evening Tribune* of August 8, 1896, referred to the "Heliotropists," artists with a supreme contempt for story-telling pictures, "whose cameras run riot in purples lurid, intense, misty, reddish or greeny yallery as suits the mood...." The emphasis upon the purple end of the spectrum seems to have been what bothered most

critics. In 1892, "W.H.W." stated in the *Art Amateur* that he had consulted an oculist and asked if there were any such malady as "purple eye."[6] Luther Hamilton, in 1886, acknowledged that:

*One of the greatest stumbling blocks in the Impressionist work, as shown here [in New York City] was the prevalence of violet shadows. In considering this, it must be remembered that there are more violets in the shadows in many parts of France than in this country; also the violet in out-of-doors pictures greatly brightens the effect of yellow sunshine....*[7]

Oscar Reutersvard in 1951 in the *Journal of Aesthetics and Art Criticism* devoted an article to "Violettomania" — the emphasis upon the blue, indigo and violet end of the spectrum in Impressionist painting.[8]

The earliest American critical comment on Impressionism as we know it today occurred about 1880, and was generally hostile. The *American Art Review* published, in 1880, an article entitled "Impressionism in France," but it ostensibly withheld comment or judgement, only quoting in translation two European critiques, one severely hostile and one mildly so, taken from *L'Artiste* and from the *Revue Suisse* respectively.[9] Lucy Hooper, the American correspondent for *The Art Journal,* wrote that year in "Art Notes from Paris" about the Impressionist exhibition there, and also of an exhibit of Manet's works, finding Manet less mad than the "other maniacs of Impressionism," the latter finding it easier to dash off an unnatural daub, defying all the rules of perspective and coloring.[10] More reflective was Samuel Benjamin in his *Art in America* of the same year who criticized a lack of spirituality and ideality rather than condemning Impressionist technique, a frequent American criticism. He wrote that these painters "undoubtedly present a keen appreciation of aerial chromatic effects and for this reason are worthy of careful attention. That they are not carried nearer to completion, however, indicates a consciousness on the part of the artist that he is as yet unable to harmonize the objective and the subjective, the material and the spiritual phases of art." Benjamin found that "Impressionism, pure and simple, as represented by its most extreme supporters, is like trying to represent the soul without the body."[11] Alfred Trumble, writing in *The Collector* in 1893, emphasized that artists such as Monet were materialistic, and that their works lacked the sentiment which so touched the observer in Courbet's *Stonebreakers.* Unlike other critics, Trumble condemned the Americans Twachtman and Weir for painting like Monet yet without the originality and power inherent in the French work.[12]

For America, as suggested by Lucy Hooper, Manet represented the first of the Impressionists. His *Shooting of Maximilian* was one of the first Impressionist, or quasi-Impressionist, pictures publicly exhibited in this country, brought here by Mrs. Ambré of Colonel Mapleson's Italian Opera Company in November of 1879, and shown at New York's Clarendon Hotel and at the Studio Building gallery in Boston. It was a publicity venture, capitalizing on the notoriety of the work which was due, however, to its inflammatory political nature rather than to its radical aesthetic. New York critics found the picture powerful and original, admiring the splashes of paint which make it appear a huge *"ebauche"*; their sympathy is surprising particularly when contrasted with the reaction in Boston, where the work was condemned for its slack execution. The American painter in Paris, Henry Bacon, wrote in 1880 that Manet represented nature out of tune.[13]

The year before Manet's painting appeared in New York City, *A Ballet* by Edgar Degas was exhibited there, at the American Water Color Society. This may well have been the earliest French Impressionist painting acquired by an American; it was purchased by Louisine Elder, later Mrs. Horace Havemeyer, in 1875 with the advice of Mary Cassatt; at the Society in 1878 it was lent by Mr. J. Elder. To present knowledge, this exhibition was the earliest public showing of a truly Impressionist picture on this side of the Atlantic. Even more remarkable is the attention and the sympathetic criticism which the work received. The critic in the *Century* wrote in April, 1878, that the picture "...gave us an opportunity of seeing the work of one of the strongest members of the French 'Impressionist' school, so called; though light, and in parts vague, in touch, this is the assured work of a man who can, if he wishes, draw with the sharpness and firmness of Holbein."[14] It is perhaps not surprising that Degas, with his classical heritage and concern for drawing and for form, in a work concerned with artistry and with controlled light, might fare relatively better than some of his Impressionist colleagues, but the work was still a radical picture in its breadth, composition and color, and might not have fared as well under the pen of a French critic of the time. The *Century* of course, spurred on by its editor, Richard Watson Gilder, had been in the vanguard of promoting foreign influences on American art and spearheading the newly formed Society of American Artists, but even most of the members of that group were not particularly sympathetic to Impressionism at the time. Interestingly too, Degas' picture is a mixture of gouache and pastel and suggests already the role that the revival of pastel painting would have in the transmission and popularization of Impressionist aesthetics during the following decade, a subject which will be discussed in the next section of this essay.

The extremely perceptive writer on art, Mariana van Rensselaer, wrote in 1884 that Manet and Degas "had much charm for those who can consent to see for a moment with the eyes of a peculiarly endowed painter instead of their own."[15] Such tolerance contrasts with the comment by a writer in *The Critic* two years earlier that "if Mr. Sargent has joined the ranks of the French impressionists it is their gain and his loss." What is surprising about that comment is that not only was it premature, since Sargent's conversion to Impressionism occurred two or three years later, but that, in 1882, he was painting some of his darkest and blackest works, figure paintings in Venice and his great canvas of *The Daughters of Edward D. Boit.*

Slowly, during the 1880s, works by Impressionist painters were coming to America, both for exhibition and inclusion in private collections. With the advice of J. Alden Weir, Erwin Davis had pioneered in such acquisitions, obtaining Manet's *Boy with a Sword* and *Woman with a Parrot* in 1881, early dark and dramatic figure pieces however, which foretold little of Impressionist tendencies. But in September of 1883, the Foreign Exhibition sent to Boston by the Paris dealer and friend of the Impressionists, Paul Durand-Ruel, and shown in the Mechanics Building, offered the first large-scale presentation of Impressionist works, including paintings by Manet, Monet, Pissarro, Renoir and Sisley. At the end of that year, New York City saw the Pedestal Fund Exhibition at the National Academy of Design arranged by Chase and J. Carroll Beckwith to raise funds to construct the pedestal for Bartholdi's *Statue of Liberty.* The exhibition featured a great deal of Barbizon painting, but again included work by Manet.

The pivotal appearance of Impressionist painting in America was the exhibition sent to this country by Durand-Ruel in 1886. From this time

on American artistic and critical attention focused upon that movement, and collectors and artists alike became overwhelmingly concerned with Impressionism. The years from 1886 to the triumph of Impressionism at the Chicago Fair in 1893 witnessed a year-by-year growth of understanding of and sympathy for the movement, though American reaction in any case was surprisingly mild and less hostile than the corresponding earlier French reaction.

In 1886, with financial difficulties of his own in Paris and the bankruptcy of an associate in the crash of 1882, Durand-Ruel — who was already well known in America as a promoter of Barbizon painting — thought to recoup his fortunes by sending over a large show of Impressionist works on invitation from the American Art Association in New York. That organization had been founded by James F. Sutton, who combined with Thomas Kirby, the auctioneer at the major auction house of George A. Levitt. About 300 works were sent, including 17 by Manet, 23 by Degas, 38 Renoirs, 48 Monets, 42 Pissarros, 15 Sisleys and 3 by Seurat, including his *Bathers* and a study for *La Grande Jatte*. As balm for more conservative taste, fifty paintings by popular artists were included.

The exhibition attracted sufficient interest that it was continued at the National Academy with twenty-one additions from American collections, including those of Alexander Cassatt, H. O. Havemeyer and Erwin Davis. About fifty of the pictures were sold, to such buyers as Desmond Fitzgerald, Cyrus J. Lawrence, William H. Fuller, and James S. Inglis (who was president of the New York branch of the art establishment Cottier & Company) and to Albert Spencer, who sold earlier work to purchase Monet's.

Critical reaction ran the gamut but was surprisingly favorable. The critic for *The Art Interchange* denounced the paintings for their ugliness, and the

artists' depiction of "even the most cheerful and frivolous themes in the most dyspeptic and suicidal manner that is conceivable." *The Art Amateur* complained about Monet's harsh juxtaposition of unrelated tones, and both critics objected to works that could be properly viewed only at a great distance. But most of the critics, such as that of *Art Age,* admired Renoir's Bougival figural pieces which depicted life as it is instead of as it ought to be, and referred to the landscapes shown as a new world of art. Luther Hamilton in *Cosmopolitan* noted the show as "one of the most important artistic events that ever took place in this country." Even more fascinated was the writer in *The Critic* who found either strange and unholy splendor or depraved materialism, and who defined accurately many of the aesthetic qualities of the art. He noted that the painters emphasized larger rather than lesser truths and believed that they neglected established rules only because they had outgrown them. He saw that the artists had eliminated tone and value gradations because of their love of pure color, and recognized that suggestiveness characterized their work. He saw that Monet was the leader of the school, and called his pictures "some of the most delicious landscapes ever painted." Curiously, he saw the feminine principle of Impressionism embodied in the landscapes, and the masculine principle in the figure paintings. And he concluded that New York had never seen a more interesting exhibition than this. Clarence Cook in *The Studio* found the show delightful, emphasizing the blue, lilac and violet tones in the works, and the lack of work of the "black band." He recognized too that it was not a typical exhibition of the picture dealers or for the usual "money bag clients."[16]

The dealers, however, were hostile, probably to the art and certainly to the profits that Durand-Ruel was seen to be reaping. The exhibition had been allowed into this country tax-free, and the dealer had only to pay the high import tax on the works sold. Complaints by the local commercial art establishment against the American Art Association led to a prohibition of sales when Durand-Ruel sent a second exhibition in May of 1887. This exhibition was actually more conservative than the previous one; the only "first" was the inclusion of work by Puvis de Chavannes.

During the ensuing years, however, French Impressionist works were attracting more and more critical attention and patronage, and were shown in this country increasingly. In the spring of 1888, Albert Spencer of New York sold his Barbizon collection in order to purchase Impressionist works. Chicago saw an exhibition in 1890 of pictures lent by Durand-Ruel, inspired by Sara Halowell, who was a close friend of the leading collector in that city, Mrs. Potter Palmer; they were to work together in 1893 in the organization of the Columbian Exposition. The 1890 show included six works by Monet, four by Pissarro and a Degas.

Monet was to become the best known of the French Impressionists in this country. New York's Union League Club held a show of his work in 1891, organized by William H. Fuller, with works lent by Davis, Spencer and others. The following year there was a Monet show at Boston's St. Botolph Club, and in 1895 Durand-Ruel organized a Monet show in New York City which was then sent to Chicago. In 1896, the American Art Association presented an exhibition of 14 of Monet's paintings of Rouen Cathedral, works about which the public would already have read, providing an opportunity of realizing the serial concept of changing conditions of light, weather and atmosphere. The literature on Monet also began to appear in the 1890s, beginning with Theodore Robinson's article in *Century* in 1892 and a notice

in *Scribner's Magazine* in 1896 and in *Modern Art* the following year.[17]

Durand-Ruel's own activities in America certainly encouraged increased interest in Impressionism. Two sales of works in his collection were held at Moore's auction galleries in New York City in 1887; the first, in May, was a significant one of 127 pictures. In the catalogue, Durand-Ruel suggested that the works of these often bold and startling artists would soon reach the value of the Barbizon painters whom he had promoted earlier. However, the works by Renoir, Pissarro, Boudin, Sisley, Monet and others went for meager amounts and only a picture by Manet brought over $1,000. The December auction was a minor affair of lesser works and watercolors.[18]

The inconveniences of selling through other galleries and auction houses and the difficulties imposed by the increasingly vexatious American tariff laws led Durand-Ruel to open his own gallery in New York City in 1888 at 297 Fifth Avenue; in 1890 the gallery was moved to 315 Fifth Avenue, and then in 1894 to 389 Fifth Avenue, a building owned by H. O. Havemeyer. From this base of operation, Durand-Ruel and his sons were able to mount frequent exhibitions of both French and American Impressionist painting and also to send out Impressionist shows to other cities, this despite the reluctance of his French Impressionist artists to have their works shown in America and enter American collections. In 1890, Durand-Ruel opened a Sisley, Pissarro and Monet show, which then traveled to the Chase Gallery in Boston. 1891 saw exhibitions devoted to Monet and to a group showing of Degas, Renoir, Sisley, Jongkind and John-Lewis Brown. In 1893, Durand-Ruel lent a group of works to the Columbian Exposition in Chicago, and in 1894 he held a show of Degas pastels. In 1895, in addition to arranging for the Monet show in Chicago, Durand-Ruel held shows in New York of Mary Cassatt, Theodore Robinson and Robert Vonnoh. In 1896 there were exhibitions devoted to Jongkind and to Pissarro, and in 1897, a show of Pissarro's *Vues de Rouen*. Despite a gallery fire early in 1898, that year saw exhibitions devoted to Mary Cassatt, to Boudin, to Sisley and to Raffaelli.

Gradually, the American press, too, was becoming aware of native converts to the methods and aesthetics of French Impressionism. *The Art Amateur* commented in 1887 that:
*Quite an American colony has gathered, I am told, at Giverny, seventy miles from Paris on the Seine, the home of Claude Monet, including our Louis Ritter, W. L. Metcalf, Theodore Wendel, John Breck and Theodore Robinson of New York. A few pictures just received from these men show that they have got the blue-green color of Monet's impressionism and "got it bad."* [19]

In the years 1891 to 1893 one can follow step by step the gradual conversion of the critical establishment from a hostile to a favorable opinion of Impressionism. In the earlier year, Alfred Trumble in *The Collector* could still write that "my contempt for such a man as Monet is the greater, because I believe he really can see and feel nature honestly, and that he distorts her for sensational effect." Charles H. Moore in the *Century* magazine in December, 1891, echoing earlier criticism by George Inness, commented that Impressionism fails by concentrating only on color, like the Pre-Raphaelites did on detail. And the respected art critic and historian William Howe Downes wrote an important article on "Impressionism in Painting" which appeared in the *New England Magazine* in July, 1892, condemning the crude and childlike work, the painty textures and the eccentricity of such artists as Manet with his purple tints. Downes noted, too, that some Americans had subscribed to the "purple mania and even

overdo it." On the other hand, a writer in *Scribner's Magazine* in May suggested that one might "call the present time an epoch of impressionism," while Theodore de Wysewa, in *The Chautauquan,* admired the clear tones, the lightness, transparency and easy elegance of the work of Berthe Morisot, concluding that the "impressionist method is especially adapted to true feminine painting." *The Art Amateur* for May of 1891, in "The Wave of Impressionism," was skeptical of the Impressionist method but decided that "it may safely be left for the future to decide."[20]

It did not wait for long. One of the most interesting critical controversies appeared in that magazine in November and December of 1892. In November, a writer identified only as "W.H.W." raged violently against Impressionism, quoting French critics and pointing the finger of cupidity at the art dealers as being the contemporary patrons. "W.H.W." appeared again the next month in a continuation of "What is Impressionism?" denigrating the uniformity of approach adopted by the Impressionist painters and speaking of the works of Monet, Pissarro and Sisley forced down the throats of the amiable American public. However, the magazine followed this with a rebuttal by "R.R." — surely Roger Riordan — who allowed for diversity in art, tracing the history of the movement back to Turner and Delacroix and finding much to admire both in the French paintings and in those by Weir and Twachtman. Riordan concluded: "We are not called upon to reject the masters of academic drawing like Lefebvre because we find something to admire in the unacademic drawings of Degas or Renoir. To come nearer home, we can enjoy at the same time the grace and refinement of Mr. Henry O. Walker's work and the sparkle and animation of Mr. Theodore Robinson's."[21]

1892 also saw Robinson's own tribute to Monet appearing in *Century,* and Cecilia Waern's fine analytical piece, "Some Notes on French Impressionism" in the *Atlantic Monthly.* A long, thoughtful and unbiased account of the French Impressionist movement and the work of the leading painters connected with it — Manet, Monet and Degas — was presented in *The Art Interchange* in July, 1892, incorporating the writings and deductions of many of the leading French critics: Paul Mantz, Maurice Hamel, Gustave Geffroy, Andre Michel, Henry Houssaye and Theodore Duret.[22]

Even in 1893, some critics persevered in their disdain for Impressionism, but they were fewer. Trumble's aforementioned "Impressionism and Impressions," complained of its materialistic nature in reference to the exhibition at the American Art Association. A much more favorable stance toward the show was taken in June by *The Art Amateur.*

1893 was the year of the Columbian Exposition in Chicago, and the ascendancy of the movement. It was sanctified by the new periodical appearing in Indianapolis, *Modern Art,* where the critic wrote:
*Although the great Impressionists are but meagerly represented, there is no lack of Impressionism. In fact, one sees it on every hand in the French, American and Scandinavian collections. Among these nations one feels it on every side. It is in the air, and the great bulk of the pictures show its influence in varying degree. Whether for good or bad, for long or short, it is the active influence in the art of to-day. So far, it has resulted in an added brilliance of light and color that is refreshing, and makes a gallery a pleasant contrast to the heavy murkiness of a few years ago, which may even still be seen in some of the art palace exhibitions.*
The first issue of *Modern Art* also contained Theodore Steele's adulatory

article on "Impressionalism," and two years later the aforementioned article by Otto Stark on "The Evolution of Impressionism" appeared there.

The major literary spokesman for Impressionism also appeared at this time, Hamlin Garland, who, in his *Crumbling Idols* of 1894, wrote of the triumph of Impressionism at Chicago, of the dazzling sunlight, unified impressions, the concept of the momentary and the rich, raw colors where five years earlier there was hardly a blue shadow. Garland was to continue to act as the spokesman for progressive, Impressionist art particularly in his role as one of the "Critical Triumvirate," published, non-fictional discourses among a Novelist (Garland), a Sculptor (Lorado Taft) and a Conservative Painter (Charles Browne). Several discussions of the "Critical Triumvirate" were published, and they will be discussed below, but the divergence of opinion between the progressive Novelist and the Conservative Painter should be mentioned here. Garland, the Novelist, in reviewing a show of American art at the Chicago Art Institute in 1894, admired Impressionist work; Browne, the Conservative, wanted more than technical virtuosity.

Even some artists at the Columbian Exposition were dismayed by the Impressionist work and influences. The elderly sporting and animal painter, Arthur Fitzwilliam Tait, complained that the pictures "....aint got no houtlines." And when the daughter of the Hudson River School landscape painter James Hart was asked if she were an Impressionist, she answered, "No, I'd like to be, but papa won't allow me!"[24]

Even after 1893, controversy continued to be heard occasionally. *The Art Amateur* in March of 1894 took partial issue with the French writer Gustave Geffroy, deploring the lack of idealization in Degas' painting of women and the sameness of Renoir's types, while insisting that Geffroy undervalued the work of Raffaelli who was, the next year, to make the first of several triumphal trips to America where his more sentimental types and more emphatic drawing combined with Impressionist brushwork and broken color found ready acceptance. And *Scribner's Magazine* in April of 1896 argued against the invariableness of blue and lilac shadows.

Nevertheless, after 1893, the cause of Impressionism was won. In his *Art for Art's Sake* of that year, the important writer John Van Dyke argued for the pictorial ideal against the old-fashioned literary idea, recognizing Impressionism as the new and valid art.[25] America had been prepared for Impressionism as France had not, though the groundwork had been laid quickly. Respected authorities and noted artists had rallied to the Impressionist cause even if they themselves were not directly involved with it. In Boston, the great Oriental art scholar, Ernest Fenellosa, lectured on the relationship of Japanese art to Impressionism. The much-admired Barbizon painter there, Joseph Foxcroft Cole, imported paintings by Monet for local collectors, and Frederic Porter Vinton, Boston's leading portraitist (who was a pupil and disciple of the Academic master Léon Bonnat) lectured on Impressionism at the St. Botolph Club in that city. Americans may have admired also that unity of style which some of the critics deplored, finding it easier to identify and thus helping to create a vogue. And though Impressionism was French-derived, it was uninvolved with the iconography of violence and sensuality that marked so many of the academic works of fame and notoriety that were shown in the Paris Salon, published in the magazines and in steel engravings, and acquired by the more traditional wealthy collectors. The controversy over Impressionism was one of aesthetics primarily; it was never a matter of morality.

1. Hans Huth, "Impressionism Comes to America," *Gazette des Beaux-Arts*, Ser. 6, Vol. 29 (April, 1946), 225-52.

2. Cecilia Waern, "Some Notes on French Impressionism," *Atlantic Monthly*, Vol. 69, no. 414 (April, 1892), 535-41.

3. Birge Harrison, *Landscape Painting*, New York, Scribner's, 1909, and his "The True Impressionism in Art," *Scribner's Magazine*, Vol. 46, no. 4 (October, 1909), 491-95.

4. Bell, *Art-Talks*, 83.

5. Theodore C. Steele, "Impressionalism," *Modern Art*, Vol. 1, no. 1 (Winter, 1893), unpaginated.

6. *The Art Amateur*, Vol. 27 (November, 1892), 140-41.

7. Luther Hamilton, "The Work of the Paris Impressionists," *Cosmopolitan*, Vol. 1 (June, 1886), 240-42.

8. Oscar Reutersvard, "The 'Violettomania' of the Impressionists," *Journal of Aesthetics and Art Criticism*, Vol. 9, no. 2 (December, 1951), 106-10.

9. Impressionism in France," *American Art Review*, Vol. 1 (1880), 33-35.

10. Lucy H. Hooper, "Art Notes from Paris," *The Art Journal* (New York), Vol. 6 (1880), 188-90.

11. Samuel Benjamin, *Art in America*, New York, Harper & Brothers, 1880, 192.

12. Alfred Trumble, "Impressionism and Impressions," *The Collector*, Vol. 4, no. 14 (May 15, 1893), 213.

13. Huth, "Impressionism," 226-29.

14. "The Old Cabinet," *Century*, Vol. 15, no. 6 (April, 1878), 888-89.

15. Mariana Van Rensselaer, "The Recent New York Loan Exhibition," *American Architect and Building News*, Vol. 15 (January 19, 1884), 30.

16. "The Impressionists' Exhibition at the American Art Galleries," *The Art Interchange*, Vol. 16, no. 9 (April 24, 1886), 130-31; "The Impressionist Exhibition," *The Art Amateur*, Vol. 14 (May, 1886), 121; "The Impressionists," *Art Age*, Vol. 3, no. 33, (April, 1886), 165-66; "The French Impressionists," *The Critic*, Vol. 5, no. 120 (April 17, 1886), 195-96; Clarence Cook, "The Impressionist Pictures," *The Studio*, Vol. 1 (April 17, 1886), 245-54.

17. Theodore Robinson, "Claude Monet," *Century*, Vol. 44, no. 5 (September, 1892), 696-701; "Claude Monet," *Scribner's Magazine*, Vol. 19, no. 15 (January, 1896), 125; Anna Seaton-Schmidt, "An Afternoon with Claude Monet," *Modern Art*, Vol. 5, no. 1 (January 1, 1897), 32-35.

18. I am extremely grateful to two of my graduate students, Therese Rosinsky and especially Frances Weitzenhoffer, for assistance in the matter of Durand-Ruel's activity in America.

19. "Greta," "Boston Art and Artists," *The Art Amateur*, Vol. 17, no. 5 (October, 1887), 93.

20. Much of this material is discussed, and a good deal more, in John D. Kysela, S.J., "The Critical and Literary Background for a Study of the Development of Taste for 'Modern Art' in America, from 1880 to 1900," unpublished M.A. thesis, Loyola University, 1964. See especially the article by William Howe Downes, "Impressionism in Painting," *New England Magazine*, Vol. 6, no. 5 (July, 1892), 600-03.

21. "R.R. [Roger Riordan], "From Another Point of View," *The Art Amateur*, Vol. 27, no. 7 (December, 1892), 5.

22. "The Impressionists," *The Art Interchange*, Vol. 29, no. 1 (July, 1892), 1-7.

23. William Forsyth, "Impressionism," *Modern Art*, Vol. 1, no. 3 (Summer, 1893), unpaginated.

24. Taken from the unpublished diaries of Theodore Robinson, owned by the Frick Art Reference Library, New York City.

25. John C. Van Dyke, *Art for Art's Sake*, New York, Scribner's, 1898, 5 ff.

*Canal, San Canciano, Venice.*
ca. 1880

Pastel on brown paper
11¼ x 6½ in. (27.9 x 13.4 cm)
The Westmoreland County Museum of Art,
William A. Coulter Fund

The notes for this chapter will be
found on page 35.

*A Reading.* 1897

Oil on canvas
20¼ x 30¼ in. (50.8 x 76.3 cm)
National Collection of Fine Arts,
Smithsonian Institution, Bequest of Henry
Ward Ranger through the National Academy
of Design

# 5 The Role of Whistler and the Impact of Pastel

In November of 1886, the important critic Charles De Kay wrote an article which appeared in *The Art Review* entitled "Whistler, the Head of the Impressionists."[1] Appearing as it did as the lead article in the first issue of a new American periodical the same year that the American public had their first extended view of French Impressionist paintings, the title would seem consciously provocative. Yet, De Kay in actuality avoids any coupling of Whistler's painting with that of Monet and his other Impressionist contemporaries. In fact, De Kay relates Whistler instead, and somewhat closely, to Frans Hals. However, a subtle implication may be inferred in the emphasis De Kay gives to Whistler's then present position as President of the Society of British Artists, for that organization was one of the first bodies of British painters to display receptivity to the newer tendencies of French art, however tentatively and short lived.

De Kay also discussed the not insignificant question of Whistler's relationship with has native land.[2] Though he was born in Lowell, Massachusetts, and did study for three years at West Point, beginning in 1851, before joining the United States Coast and Geodetic Survey as a draftsman, his artistic training effectively took place in Paris under Charles Gleyre, and he practiced his art in the French capital and in London. Whistler traveled extensively—to Holland, to Venice and late in life to North Africa and Corsica—but he never returned to the United States, though he threatened often to do so, and the imminent possibility was reported, albeit extremely cautiously, by De Kay.

The point is that Whistler's relationship to American Impressionism should be questioned on two accounts. First, should the artist even be considered American? Secondly, was he an Impressionist painter? The first has been debated by critics and historians since Whistler first rose to fame with the exhibition of *The White Girl* at the famous, or infamous, Salon des Refusés in Paris in 1863, after the picture had been refused both at the Royal Academy in London and at the Paris Salon. Attempts to locate peculiarly American qualities in Whistler's art are intriguing but perhaps ultimately futile, since they depend upon the assurance that there are artistic

characteristics which can be judged nationally distinctive. Denys Sutton for instance has discerned an Americanness in Whistler's Puritanism and austerity, his independence and loneliness, and a sense of the mystery of life displayed in the artist's affinity with the world of Symbolism.[3] Yet, these qualities in Whistler's nature must be balanced with a recognition of the totally opposite, but perhaps more pertinent here, contemporary European analysis of American artistic expression as evincing directness and sincerity. It was the art of Augustus Saint-Gaudens, Alexander Harrison and John Singer Sargent that was seen by contemporary Europeans as embodying American qualities, not the evanescent figures and landscapes of Whistler.

Yet, Whistler's impact upon American art should not be discounted. It is not only a question of the existence of American followers and imitators — painters such as Leon Dabo and printmakers such as Otto Bacher who faithfully followed the techniques of the master—nor even the adaptation of individual masterworks of Whistler's by native American painters. Certainly Dennis Bunker's most beautiful and moving portrait, that of Anne Page of 1887, is inconceivable without Whistler's *Arrangement in Grey and Black No. 1: The Artist's Mother,* and *Anne Page* is only the finest of countless renditions of homage to the famous Whistler painting. Indeed, many an elegant painting of a woman in an interior by the Tonalist Thomas Dewing likewise displays such a relationship; Dewing met Whistler briefly in 1895 but seems to have admired his work much earlier. And the portrait of Whistler's mother had been a major feature at the Pennsylvania Academy of the Fine Arts in 1881, after which its influence spread rapidly in American art in the 1880s. Previously, in 1878 at the first exhibition of the progressive Society of American Artists in New York City, two of Whistler's early, more realistic works, his *Wapping* and *The Coast of Brittany* were exhibited. It was shortly after this that, as a result of the financial disaster in the aftermath of his lawsuit with John Ruskin, Whistler went for a prolonged stay in Venice on order to produce a series of etchings; in addition to this graphic set, he also painted a large number of Venetian pastels and a few nocturnes in oil.

It was during this period of mutual expatriatism that Whistler enjoyed his most sustained contact with American artists and from which his influence penetrated most deeply into the American aesthetic.[4] He appears to have met Theodore Robinson, the future Impressionist, briefly but perhaps significantly at the end of 1879, and shortly thereafter maintained a more sustained relationship with the Munich-trained group of Frank Duveneck and his "Boys," who arrived in Venice after spending the winter of 1879-80 in Florence. Two of them, Otto Bacher and Harper Pennington, wrote interesting and perceptive studies of their association with Whistler during these months in Venice, but Whistler's impact upon American art through these contacts established in Venice was far greater than merely a contribution to historical reminiscences.

Whistler was not an Impressionist painter in any but the broadest and perhaps the original aesthetic meaning of that term in the later 19th century —a combination of an unfinished, sometimes sketchy appearance with non-traditional, certainly non-ideal, subject matter. But the concept of Impressionism as it developed in the 1870s and later—first in France and then elsewhere on both sides of the Atlantic—still involved an emphasis upon, even the analysis of, naturalistic phenomenon, an emphasis diametrically opposed to Whistler's sensibility, his increasing refinement and generalization of the form of both figure and landscape, and the

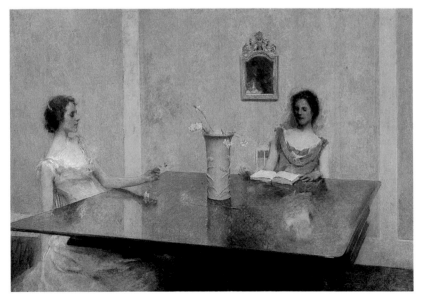

rejection not only of anecdotal and moral concerns with which the Impressionists would have agreed but also of material appearance in favor of increased simplification and suggestiveness ultimately bordering upon abstraction — whence the correlation, not only in title but in intent with musical harmonies. Robin Spencer, in *The Aesthetic Movement and the Cult of Japan*,[5] referred to Whistler as the "Aesthetic Impressionist."

Whistler himself rejected the appellation of "Impressionist," and French critics increasingly allied him with the Symbolist movement. But for the younger painters of America, Whistler represented an independent spirit — critically and historically allied with their own country — who defied the forces of tradition and conservatism, an established international figure who, if his art was at odds with the new tendencies in France which some of them were shortly to emulate, joined those tendencies in defying aesthetic convention. And at that crucial juncture in Venice, Whistler himself was striking out for a new, refreshing milieu as a substitution for the enmities and hostilities of the Ruskin fiasco, something which propitiously appeared in the form of young artists from his native land. Whistler did not, of course, shun his British contemporaries, and his influence upon British painters was to become at least as great as that upon American artists. Indeed Whistler's influence was felt even upon Italian art, as the nocturne *Imminente Luna* of 1882 by Lorenzo Delleani testifies.

And there was, indeed, immediate influence upon some of the Americans there in Venice as well. The etchings of Bacher and Duveneck bear full testimony to that. Interestingly, among the Munich-trained artists in the circle of Duveneck, the greatest and most artistically significant influence of Whistler was felt by one who was not present in Venice in 1880, though he had been there with Duveneck two years earlier — John Twachtman. Twachtman returned to Italy to assist Duveneck in his teaching in the fall of 1880, but in Florence, not in Venice, and there is no record of Twachtman's reappearance in the latter city before Whistler departed from there in November of that year. The exact nature of Twachtman's exposure to Whistler's art has not been determined, and there is no documentation of either a meeting or a direct influence, but the change from the thickly impastoed, dark and dramatic Munich manner in which Twachtman continued to paint after his return to America, in 1878, and the more generalized landscapes done in France from 1883-85, with a muted tonality, Japanese-inspired compositional relationships and a greatly increased concern with abstraction certainly suggest the impact of Whistler, rather than the art of Twachtman's teachers at the Académie Julian in Paris, who would have not been concerned with landscape painting in any case. Twachtman, as we shall see, was to abandon his French style soon after his return to America, but the concern with close tonal harmonies and rhythmic abstractions remained with him until his early death.

Certainly, in addition to the general exposure to Whistler's fame — and notoriety — Twachtman would have known of the expatriate and his art through his closest friend, J. Alden Weir, whose artist-father, Robert Weir, had been Whistler's first teacher at West Point, and who had himself met Whistler in London in 1877 on his way home from his own study with Jean-Léon Gérôme in Paris. Weir had had an introduction to Whistler through Sir Henry Thompson, an Englishman whom Weir met while studying Velasquez in Spain; Whistler was to illustrate the catalogue of Thompson's collection of blue-and-white porcelain in 1878. Their admiration for Velasquez was to form a bond between Weir and Whistler, a bond strengthened when Whistler came across Weir copying Velasquez in the National Gallery in London in 1881.[6] Weir in fact had just come from Paris where he had acquired two of Manet's most Spanish-inspired canvases for the collector Erwin Davis, the *Woman with a Parrot* and *Boy with a Sword,* which were later to enter the collection of The Metropolitan Museum. If Velasquez is to be considered an old master progenitor of Impressionism, then Whistler, both in his own art and his admiration for the great Spanish painter, figures as a force in the movement and in the American development.

Four years later, in 1885, William Merritt Chase, later to take Twachtman's place in The Ten American Artists, met Whistler, and the artists painted each other's portraits. The whereabouts of Whistler's of Chase is unknown, but Chase's of Whistler (in the Metropolitan Museum) is both one of his most Whistlerian pictures and one of his works most indebted to Velasquez. Again, however, as with Twachtman's painting, Chase's art is most like Whistler's when it is least Impressionist.[7] And the work of Whistler's closest American followers — Pennington, Dabo, possibly Lillian Genth, and a whole host of California painters, such as Charles Rollo Peters, Xavier Martinez, and Francis John McComas ("The Whistler of the West") — is not Impressionist at all, much of it rather falling into the Tonalist aesthetic, wherein may lie Whistler's greatest influence in American painting.

There is, however, one other Impressionist pursuit where Whistler's influence seems to have been extremely significant, not only for the art produced but for its favorable reception among American critics and art patrons. Whistler's primary concern during his fourteen months in Venice was with the "lesser" media of etching and pastel, precisely as these media were enjoying a renaissance in both Europe and America. The New York Etching Club had been founded only a few years earlier, in 1877, and both the work of Whistler and of those influenced by him were of tremendous significance during the great years of the etching revival of the 1880s. As for pastel painting, the Society of Painters in Pastel was organized in New York City in the winter of 1882 after the American contact with Whistler and his work. The group held only four exhibitions: in 1884, 1888, 1889, and 1890. Mariana van Rensselaer, in a seminal article in *Century* in 1884, acknowledged Whistler's influence in the "...fresh impulse and popularity with his exquisite, subtle, yet freely handled and brilliantly colored Venetian studies" when she reviewed the new American Society's first exhibition.[8]

It may well be that the activity in pastel painting contributed to the increased critical awareness and acceptance of a lightened, more colorful palette and a rapid, sketchy manner of painting which began to be seen in American art in the 1880s and which, by the time American artists turned to an Impressionist aesthetic in oil painting at the end of that decade, was no longer radical or perplexing. That is, perhaps the enthusiasm with which pastel developments were received paved the way for the inroads of similar aesthetic novelties in the more traditional, and "more important" medium. Indeed, the critic of the *Art Interchange* in 1884 acknowledged in reviewing the pastel show that "'Impressionism' is here seen at its sanest and best, and those who are susceptible to the charms of cleverness and dash can find much to delight them in this first effort to acquaint the general public with

the possibilities of pastel."[9]

That the establishment of the Society and the interest in the medium owed much to Whistler is not only vouchsafed in the criticism of Mrs. Van Rensselaer and others but in the fact that the two most acclaimed pastellists were Chase and Robert Blum, the latter who had been one of the "Duveneck Boys" in Venice in 1880. It is probably significant too that, in the later shows of the Society of Painters in Pastel, those artists who came to be identified as American Impressionists became increasingly active. Among these were Twachtman, who began using pastel in 1885 or perhaps even earlier — the period of his greatest receptivity to Whistler's art — and J. Alden Weir, both of whom showed in the exhibition of 1888. In 1889, Theodore Robinson and Theodore Butler, who had recently met Monet and moved to Giverny, exhibited pastels with the Society. In the last exhibition in 1890, works were shown by Childe Hassam, Robert Reid, Otto Bacher and Cecilia Beaux, all of whom are represented here by Impressionist oil paintings.[10]

To further underscore Whistler's influence in this development, it might be noted that, though the Society held its first show at W. P. Moore's gallery in New York City in 1884, the second exhibition was at Wunderlich & Co. in 1888. That same gallery had, five years earlier, mounted the first Whistler exhibition in America, showing 50 etchings and drypoints, and more significantly, in 1889 held the show *"Notes" — "Harmonies" — "Nocturnes,"* the first one-man show of Whistler's pastels, drawings and watercolors in this country. Whistler's art in general was already very well known in America, but it was regularly seen at the same gallery which became identified with the Society of Painters in Pastel.

The Society held no more exhibitions after 1890, but this signifies not the lessening of interest in the pastel medium on the part of either the artist or the patron, but rather the incorporation of the pastel aesthetic into the technical and expressive range of other media — not only oil painting but especially watercolor — and the inclusion of pastels themselves in shows featuring those media. It is significant that the "New York Watercolor Club" was founded in 1890, the same year as the pastel Society's last exhibition, involving some of the same artists and including pastels as well as watercolors. Indeed, many watercolors of this period look like pastels in their rich, and very thick and colorful use of gouache.[11] The Society of Painters in Pastel had been sufficiently successful so that there no longer remained a need for a separate organization, for the medium had become a fully recognized one and had, in fact, exerted an influence upon oil and watercolor painting. That influence seems to have had strong Impressionist overtones and Whistler appears to have played a key role in that development.

1. Charles De Kay, "Whistler, the Head of the Impressionists," *The Art Review,* Vol. 1, no. 1 (November, 1886), 1-3.

2. The Whistler bibliography is enormous, greater than that devoted to any other American artist, and certainly this is due in part, at least, to the claims of two nations and their respective art historians upon the artist, in addition to the quality of his work and the international ramifications of his art. It would be fatuous to attempt to select a partial preference of pertinent material to which to refer the reader; however, Denys Sutton's *Nocturne: The Art of James McNeill Whistler,* London, Country Life, 1964, is an excellent general study of the artist and his work, and the exhibition catalogue with essays by Allen Staley and Theodore Reff, *From Realism to Symbolism, Whistler and His World,* Wildenstein, New York City, 1971, is of especial use here.

3. See Sutton, *Nocturne.*

4. See especially Otto Henry Bacher, *With Whistler in Venice,* New York, 1908; Bacher had previously published two articles on the subject in *Century,* Vol. 73 (December, 1906), 207-18 and Vol. 74 (May, 1907), 100-111. Harper Pennington's articles appeared in *International Quarterly,* Vol. 10 (October, 1904), 156-64, and *Metropolitan Magazine,* Vol. 31 (1910), 769-76. For Whistler in Venice, see also the two articles by William Scott, "Reminiscences of Whistler," *Studio,* Vol. 30 (November, 1903), 97-107, and *International Studio,* Vol. 21, no. 82 (December, 1903), 97-107.

5. See Robin Spencer, *The Aesthetic Movement and the Cult of Japan,* London, The Fine Arts Society, 1972.

6. See the comments concerning Whistler's debt to Velasquez in Robert Alan Mowbray Stevenson, *Velasquez* (originally The Art of Velasquez, 1895), 2nd edition, 1899, new edition, London, G. Bell and Sons, 1962, 150-51, where Stevenson speaks of Velasquez' Impressionism as influential on the modern movement.

7. For their volatile relationship, see William Merritt Chase, "The Two Whistlers," *Century,* Vol. 80 (June, 1910), 218-26.

8. Mariana Van Rensselaer, "American Painters in Pastel," *Century,* Vol. 29, no. 2 (December, 1884), 204-10.

9. "The Pastel Exhibition," *The Art Amateur,* Vol. 10, no. 6 (May, 1884), 123-24.

10. The major study of the pastel movement is Dianne H. Pilgrim, "The Revival of Pastels in Nineteenth-Century America: The Society of Painters in Pastel," *The American Art Journal,* Vol. 10, no. 2 (November, 1978), 43-62.

11. The relationship of pastel painting to the changing aesthetic of watercolor is perceptively discussed in Theodore E. Stebbins, Jr., *American Master Drawings and Watercolors,* New York, Harper & Row, 1976, 222-37.

*Dennis Miller Bunker Painting at
Calcot.* 1888
Oil on canvas
26¾ x 25 in. (66.2 x 63.5 cm)
The Daniel J. Terra Collection

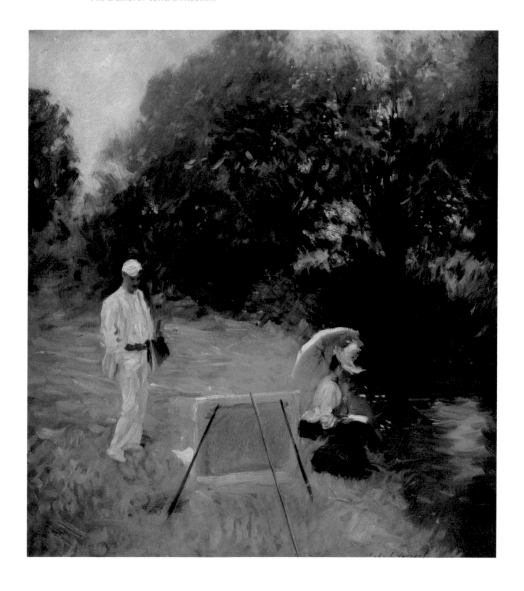

The notes for this chapter will be
found on page 43.

*Gourds.* n.d.
Watercolor on paper
13⅞ x 19¾ in. (33 x 48.4 cm)
The Brooklyn Museum, Purchased by special
subscription, 1909

# 6 John Singer Sargent and the Beginning of Impressionist Painting in America

The career of John Singer Sargent is one of the most fascinating, most successful and most complex in late 19th century American art, and one undergoing renewed study from various points of view.[1] Sargent was an artist of international acclaim, prominent in France, Great Britain and America, and renowned equally as a great portrait painter, a muralist and a watercolor specialist, as well as the creator of intensely dramatic genre paintings and vibrant landscapes. Since his fame in his own time rested upon his triple accomplishments in the first three categories, it is not surprising that the works of the last two have been somewhat overlooked, certainly less studied. Yet, his genre and landscape paintings are among his finest and most personal, and the landscapes are among the earliest Impressionist paintings by an American.

As with Whistler, the debate over Sargent's American affiliations and indebtedness has gone on for a century. In Sargent's case, despite his international standing and his residence primarily abroad, his American connections are greater and more explicit. He was born in Florence of American parents and made many trips of some duration back to this country, particularly from the mid-1880s on. Many of his patrons were American, and a number of his paintings were exhibited in this country and entered American public collections early on. His three major mural cycles, for the Boston Public Library, the Museum of Fine Arts in Boston and Harvard University are, of course, all here. Also, many of the artists with whom he shared experiences and whom he influenced were American.

Like the majority of American painters who figure in this essay and this exhibition, Sargent was trained primarily in France. The significance of this training for the character of American Impressionism has been too often overlooked and will be discussed more thoroughly in a later chapter. Here, however, it should be pointed out that Sargent studied, not at the École des Beaux-Arts, or in the ateliers of any of the French academicians, but with Charles Durand, better known under his more distinctive and euphonious pseudonym, Carolus-Duran. Carolus-Duran was a master

of bravura brushwork which he successfully used to interpret both the scintillating personalities and the rich costumes of his often chic patrons of Parisian society, and which he imparted to his young and precocious American student. J. Carroll Beckwith and Will Low were among the other American students of Carolus-Duran, but Sargent became the best-known, and most closely followed his master as a society portrait painter. Sargent's art is the greatest testimony to the success of Carolus-Duran's teaching, but Sargent did pay homage to his teacher in his great portrait of Carolus of 1879.

Sargent's earliest success was his second Salon entry, *The Oyster Gatherers of Cancale* of 1878, which won an honorable mention. The genre he chose for this major debut was a popular one during the 1870s: the depiction of French peasant life which attracted scores of artists, French and foreign, in the decades after Millet first introduced this genre. Sargent's essay in it is, in fact, contemporary with major works by such leading practitioners and specialists as Jules Breton, Léon L'Hermitte and Jules Bastien-Lepage. What is radically different in Sargent's masterwork, however, is the sense of sparkling air and light combined with the Carolus-influenced fluidity of paint. The light-colorism and scintillation neutralize, even negate, the by then traditional emphasis upon the toil and misery of the life of the lower classes to the point that the work is usually eliminated from that contemporary context, which would include peasant paintings by such young American contemporaries as J. Alden Weir, Wyatt Eaton, Robert Wylie and, shortly afterwards, by Charles Sprague Pearce.

*The Oyster Gatherers of Cancale* is an unusual work for Sargent; more in accord with the landscape painting of his time — with Otto Stark's "grey period" — are several views of the Luxembourg Gardens in Paris painted in the cool, overall tones of evening. But Sargent was, in the manner of his teacher, emerging as a society portraitist, and achieved real success with his *Portrait of Mme. Edouard Pailleron* of 1879. The combination of elegance and personality is noteworthy, and Sargent works here in the grand tradition of aristocratic elongation. Structure is significant, but Sargent sets the figure out-of-doors, and the soft and fluid treatment of the landscape in which the figure is set contrasts in its pale tonality with the dark and dramatic form of the wife of the eminent playwright. Sargent displays in his handling of color and composition not only his heritage from Carolus but his awareness both of the newer modes of Impressionism and the spatial treatment of Bastien-Lepage and others, placing his figures far down in the canvas with the landscape rising almost up to the top edge of the canvas, creating an extremely high horizon and flattening the picture plane, focusing attention upon the foreground elements — in this case, Mme. Pailleron herself.

A key to the complexity of Sargent's aesthetic character lies in the seeming contradictions in his artistic career. Thus, in 1880 and more significantly, in 1882, Sargent spent time in Venice, but instead of joining the attraction to Mediterranean light and color, the sparkling tradition of Canaletto, Sargent painted in Venice his darkest, most dramatic canvases. Rather than capitalize on the baroque architectural marvels or the picturesque canals and lagoons, Sargent's subjects were the working classes in the narrow side-streets or dimly lit, austere, Venetian interiors.

Likewise, it was only during the early years of his English residence, after the scandal over his controversial likeness of *Madame X* at the Paris Salon of 1884, that Sargent adopted and developed a modified Impressionist

technique, despite the English hostility to French artistic currents generally and to Impressionism in particular. Like Whistler, whose old studio Sargent took in 1886, Sargent moved closer to American colleagues after a public controversy which caused the artist to relocate.

Though Sargent visited England in the summer of 1884, it was the following year that his move became a permanent one. In the summer of 1885, he became friendly with the American expatriate, Edwin Austin Abbey, with whom he was much later to share the decoration of the Boston Public Library. Sargent injured himself while swimming with Abbey in the Thames, and Abbey took Sargent to the picturesque village of Broadway in Worcestershire, where Abbey's good friend, the American painter Frank Millet, had settled with his wife Lily and their children.[2] The Millet home and studio, first Farnham House at the end of the Broadway green and then Russell House at the entrance to the village, became the center for an Anglo-American artists' and writers' colony that was perceptively described by one of the visitors, Henry James, in *Harper's New Monthly Magazine* in June of 1889.

Sargent painted at Broadway during the summers of 1885 and 1886. His scene in Millet's garden of 1886, has a freedom, a rich colorism, and a sensitivity to light unparalleled in either English painting at that time or in the work of any American landscape painter. It would have been a painting such as this which would have earned for Sargent the appellation derisively assigned him by the critic in *The Art Journal* in 1887 as "the archapostle of the dab and spot school."

It was at Broadway, also, that Sargent undertook his most ambitious semi-Impressionist work — his first large subject picture following *The Oyster Gatherers* — *Carnation, Lily, Lily, Rose,* painted in the successive summers of 1885-86. He began the painting in September of 1885, shortly after he arrived in Broadway. Before his accident at Pangbourne Weir on the Thames, Sargent had been struck by the effect of Chinese lanterns hung among the trees and beds of lilies there, and he recreated the arrangement at Broadway centering two young girls in the fields of tall lilies. The composition had been anticipated the previous year in a more formal arrangement of the *Vickers Children,* painted in England at Lavington Rectory in 1884. In plunging the children up close in the dense flower bed, and using the white lilies as a foil for the figures, it is a precursor of the more famous *Carnation, Lily, Lily, Rose,* but the differences between the two are also significant, for in the later picture Sargent adopted what was essentially an Impressionist mode. Not only is the color more prismatically varied and of higher key, and, in some areas, forms more broadly defined, but Sargent painted the picture only a few minutes each evening, in order to record the light and its effects at a certain time of day. Sargent's concern with fleeting effects of light and indulgence in out-of-doors painting is radical for him and a very early manifestation of Impressionism in England.

Sargent began by posing the dark haired Kate Millet in a blond wig, but switched to the daughters of the English illustrator, Fred Barnard, after they arrived in Broadway. Edwin Blashfield described the procedure Sargent chose:

*It was midsummer — each evening at twenty-five minutes to seven Sargent would drop his tennis racket and going into the seventy-foot long studio would lug out the big canvas as if he were going to fly a huge kite. We would all leave our tennis for a time and watch the proceeding. Little Pollie and Dollie Barnard, daughters of the well known English illustrator, who himself was hobbling about the garden on crutches, after an accident, would begin to light the Japanese lanterns among the tall stemmed lilies. For just twenty-five minutes, while the effect lasted, Sargent would paint away like mad, then would carry the canvas in, stand it against the studio wall and we would admire.*[3]

Of course, Sargent's is a modified Impressionism. Though painted primarily in the out-of-doors, *Carnation, Lily, Lily, Rose* was finished in the studio in London in the fall of 1886. He chose the dimmer, evening light, rather than the full sunshine of midday, and his figures are posed in a shadowed field, not truly "in the open." And form is not dissolved; in fact, the degree of Impressionism is certainly selective — a broader treatment for the landscape and flowers, sharper, more defined for the figures. Also, subject matter is not abandoned. While Sargent eschewed the anecdotal, specific sentiment is present enough to have insured a positive reception in London for these "Botticelli-like angels," who glowed among the staid and subdued canvases of the Royal Academy exhibition.

Sargent did not return to Broadway the following year, but rather traveled to America in 1887, where he was engaged in portrait painting and where his career took a great turn upward; he was lionized by society, deluged with commissions and he enjoyed his first one-man show at Boston's St. Botolph Club in January of 1888. When Sargent returned to England in May, he took a house at Calcot on the Thames, and the pictures he painted there that summer, and at Fladbury the following summer of 1889, constitute the culmination of his relatively short-lived but extremely significant investigation of the Impressionist aesthetic.[4]

These pictures, in their greater range of color and broader brushwork, are also closer to the French Impressionist aesthetic than the Broadway pictures; their brushwork is usually, though not always, more uniform and involves greater dissolution of form. Sargent's aesthetic was then closer to that of Claude Monet and logically so. Sargent would have seen Monet's work at the first Impressionist show in Paris in 1874, and he met him at Durand-Ruel's gallery as early as 1876. When their friendship developed has not been ascertained, but it was by the time of Sargent's well-known painting *Claude Monet Painting at the Edge of a Wood,* probably painted in 1887 when Sargent also painted a profile portrait of Monet at Giverny; whether or not Sargent had visited Giverny earlier is not known. That same year, Sargent acquired Monet's painting *Rock at Tréport,* about which he wrote his French colleague, "I have remained before it for whole hours at a time in a state of voluptuous satisfaction, or enchantment, if you will. I am overcome to have in my house such a source of pleasures." They met again at the Universal Exposition in Paris in 1889, and showed together at the New English Art Club, Monet's address given as care of Sargent.

Sargent's typical paintings done at his summer retreats in 1888 and 1889 usually depict figures absorbed in an intimate landscape setting or cul-de-sac. Sometimes, as in his *Back Water, Calcot Mill* of 1888, the figures are almost camouflaged in nature, and joined to it by the slashing, long, quill-like brushstrokes which became a signature of his Impressionist mode. The figures are generally women, Sargent's sister Violet often posing for him, as in such works as his *Morning Walk* or *Two Women in a Garden.* In such paintings, the neutral tones are almost all eliminated and the figure and landscape sparkle in a warm, vibrant coloration.

Yet, Sargent was never able or willing to wholly give up the neutral tones, and René Gimpel quoted Monet as recalling that Sargent had once asked him for some black when they were painting together. When Monet responded that he had none, Sargent answered, "Then I can't paint." Likewise, as in the earlier *Carnation, Lily, Lily, Rose,* or the pure landscape *Home Fields* of 1885, Sargent still preferred the subdued evening light to the midday brilliance. Monet himself said that Sargent was not an Impressionist.[5]

Sargent's major involvement, even during the later 1880s, was with portraiture. He did show with the New English Art Club, and the sketches seen there were probably the most advanced work included. He did not exhibit in 1889 in the Impressionist show at Goupil's in London however, and after the summer in Fladbury that year, his engagement with Impressionism lessened. In December of 1889 he returned to America, and some of the portraits done there in 1890 reflect the looser brushwork developed during the previous years, while the landscape background in his virtuoso depiction of *Sally Fairchild* — her face only barely visible through veiling — reflects the broadly quill-like strokes of his Calcot and Fladbury summer work. This use of veiling, which can be found in contemporary work of such artists as Chase, is not only a reflection of style but also an interest in the manipulation of form within a surface penetrated by light and air.

It was in America in 1890 that Sargent received his great commission for the Public Library murals, and his involvement with this decorative scheme, in addition to his portrait commissions, precluded a return to the looser, more relaxed forms of Impressionism; in fact, his art took on a new severity and classicism. Much of 1890 was spent in Egypt studying its ancient civilization and painting the inhabitants in preparation for his murals. He was back in Giverny in 1892, where Theodore Robinson recorded in his diary "so many painters following after one another like sheep — makes one sigh for a black picture."

Although Sargent's Impressionist "period" was over, his enthusiasm for brilliant color and broader, freely painted forms recurred, particularly in some of his watercolors, especially such nature studies as his *Gourds* of 1908 and *Pomegranates:* depictions of still-growing objects amidst a dense maze of light-reflecting foliage. His oil paintings done for relaxation in the summers in the Alps during the first decade and a half of the 20th century also display a relaxed freedom and heightened coloration, the surface of the paintings animated with splashes and swirls which recall his informal Impressionist works of the late 1880s, although they are not as formalistically reflective of the French Impressionist aesthetic. And Sargent's Alpine light is the brilliance of midday, not the opalescent glow of evening. Perhaps closest among his late oil paintings to such earlier works like the depiction of *Claude Monet Painting* is *The Sketchers,* of about 1913, depicting his friends, the artists Jane and Wilfred de Glehn. The work, with two figures within a limited, absorbing landscape environment, is akin to many of his pictures of 1888-89, but it is less systematized and more expressive. Strokes may be long or stubby, flat or rounded, thick or thin as suited to the objects depicted. Areas such as the garments and the umbrella may be flattened while others are extremely animated, and the figures are quite clearly defined within their limited space, unlike the sometimes peculiar recession of forms and even disappearance of figures swallowed up by the reedy landscapes of Calcot. By the 20th century, Impressionism had contributed to Sargent in his more informal works a means for greater

pictorial expressiveness rather than a doctrine of landscape technique. His own conception of Impressionism was defined, somewhat confusingly, in a letter to his friend Dougall MacColl in 1912:

*I daresay I muddled what I said about Impressionism last night and perhaps this is a clear definition of what I think Monet would mean by the word, "The observation of the colour and value of the image on our retina of those objects or parts of objects of which we are prevented by an excess or deficiency of light from seeing the surface or local colour."*
*Of course to a very astigmatic or abnormal eyesight the whole field of vision might offer phenomena for the notation of an impressionist, but to the average vision it is only in extreme cases of light and dark that the eye is conscious of seeing something else than the object, in other words conscious of its own medium — that something else is what the impressionist tries to note exactly....*[6]

An Anglo-American artist whose involvement with Impressionism may predate Sargent's was Mark Fisher, but Fisher appears to have been far less significant or influential than Sargent, though he too, was esteemed in his own time.[7] He studied with George Inness at Medfield, Massachusetts, and in 1863 a patron of Inness' sent him to Paris to study, where he entered the atelier of Charles Gleyre, a somewhat unusual choice at a time when Americans were still partial to Thomas Couture. Still, Whistler had previously studied with Gleyre, and Fisher soon came into contact with Alfred Sisley, another pupil of Gleyre's. On his return to the United States, Fisher met with little success and went back to Europe, this time for good. Though he was briefly in Paris and in Normandy in 1871, the following year he settled in England.

In France, Fisher had also been exposed to the influence of Daubigny, and his early landscapes suggest strongly Barbizon affiliations, not surprising for a painter who had initiated his study with Inness. Fisher was a painter of rural scenes, and spent his time not in London but at Steyning in Sussex, and later in Bourne End and Hatfield Heath. Just when his work began to take on the lighter, more varied tonalities and the broken brushwork of Impressionism is not documented, but in 1883, after seeing Fisher's work at a Royal Academy exhibition, Lucien Pissarro wrote to his father in Paris that there were only two painters whose work he admired: John Everett Millais, and Mark Fisher, whom he stated painted like his father.

Fisher's sympathy with the new art of France led to his involvement with the New English Art Club, at which he was an early exhibitor along with Sargent, Whistler, Philip Steer, Walter Sickert and others, but it would be erroneous to suggest that the Club was a stronghold of Impressionist tendencies. French influence meant a great many different things, and the Club offered no one dominant aesthetic; probably the strongest direction exhibited by its members was the modified plein-airism influenced by Bastien-Lepage and seen in the work of Frank Bramley and some of the other painters of the Newlyn School.

Fisher's fellow club member Sickert, a disciple first of Whistler and then of Degas, admired Fisher's painting, and the well-known critic George Moore called him the best landscape painter in England.[8] Other English critics referred to him as a "Vibrist" or an "Iridescent." Fisher may well have been the earliest American Impressionist, though his art is in need of more detailed study, but by the time he was related to that aesthetic, he had divorced himself from his native land, and not only did not return but he did

not maintain or assume the rapport with American artists that Sargent did.

Nowhere was Sargent's influence in regard to Impressionism stronger than on Dennis Miller Bunker. Bunker was one of the most attractive American painters of the late 19th century, and the high regard in which he was held has gained added stimulus because of his tragically short life — he died at the age of thirty.[9] Bunker grew up in New York City and was an early pupil of Chase's at the Art Students' League in the late 1870s; he also spent time on Nantucket, which allows speculation on some association with Eastman Johnson there. In 1882 he went to Paris for two years, where he studied at the École des Beaux-Arts with Gérôme and at the Académie Julian. This academic training was significant for Bunker, and he was one of many French-trained Americans who maintained a great respect for Gérôme. On his return to America, Bunker settled in Boston where he began to teach at the newly opened Cowles School. Though he was a reluctant teacher and professed to dislike Boston intensely, he is claimed as a major figure in the history of late 19th-century Boston art, and rightly so. Bunker was the major inspiration to a whole generation of Boston artists: William Paxton was one of his pupils, but the whole generation of Boston Impressionists acknowledged his significance; Lucia Fairchild, the daughter-in-law of George Fuller and a muralist at the Chicago Columbian Exposition, was another of his pupils. Bunker was a young yet key figure in the Boston cultural and social world of the late 1880s, a member of the leading clubs, the St. Botolph and the newly founded Tavern Club, and much patronized by the leading collectors of the day: the Montgomery Searses, Henry Lee Higginson, Mrs. Samuel Peabody and especially Mrs. Jack Gardner.

Bunker, as we shall see, was an important link between European and American Impressionism, but it should be stressed that the majority of his work was not Impressionistic. Bunker applied his art to a variety of themes, not only landscapes but still-life painting and especially figures; the latter included genre groups, ideal figures and particularly portraits. In the great majority of his works, and especially those involving the figure, his academic training is evident, and magnificently so. His manipulation of form, his concern with an understated but very conscious composition, and his dark and restrained tonalities come directly from his Parisian training. Bunker added to this his special endowments: a sense of delicate restraint and a sensitivity to character which just slightly modified his basically objective attitude toward the portrait, qualities that make his very Whistlerian *Anne Page* of 1887 one of the great portraits of the late 19th century.

What must be stressed here, in fact, and indeed what is paramount to our understanding of the phenomenon of American Impressionism, is that the majority of American painters involved in that movement did not turn to Impressionism in reaction to or in rejection of their academic training, training gained primarily abroad — in Paris and Munich particularly. American artists, generally, were too proud and thankful of the opportunity of gaining academic mastery over form to simply reject it afterwards. American art history is replete with discussions about artists such as Theodore Robinson, J. Alden Weir and a host of others — which could include Bunker also — concerning a dichotomy or duality between French Impressionism and American Realism in aesthetic direction and allegiance. This is a convenient, but extremely confusing and ultimately false and illogical analysis. "Realism" was as much a French (Courbet), or English (Pre-Raphaelite), or German (Menzel or Leibl) art movement as it was an American tradition. If a Robinson, or Weir, or Bunker aimed at "realistic" mastery, it was not so they could continue the traditions of John Singleton Copley but so that they could compete with the Realism of Gérôme, whose work they admired, and whose pictures were honored in the Paris Salons — to which the Americans submitted their work — and were purchased by American collectors.

What the Americans, and European art students also, learned in their academic ateliers was the art of the figure. When they returned home, they maintained their academic allegiance in the painting of the figure. When, during their student years, they turned to landscape painting, they were more at liberty, if also at sea, to approach the landscape with less manipulated and inculculated concepts, freer to respond to and adopt the less traditional approaches advanced by recognized but still more progressive masters. This meant primarily Barbizon influences and connections throughout the third quarter of the century and even later; eventually a number of American painters began to explore light and color more fully, though often still maintaining an academic control of form and a dominance of line, as in the Glare aesthetic adopted by Picknell in his *Road to Concarneau*. And eventually this path led to Impressionism.

But what did *not* happen was a simplistic supplanting of academically-dependent art by Impressionism. Nor can we accept an easy judgement that the American painters were necessarily "more" Impressionist when they painted in France than when they painted back home. J. Alden Weir's American landscapes utilize many extreme aspects of an Impressionist technique by the last decade of the 19th century, while his figure paintings, particularly those painted under controlled light, are still firmly constructed. More closely related to Bunker's experience is the case of Frederic Porter Vinton. Vinton was one of Boston's finest and most established portrait specialists of the late 19th century; he may be considered the "official"

Boston portraitist of the period, one who was often host to Sargent on his trips to America. Vinton's portraits are solidly crafted, dark and dramatic pictures, bearing witness to his various study: first with William Morris Hunt with whom he studied in Boston and whose heir in Boston portraiture he was; then in Paris where he studied with Jean Paul Laurens and, perhaps more significantly, with Léon Bonnat, from whom he gained a preference for a Spanish-influenced dramatic intensity which stood him in good stead. Yet, Vinton's landscapes range from suggestions of Daubigny and Boudin, whose work he owned, to light-filled, sparkling studies which can be called Impressionist. One group did not supplant the other in either chronology or quality. Nor is Vinton's a schizophrenic art. His figure work — portraiture — pays homage to the academic tradition which he honorably joined and mastered; the landscapes bear witness to his investigation of and sympathy toward the newer aesthetic tendencies.

The same holds true for Vinton's good friend and colleague, Dennis Bunker. Bunker, in fact, was as much a landscape painter as a figure and portrait artist, much more so than Vinton, but, in his case, the early landscapes themselves, done in France and then back in America, suggest strong structural qualities along with a limited tonal range which are Barbizon related, not dissimilar to Courbet's landscapes. In addition, he painted numerous pictures of beached boats, which have a haunting, desolate quality which deserves greater study; none of these, however, remotely suggest Impressionism.

Then, however, in the summer of 1888, Bunker journeyed to England and stayed with Sargent at Calcot. Sargent, as an individual and as an artist, fascinated Bunker, and Bunker was present at the time that Sargent was painting his most Impressionist pictures. Indeed, a fascinating document exists in Sargent's depiction of Bunker painting outdoors, which, in its similarity to Sargent's similar painting of Monet working in the woods near Giverny, is a pictorial testimony to the transmission of Impressionist influences from France to England to America.

Bunker not only admired but adopted Sargent's landscape technique. Bunker's portrait and figure paintings created during his last two years remain consistent with his previous work, but the landscapes he created during those two summers of 1889 and 1890 when he, like Sargent in his rural summers and like Vinton in his relaxed, "holiday" landscapes, turned to a theme and subjects of his own choosing and not on commission, Bunker adopted the aesthetic that Sargent had developed. These are the Medfield landscapes. As did Sargent, Bunker chose informal, seemingly uncomposed sections of landscape turf, totally ignoring classical construction and composition. Bunker, even more than Sargent, "zeroes" in on a small segment of grassland, painting with broad, long quill-like strokes, though sometimes more curvilinear and whip-like than Sargent's. (Edmund Tarbell, speaking with Frank Benson, was to refer to Bunker's brushstrokes as "fishhooks.") Again, there is not the total dissolution of form as in Monet's painting, nor is there ever the full prismatic range; many of Bunker's Medfield canvases are more muted, and the light, as in Sargent, often evening light, is never as rich and golden as in contemporary French Impressionist work. Like Sargent, Bunker usually composed along a long diagonal, creating a sense of depth despite the close-up composition; as in the work that John Twachtman was beginning to develop at the same time, Bunker raised his horizons high in the composition and sometimes

eliminated them altogether, a conception which tended to emphasize the flatness and two dimensionality of the canvas as the picture plane. Not guided by his academic training, Bunker questioned himself over the matter of "finish." He disliked the clever look of incompleteness, the raw look of a work only commenced, but he equally disdained a labored appearance.

Bunker's new semi-Impressionist work was not ill-received in Boston, and that city's leading patron of the arts, Mrs. Jack Gardner, acquired a number of his landscapes. One of these, his *Chrysanthemums* of 1888, was painted in Mrs. Gardner's Brookline, Massachusetts, greenhouse and must certainly be one of the first of Bunker's works in the new style after his return from Calcot. While the picture depicts his patron's favorite flower it also reveals Bunker's sympathy with floral subjects, though pure still lifes seem to have been painted by him more to be given away as expressions of friendship than as a commercial venture. The chrysanthemum was a popular flower in the late 19th century, first due to the vogue for things Japanese and then because of its combination of rich color and wispy petal construction, which made it an ideal form for Impressionist interpretation. Bunker's picture is also an early example of the popular Impressionist garden composition, one which Childe Hassam would exploit a few years later on the Island of Appeldore.

Bunker's work was early recognized by Hamlin Garland, who was to become a major champion of Impressionism, in his *Roadside Meetings.* In 1890 the artist began to suffer from eye trouble and spent some time at the art colony in Cornish, New Hampshire, where St. Gaudens, George de Forest Brush and Dewing had studios; Bunker's best known figure painting, his *Jessica* of that year, vividly recalls Dewing's work. But he was not comfortable there and returned to Massachusetts, summering in Medfield and marrying. By then he had carried out a resolution to leave Boston and the couple returned to New York City, but Bunker died of influenza in December. With more validity than in most cases of romantic speculation, the art lover and historian may wonder at the course that American painting

of the last decade of the 19th century would have taken had Bunker lived.

A Boston contemporary of Bunker's was John Joseph Enneking.[10] He was born in Minster, Ohio, but after serving and being wounded in the Civil War he went first to New York and then to Boston, where he studied with the New England landscapist Samuel Gerry. In 1872, the young Frederic Vinton advised him to go to Europe where he studied with Bonnat and, like so many Americans, also fell under the influence of Daubigny. His biographers suggest an early contact with the Impressionists, this at a crucial moment for the development of that school, but there seems no documentation for this. He also painted in Munich and in Venice and was back home by 1876, settling at Hyde Park, Massachusetts, and establishing a summer home in the early 1880s at North Newry, Maine.

Enneking's art offers another example of attempts to circumscribe an artist's development too easily. While his earliest pictures are predictably a reflection of the local Boston equivalent of the Hudson River School, his later paintings show a wide variation in style. His present-day champions refer to him as an early Impressionist, but this is very obviously not the case, although some of his landscapes do show Impressionist qualities. Others, however, suggest closer affinities with Barbizon painting and some with Tonalism. Yet, it would be equally incorrect to define a progression from Barbizon, to Tonalism, to Impressionism, despite the difficulties in dating Enneking's work. Contemporary critics are equally unhelpful. In 1908, Edmund von Mach referred to Enneking as "...an Impressionist of the Impressionists,"[11] while another writer said that he combined the qualities of Impressionist, Luminist and Tonalist schools. Enneking was a close friend of George Fuller's and had a studio next to Fuller's; he and Inness were also friends. It would seem logical that he would have known Bunker well in the 1880s, but there seems little documentation of that, though they must have been acquainted.

Enneking's art comes closest to Impressionist modes in pictures he painted of flowering orchards in bright sunlight; they are joyous and bright pictures, but even here Enneking emphasizes an overall decorative quality, and writers pointed to "unity" as an overriding concern which allies his art with that of Ranger and his brand of Tonalism. The other problem with aligning Enneking with Impressionism is that, while some of his works may border upon the aesthetic of that movement, his finest pictures, recognized also as such in his own time, were his more subdued autumnal views — not of the most brilliant foliage of autumn but the subdued, grave characteristics of late fall. He was most widely known for his November scenes and his dusk and twilight interpretations, esteemed for a concern with "time" rather than "place." In this interest in Nature's moods, he reflects a basically Barbizon aesthetic, seen at his best in close-up views of pools and nooks in New England. In these, his more quiet paintings, Enneking does reveal a color interest and sometimes a greater and more pronounced freedom of brushwork than many Barbizon artists, but his Impressionism was tentative at best when *he* was at *his* best. Enneking was also active as an illustrator for *Scribner's, Harper's* and other magazines and in 1907 painted a spectacular impression of The First Church of Christ Scientist for Mary Baker Eddy.

Another Boston artist who ventured toward Impressionism in the late 19th century without ever fully committing himself was John Appleton Brown.[12] In 1874 Brown studied with that once-famous French landscapist, Emile Lambinet, extremely popular with American artists and collectors, but by

the late 1870s was working in a manner more free than his teacher's. He early visited the Isles of Shoals off the coast of New Hampshire, with William Morris Hunt, and he is associated with the center for the arts there where the poet Celia Thaxter attracted artists and writers to her summer home and garden. Brown was one of the leading figures in her entourage, but his fame is overshadowed by that of Childe Hassam. Brown also visited Frank Millet and Edwin Abbey at Broadway in England in 1886, and presumably met Sargent there. Brown's best known paintings are light and airy views of orchards, featuring the opening blossoms expressed with buoyancy and optimism; indeed, he early earned the cognomen of "Appleblossom" Brown. His paintings are somewhat repetitious, but they represent well a stage before full Impressionist expression, with their feathery brushwork in bright, June sunlight, subtle and delicate rather than strong and robust. In the early 1880s, Brown was also an artist important in the revival of pastel painting, itself an important link in the development and acceptance of Impressionism in America.

One final "semi-Impressionist" landscapist should perhaps be mentioned here. Arthur Hoeber was a significant figure in American painting at the end of the 19th century and the beginning of the 20th, as one of the two American landscape painters who were equally active, and therefore possibly influential, as writers on art; the other was the Tonalist, Birge Harrison, about whom Hoeber wrote an important article.[13] Hoeber's writings appeared in almost all of the general and many of the specialized art periodicals over the twenty-five-year period between 1890 and 1915, when he died. His writing appeared mainly in *Harper's Weekly,* and later in *International Studio* and *Bookman;* he wrote a series on "American Art" for the last, in 1900. He also wrote extensively for the newspapers *The New York Times* and the *Commercial Advertiser.* He covered a wide range of subjects, but he only occasionally dealt with Impressionist, never with more advanced, artists, and his general articles tended toward the conservative. Significantly, one of the earliest and most important, "The New Departure in Parisian Art" which appeared in the *Atlantic Monthly* in December of 1890, does not, as one might assume, describe tendencies of Post-Impressionist or even Impressionist painting, but rather Meissonier's breakaway group of the Société Nationale des Beaux-Arts, organized against the traditional Salon system. And his one discussion of a *major* Impressionist, a short piece on Mary Cassatt which appeared in *Century* in March, 1899, is revealing in his basically conservative if sympathetic bias:

*Time was when Miss Cassatt gave strong evidence of her predilection for the curious group of Frenchmen who, sacrificing line and form, composition and harmony or arrangement, even beauty itself, concerned themselves solely with problems of light, air, and the effort to produce scintillating color. Then came her leaning toward those Oriental workers in the land of chrysanthemums, and Miss Cassatt produced many delicately conceived etchings, drawings, and paintings, betraying her affiliations with a wonderfully decorative race. Through all the efforts, however, there were seriousness, intelligent searching, and always individuality.*

*It would seem, however, that Miss Cassatt has found her true bent in her recent pictures of children and in the delineation of happy maternity.*[14]

Hoeber himself studied at the Cooper Union and the Art Students' League under J. Carroll Beckwith before going to Europe in 1881 with letters from the famous actor Lew Wallack to his brother-in-law, Sir John Everett

Millais; Hoeber was later to write several articles about Millais. Millais sent Hoeber on to study with Gérôme in Paris, and following the usual course, Hoeber spent his summers in the lands of the peasants, in Normandy and at Concarneau in Brittany, where he became close friends with the American expatriate Alexander Harrison.

Earlier in his career, Hoeber painted several monumental peasant subjects of the kind popularized in the Salon by Frenchmen such as Bastien-Lepage and Americans like Daniel Ridgeway Knight, Charles Sprague Pearce and others. But on his return to America he spent much of his time on Cape Cod and Long Island, though he was one of the first artists to settle in the new art colony in Nutley, New Jersey. He became primarily a painter of marshlands, preferring low, flat horizons and constructing a geometric division among the elements of nature, contrasting parallel sweeps of land and sky. Stability of form paralleled stability in nature; he reduced the elements of his composition to the minimum and tended to omit foliage. His reductive compositions relate his art to that of J. Francis Murphy and Tonalism, but at his most interesting he infused those marshy landscapes with a colorism that reflected the Impressionist aesthetic he appears otherwise to have disdained. Perhaps he felt he had achieved a landscape art which retained "line and form, composition and harmony of arrangement, even beauty itself..." and still combined these elements with "light, air, and the effort to produce scintillating color."

1. The bibliography on Sargent is prodigious; the best recent general study is Richard Ormond, *John Singer Sargent*, New York and Evanston, Harper & Row, 1970.

2. For the artists' colony at Broadway, see Henry James, "Our Artists in Europe," *Harper's New Monthly Magazine*, Vol. 79, no. 469, (June, 1889), 50-66, and Alice Van Sittart Carr, *Mrs. J. Comyns Carr's Reminiscences*, London, 1926, 172-79.

3. Edwin Howland Blashfield, "John Singer Sargent — Recollections," *North American Review*, Vol. 221, no. 827 (June, 1925), 643-44.

4. Donelson F. Hoopes, "John S. Sargent: Worcestershire Interlude, 1885-1889," *The Brooklyn Museum Annual*, Vol. 7 (1965/66), 74-89, is a very thorough study of this period of Sargent's career.

5. Evan Charteris, *John Sargent*, New York, Scribner's, 1927, 133; see also in this very valuable study the general discussion of Monet and Sargent, 122 ff.

6. Charteris, *John Sargent*, 123.

7. For Fisher, see Vincent Lines, *Mark Fisher and Margaret Fisher Prout*, London, privately published, 1966, and C. Lewis Hind, "Mark Fisher," *The Art Journal*, Vol. 72 (January, 1910), 15-20.

8. See the essay by M. L. D'Otrange Mastai in the catalogue *Mark Fisher, 1841-1923, the Impressionist*, Vose Galleries of Boston, 1962.

9. For Bunker, see the extremely sympathetic volume by R. H. Ives Gammell, *Dennis Miller Bunker*, New York, Coward-McCann, 1953, and the essay by Charles B. Ferguson in the catalogue *Dennis Miller Bunker (1861-1890) Rediscovered*, New Britain Museum of Art, New Britain, Connecticut, 1978.

10. For Enneking, see Patricia Jobe Pierce and Rolf H. Kristiansen, *John Joseph Enneking: American Impressionist Painter*, North Abington, Massachusetts, Pierce Galleries, 1972, which, however, leaves unresolved many questions concerning the painter's art. The reader is advised also to consult the articles by William Baxter Closson, Ralph Davol, and Jessie B. Rittenhouse listed in the bibliography.

11. Edmund Von Mach, *The Art of Painting in the Nineteenth Century*, Boston and London, Ginn and Company, 1908, 109.

12. For Brown, see the article by William Howe Downes, "John Appleton Brown, Landscapist," *American Magazine of Art*, Vol. 14, no. 8 (August, 1923), 436-38, and the section concerning him in Frank Torrey Robinson, *Living New England Artists*, Boston, S. E. Cassino, 1888, 21-28. His early work is noticed in "American Painters — J. Appleton Brown," *The Art Journal* (New York), Vol. 4 (1878), 198-99.

13. For Hoeber's own painting, see Charles H. Caffin, "Arthur Hoeber — An Appreciation," *New England Magazine*, Vol. 28, no. 2 (April, 1903), 223-33. Hoeber's various periodical contributions are far too numerous to list. Many are on general issues of the day; others concern specific contemporaries such as Mary Cassatt, Joseph De Camp, Gari Melchers, Robert Reid, William Sartain, Edward Emerson Simmons, and F. Hopkinson Smith. His study of Birge Harrison was published in *International Studio*, Vol. 44, no. 173 (July, 1911), iii-v.

14. Arthur Hoeber, "Mary Cassatt," *Century*, Vol. 57, no. 5 (March, 1899), 740-41.

**Mary Stevenson Cassatt**

*A Cup of Tea.* ca. 1880

Oil on canvas
25⅝ x 36⅜ in. (63.5 x 91.4 cm)
Museum of Fine Arts, Boston, Maria
Hopkins Fund

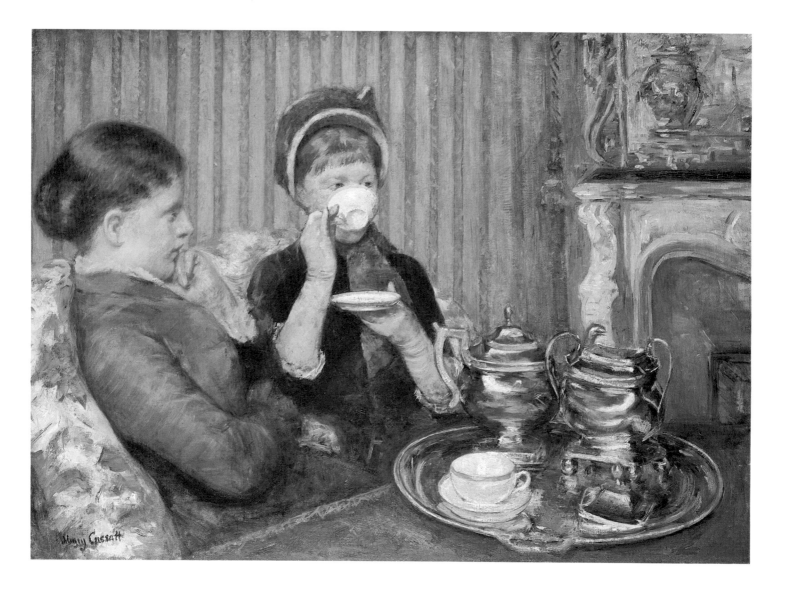

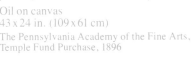

*New England Woman*
*(Mrs. Jedediah H. Richards).* 1895
Oil on canvas
43 x 24 in. (109 x 61 cm)
The Pennsylvania Academy of the Fine Arts,
Temple Fund Purchase, 1896

# 7 Mary Cassatt and Cecilia Beaux

Mary Cassatt became not only the greatest American woman artist of the 19th century but probably the finest woman painter of that century in the Western world. The designation of "woman artist" is not meant to imply a limitation in the quality of her art but rather Cassatt's triumph over the limitations imposed by societal traditions and practical obstacles through the 19th century. Like her mentor, Edgar Degas, Cassatt developed into one of the strongest figure painters of the period, and like him also, her place in the Impressionist movement and the relationship of her painting to the Impressionist aesthetic is complex and, in some ways, contradictory.[1]

Her designation as an "American" artist is as debatable as the appellation to her of "Impressionist." Almost all of her training took place and almost her entire maturity was spent abroad. She is usually grouped with Whistler and Sargent as the triumvirate of great American expatriates,[2] but she spent an even shorter period in this country engaged in the pursuit of art than Whistler, and returned to this country for far fewer visits than Sargent. Yet, her impact upon American art and taste was enormous, for she transmitted aesthetic conceptions based upon her European contacts to her native country. Her work was seen in American exhibitions, judged by American critics and acquired by American collectors, and she influenced wealthy Americans to purchase the work of her French colleagues as well as directing their acquisition of old master pictures. But she was also American in a less definable, less tangible, yet still significant manner because she was known as an American among artists, writers and patrons on both sides of the Atlantic, and this not only influenced the judgment of her and her work but defined the placement of her art, critically and historically, as it did Whistler's also. Parenthetically, she knew both Whistler and Sargent; she did not like Sargent's art though she admired Whistler's, but she was not sympathetic to the irregular nature of the latter's life.

In addition to the problems arising from her designation as an "Impressionist" and an "American," Mary Cassatt's reputation has suffered from the limitations suggested by the title of Achille Ségard's study of 1913, designating her as a painter of mothers and children.[3] Not only does the tradition regarding that theme suggest a sentimental motivation and interpretation almost totally absent from Cassatt's work, but while a great many of her pictures are of mothers and children, the theme was not so great a preoccupation as the critical literature would lead us to believe. Such an unfortunate limitation developed because Cassatt's fame, and the recognition of her individuality as distinct from her role as a member of the French Impressionist group, began to be acknowledged around 1890, at about the same time that her thematic concern began to be more single-mindedly maternal. But such simple designation particularly ignores some of her greatest painting of the late 1870s and the 1880s, especially those for which her beloved sister Lydia and her mother posed.

Mary Stevenson Cassatt was born of a wealthy and socially prominent Pennsylvania family in Allegheny City. She grew up in Philadelphia and visited Paris as a child, an environment which obviously took strong hold. As an artist she matured slowly; in the middle of the 1860s she studied at the Pennsylvania Academy, studying from plaster casts and copying older paintings. The instruction at the Academy was not agreeable to her, and she went to study art in Europe at the end of the decade, but returned to Philadelphia at the time of the Franco-Prussian War. In 1872 she was in Italy, studying with Carlo Raimondi in Parma and working after the old masters,

The notes for this chapter will be found on page 49.

## Mary Stevenson Cassatt

*La Famille ('The Family').* ca. 1887
Oil on canvas
32¼ x 26⅛ in. (81 x 66 cm)
Chrysler Museum at Norfolk, Virginia, Gift
of Walter P. Chrysler, Jr.

but the latter seem to have had little influence on Cassatt's art.

1873 was a crucial year in her development as an artist, for that year she visited Spain and painted her earliest thoroughly mature and professional works. These paintings of toreadors and young Spanish women were shown in Paris and back in America. Cassatt was one of the first American painters to find inspiration in Spain, though she had been preceded by Thomas Eakins and several others; the French artists' attraction to Spain began in the 1830s. The lure of Spain was two-fold: some painters were drawn to the traditions of 17th-century Spanish painters, above all Velasquez, others went to explore the picturesque nature of Spanish life. In the 1860s, Edouard Manet had produced a series of monumental Spanish figure subjects even before he visited Spain, and Cassatt's Spanish pictures of the following decade are in the vein of early Manet — strong figure painting still within an academic tradition of modeling, but unidealized figures caught in informal moments, glowing richly in dark and vivid colors. In these pictures, the paint "lives" on the surface of the canvas, as in the works of Manet or the late works of Velasquez, which impressed Cassatt. A group of the most important of these pictures were shown at the Cincinnati Industrial Exposition of 1873, works amazingly advanced for their time, though not yet Impressionistic.

It was in 1873 also that the artist met Louisine Waldron Elder, the wealthy young American who was to marry Horace Havemeyer.[4] Cassatt advised her on the acquisition of the Degas pastel mentioned above, perhaps the first Impressionist picture acquired by an American and exhibited in this country. A work of Cassatt's attracted the attention of Degas in 1874 when shown at the Salon. In 1875 she was persuaded by her family to study with Charles Chaplin, a popular artist of fashionable, pearly pink figures and nudes, but Cassatt was not at ease with Chaplin's formularized methods. Some of her painting at this time was already becoming more broadly painted and lighter in tonality, though still solidly formed — moving in the direction of Degas even before she finally met him in 1877. She had known of the Impressionist group since their exhibitions had begun in 1874; now she was invited to join them, and she never again sent her work to the Salon, rejecting the concept of the juried exhibition.

1877 also saw her joined by her sister Lydia and her parents, and the next five years constituted probably the happiest days of her life and career. From 1879 on — the year she first exhibited with the Impressionists — her work, at its best, maintained a balance of strong figure modeling and brilliant coloration, her palette lightening. Cassatt's brushwork became increasingly fluid, but she never adopted totally the broken brushwork of Monet or Renoir, at least not in her work in oils. Something of Renoir's elegance characterizes her earlier depictions of Lydia, but it is Degas' influence which is paramount, both formally and thematically. Like Degas she preferred brilliant artificial light which was constant and controlled. The theatre and the opera offered the settings for some of her finest paintings, but she concentrated upon single or paired figures, created in easy confidence of the structure of the form and the movement of the figure. Cassatt adopted Degas' radical compositional thrusts, strong diagonals or curving two-dimensional forms repeating the sweeping curves of distant ranges of theatre boxes far behind, with no intermediate "middle distance." Like Degas, or the late Manet of the *Bar at the Folies Bergères,* Cassatt frequently employed mirrors, not only to duplicate yet reverse images, but also using

the light off reflective surfaces to subtly alter the atmospheric density and repeat, yet vary, identical shapes which balance the forms of the mirrors themselves.

From Degas, Cassatt adopted natural poses, often viewed as awkward by critics who could not comprehend their untraditional aspects, though her sense of style and taste, and the concern for accurate draftsmanship which she shared with Degas, kept her work from the damning criticism often visited upon many of her Impressionist colleagues. She seldom painted genre scenes or landscapes, and still lifes almost never. When her subjects were situated in the out-of-doors, the backgrounds conformed to the free brushwork of Impressionists but the figures maintained their structural clarity. From Degas, too, she gleaned an enthusiasm for the pastel medium, and the methodology also — using pure color, wetting some of it down, and allowing it to become runny in areas, gummy in others, and reworking the pastel. She was one of the great pastellists of the late 19th century.

In 1880, Cassatt took a summer home at Marly, in a villa next to Manet's. Monet advised her to pose her models there, and she did so increasingly, but she remained more at ease with indoor pictures as in her great *Cup of Tea* of the same year, shown in the fifth Impressionist exhibit of 1880. Lydia appears in profile, amidst an abstract design of vertical, horizontal and diagonal patterns, and the contrast of patterns and flat areas of color look forward to the painting of Vuillard and Bonnard while acknowledging a debt to the assymetric, abstract rhythms of Japanese art. The relaxed informality and the momentary pose of the teacup, deliberately creating tension through obscuring the face, are of a manner at once original yet indebted to her mentor, Degas. It should be emphasized that Cassatt was never Degas' pupil though she did follow his aesthetic closely, rejecting the near-total dissolution of form practiced by some of their fellow Impressionists. They shared an interest in similar subject matter, though in this sphere she shunned both the more "vulgar" thematic preoccupations of working women and bathing nudes, and the subjects concerned with the taut anatomy of implicit movement: the race horses and ballet dancers.

Cassatt maintained her contacts with America in the early years to a limited extent, exhibiting both at the National Academy and the newly formed rival organization of the Society of American Artists, showing there not in 1878, the year of the first exhibition, but in the second in 1879; she also exhibited with the American Watercolor Society. Yet, it should be emphasized that, although she had already had contact with the Impressionist group in 1877, the works that she exhibited in America in the late seventies and early eighties were not her most "advanced" paintings. Her *Woman in Black at the Opera* of 1880, shown at the Society of American Artists the following year was actually one of her more monochromatic works, dark and dramatic. William Brownell recognized it as lacking charm, but forceful, and characterized it as of the "better sort of Impressionism," though it is not, in truth, Impressionist at all.[5]

Although Cassatt's figures were based upon live models, portraits per se are relatively rare in her oeuvre, and often when she painted a likeness *as* likeness — though even then formal considerations were often primary and motivating — it was not deemed successful by the subjects or their families. Such considerations were not particularly significant when Lydia or her mother were the models, and paradoxically these are among her most successful works, as pictures and as portraits. Perhaps her finest portrait is

that of her mother, *Reading the Figaro,* traditionally dated 1883 but exhibited early in 1879 in New York, and thus probably done at the end of the previous year.[6] It is both a monumental image and a strong, objective yet not unsympathetic likeness, but it owes more to Manet than to Degas, perhaps not surprising in view of its early date. Again, it should be emphasized that the degree of concern with Impressionist aesthetics is no measure of the success of Cassatt's art. She was often more confident and assured in her handling when form and drawing were emphasized, rather than color, light and loose brushwork.

Mary Cassatt's involvement with the maternal theme began in the early 1880s though it did not become paramount for almost a decade. She preferred natural poses, and sometimes lively, sometimes thoughtful, but never saccharine images, often turning away the face of either the mother or the child, deliberately avoiding an overemphasis upon their psychological interdependence. She often preferred to depict countrywomen, emphasizing a tender yet practical material affection. Critics often, not surprisingly, compared her work with that of her colleague, the Frenchwoman Berthe Morisot.[7] Morisot, similarly, enjoyed the domestic theme, though the maternal was not her specialty. A sister-in-law of Manet, Morisot's "Impressionist" paintings exhibit the looser, broken brushwork of orthodox Impressionism, but the critics rightly found Cassatt's painting stronger and more powerful. Cassatt and Morisot were friendly rivals.

By the late eighties and early nineties, Cassatt's painting had developed toward a more powerful and more linear rendering of form and design. The brushwork in her oils often was less free, while interior modeling of form was flatter and less bold. The change in aesthetic was not total; more loosely modeled figures could still be found in her oeuvre, but among her major works there were many depicting figures with strong, sharp outlines and more firmly patterned designs both in the overall compositions and in the patterning of textile costumes and coverings.

This quite significant change was due in part to her increased interest in Japanese art. She had been familiar with the principles of the Japanese aesthetic long before, and, indeed, a concern with juxtaposed flat shapes and cropped forms in compositions stems in part at least from her acquaintance with Japanese art, both directly and through Degas. But in 1890 she was much impressed by an exhibition of Japanese prints she visited with Degas. The clearest impact of the Japanese print aesthetic can be seen, of course, in the magnificent series of intaglio prints she produced in 1891, a translation of the effects of the Japanese woodblock into a complex combination of drypoint, soft-ground and aquatint. Her interest in the print medium itself had been aroused by Degas as early as 1879, when she experimented with printmaking for contributions to an abortive journal, *Le Jour et La Nuit,* to which she was to contribute along with Degas and Pissarro, but her greatest triumph in the graphic medium were the series of ten Japanese-inspired works she produced in 1891. Two more done the following year were added to an exhibition of the work shown by Durand-Ruel in Paris in 1893. Though the prints did not sell well, they greatly impressed her fellow artists, and Mary Cassatt is credited with a major place in the aquatint revival of the late 19th and early 20th century.[8]

These prints, and about half a dozen similar ones done *circa* 1894-95, continued her interest in the domestic themes of mothers and children, and women alone, but in a wonderfully austere yet decorative manner,

*Lydia Cassatt, the Artist's Sister
(Lydia Reading the Morning
Paper #1).* 1878

Oil on canvas
32 x 23½ in. (81.3 x 59.7 cm)
Joslyn Art Museum, Omaha, Nebraska

displaying a firm control of line, forms seen obliquely—often from overhead—and tinted with delicate, flat tones. Their artistic success was part of her increasing critical success and interwove with the increasing influence of the Japanese aesthetic in her painting. Though the Oriental influence in Western art in the late 19th century is parallel to the development of the advanced aesthetics of Impressionism and Post-Impressionism, it is in some ways diametrically opposite to the practices of the former movement. Japanese art is concerned with strong linear design, flat-colored tones and surface flatness; Impressionism in an orthodox sense eliminates line, dissolves form, and breaks up colored areas into multi-chromatic ones.

The change in Cassatt's art, incorporating increased Oriental design sensibility, united with the Post-Impressionist concern with more emphatic form and design as represented especially by the monumental, allegorical work of Puvis de Chavannes and the mural revival of the late 19th century in the Western World. The rejection of illusionism and the new respect for the integrity of the flat wall surface in mural painting found an equivalent in easel painting in the concern both artistic approaches shared for the flat surface. Much of Cassatt's art of the early 1890s was involved with this aesthetic approach, works such as *Young Women Picking Fruit* of 1891, *The Bath* of 1891-92, and *The Boating Party* of 1893, the last the most radical in design, the most Japanese-influenced of all her work.

Such an aesthetic turn stood Cassatt in good stead when she was invited by the wealthy Chicago art patron, Mrs. Potter Palmer, to contribute to the Columbian Exposition in Chicago held in 1893. She created one of the two major murals in the Woman's Building—Mary Fairchild Low painted the other—a structure completely designed and decorated by women and filled with an exhibit of women's art work of all nations. Cassatt's three-section mural depicting *Modern Woman* was a vast work, about 12 x 50 feet, which was painted in France on canvas and sent over to Chicago to be mounted. At the left and right were depictions of *Young Girls Pursuing Fame* and the *Arts of Music and Dance,* surrounding an allegory of *Young Women Plucking the Fruits of Knowledge and Science.* The central section was an expansion of her several depictions of women with children picking fruit, and the concept of a modern allegory relates closely to Puvis and the recent achievements in mural painting both in theme and in style. The distinguished critic, Mariana van Rensselaer, wrote of the Cassatt mural:
*There is to be no serpent in this nineteenth century Eden, no hint of any angel approaching with a flaming sword. For today the forbidden fruit is no longer forbidden. Adam himself actually tempts Eve to partake of it; and as she has learned to let Worth and Doucet dress her, so she has learned that it is better to eat of the Tree of Knowledge than to feed upon husks and straws, or to try and sustain life on nothing at all.*[9]

Despite the significance of Cassatt's mural and its vast dimensions, it disappeared almost immediately after the close of the great international exposition and to this day remains lost, perhaps destroyed.[10]

In 1898-99, Cassatt returned to America for her first visit in almost thirty years. Her mother had died in 1895 and she was free from the responsibility of family care. She made another trip back to America in 1904, but France remained her home until her death. She traveled a good deal with the Havemeyers, visiting Spain and Italy in 1901, encouraging them to purchase works by El Greco and Goya, Moroni and Veronese as well as more modern

French artists. In her *Memoirs,* Louisine Havemeyer wrote that "Mary Cassatt has the flair of an old hunter, her experience made her as patient as Job and as wise as Solomon."

Cassatt made her last visit to America in 1908-09. Meanwhile, though her artistic production did not abate in the first decade of this century, Cassatt was becoming increasingly infirm and, in particular, her eyesight began to weaken and fail her. She was still capable of successful, even monumental renderings of maternal and domestic scenes, but usually painted with less concentration and a lighter touch, returning to greater freedom of brushwork and less linear precision as these qualities became increasingly difficult for her to control. She remained more consistently successful in her continued use of pastel — the soft, chalky medium being more suited to the restrictions imposed upon her by her physical condition. And in some of her later oils the medium is treated almost like pastel chalks.

Finally, she was forced to stop painting in 1911; she resumed her art valiantly in 1913 for a short while, but the following year had to stop altogether. Many of these last works, all pastels, are coarse with an evident loss of control of form, and even color. A strong-minded, often opinionated woman, she became increasingly embittered in her very lonely last years. She who had been a champion of progressive aesthetic developments and an artist tremendously respected irrespective of her gender, ended her days a violent opponent of modern artistic developments.

There were critics at the turn of century who considered Cecilia Beaux a painter superior to Mary Cassatt. Beaux, somewhat younger, was, like Cassatt, a figure and portrait painter, though she painted far more commissioned portraits than did Cassatt. In her dignified portrait likenesses —combining monumentality with a free, vigorous technique—Beaux's art was more like Sargent's, to whose work her paintings were often likened. Sometimes, indeed, Beaux's art was considered superior to her more famous contemporary.[11]

Beaux grew up in Philadelphia as did Cassatt. Studying there, she submitted her work to the Paris Salon before actually going there, where she enrolled at the Académie Julian; critics, however, saw in her work the influence of Carolus-Duran, Sargent's master. Returning home in 1891, she continued to submit her work to the Salon.

Beaux was not an Impressionist, although the same reservations can easily be made of Sargent and, to a degree, Cassatt. However, in some of her paintings, and these are among her finest, Impressionist influences penetrated her usually more structured and tonal figure painting. Beaux painted no more beautiful nor more moving painting than her rendition of a *New England Woman* of 1895. The sympathetic, even beautiful, yet restrained depiction of old age, infused with the suggestion of traditional regional character, may be effective primarily through the artist's interpretive sensitivity, but the warmth of personality is memorably echoed in the glowing light through the window at the left, creating an almost spiritual infusion. The light in turn dissolves the pure white of her costume into glowing purples, blues and other varied chromatic tints, in an aesthetic delicately informed by Impressionism, this at a time when that movement had triumphed in America. Beaux's *New England Woman,* so closely related to Whistler's famous image of his mother in its composition, reverses the latter's objective interpretation to a sympathetic, subjective one and a monochromatic treatment to a sensitive exploration of luminous colorism.

1. While there are a number of volumes on the art of Mary Cassatt both in English and in French, many of these are primarily biographical and her art is still deserving of scholarly study. See the volumes on her by E. John Bullard, Julia M. Carson, Nancy Hale, Frederick A. Sweet and Forbes Watson in English, and Achille Ségard and Edith Valerio in French. The most important monographs are the two catalogues raisonnés by Adelyn Dohme Breeskin, of the graphic work and the paintings, 1948 and 1970, respectively. Mrs. Breeskin also wrote the introduction to the exhibition catalogue of Cassatt's work for the National Gallery of Art, Washington, D.C., in 1970.

2. See the catalogue, Frederick A. Sweet, *Sargent, Whistler and Mary Cassatt,* The Art Institute of Chicago, 1954.

3. Achille Ségard, *Un Peintre des enfants et des mères: Mary Cassatt,* Paris, Ollendorff, 1913.

4. Very important for this connection and for Cassatt's influential role in regard to American collectors is Louisine W. Havemeyer, *Sixteen to Sixty, Memoirs of a Collector,* New York, privately printed, 1961. See also Arsene Alexandre, "La Collection Havemeyer et Mary Cassatt," *La Renaissance,* Vol. 13, no. 2 (February, 1930), 51-56. Frances Weitzenhoffer is preparing, as a doctoral dissertation for the City University of New York Graduate School, a study of the Havemeyer Collection and the role of Mary Cassatt in its formation.

5. William C. Brownell, "The Younger Painters of America, III.," *Scribner's Monthly,* Vol. 22, no. 3 (July, 1881), 333.

6. See S. N. Carter, "Exhibition of the Society of American Artists," *The Art Journal* (New York), Vol. 5 (1879), 157.

7. For instance, Vittorio Pica, "Artisti Contemporanei: Berthe Morisot — Mary Cassatt," *Emporium,* Vol. 26, no. 151 (July, 1907), 3-16, and Francis E. Hyslop, Jr., "Berthe Morisot and Mary Cassatt," *College Art Journal,* Vol. 13, no. 3 (Spring, 1954), 179-84.

8. Cassatt's prints have, quite understandably, been the basis for numerous articles. Perhaps the most interesting is Sue Fuller, "Mary Cassatt's Use of Soft-Ground Etching," *American Magazine of Art,* Vol. 43, no. 2 (February, 1950), 54-57. See also Christian Brinton, "Concerning Miss Cassatt and Certain Etchings," *International Studio,* Vol. 27, no. 108 (February, 1906), i-vi; Frank Weitenkampf, "The Dry-Points of Mary Cassatt," *Print Collector's Quarterly,* Vol. 6, no. 4 (December, 1916), 397-409; Arsene Alexandre, "Miss Mary Cassatt, aquafortiste," *La Renaissance,* Vol. 7, no. 3 (March, 1924), 127-33; Una E. Johnson, "The Graphic Art of Mary Cassatt," *American Artist,* Vol. 9, no. 9 (November, 1945), 18-21.

9. *The New York World,* December, 1892.

10. For an excellent treatment of the mural, see John D. Kysela, S.J., "Mary Cassatt's Mystery Mural and the World's Fair of 1893," *The Art Quarterly,* Vol. 29, no. 2 (1966), 129-45.
(Due certainly in part to the activities of women artists at the Columbian exposition, other women such as Violet Oakley became involved in mural painting in America and other commissions were awarded them. Cassatt herself competed in 1905 for the mural commission for the state capitol in Harrisburg, Pennsylvania; when she withdrew, the contract was awarded to Oakley.)

11. For Beaux, see the volumes by Henry Drinker and Thornton Oakley and the articles by Mrs. Arthur Bell, Frederick Hill, Leila Mechlin and William Walton listed in the bibliography. The most interesting treatment of her life is naturally her autobiography, *Background with Figures,* Boston and New York, Houghton Mifflin, 1930; the finest analytical study is that by Frank H. Goodyear, Jr., in the catalogue *Cecilia Beaux: Portrait of an Artist,* Pennsylvania Academy of the Fine Arts, 1974-75.

**Theodore Robinson**

*Union Square.* 1895
Oil on canvas
20 x 17 in. (51.8 x 44.1 cm)
New Britain Museum of American Art, New
Britain, Connecticut, Alix W. Stanley Estate

The notes for this chapter will be
found on page 55.

# Theodore Robinson

One of the most admired of the American Impressionists was Theodore Robinson, one of several who have been termed the earliest American convert to that movement.[1] That appellation is false as we have seen and, in fact, Robinson became involved with Impressionism at the end of the 1880s, at very much the same time as his fellow artists and friends, John Twachtman, J. Alden Weir and Childe Hassam, making it difficult to account for the suggestion of his precedence. It may be due to his early demise, lending not only a tragic aura to an attractive figure and very able artist but cutting him off with so brief an Impressionist career. Since he did not live to see the establishment of the organization of "The Ten American Painters," critics may have thought he adopted the Impressionistic mode before his colleagues who were involved with that Impressionist-oriented group.

As with many short-lived figures in the history of art, writers have speculated on the nature of Robinson's art had he lived beyond his mid-40s. Yet, it seems unlikely that his style would have evolved in a radically different direction than it had taken. That possibility may have been raised, however, because of inconsistencies which critics have always recognized in his work, a dichotomy usually defined as French-inspired Impressionism and American Realism. There may have existed a dichotomy, but that was not it.

Robinson was significant for the development of American Impressionism because he represented a direct link with the masters of the movement in France. He knew Pissarro, but he was particularly close to Monet, more so than any other major American painter of the movement; Theodore Butler, who married Monet's step-daughter in 1892, was obviously even closer, but he had little effect on American art and was, in any case, a relatively minor talent and a more imitative one. Despite the recognized inconsistencies in his work, Robinson has remained, with John Twachtman, one of the two continually admired figures of the American Impressionist movement. Two major museum retrospectives and deeply appreciative studies accompanying the shows at The Brooklyn Museum in 1946 and The Baltimore Museum of Art in 1973 testify to this.[2] In addition, his diaries of the last four years of his life, deposited at the Frick Art Reference Library in New York City, delightfully reveal an alert, modest and very admirable figure.

Robinson was born in Irasburg, Vermont, and his return there at the end of his life indicates a "sense of place" which might otherwise seem masked by his peripatetic course during his years as an artist. The family moved to Illinois and then Wisconsin when he was a small boy, and he later studied art in Chicago. In 1874 he continued his art training in New York City, for two years at the National Academy of Design and then as one of the first students at the newly formed Art Students' League. At this time he is known to have called upon Winslow Homer, and Homer's bucolic images of farm hands in rustic settings saturated in vivid if still tonal light of the mid-1870s are not unrelated in subject and style to Robinson's figurative images painted later in his career.

In 1876 Robinson went to Paris where he studied first with Carolus-Duran. He may have learned there to appreciate the bolder, more painterly manner that Carolus practiced and imparted to many of his students such as Sargent, but Robinson transferred to the atelier of Jean-Léon Gérôme, the most famous of the academic masters, with whom the greatest number of Americans studied. At this time, Robinson seems to have evinced no interest in the new and controversial Impressionist movement; a summer spent outside of Paris at the artists' colony in Grez in 1877 may have had a greater impact upon his work.[3] Many American and British artists and writers were there during the late seventies and eighties, including the critic and historian R. A. M. Stevenson — the cousin of Robert Louis Stevenson who was also there — the American painters Willard Metcalf, Will Low and the brothers Birge and Alexander Harrison, and a large group of Irish and Scottish painters. These artists combined the current interest in plein-air painting with the study of rustic peasant subjects. Robinson's relationship with some of his colleagues there is worthy of further study in terms of direct, or perhaps indirect, influence; in particular, some of his figure paintings, in subject and in color, are quite similar to the works of the outstanding Irish painter Frank O'Meara. O'Meara and other British and Irish artists combined academic concerns with an interest in outdoor phenomena of light and atmosphere, a pursuit which came to center upon Bastien-Lepage and his painting, but Bastien's contact with the artists of the Grez colony occurred in the early 1880s, after Robinson had left. Nevertheless both Marsden Hartley and Frederic Fairchild Sherman were to liken Robinson's later work to that of Bastien.[4]

In 1877, Robinson's now unlocated painting of *A Young Girl* was shown at the Paris Salon, and the following year his work was exhibited at the first exhibition of the Society of American Artists in New York; he was thus identified with the more progressive, and foreign-influenced, younger painters even before he returned late in 1879. He must have visited Venice briefly just prior to leaving Europe, for there is a small work by Whistler inscribed to Robinson when they were both in Venice, and Whistler only arrived in September of that year.

Back in this country, Robinson was occupied in a variety of ways. He worked as an illustrator for *Harper's Young People*; Will Low helped secure him a teaching position, and he became involved with the surge of interest in the decorative arts, doing work in mosaic and stained glass. He enjoyed artistic contacts with the members of the Society of American Artists, and spent the summer of 1882 on Nantucket Island with Abbott Thayer. His own painting continued in the tradition of rustic scenes, and Robinson was to remain an admirer of the work of the American Realists. He thought highly of Eakins' work, and purchased a Winslow Homer watercolor.

In 1884, Robinson returned to Paris where he remained more or less for eight years, despite frequent short visits back to America. It was during this period that he turned to a more Impressionistic aesthetic, coinciding with the development of his friendship with Monet. The exact course of Robinson's development prior to his Impressionist "conversion" is, however, difficult to ascertain. As we have seen, he was subject to a multitude of influences and artistic relationships, but relatively few significant works painted before 1888 are known. A number of major paintings of his first years back in Paris suggest an interest in individual craftsmen and their trades, such as the *Cobbler of Old Paris* of 1885 and the *Apprentice Blacksmith* of 1886. These are still dark, tonal paintings, set in sharply delimited interiors.

In 1887, Robinson went out to Giverny for the first time. It was there that Monet had settled in 1883, and it was to Giverny that young artists and art students began to travel, to paint in the shadow of Monet. Robinson was not the first American to go there; a number had visited there early on, painters who were later to be identified with the Impressionist movement such as

**Theodore Robinson** (above)

*Winter Landscape.* 1889
Oil on canvas
18¼ x 22 in. (49.8 x 55.9 cm)
The Daniel J. Terra Collection

**Theodore Robinson**

*Canal Scene.* 1893
Oil on canvas
16 x 22 in. (40.6 x 55.9 cm)
The Daniel J. Terra Collection

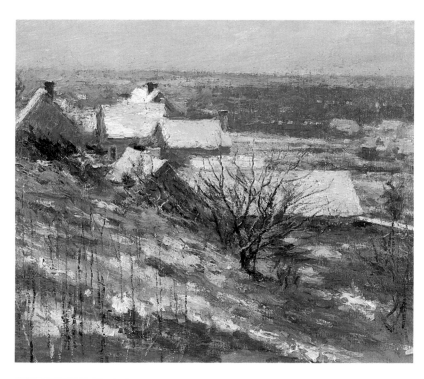

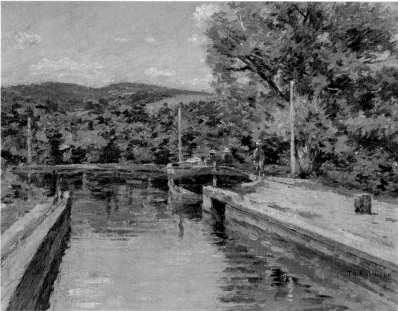

Willard Metcalf. John Leslie Breck and Theodore Wendel were also among those who had preceded Robinson.[5] Breck had studied in Leipzig, Munich and Antwerp before returning to America in 1883. He spent the next two years in Boston, but in 1886 returned to Europe, this time to France, where he studied at the Académie Julian in Paris and spent his summers in Giverny, until in 1890 he returned home to stay for the remainder of his short life, with the exception of a trip to England in 1891. A portrait by Breck of Monet's step-daughter Blanche is known, but most of the few paintings by this still little-studied artist have come to light are small, intimate patches of flowering gardens rendered in blazing color which is broadly applied in an Impressionist manner. It was very probably a group of such pictures shown back in Boston by Lilla Cabot Perry in the late 1880s which hastened the acquaintance with the new aesthetic among her young artist colleagues such as Dennis Bunker,[6] and it may be significant that Bunker's *Chrysanthemums* of 1888, a relatively early Impressionist work for him, is quite close in subject and style to Breck's pictures. Hamlin Garland, in his *Roadside Meetings,* commented on the group of Breck's paintings in Perry's studio, with their blazing, primitive colors and their very European look.

Theodore Wendel was a Cincinnati artist who studied there at the School of Design before departing in the late 1870s for Munich, following the course of many Cincinnati painters. He became one of the "Duveneck boys" but as with a number of Munich-trained Cincinnatians —John Twachtman is another— Wendel went to Paris in the mid-eighties. He studied at the Académie Julian, but his first summer in France in 1886 was spent in Giverny, where he adopted a higher-keyed chromatic range and a greater interest in light and atmosphere. His early Giverny subject matter remained rustic —peasants, farms and haystacks —and perhaps more in the manner of Pissarro than Monet, though the traditional rustic significance of the haystacks of Monet's great series should not be overlooked. Wendel returned to America in 1888, teaching in Boston at the Cowles school, and joined with Robinson in a significant two-man exhibition at Williams and Everett Gallery in 1892, a major presentation of Impressionist painting in Boston. In 1899, Wendel settled in Ipswich, Massachusetts, where he continued to practice his modified Impressionism, often painting his adopted town in a manner recalling the compositions of the Parisian scenes of Renoir and Pissarro.

In the summer of 1888 Robinson returned to Giverny, and this time settled there next door to Monet with whom he became an intimate friend, though Monet was never Robinson's teacher. Monet however offered the young American much advice and encouragement, and it was in 1888 that Robinson adopted many of the aesthetic qualities of Impressionism. This can be seen in such works as *La Vachere* of that year, a monumental presentation of a peasant cow-girl. The subject is not an unusual one; in fact, it should be recognized as part of a popular tradition of life-size peasant figures, ultimately stemming from Millet's peasant art and then monumentalized by such popular followers of Millet as Jules Breton and Bastien-Lepage. What is unusual in Robinson's painting is a Salon-size subject interpreted in an Impressionist manner: a figure partially dissolved in broken brushwork, and greater chromatic variation and brilliance.

Robinson's finest work includes many paintings of this nature —single figures in a pastoral landscape in a meditative, relaxed situation. Robinson's color is soft, and forms are broken by dappled sunlight. Yet, while drawing

**Theodore Robinson** (above)

*Boats at a Landing.* 1894
Oil on canvas
18½ x 22 in. (47 x 55.9 cm)
Collection of Mr. and Mrs.
Meyer P. Potamkin

**Theodore Robinson**

*La Débâcle ('The Debacle').* 1892
Oil on canvas
18 x 22 in. (45.8 x 55.9 cm)
Scripps College, Claremont, California, Gift
of General and Mrs. Edward Clinton Young,
1946

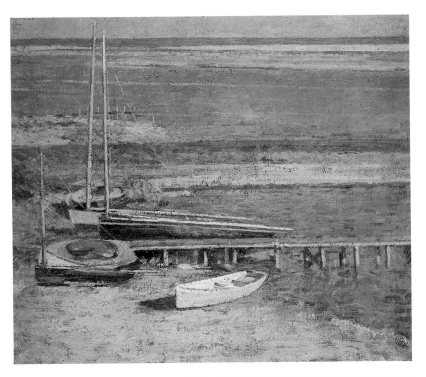

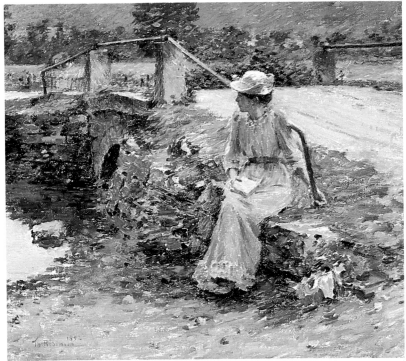

is never emphasized at the expense of light and color, form never becomes fully dissolved and structure remains a concern. Again, as has been stated in the case of Bunker, this should not be interpreted as a holdover of "American Realism." Rather, what is evident is Robinson's continuing insistence upon the benefits of his previous academic training which he wanted to maintain along with the more innovative techniques derived from Monet. As he himself wrote:

*Altogether the possibilities are very great for the moderns, but they must draw without ceasing or they will get left, and with the brilliancy and light of real outdoors, combine the austerity, the sobriety, that has always characterized good painting.*[7]

The combination of outdoor light (and radiance) with sober academic drawing may, indeed, have led Robinson and other ambitious young Americans toward inconsistent and inconclusive paintings, but neither concern stems from a nativist tradition or native training.

Robinson's color was never the brilliant chromatic range of Monet; it was, in fact, closer to the more somber and muted tones of Pissarro, himself closer to the pastoral tradition of Millet. Robinson preferred a limited color range that emphasized bluish purple tones and a range of greens. Many of Robinson's landscape compositions have an obvious geometric structuring, based upon a series of dominant, parallel diagonals which are determined by the viewpoint selected, the placement of the forms of buildings and other elements in the landscape, and echoed by the repeated diagonal direction of the broken brushwork. A kinship with the work of Cézanne is suggested here, but a connection between the two artists is so far unrecorded. Many of these qualities continued in his finest French works, such as *The Watering Pots* of 1890 and *La Débâcle* and *The Layette* of 1892. Many such figure paintings involve the image of his favorite models, Josephine Trognon and a young woman named Marie.

Another quality found in many of Robinson's finest pictures is the high horizon line, distinguishing his work from that of his mentor Monet, but typical of the innovations of Bastien-Lepage. The high horizon seals off the top of the picture, forcing the work to be read vertically. It also tends to flatten the composition despite the panoramic nature of some of Robinson's masterworks—another dichotomy in his art. In emphasizing the picture plane and the intrinsic nature of the paint upon a basically flat surface, Robinson was sharing an innovative aesthetic approach with his American colleague John Twachtman, who was also adopting the high horizon at the same time, but back in this country.

The monumental nature of *La Vachere* was exceptional for Robinson, most of whose paintings are quite small. Robinson's nature, an unassuming one, was reflected in his art; he described one of his works in his diary as "not important, but [it] wears better than clever and brilliant things." The critics, too, felt that his smaller, more unassuming works were his best; Christian Brinton wrote much later that Robinson was "...the purist lyric talent we have so far produced...." praising his modest themes which possess no pose or pretense.[8]

Robinson returned to New York late in 1888 and showed his first Impressionist works at the Society of American Artists in 1889, where he was quickly recognized as a leader of the more progressive school. He continued to make brief returns during his Giverny years, exhibiting here and in 1890 winning at the Society the Webb prize for the finest landscape by

an American under forty years of age. He won the Shaw prize for figure painting at the Society in 1892.

Robinson has been noted as being one of the American painters most influenced by and receptive to photography. A number of his finest and most interesting paintings are based at least in part upon surviving photographs, for example his *Two in a Boat* of 1891, where not only the basic composition —itself preserving his preference for strong structure and diagonals—but even the close tonalities are quite similar to a surviving photograph, although Robinson has altered the view by eliminating a distracting second featured boat. In other paintings based upon photographs, blurred areas of form and washed out, light-struck areas are preserved, harmonizing generalized features and forms with his manner of broken brushwork. Robinson used photography primarily for his figure work, not only for its aesthetic contribution but for very practical considerations; it saved on the cost of models, though he would utilize both models and photographs for the same painting.

Robinson continued to show Monet his work, and relied to a degree upon Monet's comments and criticism. Robinson's *Road by the Mill* of 1892 was criticized by Monet who liked the painting but found the values rather equal. Robinson adapted some of Monet's subjects also, such as the master's preferences of haystacks and rows of poplar trees. Robinson's handling of these and other themes associated with Monet, however, is quite distinct, usually employing a more limited and muted palette and a more structured, less decorative composition.

Robinson saw Monet's series of Rouen Cathedral soon after his return to Giverny from New York in May of 1892. He admired them enormously, the grey-day ones more than those of brilliant sunlight, which he agreed with Monet had the air of Venice or Sicily. Robinson was impressed by their grandeur and the filling up of the composition, noting that there was "...not a line anywhere, yet all construction and solidity." This led him to begin his own "mini-series," a group of three views of the *Valley of the Seine,* that year: one in sunlight, one somewhat overcast, and one on a grey day. As with Robinson's estimation of Monet's series, Monet preferred Robinson's scene set in a grey atmosphere. Robinson had at first planned only two pictures, beginning with a view in full sunlight and then a clouded one, and later adding a third with floating shadows.

Robinson's series, concerned with changing conditions of light and weather depicted from the same spot and of the same topography, is his closest approach to the temporal aspect of Monet's art, but it is significant that he has deliberately altered or even reversed Monet's treatment of the subject in the latter's impressive series. Robinson's paintings also center upon a church, the steeple of which rises above the distant view of the town of Vernon, a city near Giverny on the Paris-Rouen railroad, and Robinson's diary mentions including the church, almost certainly therefore as a subtle homage to Monet, though the significance of the ecclesiastical structure to both artists should not be overlooked. But Robinson also emphasized the panoramic nature of his work. The contrast with Monet's up-close view of a monumental structure is deliberate; Robinson totally shied away from Monet's intent of making "architecture without lines."

Another major canvas of Robinson's of 1892 is *The Wedding March,* commemorating the summer wedding of Monet's step-daughter, Suzanne Hoschede-Monet, to the American artist resident in Giverny, Theodore Butler. This is a rare subject picture for Robinson, though the glaring summer light and the blurred vision of forms moving quickly down the road, one of them seen only through veiling, must have been appealing to the artist-friend of the bride and groom. The same year also saw the publication in the *Century* magazine of Robinson's article on Monet. This was Robinson's last summer in Giverny, however, and the following winter he returned to America for good.

Back in this country, Robinson, always unsure of himself, became increasingly self-mistrustful. He wrote in his diary: "I should aim for more vitality. I have a horrible fear that my work pleases women and sentimental people too much. I should do more important pictures. I should paint local scenery at home, even if it is ugly as it may appear to some." He was conscious that his European pictures sold better than his American ones, though this was based on a preference for foreign scenery, not a discrepancy in style. Robinson lived in New York, painting the regions around the metropolis. He did pictures in Greenwich while visiting nearby with Twachtman. Other pictures were painted elsewhere during summers that he spent teaching, for example, his *Port Ben, Delaware and Hudson Canal,* painted in 1893 at Napanoch, New York, while teaching for the Brooklyn Art School. The work was a controversial one, rejected by The Metropolitan Museum of Art after Robinson's death when it was offered to the Museum by a group of his friends.

A corollary to the traditional interpretation of Robinson as an artist torn between nativist and foreign tendencies has been that he returned to more Realistic painting after he left France. *Port Ben* —and others among his best work—testify to the inaccuracy of this for the picture is even more colorful and light-filled than his Giverny paintings. The critics were responding to his art; Roger Riordan in *The Art Amateur* for December, 1892, praised the "sparkle and animation" in his work. But if the foreign technique was now admired, the Impressionism of Robinson and others drew another form of criticism. Even so vigorous a champion of Impressionism and an admirer of Robinson as Hamlin Garland felt that the artist's subjects were unworthy of his skill and study, that an artist should have more than a seeing eye and a sensitive hand, and that his work should have a relationship to sentiment. This was Garland's ultimate response to Robinson's work, with which he may have first become acquainted at the Chicago Columbian Exposition in 1893, where the artist exhibited three works, including *The Layette,* and where he painted a brilliantly colored rendition of the fair.

Several of Robinson's most beautiful pictures were painted at Cos Cob, Connecticut in June of 1894, concerning which critics have noted a new austerity and a strong sense of abstract, geometric design, based upon the construction and rigging of boats and the linear docks. These reflect his own new appreciation for Japanese art and even his acquisition of a Japanese print, from which he purposefully aimed to draw a new refinement and precision.

Robinson continued to teach, in the summer of 1894 at Evelyn College in Princeton, and at Brielle, New Jersey. He also taught at the Pennsylvania Academy that fall. In 1895 he had an exhibition in New York at the Macbeth Gallery, which then traveled to Atlanta, St. Louis, Fort Wayne and Cincinnati. The critics reacted favorably to the show, characterizing it as realism with Impressionist overtones, but, like Garland, decried the lack of sentiment and imagination. In the winter of 1894-95 Robinson turned to the

painting of urban views, following the lead of his fellow-Impressionist Childe Hassam and even of such Tonalist painters as Birge Harrison, and in the manner of his French Impressionist colleagues. Such a subject as Union Square—perennially a favorite of artists including Robinson's friend and colleague J. Alden Weir—allowed Robinson to explore the momentary effects of falling snow and changing atmosphere, in combination with solid drawing and the rendition of architectural structure.

In May of 1895, Robinson painted at Haverstraw, New York, another series of three similar views—in sunlight, in fog, and in sunlight through fog—works closer to his French landscape series in their exploration of changing temporal conditions. That summer he returned to his native Vermont, bringing an art class to Townsend, under the supervision of his cousin, Agnes Cheney. Her daughter, Alice, posed for him though he utilized photographs also. One of these pictures showed her in a hammock, a not infrequent device for artists of the period; Robinson himself had painted a similar work at Princeton the previous autumn. Hammocks not only were associated with the outdoors and reinforced a mood of informal leisure, but, just as the veils with which many artists of the period experimented, the hammock material allowed light and air to pass through it, a fabric itself almost in dissolution.

Robinson felt that he had found his place in America by returning to Vermont, and he planned to continue painting there, perhaps even during the winters as well as summers. He began a series of views of the West River Valley in Vermont, emphasizing the effects of cloud shadows on the land, but completed only one of them. He also wanted to incorporate qualities of Vermeer into his art, writing more and more about his love of Vermeer's homely detail, but his career was brought to a halt by his death from asthma in April of the following year, 1896.

Robinson was reserved in his judgment of his fellow Impressionists. He admired Twachtman's painting and wanted to capture some of its qualities, and perhaps it is not surprising that the two shared later critical esteem more than most of their contemporaries. He found Weir artistic, but decried his bad drawing. He viewed some of the early works of the young Ernest Lawson, and found them not very personal and not delicate, but he later amended his judgment, admiring their refreshing, primitive rudeness. He thought Metcalf's and Hassam's work clever, but judged the latter "a tinsel sort of art." His own was not. Robinson's path was more rocky than Hassam's, but his achievement was a sound one, and he produced some of the most beautiful works of the Impressionist movement though, like the artist himself, they are modest and unassuming.

1. The basic studies of Robinson are the two admirable essays in the catalogues by John I. H. Baur, *Theodore Robinson, 1852-1896*, The Brooklyn Museum, 1946, and Sona Johnston, *Theodore Robinson, 1852-1896*, The Baltimore Museum of Art, 1973. See also the earlier articles: Eliot Clark, "Theodore Robinson," *Art in America*, Vol. 6, no. 6 (October, 1918), 286-94, and his "Theodore Robinson, A Pioneer Impressionist," *Scribner's Magazine*, Vol. 70, no. 6 (December, 1921), 763-68; Hamlin Garland, "Theodore Robinson," *Brush and Pencil*, Vol. 4, no. 6 (September, 1899), 285-86; Pearl H. Campbell, "Theodore Robinson, A Brief Historical Sketch," *Brush and Pencil*, Vol. 4, no. 6 (September, 1899), 287-89; and the several later articles by Florence Lewison cited in the bibliography. Baur's article, "Photographic Studies by an Impressionist," *Gazette des Beaux Arts*, Ser. 6, Vol. 30 (October-November, 1946), 319-30, is of special interest.

2. Baur, *Theodore Robinson*, and Johnston, *Theodore Robinson*.

3. See the important article by Birge Harrison, "With Stevenson at Grez," *Century*, Vol. 93, no. 2 (December, 1916), 306-14. The bibliography on Grez as an art colony of the period is fairly extensive.

4. Marsden Hartley, *Adventures in the Arts*, New York, Boni and Liveright, 1921, 77; Frederic Fairchild Sherman, unpublished manuscript on Robinson, copy at the Frick Art Reference Library, New York City.

5. To date, no study of Breck has been made; Wendel was the subject of an article by John I. H. Baur, "Introducing Theodore Wendel," *Art in America*, Vol. 64, no. 6 (November-December, 1976), 102-121, and an exhibition at the Whitney Museum of American Art in New York City that year.

6. Gammell, *Dennis Miller Bunker*, 63. See also Hamlin Garland, *Roadside Meetings*, New York, Macmillan, 1930, 30-31.

7. This and the following quotations are taken from the unpublished diaries of Theodore Robinson on deposit at the Frick Art Reference Library. Sona Johnston of The Baltimore Museum of Art is presently editing the diaries.

8. See Christian Brinton, *Impressions of the Art at the Panama-Pacific Exposition*, New York, John Lane, 1916, 95.

**Frederick Childe Hassam**

*Le Jour de Grand Prix.* 1887

Oil on canvas
24 x 31 in. (61 x 78.7 cm)
Museum of Fine Arts, Boston, Ernest
Wadsworth Longfellow Fund

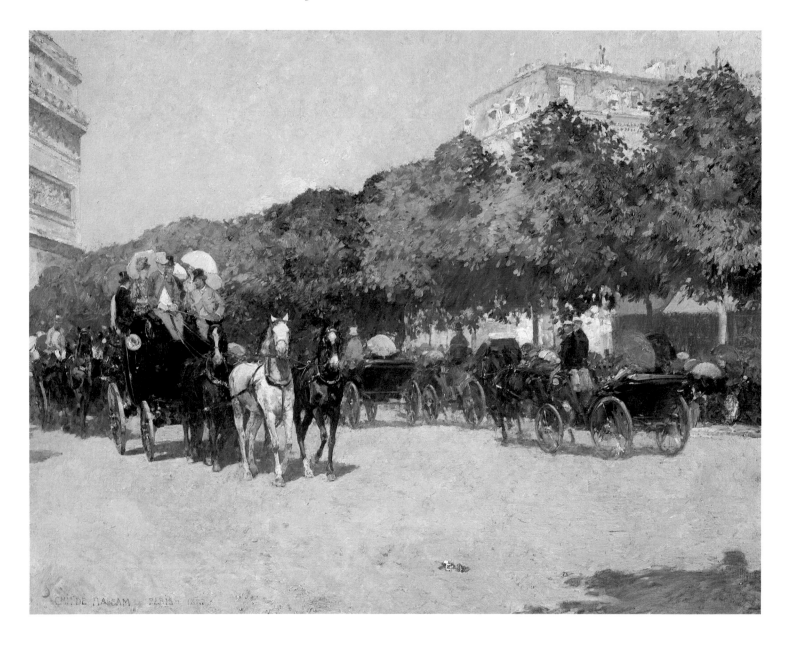

*Commonwealth Avenue, Boston.*
ca. 1892
Oil on canvas
22¼ x 30½ in. (55.9 x 76.5 cm)
The Daniel J. Terra Collection

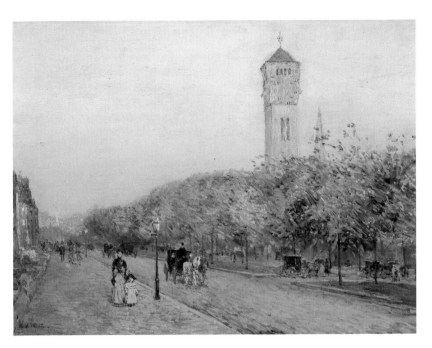

The notes for this chapter will be
found on page 61.

# Childe Hassam

Of the major figures of the American Impressionist movement who were active in their native land — that is, excluding the expatriates Cassatt and Sargent — Childe Hassam has always been the best known.[1] (His full name was Frederick Childe Hassam but the first name was not used professionally). Hassam's success and fame have been responsible, in part, for the undoing of his critical reputation. Hassam's work, much of which is closer to the orthodox aesthetic of Monet than that of any of the other leading Americans, has consistently been depreciated as derivative and imitative, as well as repetitious and often extremely mediocre, though in his own lifetime he had many proponents.

All of those criticisms of Hassam's work have some validity, but they must all be qualified also. In his later years particularly, Hassam produced a large number of paintings which were often almost variants one of the other. The later pictures of the rocks and coast of the island of Appledore are often extremely similar and would appear to be little more than potboilers. And, unfortunately, as Hassam lived a long and productive lifetime, there is a large number of such repetitive works. It would seem incontestible that during the last two decades of his life, the quality of Hassam's painting deteriorated, due more it would seem to a relaxation of his inquiring and inventive powers than to any decrease in his faculties. Many of his later works, done in Connecticut and Long Island, are frankly decorative and quite undemanding paintings, and these, probably unfortunately, include some of the artist's larger pictures.

The charge of derivativeness is a more complex issue. It is true that many of his works are completely in the technique of the French Impressionists, but if American art history and criticism has finally come to acknowledge the advantages of European academic training, allowing painters such as Frederick Bridgman, George De Forest Brush and Thomas Dewing to approach the technical achievements of such masters as Gérôme, then there would seem little reason to condemn Hassam for best mastering the style of Monet. And what has too often been overlooked in the estimation of Hassam's career is the degree of originality he brought to the utilization of an orthodox Impressionist technique. In fact, there is more diversity in Hassam's professional achievement than that of any of the other American Impressionists.

Hassam was born in Dorchester, Massachusetts and, as with so many American artists, began his professional career as a draftsman designing works to be engraved; Hassam's design for the *Marblehead Messenger* was still in use in the 1930s. He also provided designs for the major magazines of the late 19th century, *Harper's, Century* and *Scribner's*. This work in graphics undoubtedly provided the foundation for the later investigation of etching and lithography which he undertook brilliantly in the 20th century. More immediately, he was involved in providing designs for illustrated books beginning in 1883. His finest, however, are those that appeared in the 1890s. By 1892, when he had fully converted to the Impressionist aesthetic, his scintillating, sparkling illustrations for William Dean Howell's *Venetian Life* were markedly more original and more eye-catching than those by Hassam's friend, Ross Turner, and the other artists involved. The finest of all of his illustrations are those he provided for his friend Celia Thaxter in her 1894 *An Island Garden,* which was totally illustrated by Hassam. A volume devoted solely to his urban observations of Paris, London and New York appeared in 1899, entitled *Three Cities*.

In the early 1880s, Hassam drew at the Boston Arts Club where he joined a number of young landscapists; he also studied at the Lowell Institute. His first teacher, however, was Ignaz Gaugengigl, an appealing Boston painter who was a specialist in small, carefully articulated figure compositions in the manner of Meissonier and the Dutch little masters. Hassam spent the year 1883 traveling abroad, and on his return took a studio in Boston next to that of George Fuller, with whom he became good friends. Joseph Enneking was another congenial colleague, and some of Hassam's early works of the mid-1880s are quite similar to Enneking's admixture of Barbizon and muted Impressionist qualities. But Hassam's career and his production during these formative years are very imperfectly known. Indeed, he was better known as a watercolorist at the time; Boston's Williams and Everett Gallery gave a show of 67 of his watercolors in 1883, but relatively few of these have so far come to light. When his good friend Ross Turner went to Europe, Hassam took over his art classes, where among his pupils were Jane Hunt, the sister of William Morris Hunt, and Celia Thaxter, whose father, a lighthouse keeper in the Isles of Shoals off the coast of New Hampshire, had been portrayed by Hunt. Celia Thaxter started to purchase Hassam's watercolors, and the artist began to spend his summers at the brilliant colony of artists and writers formed at her home on the island of Appledore. She herself was a well-known writer and poet, and her flower garden was renowned for its beauty; it served well a number of floral painters.

Hassam's earliest major oils, painted in Boston in 1885-86, are large, Tonalist interpretations of the urban scene. Although emphasizing close-keyed neutral tones and showing a preference for evening effects similar to Enneking and George Inness, the integration of the figure and urban atmosphere prefigures his later application of Impressionism to this subject. Several of these are scenes of Boston streets in the rain, a theme that was to continue to occupy his attention; indeed, his concern with weather and changing atmospheric conditions was easily convertible into Impressionist terms. Perhaps the most striking quality of these early compositions is the assured emphasis upon deep perspective, with plunging axes of buildings and streets precipitously carrying the eye back into space. This was, in fact, an international phenomenon in urban painting of the 1870s and 80s, much admired at the time in the work of the Italian painter working in Paris and London, Giuseppe de Nittis, and seen in the painting of such diverse masters as Jean Béraud and Vincent Van Gogh. Indeed, Hassam's *Rainy Day, Boston* of 1885 bears an uncanny resemblance to Gustave Caillebotte's *Rue de Paris; temps de pluie* of 1877, and although the latter work was much noticed when it was shown in the Impressionist exhibition of that year, there is no documentation that Hassam had had the opportunity of viewing the French masterwork or had seen reproductions of it.

These important paintings evince no knowledge of or interest in Impressionism, suggesting that Hassam had not sought out paintings of the more progressive movements when he was abroad; more likely, if he knew the Caillebotte at all, it was through reproduction. In 1886 he returned to Europe for three years, this time going to Paris to study at the Académie Julian, where he studied figure painting with Boulanger and Lefebvre as did so many of his fellow Americans. Perhaps Hassam should have remained longer, for his treatment of the figure and the nude was always summary.

One of his first major Parisian pictures was *Une Averse, Rue Bonaparte* of 1887, an extremely large work which is something of a reprise of his Boston pictures of rainy streets seen in deep perspective, but now with a greater concern for textured surfaces and the use of a lighter palette suggesting sunlight glistening in the pouring rain. The work was a great success in the Paris Salon, though Boston critics of a show held that year at Noyes, Cobb & Co. advised Hassam to "come in out of the rain."[2]

He did. That same year he painted *Le Jour de Grand Prix,* vividly utilizing the Glare aesthetic in an urban, Parisian scene of great depth, with strong contrast of light and shadow, and a new chromatic range combined with Oriental asymmetry. Hassam's work in these seminal years of the late 1880s did not steer a direct course from more conservative tonal painting to the full chromatic range and broken brushwork of Impressionism, and dark, dramatic scenes of Parisian streets in the rain at night appear at the same time as richly colored, sunlit ones, though there is a new sketchiness and greater texturing and impastos than had appeared in his American works.

Hassam began to spend his summers in Villiers-le-Bel, where Thomas Couture had lived. Balancing his urban scenes came a series of depictions of figures in gardens, vigorously painted with rich contrasts of bright red flowers, green foliage and sunlit walls, all in dappled light. These paintings often portray deep spatial recessions, and the figures are usually flat forms with strongly defined profiles, which act as spatial markers and take a role not unlike the figures in such works as Seurat's *La Grande Jatte* of a few years earlier. Hassam, like Seurat, maintains a geometric structure of form and composition combined with intense colorism.

Weary of the hubbub surrounding the Paris 1889 International Exposition, Hassam returned home via England in the late summer. Perhaps the suggestion of an evanescent mood in the urban scene that emanates from some of his later pictures derives from an appreciation of Whistler, but an exposure to the earlier artist's urban nocturnes need not have been gained during this brief stay in Britain; generally Hassam's art was too palpably rooted in the reality of fact to bear too great an association with Whistler's Aestheticism. Hassam settled in New York City with a home at Fifth Avenue and 17th Street, near the Players club. Hassam now became the major interpreter of the New York urban scene, painting views of Washington and Union Squares, Fifth Avenue, and concentrating upon individual structures such as the Washington Arch, the A. T. Stewart mansion, and the Church of the Paulist Fathers. Architectural integrity is maintained, but color predominates now, the artist eschewing neutral tones and applying his pigment thickly but often with a delicate touch. In some of these scenes of the city, Hassam adopted a high, bird's eye viewpoint that allowed him to create a panoramic vastness. The viewer looks down and out, and reads up to a high horizon so that Hassam combines deep space while still concentrating on the vertical picture plane. Such works, with a few flecked strokes defining small figures below, relate to the contemporaneous paintings of Pissarro and Monet.

Hassam painted the city in its many moods. He showed her streets, parks and buildings in full sunlight and in evening, in lush springtime and in the cold of winter. Hassam was, in fact, a major winter landscapist. Previous artists favoring winter —George Durrie, Thomas Birch and even Hassam's contemporary John Twachtman— were painters of the rural scene, but Hassam painted winter in the city: buildings, carriages and figures against a foil of snow. Flecked white and cold blue areas predominate; contemporary critics sometimes found an excessive use of blue, making Hassam part of the

"bitumen and molasses school."[3] These cooly atmospheric winter scenes especially suggest a relationship to Whistler. New York against a backdrop of rain and snow is featured in the American section of his *Three Cities* of 1899. Hassam was also one of the earliest interpreters of the Brooklyn Bridge, that new symbol of Modernism, prefiguring its later, better-known associations with Joseph Stella, Hart Crane and others.

Possibly Hassam's finest paintings, certainly among his most beautiful, are those he painted at Appledore, to which he returned in the summers after his European sojourn. He continued to visit there long after Celia Thaxter's death in 1894, with the works done in the early nineties constituting some of his best paintings, and they are among the most lovely American Impressionist works. These centered around her garden, oil paintings neither solely landscape or still life, but combining both in a blaze of color, the red poppies with their green foliage silhouetted against the white rocks and the deep, cloudless blue sky, though perhaps the finest of these oils includes the silver-haired Celia in a vivid white dress too, herself one of Hassam's best rendered figures. It is a translation of his French garden scenes into a very familiar native environment, where thematic distinctions blur into a totality of environment. This painting of 1892 was followed two years later, the year of Celia's death, by the well-known *Room of Flowers,* a tribute to her where a purposeful confusion of furniture, objects and many floral bouquets reflects the persona of the woman, though the reclining female figure — almost lost in the clutter — appears to be too young to represent Celia herself. One Parisian journalist felt that the picture should have been entitled *"Cherchez la Femme,"* but he missed the point.[4] The room, as the earlier depiction of the garden, *was* Celia.

Hassam's watercolors of the Appledore garden done in the early nineties and used in 1894 as illustrations for Thaxter's book, *An Island Garden*, are among the artist's most lushly colorful and beautiful works in that medium. It was a touching collaboration, she writing of her garden and he illustrating it; published the year of her death, it became a memorial to Celia. Earlier, in 1890, she had written a sonnet about Hassam, which went in part:

*A crescent with its glory just begun*
*A spark from the great central fires sublime*
*A crescent that shall orb into a sun*
*And burn resplendent through the mists of time.*[5]

In her imagery, Celia Thaxter recognizes the Impressionist preoccupations with sunlight, atmosphere and mists which were among Hassam's principal aesthetic concerns.

Hassam continued to visit Appledore for many years after Celia's death, but the inspiration derived from that ambience lessened, and he traveled elsewhere also. In 1895 he went to Cuba; although he responded to the tropical light of the island, his renditions of the exotic land were quite factual, with little sense of poetry. He returned to France in 1897, and continued pursuits begun a decade earlier, rendering urban scenes, flower gardens and figures in profile in a fully Impressionist technique. He went also to Italy that year, and under the impact of the light and glare of the Mediterranean climate he produced some of his most colorful paintings totally in the French Impressionist manner. In his several views of the Piazza di Spagna in Rome, Hassam manipulates the space to emphasize a steep vertical structure.

On his return to New York in 1898, Hassam became an integral part of the advanced art establishment. He was one of the major organizers of "The Ten American Painters," a group who seceded from the Society of American Artists when that organization rejected a winter landscape by John Twachtman. Hassam was a good friend of all the artists of the Impressionist movement in America, those of The Ten and Theodore Robinson, as well as other progressive painters such as Albert Pinkham Ryder.

He continued to paint New York urban scenes, but ventured elsewhere too. He began visiting at East Hampton out on Long Island where he was later to reside. In 1899 he was in Gloucester, the following year in Provincetown, and in Newport in 1901. His panoramic views of those coastal towns are among his finest landscapes: a kind of more prosaic, more solid and factual equivalent of Monet's *Argenteuil* or *Vétheuil*. In these paintings Hassam maintains a strong and rigorous geometric structure of topographical outline, building forms and shapes of boats and docks, and carefully balancing horizontal and vertical accents which culminate in the church spire. The understated emphasis upon the New England church building should not be ignored; Hassam later and more eloquently brought the ecclesiastical structure to the fore in his views of the church at Old Lyme, where the building serves as the central focus of the paintings. The Old Lyme church was more than Hassam's Rouen Cathedral; whether in Provincetown, Gloucester or Old Lyme, the respect for the New England heritage exemplified in the church is integral to both formal and philosophical aspects. Critics such as Albert Gallatin wrote that Hassam's nationality was visible in his work; others spoke of his establishing a school of *American* landscape painting.[6]

The early years of the 20th century saw Hassam investigating a variety of themes, and displaying an inquiring aesthetic greater than that for which he is usually credited. Although Hassam's finest still lifes appear in his garden pictures, he painted more formal, traditional still lifes throughout his career; his 1904 *Fruit* is one of the finest, not unlike Monet's paintings of fruit, though Hassam's picture is stronger and more coarse, his tones less close and his impastos more jagged. Hassam painted several pictures of workers and industry, the most monumental being *The Hovel and the Skyscraper* of 1904, which prefigures by several years works by the artists of the Ashcan School and George Bellows; Lucinda Bryant in 1917, in fact, emphasized Hassam's role as the painter of modern industry and the working man.[7] Coincidentally, the Italian Futurist artist Giacomo Balla, in his early *La Giornata dell'operario,* similarly applied an Impressionist aesthetic to a depiction of skyscraper construction the same year that Hassam did.

In 1908, Hassam went out West to Portland, Oregon, visiting the major collector there, Colonel Charles Erskine Scott Wood, a friend and patron of Hassam, J. Alden Weir, Albert Ryder and the sculptor Olin Warner. Hassam painted murals in Wood's home, and did panoramic views of Oregon scenery in the Harney desert. Unlike some of his fellow Impressionists, this venture into the newly revived art of mural painting was a rarity for Hassam.

The simplified spatial treatment and a growing tendency toward an overall, tapestry-like design is noticeable in Hassam's painting of this period, and may suggest the influence of Post-Impressionism. Such an aesthetic, incorporating also a coarser, more gritty brushwork, is somewhat akin to the painting of some of the younger Impressionist-influenced artists such as Ernest Lawson and the early Marsden Hartley, or the painting of

*Celia Thaxter in Her Garden.* 1892
Oil on canvas
22⅛ x 18⅛ in. (56 x 46 cm)
National Collection of Fine Arts,
Smithsonian Institution, Gift of John Gellatly

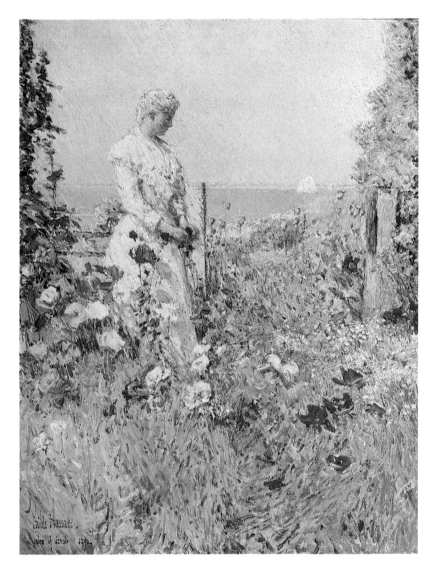

Maurice Prendergast. Hassam's 1911 *Sunset* is a quite amazing picture, a seascape reduced to ultimate simplification. The spare geometry of the picture — divided solely into the two zones of sea and sky with the horizon barely indicated by a tiny boat in the distance, and both areas filled with glowing striations of Impressionist color — advances toward almost total abstraction. Hassam also here adopts the square format which he used earlier in some of his Provincetown, Gloucester and Newport pictures, which, in the conscious refusal to indicate a horizontal or vertical axis and dominant direction, adds significantly to the emphasis on the abstract.

Such inventive gestures were conceived at the same time Hassam was increasingly producing works of decorative charm, which the critics noted for their surface appeal, however much they admired the artist and his work. Even his friend and patron Colonel Wood described Hassam to Weir as follows:

*He is certainly a Kodak. But he pays the penalty of skill and fertility. He stops at externals. It is inevitable. The facile man, psychologically sees and does the superficial. I may say, though it is hardly fair to apply the word. Beautiful of course. –it is the beauty that impels. The brooding and introspective man is bound to be slow. Haste is incompatible with brooding. And wanting so much more than the surface, he finds it difficult to achieve his desires.*[8]

The comparison almost certainly refers to their mutual friend Albert Pinkham Ryder, and his art, in contrast to that of Hassam.

Increasingly, after the turn of the century, Hassam painted the nude. These works varied greatly in both quality and approach. Some are close-up views of the figure — usually placed in an outdoor setting, sometimes in an interior — who is often posed in his favored profile view: clearly outlined and rather stiff, simplified forms. Sometimes these are decorative tableaus — Impressionist, coloristic variations on the work of Puvis, and suggesting tapestry and modern mural aesthetics. In others, the nude is placed in sheltered and secluded landscape and pool settings, almost dissolved and certainly hidden in the prismatic, light-filled environment. These are the nudes that the critic Royal Cortissoz preferred, where the figures were, as he said, "piquant accents."[9] Often Hassam's paintings of the nude bore classical or mythological titles: *Pomona, Phryne,* the *Lorelei.*

There were three departures in Hassam's art in the second decade of the present century, but one of them, his involvement with printmaking in 1915, is beyond the scope of the present discussion of Impressionist painting.[10] Earlier, around 1912, he began the "Window" series, as Cortissoz called them, a major group of often large interiors with figures that to some extent justify the later estimation of Hassam as a man of the studio. These works combined the urban interior setting with images of women, and often important still-life accessories — flowers, china, glass, etc. — all integrated by light and by mood; the figures were sometimes shown in contemporary, at times vaguely generalized, drapery, a kind of modern-day Aestheticism. Light passes through windows and is in turn reflected in mirrors or highly polished surfaces, so that the entire scene is animated and sparkles, while strong compositional control is maintained through the limited setting and the geometry of the mirrors, screens and window mullions. Some of the Window series which he painted from about 1912 until about 1922 are fairly prosaic; others are amazing works which remain his most unappreciated paintings, though it was believed in 1927 that he would be best remembered for them.[11]

What he *is* well remembered for today is the Flag series of at least thirty paintings. In 1910, Hassam made another trip to Europe, traveling to Spain and to France. One of the pictures done in Paris at the time was his *July 14th, Rue Daunou,* a celebration of Bastille Day; some of the old interest in vivid street life seen from on high was revived upon his reacquaintance with Paris, but, more importantly, Hassam was struck by the elegant pattern of the blazing color of flags and the animation of their fluttering against the neutral tone of brownish-beige buildings. Six years later he painted several New York scenes on Fifth Avenue, commemorating the preparedness parade after the sinking of the Lusitania, and introducing flags for decorative purposes. With America's entrance into World War I, there was much pageantry which Hassam memorialized—a combination of his interest in the urban scene with an appeal to patriotism. The series culminated with a large number of canvases painted in 1918 which celebrate the Allied victory and the end of the war. Some blocks along Fifth Avenue between 26th and 58th Streets displayed a multitude of different flags, while others were devoted solely to one of the major nations involved in the war, so that the paintings variously displayed a variety of colors and patterns, or repeated the Union Jack or the American banner. In these major works, the flags appear solid and massive, while the rest of the city and its inhabitants appear to dissolve below. A show of Hassam's Flag series was mounted by Durand-Ruel Galleries in 1918 for the Liberty Loan drive to promote the sale of Liberty bonds. Ernest Haskell wrote that the Flag series was uniquely Hassam's,[12] but Hassam's work and success seems to have inspired others to emulate him, artists such as Jane Peterson, Theodore Butler and Arthur C. Goodwin.

Hassam remained a mainstay of the American art world, though his art was basically unchanged, while many younger artists became involved with Modernist movements. He was associated with a number of art colonies; he participated in the foundation and development of Cos Cob, centering around the famous Holley House which Hassam first visited in 1896, and which Donelson Hoopes has referred to as the "American Giverny."[13] Hassam was an important figure in the development of Old Lyme as an artists' center, and he began in 1919 to summer at Egypt Lane cottage in East Hampton, a town already known for its attraction to artists such as Thomas Moran. On his death, he left—under the supervision of the dealers who had understood and handled his painting, Albert Milch and Robert Macbeth—almost 500 works to the American Academy of Arts and Letters to be sold for the support of younger painters. Hassam had left a legacy also of a solid contribution to the American Impressionist aesthetic.

1. The major published studies are Adeline Adams, *Childe Hassam,* New York, American Academy of Arts and Letters, 1938, and Donelson F. Hoopes, *Childe Hassam,* New York, Watson-Guptill, 1979; the latter was unavailable for review at the time of this essay. Studies in progress include those by Betty Dillard, Stuart Feld, and Stephanie Wise. The material gathered by the late Barbara Anderson has been deposited at the University of Wisconsin. Hassam has been the subject of a good many exhibitions, and the catalogues for the most significant of these contain excellent introductions: Charles E. Buckley, *Childe Hassam: A Retrospective Exhibition,* Corcoran Gallery of Art, Washington, D.C., 1965, and University of Arizona Museum of Art, *Childe Hassam, 1859-1935,* Tucson, 1972, introduction by William Steadman. See also the volume compiled by Nathaniel Pousette-Dart in the Distinguished Artists series, *Childe Hassam,* New York, Frederick A. Stokes, 1922. Significant periodical articles were written by Charles L. Buchanan, Eliot Clark, Frederick W. Morton, Frederic Newlin Price, and Israel L. White especially. Jennifer Martin Bienenstock prepared an excellent study of Hassam's early urban scenes, for the City University of New York Graduate Program, 1978. The reader should also consult Hassam's opinionated but witty and perceptive review of the art of the first quarter of the 20th century, "Twenty-Five Years of American Painting," *Art News,* Vol. 26, no. 28 (April 14, 1928) 22-28.

2. This is a quote from a clipping taken from the *Boston Transcript* of 1887 on deposit at the American Academy of Arts and Letters in New York City, which has a large quantity of Hassam material in their files.

3. See A. E. Ives, "Mr. Childe Hassam on Painting Street Scenes," *The Art Amateur,* Vol. 27, no. 5 (October, 1892), 116-17.

4. Adams, *Childe Hassam,* 83.

5. Quoted in Adams, *Childe Hassam,* 2.

6. The national theme is stressed throughout the last chapter in Albert Gallatin, *Whistler: Notes and Footnotes,* New York, The Collector and the Art Critic Co., 1907, 89-95; also, Giles Edgerton, "Pioneers of Modern American Art," *The Craftsman,* Vol. 14, no. 6 (September, 1908), 598.

7. Lorinda Munson Bryant, *American Pictures and Their Painters,* New York, John Lane, 1917, 176.

8. Dorothy Weir Young, *The Life and Letters of J. Alden Weir,* New Haven, Yale University Press, 1960, 255.

9. Royal Cortissoz, *American Artists,* New York, Scribner's, 1923, 140-41.

10. These, however, have been the subject of numerous articles. See the articles by John Taylor Arms, Carlo Beuf, and Frank Weitenkampf cited in the bibliography; the discussions of his etchings in "The Etchings of Childe Hassam," *The Nation,* Vol. 101, no. 2632 (December 9, 1915), 698-99, "Childe Hassam and His Prints," *Prints,* Vol. 6, no. 1 (October, 1935), 2-14, 59, Frances Weitzenhoffer, "Estampes Impressionistes de peintres américains," *Nouvelles de l'estampe,* No. 28 (July-August 1976), 7-15, and David W. Kiehl's essay in the exhibition catalogue *Childe Hassam as Printmaker,* The Metropolitan Museum of Art, New York City, 1977. Catalogues of the etchings and the lithographs have been prepared by Royal Cortissoz, Paula Eliasoph, Fuller Griffith, and James C. McGuire.

11. See American Academy of Arts and Letters, *A Catalogue of an Exhibition of the Work of Childe Hassam,* New York City, 1927.

12. Pousette-Dart, *Childe Hassam,* viii. See also the catalogue *Childe Hassam: An Exhibition of His "Flag Series" Commemorating the Fiftieth Anniversary of Armistice Day,* Bernard Danenberg Galleries, Inc., New York City, 1968.

13. Donelson F. Hoopes, *The American Impressionists,* New York, Watson-Guptill, 1972, 16. See also Charles Eldredge, "Connecticut Impressionists: The Spirit of Place," *Art in America,* Vol. 62, no. 5 (September-October, 1974), 84-90.

**Frederick Childe Hassam**

*Geraniums.* 1888

Oil on canvas
18¼ x 12⅞ in. (46 x 30.5 cm)
The Hyde Collection

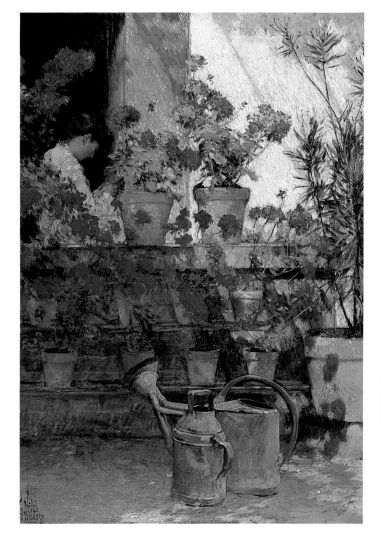

**Frederick Childe Hassam**

*Still Life, Fruits.* 1904

Oil on canvas
25 x 30¼ in. (63.5 x 76.8 cm)
Portland Art Museum, Portland, Oregon,
Gift of Col. C. E. F. Wood, in memory of his
wife, Nanny Moale Wood

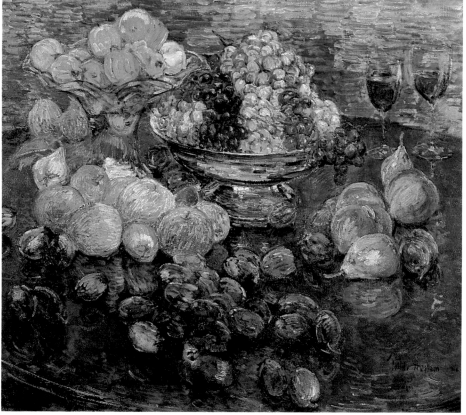

**Frederick Childe Hassam**

*Washington Arch, Spring.* 1890

Oil on canvas
26 x 21½ in. (66.1 x 53.3 cm)
The Phillips Collection, Washington, D.C.

**Frederick Childe Hassam**

*The Union Jack, New York, April
Morn.* 1918

Oil on canvas
36 x 30⅛ in. (91.3 x 76.5 cm)
Hirshhorn Museum and Sculpture Garden,
Smithsonian Institution

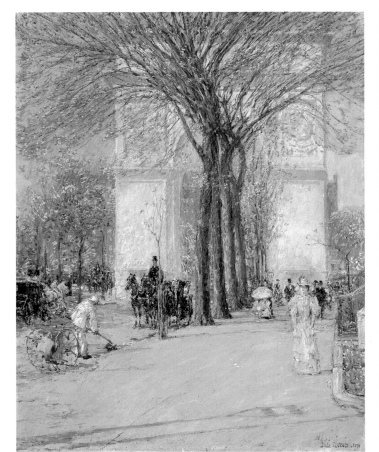

*Yellowstone Falls.* ca. 1895

Oil on canvas
30 x 30 in. (76.2 x 76.2 cm)
Collection of Mr. and Mrs. William Marshall
Fuller, Courtesy Amon Carter Museum

The notes for this chapter will be
found on page 69.

# John Henry Twachtman

The most consistently and continually admired of all the major American Impressionist painters has been John Henry Twachtman, whose work won encomiums by artists and critics from the end of the 19th century to the present. Like Robinson he died quite young, and his fellow artists of The Ten American Painters wrote sincere tributes to him which were published in the *North American Review* in 1903. Major historians of American art of the late 19th and early 20th century who wrote articles or short monographs about Twachtman include Duncan Phillips, Forbes Watson, Eliot Clark, Charles De Kay and the artist-critic Allen Tucker. Twachtman's achievement was sensitively studied by John Douglass Hale in an unpublished Ph.D. dissertation in 1957 which included a catalogue raisonné, rare for an artist of this period in America, and more recent writers often single out Twachtman as the most sensitive and original of the American Impressionists. Strangely however, he had not been the subject of a major (published) monograph, until Richard Boyle's recently appeared.[1]

Twachtman's background and artistic development are unusual among the American Impressionists, though many other late 19th-century painters followed the same pattern of training that Twachtman did, particularly artists from Cincinnati and the Midwest. He was born in that Ohio city, a center of German-American culture to which he was exposed, and was a product of the "Golden Age of Cincinnati Art," the period of *circa* 1870-90. The city had long been regarded as "The Athens of the West," with art organizations and academies such as the Ohio Mechanics Institute and the McMicken School of Design. Twachtman attended the former and then transferred to the McMicken in 1871. He met the Munich-trained Frank Duveneck, who was back home in Cincinnati in 1874, and began to study with him. Though Duveneck's work did not meet with great success in Cincinnati, it attracted a great deal of favorable attention in Boston where some of his pictures were shown in 1875, and attempts were made to persuade him to remain there. Duveneck, however, was intent on returning to Munich, and with him went a number of young Cincinnati art students seeking broader experience and more solid training than could be found in Cincinnati, or even in America. Twachtman was among these, and included also were the future Indian painter Henry Farny and the able but short-lived sculptor Franz Dengler. Twachtman studied in Munich for two years under the sympathetic friend of Duveneck, Ludwig Loefftz; he also worked at Polling where many artists who evinced a preference for landscape painted.

In 1877 Twachtman went to Venice with Duveneck and Chase, and he sent two paintings back to the first exhibition of the Society of American Artists in New York in 1878. Twachtman's early manner is characteristic of the more progressive tendencies of Munich at this period: rough but dramatic painting featuring very bravura brushwork and strongly contrasting tones with an emphasis upon rich blacks. Subjects were interpreted in a deliberately unsentimental, informal and untraditional manner, and this is true also of Twachtman's interpretations of Venice, which exhibit a preference for the reality of the local inhabitants presented in an almost shorthand manner, rather than the tourist-oriented emphasis upon gorgeous architecture illuminated by limpid sunlight. Pictures of this nature helped reinforce New York critical estimation that the Society of American Artists was at first not only foreign-oriented but directed more toward Munich than toward Paris. Such pictures by Twachtman are the antithesis of his later Impressionist manner, and demonstrate the artist's range and the degree of change that

occurred in his development within the search for a modern expression.

On the death of his father, Twachtman returned to Cincinnati, but finding the artistic climate still oriented more toward anecdotal genre, he traveled to New York City by the end of 1878, interpreting the harbor in a manner not dissimilar from his previous Venice scenes. In the seminal article that appeared in *The American Art Review* in 1881, "Cincinnati Artists of the Munich School," George McLaughlin categorized Twachtman as a marine painter.[2] In 1880 Twachtman was back home teaching, but the pull of New York remained strong, and he returned; his friendship with J. Alden Weir was developing, and the two were often to be associated in the minds of critics and patrons, and in public exhibitions as well.

In the fall of 1880, Twachtman was back in Europe joining Duveneck in Florence as one of the "Duveneck Boys." The following year he returned to Cincinnati to be married, and then he and his wife, with Weir and several other artists, traveled through Europe. At this time Twachtman was exposed to a variety of influences, meeting Anton Mauve in Holland and Jules Bastien-Lepage before returning to Cincinnati in 1882. It was then, also, that Twachtman, along with the critics, came to the realization that he had carried the Munich manner as far as he could. The following year, financed by his father-in-law, he went to Paris to study at the Académie Julian with Boulanger and Lefebvre. Although he studied figure painting there, he was to paint only a few not especially successful figure works later in his career. More significant were the friendships he developed at the time with the Paris-oriented artists such as Robert Reid, Frank Benson, Edmund Tarbell, Childe Hassam and Willard Metcalf, a group which became the basis of The Ten American Painters. He spent his summers painting landscape, at Arques-la-Bataille near Dieppe, and at Honfleur.

These French works mark Twachtman's second manner, a short period in the mid-1880s during which many historians believe Twachtman produced some of his finest paintings. They are markedly different from his Munich work. They are thinly, rather than thickly painted; they are based on close and subtle rather than dramatic tonal relationships, and a distinct, limited range of color which emphasizes grey-green tones prevails; and there is a tremendous sense of near-abstract design which in its flatness and asymmetry suggests a strong derivation from Japanese art, either directly learned or drawn from Whistler, for the paintings are markedly Whistlerian in mood and technique. Both Duncan Phillips and Forbes Watson were later to stress the influence of Whistler, and another critic stated that Twachtman painted days as Whistler painted nights.[3] One of these works, *Windmills*, won the Webb prize for the finest landscape by an artist under forty at the Society of American Artists in 1888.

Twachtman rejoined Duveneck in Venice in the winter of 1885, and he became closer to Robert Blum, another Cincinnati-born artist, there. A further connection with Whistler, and with Blum and Weir also, was Twachtman's increasing practice of pastel painting. Blum was the guiding spirit of the pastel revival in America in the 1880s, and Twachtman was to exhibit some of his Venice pastels at the Wunderlich galleries in the second exhibition of the Painters in Pastel, in 1888. Critics described Twachtman's pastels as comparable to Whistler's, both artists making abundant use of the tone of the colored paper and the sketchy nature of the chalks.

Twachtman was back in America in 1886, this time for good. It was

**John Henry Twachtman**

*Old Holley House, Cos Cob.*
**ca. 1890-1900**

Oil on canvas
25 x 25⅛ in. (63.5 x 64.1 cm)
Cincinnati Art Museum, John J.
Emery Endowment

66

**John Henry Twachtman** (above)

**John Henry Twachtman**

at this time that his association with Weir became a close camaraderie. In 1887 Twachtman rented land at Branchville, near Weir, and in 1887-88 he purchased a 17-acre farm at nearby Cos Cob, where they worked often close-by one another. Twachtman also began teaching at the Art Students' League, which he continued for the rest of his life. He was an influential teacher, numbering among his students such later Impressionists as Ernest Lawson and Allen Tucker, and two of his students, Tucker and Caroline Mase, wrote critical essays about his work. Twachtman's work began to be exhibited more regularly at this time also; he and Weir had a two-artist show in 1889 at the Ortgies Art Galleries on Fifth Avenue in which they each showed 42 works. They met with critical success, though Weir always sold better than did Twachtman. Twachtman had a one-man show at the Wunderlich galleries in 1891, and was included in a four-artist show at the American Art Association in 1893, joining Weir, and the Frenchmen Monet and Albert Besnard.

By this time, Twachtman had abandoned his French manner in favor of his best known and most typical approach to landscape painting, sometimes referred to as his Greenwich style, and an aesthetic related to Impressionism. Critics quickly recognized this, though at first some were confused by it. In the 1893 show, unsympathetic writers recognized at least grudgingly the originality of Monet's work, but felt that Weir and Twachtman were only imitators without even the force of the original master. [4]

Twachtman's development in his mature work is difficult to follow and assess, for he almost never dated his works, and even the year he began this phase of his painting is unclear. However, it has been demonstrated recently that one of Twachtman's finest, most original and most typical works of this period, his *Icebound* in the collection of The Art Institute of Chicago, was in all likelihood painted in the winter of 1888-89. [5] Therefore, one may state with some confidence that this new manner must have begun about 1888. Other works can occasionally be given a tentative date either by exhibition records or by geographic locations, but Twachtman's tendency to repeat titles and to continue to paint the same subject over a period of years makes such methodology only partially reliable.

The subjects of Twachtman's landscapes were, for the most part, his home and the land around it, and such local features as Horseneck Brook and the Blue Brook waterfall, or that favored artists' meeting place, the Old Holley House in Cos Cob. Twachtman's great achievement lay in his ability to project his emotional response to these scenes, which are not at all spectacular in themselves. He painted the same subjects over and over again, in different lights and at different seasons. Such a procedure would seem to reflect Monet's contemporaneous manner in his series of haystacks and cathedrals, but Twachtman's interest was not in the recording of changing natural phenomena but in a very personal, subjective response. In effect, his art offered satisfaction to the critics who deplored Impressionism not for its rejection of traditional discipline but because it rejected sentiment and soul.

Twachtman's method was certainly not that of orthodox Impressionism, but it drew upon that aesthetic. His paint became heavier and grittier than the thin washes of his French years. He built up his forms with thick, opaque layers of paint and then glazed them over and over again, allowing the glazes to dry and bleach in the sunlight, thus creating the impression of a

misty veil of luminosity and atmosphere. Yet, a strong sense of abstract design remained, and in some of his work the reduction of form to an almost two dimensional design of landscape forms bound by snaking, whip-like outlines almost anticipates the linearism of Art Nouveau. Horizon lines are often extremely high in his paintings and sometimes disappear completely, so that the viewer is forced to read the painting as a two dimensional surface design, since illusionistic space is at least partially eliminated. This aesthetic is reinforced by the square format that Twachtman often chose for his paintings; in fact, Twachtman appears to have painted more square paintings than any other American, though this conscious artistic choice was echoed by such European contemporaries as the Austrian Gustav Klimt, and some of Twachtman's younger American admirers, such as Marsden Hartley, followed suit in the succeeding decades.

Like Hassam, Twachtman emerged in the last decade of the 19th century as one of the major painters of the winter landscape, though Twachtman's were always country rather than city—part of what Hassam referred to as the "Cos Cob Clapboard School," emphasizing the rural nature of the art of the painters working in the area. Unlike his French contemporaries, Twachtman's winter pictures are often monochromatic, with the overall whiteness only very subtly flecked with color, rather than the more prismatic winter scenes of orthodox Impressionism, or the blue and violet shadows which critics usually identified with Impressionism. Twachtman summed up beautifully his attitude toward nature, and especially the winter season, in a letter to his friend Weir. He said: "I can see how necessary it is to live always in the country—at all seasons of the year.... Never is nature more lovely than when it is snowing. Everything is so quiet and the whole earth seems wrapped in a mantle.... All nature is hushed to silence."

Small waterfalls and pools are often incorporated into his compositions, and add shimmering qualities to the lightness and airiness of Twachtman's landscapes. Though Twachtman made use of broken color, his application of the brush was not overly systematic, and his closer, more nuanced tones are allied to the work of the Tonalists and of his friend Weir, projecting an intimacy similar to theirs and to Inness' contemporaneous late work.

Twachtman's painting is limited even within the thematic scope of landscape. The works seldom portray full sunlight, and he was never a painter of nocturnal scenes. He preferred the various aspects of winter, a full snow scene or the melting of snow at the end of winter, yet the verdant seasons of spring and summer appear beautifully also, though the riot of autumnal coloration was not agreeable to his aesthetic. He generally preferred a closed-in view rather than the panoramic, and the quiet flow of water seems to have produced a more genuine response than did a dramatic torrent. He was not a still life painter, but his close-up views of flowers growing in gardens are thematically akin to Hassam's work on Appledore, even less botanical and more moving; Charles De Kay praised these particularly, as flower painting only surpassed by the still lifes of John La Farge.[6]

The fragility, asymmetry and sense of abstraction drew much critical comparison with Oriental art. Christian Brinton recognized a similarity with Japanese art when a large group of Twachtman's works, including many flower pictures, was shown at the Panama-Pacific Exposition in San Francisco in 1915. Brinton saw in these paintings the essentials of Impressionism combined with the subtle abstraction of Japanese art, and

Marsden Hartley recognized Japanese qualities in the flat planes and rhythmical shapes of Twachtman's landscape design. On the other hand, Sheldon Cheney, in *The Story of Modern Art*, identified Twachtman's source as Chinese landscape, and other writers saw the inspiration of Zen Buddhism. This last was the conclusion of John Laurvik in the catalogue of the San Francisco Exposition, and of John Cournos a year earlier when he found the contemplative and ethereal nature of Twachtman's painting related to Zen concepts, where the material was secondary to the idea. Twachtman was seen as creating an artistic Nirvana, and in capturing nature's soul; his work was viewed as quite distinct from that of his French colleagues.[7]

The emphasis upon the spiritual and the contemplative is not meant to suggest that Twachtman had retreated from the reality of the American art world; far from that. He taught at both the League and the Cooper Union, and was involved with most of the major art organizations in New York, not only exhibiting at the Society of American Artists and the Painters in Pastel but also with the New York Etching Club and the American Watercolor Society. He was a member of the Players along with many of his fellow artists. And he was instrumental in the founding of The Ten American Painters in 1898, although he only lived four more years; his place taken in 1902 by William Merritt Chase.

In 1893 he refused to join his colleagues and friends J. Alden Weir, Robert Reid and Edward Simmons in the commission for murals in the Manufactures and Liberal Arts Building at the Chicago Columbian Exposition; his was an intimate, not a public art. But in 1894 he visited Buffalo and went on to paint a series of depictions of Niagara Falls, rendering it as a poetic vision rather than the traditional interpretation as a natural wonder. In turn, Major W. A. Wadsworth of Buffalo, who admired these, commissioned Twachtman to paint several views of Yellowstone, works mentioned by Theodore Robinson in his diary of 1895. Critics such as Eliot Clark felt that Twachtman was uninspired by the grandeur of Western scenery, and that he was an artist who responded more completely to humanized landscapes,[8] but some of his Yellowstone views are quite monumental, incorporating a breadth of treatment and rich coloration with his still very personal vision. He may have been more secure, however, with his several views of the Emerald Pool at Yellowstone—bits of opulent color, abstracting the curves of natural forms into the flat shapes and sinuous outlines that were unique to his aesthetic at the time.

A fourth period in Twachtman's artistic career has been discerned by critics in the work done in his last years, 1900-02. During the summers of those years Twachtman painted in Gloucester, Massachusetts, along with his old mentor Duveneck, and another Cincinnati follower of Duveneck who was likewise transplanted to the East, Joseph De Camp. Perhaps partly influenced by them, a greater sense of geometric structure, stronger tonal contrast with the reintroduction of black, and more forceful brushwork returned to his art. These pictures from Gloucester, such as *Italian Salt Barks* and his last, unfinished work, *Harbor View Hotel,* were painted *à premier coup*—vigorously and immediately—and are not the result of great premeditation and the drying out of multiple layers of glazes over a heavy underpaint. Some of the paintings done at this time incorporate a strong rush back into space, and often a successful compositional integration of a clear and forceful two and three dimensional design. The compositions are also enlivened by contrast of active and empty areas, again an Oriental element.

# John Henry Twachtman

*View of the Seine, Neuilly.* n.d.
Oil on wood panel
13¼ x 15½ in. (33.1 x 38.2 cm)
University of Nebraska Art Galleries,
Howard S. Wilson Memorial Collection

It is difficult to date Twachtman's work from even these few years, however, and their differences from his work of the previous decade are matters of degree, not changes in fundamental aesthetic manner as characterized the earlier artistic transformations. Though some of his last works take on occasional Munich characteristics, he did not return to a Munich manner. As to whether or not he might have developed a stronger and more vigorous approach to landscape painting had he lived is left to speculation only.

Twachtman's sudden death in August of 1902 at Gloucester was a sad shock to the progressive art world and to his friends and colleagues among The Ten. In their tributes, Reid and Hassam praised the subtle beauties of his work, Weir his intimate love of nature, and Dewing suggested that he would become a classic, though he was too modern then.[9] A few years later, Giles Edgerton (Mary Fanton Roberts) spoke of him as without a peer in American art, and later still, in 1921, his pupil Carolyn Mase called him one of the greatest painters America had ever produced.[10] He was certainly one of the most individual, and his paintings some of the loveliest.

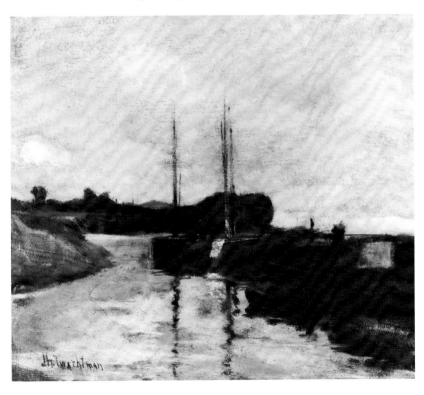

1. The works of all these authors concerning Twachtman are cited in the bibliography; there are three studies by Eliot Clark. See also John Cournos, "John H. Twachtman," *The Forum,* Vol. 52 (August, 1914), 246; the articles by Twachtman's fellow artist Charles C. Curran, his students Carolyn Mase and Katherine Roof, and Jonathan Thorpe; and the excellent essay by Richard J. Boyle in the catalogue *John Henry Twachtman,* Cincinnati Art Museum, 1966.

2. George McLaughlin, "Cincinnati Artists of the Munich School," *The American Art Review,* Vol. 2, Part 1 (1881), 1-4, 45-50. The article by W. Mackay Laffan, "The Material of American Landscape," which appeared in the same magazine, Vol. 1 (1880), 29-32, showers nationalist praise on the interpretation of an American harbor scene—almost certainly New York—by an artist who had studied in Europe and worked in Venice, who is very likely Twachtman. The article concludes in this manner: "There shall be more joy over one honest and sincere American horsepond, over one truthful and dirty tenement, over one unaffected sugar-refinery, or over one vulgar but unostentatious coal-wharf, than there shall be over ninety and nine Mosques. . . ."

3. Cournos, "John H. Twachtman," 246.

4. See Alfred Trumble, "Impressionism and Impressions," *The Collector,* Vol. 4, no. 14 (May 15, 1893), 213-14.

5. James L. Yarnell, "John H. Twachtman's 'Icebound,' " *Bulletin of the Art Institute of Chicago,* Vol. 71, no. 1 (January-February, 1977), 2-5.

6. Charles De Kay, "John H. Twachtman," *Arts and Decoration,* Vol. 9, no. 7 (June, 1918), 76.

7. Brinton, *Impressions of the Art,* 95; Hartley, *Adventures in the Arts,* 75; Sheldon Cheney, *The Story of Modern Art,* New York, Viking Press, 1941, 432; John E. D. Trask and John Nilsen Laurvik, *Catalogue De Luxe of the Department of Fine Arts, Panama-Pacific International Exposition,* San Francisco, 1915, 44-46; Cournos, "John H. Twachtman," 245.

8. Eliot Clark, *John H. Twachtman,* New York, privately printed, 1924, 50-51.

9. Thomas W. Dewing, et al., "John H. Twachtman: An Estimation," *North American Review,* Vol. 176, no. 557 (April, 1903), 554-62.

10. Edgerton, "Pioneers," 605; Carolyn C. Mase, "John H. Twachtman," *International Studio,* Vol. 72, no. 286 (January, 1921), lxxi.

**Julian Alden Weir**

*River Scene.* n.d.
Oil on canvas
22¾ x 29¾ in. (55.9 x 73.6 cm)
The Daniel J. Terra Collection

The notes for this chapter will be found on page 75.

# 11 J. Alden Weir

If there is a patriarchal figure among the American Impressionists, it is Julian Alden Weir. This estimation resides not in age — Weir was substantially of the same time as many of his fellow members of "The Ten," though he outlived several of his close friends among them, such as Twachtman and Robinson. Neither does it lie in his early assumption of that style; actually his commitment to Impressionism was never as total as Hassam's or even Robinson's, and his exploration of Modernist, avant-garde aesthetics was minimal compared to Twachtman's. Weir, however, was a thoroughly sympathetic figure, a warm friend to many of his colleagues, a bridge to some of the major collectors of the period whom he advised, sympathetic to artists, critics and movements of greatly diverse standpoints, and a man of organizational ability, who was often sought after for administrative positions in the art organizations of his day. Moreover, early in his professional life he achieved the means to be able to better give of his time and his support to aiding the cause of American art.

Weir is also blessed by the most discerning biographical treatment of any of the group so far published, the 1960 biography written by Dorothy Weir Young, one of his three daughters, all of whom were devoted to their father's memory and his art, and who were often the models for his figure paintings. The volume's strength lies in detailing the artist's early life and training in France, where the reader finds the suspicions and misapprehensions of Modernism typical of American artists, opinions that substantially reinforced their devotion to and belief in the principles of the Academies and the standards of the Salon, which they would only reluctantly abandon, even as they became converts to the opposing aesthetics of Modernism later in their careers.[1]

In his own lifetime and immediately afterwards, Weir was a much admired figure, though particularly by critics themselves generally conservative: Royal Cortissoz, Frank Jewett Mather and especially Duncan Phillips. After the memorial tributes that emerged in the several years after his death, however, Weir's art and reputation fell into a semi-oblivion from which it began to emerge only in the years around 1950. He is now seen as a major figure of the American Impressionist movement, a poetic artist of great charm, but not as exciting, colorful or original as his major colleagues. And as with many of his contemporaries, artists such as Bunker, Robert Vonnoh and numerous others, Weir's art displays a dichotomy, not only between earlier and later styles but also between outdoor and indoor pictures, and between landscape and figural subjects.

Weir's generally sympathetic outlook toward his environment and his culture, and his warmth toward the artistic community were certainly nurtured in his familial upbringing, a particularly fortunate one for a young man at mid-century. He was born at West Point, the son of Robert Weir, the drawing instructor there, who had, himself, occupied a somewhat patriarchal and ultimately venerable position among the American artists of that earlier generation. The father's contact with the Knickerbocker community of artists, writers and patrons, and the intimate artistic environment complete with a major collection of art books and engravings, stood the young J. Alden in good stead. So did the example of his older brother, John Ferguson Weir, who had already embarked upon an artistic career in New York City when J. Alden went there in the winter of 1867-68, to study at the National Academy of Design schools. John Ferguson Weir was an artist of considerable ability, whose creative talents were later decisively deflected, though to considerable achievement, as the head of the Yale University Art School for many decades. His art appears to have been only tangentially influenced by Impressionism; his painting is perhaps closest to that of his more famous brother in the area of still life. But John gave his younger brother great support, and on his wedding trip in 1869, he encouraged J. Alden to travel and study abroad by writing to him of the superiority of European training.[2]

J. Alden Weir made contacts in New York in his early years that remained with him for life, establishing friendships with Albert Pinkham Ryder in 1868 and with Chase the following year. Still, it was natural that he felt the pull of Paris by the early seventies, and with the aid of Mrs. Bradford R. Alden, whose husband, a captain at West Point, had been a patron of Robert Weir's and the young J. Alden's godfather, the young art student was enabled to go to study in France. He left in 1873, stopping off to acquaint himself with the earlier masters in London, and entered the studio of Jean-Léon Gérôme. Gérôme provided him the basic foundations for his future art, a strong concern with drawing and the structural modeling of form; the *academies* that Weir painted under Gérôme are among the finest by any American. Weir was impressed and convinced by the search for representational truth among the French masters such as Gérôme and Bonnat, and he supplemented his studies with the examination of the old masters, particularly those like Holbein for whom drawing was paramount.

Yet, in his four years abroad, Weir's concerns and sympathies showed a certain subtle shift not uncharacteristic of an aware if basically conservative young artist. Even as early as 1874, he revealed a coloristic interest that was not supported by his training with Gérôme, and in the winter of 1874-75, a trip to Belgium and Holland led to a new admiration for the work of Franz Hals, himself an idol of the more advanced artists in Munich; Weir was to admire the work of Frank Duveneck also. Back in Paris he gravitated to the brilliant, light-filled work of the contemporary "little masters" such as Meissonier, but a decisive friendship was formed with the rising young French artist Jules Bastien-Lepage, whom Weir had met in 1873. Bastien's balance between correct figure drawing and plein-air painting, distinctive in its luminous grey light and atmosphere and firm spatial control leading to a high horizon, and which portrayed the French peasantry on a monumental scale, became a model for searching young artists of Europe and America for the next decade and a half, continuing even after Bastien's early death in 1884. Although Weir's own painting reflected a total commitment to Bastien's precepts for only a short time — unlike that of his countrymen such as Charles Sprague Pearce or his own close friends in Paris, Wyatt Eaton and Will Low — elements of Bastien's style were to remain guideposts, or possibly limitations, throughout Weir's career. And he was to advertise and advance Bastien's reputation with American collectors and artists, even reluctant ones like John Twachtman.

But Weir at this time was (to use the phrase of the earlier American painter Washington Allston) "a wide liker" if a confused one. Side by side with his appreciation of the fluid brushwork of Hals and Duveneck, and, in France, the painterly manner of Carolus-Duran and Paul Baudry's ceiling for the Paris Opera — which would provide a model for Weir's contribution to the Chicago Columbian Exposition in 1893 — remained his admiration for the academic masters of line: Gérôme, Bonnat, or earlier, Ingres. Gérôme, not nearly so opposed to alternate aesthetic notions then in the air as later

historians have made him out, advised Weir to go to Spain, but he was surprisingly disappointed with the painting of Velasquez and thought even worse of Goya. He did meet there the Englishman Sir Henry Thompson, of whose great collection of Oriental blue-and-white porcelain Whistler was just then making wash drawings for a sumptuous catalogue, and Thompson promised Weir an introduction to Whistler when the young American visited London.

In France, Weir's own art followed the course of many young French, British and American painters of his day, avoiding both grandiose historical narrative and radical artistic departures, and applying his newly gained abilities at figure rendering to scenes of peasant life; like many he chose the most traditional and picturesque peasants of Brittany, in such works as *A Brittany Interior* of 1875, a painting shown at the Paris Salon, or his *Breton Peasant Girl*. The appeal of Brittany was based on a number of factors. An art colony existed there where young artists of many nations, and especially Americans, congregated at the villages of Concarneau and Pont-Aven in the summers when the Paris *écoles* and ateliers were closed; Weir, drawn to Pont-Aven by the example of the short-lived, much admired Robert Wylie, worked there in 1874, executing his major peasant pictures. These villages offered camaraderie, picturesque subject matter and extremely inexpensive living and models — necessities for impecunious art students. At the same time they provided the subject matter for ambitious young artists to explore a major theme popular both critically and artistically at the time: the unchanging peasant life, simple, pure and supposedly immune to the hectic pace and changing mores and values of the modern world even when, in fact, that traditional existence was becoming increasingly threatened by mechanization and conglomeration. Actually, remote Brittany was the last outpost of the old traditions in France. Weir, Wylie and other American painters of the peasantry such as Eaton and Pearce were thus joining the second generation of artists such as the Frenchmen Jules Breton, Léon L'Hermitte and Bastien-Lepage in monumentalizing the figures first introduced into modern French art by Jean-François Millet.

To such an artist, abhorrence of the wild palette, the lack of construction and the omission of moral purpose in Impressionist painting was only logical, and predictably Weir's first contact with the new movement, his visit to the third Impressionist show in April of 1877, resulted in disgust. Referring to the artists as "Impressionalists," he called the show "worse than a Chamber of Horrors" castigating the lack of drawing or form. He found the work, in fact, demoralizing, and left the exhibition with a headache. Uncharitably — and certainly inaccurately! — he charged that the painters in the show were all rich.[3]

Weir's basic commitment at this time to the academic standards of his training was further invoked later that year when he returned to America. On his way back, he stopped in London and called upon Whistler, with whom he established a friendship, but he felt that Whistler's paintings were only "commencements." Weir arrived back in New York at a singularly propitious moment for a young, Parisian-trained painter, for it was the year of the formation of the Society of American Artists. Weir participated in the new organization, and his work was singled out by the influential critic of the *Tribune,* Clarence Cook, in the review of the Society's first exhibition in 1878. His major work shown at the Society's 1879 exhibition, *In the Park,* was a dark and dramatic "contemporary" figural scene subsequently cut into

three separate sections by the artist, perhaps because of the criticism of the work as crowded and enigmatic.[4]

Weir became an important personage in New York art life. He took a studio in the University building in 1878 and then, in 1880, in the new Benedict Building on Washington Square East, along with many of his artist friends such as Eaton, Ryder and the sculptor Olin Warner, whose bust of Weir is one of the finest American portraits of the late 19th century. He was a member of the Tile Club during its decade-long existence, 1877-87. Weir was active both in the Society and in the National Academy, and with the American Water Color Society, and later in the 1880s with the Painters in Pastel. He taught at the Art Students' League, the Cooper Union and privately.

Weir was also active in advising American collectors on acquisitions of European art, both older masters and more recent painters, assisting Henry Marquand and particularly Erwin Davis. Davis became a significant collector, owning works by Weir, Twachtman, Eaton, Gericault, Delacroix, Millet, Corot, Monticelli, Bastien-Lepage and others; Weir aided him in acquiring, among other works, Manet's *Woman with a Parrot* and *Boy with a Sword.* Of greater significance to Weir, he aided Davis in securing Bastien-Lepage's great *Joan of Arc* of 1880, which was shown at the fourth exhibition of the Society of American Artists in 1881. Such a role enabled Weir to return to Europe, traveling with his brother John and with Twachtman to Holland in 1881. In 1883, Weir married Anna Baker. She had a home in Windham, Connecticut, and Weir was able to secure a summer home in Branchville, Connecticut, from Davis in exchange for a painting. The Weir home at Branchville became the center of an informal artists' colony, with painters such as Robinson, Ryder, Hassam and John Weir visiting frequently and painting there. Twachtman rented a place near Weir in 1887, and then purchased his own home nearby in Cos Cob. The work executed by these artists, some of them among the American Impressionists, evinced an interest in the native and the local: understated paeans to the rural New England landscape. When Ryder visited in 1897, he said he had never seen the beauty of Spring before, the landscape and the air so full of promise. Sargent's good friend and traveling companion, the artist Wilfred von Glehn, wrote in 1903 of "quiet, peaceful, pastoral Branchville."[5]

Weir's painting of the 1880s, the first decade after his return from Paris, consisted of quite conservative but strong figure painting and still life. In addition to teaching and art advising, he was a first-rate portraitist, particularly of male subjects, many of whom were artist-friends (Olin Warner, Arthur Quartley, Albert Pinkham Ryder) or art patrons like the previously mentioned Colonel Charles Wood of Portland, a former West Pointer. Weir also painted a good many figure paintings, often using members of his family as his subjects, and in these usually emphasized the theme of domesticity. Weir achieved in such works a remarkable combination of monumental structure with delicate mood, perhaps closer to Whistler than any other source; of one of these paintings a critic wrote of Weir's "customary dark harmony of black and gray," which could describe as well a figure or nocturne by Whistler. Less well-known today are several works closer in manner to Bastien, Weir's early *Good Samaritan* or the *Burial of the Bird,* and several ideal figure works such as *The Muse of Music* of 1884, which two years later Charles De Kay called Weir's most successful

**Julian Alden Weir**

*The Factory Village.* **1897**
Oil on canvas
29 x 38 in. (73.6 x 96.5 cm)
Collection of Mrs. Charles Burlingham

painting, except for his flower pictures.[6] These last, a large series of flower pictures begun in the 1880s, were Weir's most sought-after oil paintings. Weir was the American Impressionist most involved with still life painting, but his paintings of this theme, though unquestionably among the most gorgeous American flower pictures, are dark and dramatic works, most often contrasting delicate and fragile light roses with glistening, elaborate metal and ceramic vessels. Weir's production of still lifes fell off sharply at about the time he turned to a modified form of Impressionism, though he did not abandon the theme completely, and some pictures of peonies and chrysanthemums — soft, airy blossoms readily adapted to the new aesthetic — are interpreted by Weir in a different manner.

In 1884, Bastien died, and with the sad event, J. Alden Weir's ties with his earlier Parisian years weakened, though he was to write the section on Bastien in John Van Dyke's *Modern French Masters* of 1896. Two years later he was genuinely impressed by the exhibition of paintings sent to New York by Durand-Ruel, and he found some among the Impressionist pictures remarkable, advising his brother John not to miss the show. At the same time, he turned more and more to landscape painting in both oils and pastel and away from portraiture and still life, exhibiting many landscape paintings in the two-man exhibition and auction he shared with Twachtman at the Ortgies Galleries in 1889. He began to sell quite well, often exhibiting with Twachtman, and at times persuading collectors to acquire a picture by his colleague along with one of his own. In 1891 Weir had a one-man show at the Blakeslee Galleries in New York, where critics noted a new, high-keyed colorism.

The 1890s saw the development of a more personal style in his art, one nevertheless being shaped by Weir's growing enthusiasm for Impressionism. Even here, however, he remained more cautious in his traditional figure work than in the new enthusiasm for landscape. The majority of his landscapes are rural scenes, of the lands around his Connecticut estate: fertile livable farmland. In many of these, farmers and their animals such as oxen are at work, a heritage from his exposure to French peasant painting and the influence of Bastien, but now gentle pictures of farmers in harmony with their land, rather than straining under the yoke of labor. From around 1895 to about 1910 Weir produced his finest paintings in a modified Impressionist manner, with broken but not aggressive brushwork, and somewhat tonal, rather than chromatic, Impressionism, with the emphasis upon a limited palette of varied hues — working with his favorite blue- to yellow-greens rather than a full spectrum. In a tribute to him, Edwin Blashfield wrote that Weir preferred green haunts and loneliness; Duncan Phillips, calling Weir the finest American landscapist since Inness, spoke of his preference for open hill country, seen near noontime, and for mid-summer.[7]

Weir's art was one of gentle modernity, and the theme of modern labor and industry was harmoniously incorporated into some of his finest paintings in a unique and successful way, in part perhaps a heritage from his brother John, whose most famous paintings done early in his career had been two major foundry scenes, *The Gun Foundry* of 1866 and *Forging the Shaft* of 1867 (known today only through a replica of ten years later). For the spectacle of John Weir's earlier works, his younger brother substituted a tour-de-force of beauty and harmony, exemplified in the newly-painted iron *Red Bridge* of 1895 or the series of mill factories painted in Willimantic

around two years later. Smokestacks and telephone poles coexist with verdant nature, modern factories with New England churches, a modern subject interpreted in a modern style which critics such as Royal Cortissoz praised for their Americanism.[8]

Weir was slower to abandon the dark tonalities and Whistlerian Aestheticism in his figure painting. In the works he contributed to the first exhibition of The Ten American Painters in 1898, landscapes such as *The Factory Village* displayed a far lighter and more colorful approach than the more solidly constructed figure paintings, but in works such as *The Grey Bodice* and *The Green Bodice* he began to interpret human form with more broken brushwork, though the tones were still far less varied and more neutral than in his non-figural work; probably the loveliest of these ideal figure paintings is *The Orchid* of 1899, where woman and flower partake of the same soft and delicate mood, and critics praised these pictures for their lyrical purity. At the very end of the century, he began painting large figural works in the out-of-doors, for example, *In the Sun* and *The Donkey Ride,* both of 1899, and *Visiting Neighbors* of 1903, in which the paint is applied in a tapestry-like manner — long, coarse strokes with a minimum of chiaroscuro, and a tendency toward spatial reduction of forms to a single, flat plane. An overall abstract unity is achieved through the undifferentiated surface treatment, in an original aesthetic somewhat akin to Post-Impressionist developments and prefiguring the later technique in America of Ernest Lawson and Maurice Prendergast. The basic technique is Impressionist however, with long, visible brushstrokes and, with *In the Sun,* the strong concern with full sunlight.

Weir was one of the many artists involved in the mural decoration of the Manufactures and Liberal Arts Building at the Columbian Exposition in 1893. It was a landmark in the history of American mural painting because of the magnitude of the commission and the collaboration of many painters, sculptors and architects, but the murals themselves were ephemeral, and given the lack of previous experience at mural painting by many of the artists involved, their lack of critical success is not surprising. Some of the painters involved did turn largely to mural painting subsequent to the Chicago commission, but Weir was not among them. Nevertheless, his ceiling decorations of The Goddesses of Pottery, Goldwork, Decoration and Printing were among the most favorably received, praised for their simplicity of line and their delicate, evanescent pale purple, blue and green coloring — again, perhaps, related to his new Impressionist interests.[9]

Around 1910-11, Weir painted a pair of unusual New York night scenes of the Queensboro Bridge and the Plaza, excursions into subject matter related to Whistler's nocturnes and the urban paintings of Hassam and Birge Harrison. In general, however, Weir's creative inspiration, and to a degree his poetic lyricism also, began to decline in his last decade, though he remained an active if by then conservative painter. He was still a vigorous figure in the contemporary art world, however, and was elected the first president of the Association of American Painters and Sculptors, the group that was to form the International Exhibition of Modern Art which became known as the Armory Show of 1913. He resigned, however, when it was imputed that the Association was formed in opposition to the National Academy, of which he was a devoted member. He did, in fact, exhibit in the Armory Show, and was not unsympathetic to contemporary trends of the period, although he was puzzled by Cézanne and offended by Matisse. In

*The Plaza: Nocturne.* ca. 1911

Oil on canvas mounted on board
29 x 39½ in. (73.6 x 100.3 cm)
Hirshhorn Museum and Sculpture Garden,
Smithsonian Institution

1915 he became President of the National Academy and of The Metropolitan Museum of Art, while continuing to display his work with The Ten American Artists, who had their last exhibition in 1918-19. In 1919, a new revolt against the National Academy was begun by a group calling themselves the New Society of American Painters, Sculptors and Gravers who sought Weir's participation; Weir did join with this group, but died soon after.

Critical tributes to Weir abounded immediately after his death, though many writers appeared puzzled by a lack of consistency, unsure whether to judge his art as inconsistent or inventively varied. A number of writers sought out the peculiarly American in his art: Catherine Ely finding Weir's painting un-European and anti-modern, and Weir's champion, Duncan Phillips, discerning a spirit more Puritan than pagan, especially in contrast to the painting of Childe Hassam. Perhaps Eliot Clark summed up the prevalent opinion best when he recognized the diversity of subjects, color, key and technique, but nevertheless saw an overall unity of purpose and a simple serenity in Weir's art.[10]

1. Dorothy Weir Young, *The Life and Letters of J. Alden Weir.* The other significant item in the Weir bibliography is *Julian Alden Weir: An Appreciation of His Life and Works,* with essays by Duncan Phillips and others, New York, E. P. Dutton, 1922. This volume was produced by Phillips after he took over the copyright from the Century Association, which had originally published the book the previous year. The second edition of the volume includes eight additional illustrations. Phillips also authored several essays concerning Weir which appeared in magazines, as did Kenyon Cox, Guy Pene Du Bois, Eliot Clark, Catherine Beach Ely and Frederic Newlin Price. The reader should consult the essays by Mahonri Sharp Young in the catalogues *J. Alden Weir, 1852-1919, Centennial Exhibition,* American Academy of Arts and Letters, New York City, 1952, and *Paintings by J. Alden Weir,* The Phillips Collection, Washington, D.C., 1972. In addition, see Edwin Blashfield, *A Commemorative Tribute to J. Alden Weir,* New York, American Academy of Arts and Letters, 1922. Weir's prints were discussed by Elizabeth Luther Cary, Walter Pach, Margery Ryerson, Frank Weitenkampf and Agnes Zimmerman; by his daughter Caroline Weir Ely in the catalogue for the 1927 Keppel Gallery show; by Robert Spence for the University of Nebraska Art Galleries in 1967; and especially important is Janet Flint, *J. Alden Weir, An American Printmaker, 1852-1919,* National Collection of Fine Arts, Washington, D.C., 1972. All of these are listed in the bibliography.

2. Young, *Life and Letters,* reproduces many letters between John and J. Alden Weir as well as among other members of the family. Later in her book there is particular emphasis upon the correspondence between J. Alden Weir and his major patron, Colonel Charles Wood.

3. In a letter to his parents, Young, *Life and Letters,* 123.

4. See "Two Paintings by J. Alden Weir," *The Brooklyn Museum Quarterly,* Vol. 13, no. 4 (October, 1926), 124-25, and John I. H. Baur, "J. Alden Weir's Partition of 'In the Park,'" *The Brooklyn Museum Quarterly,* Vol. 25, no. 4 (October, 1938), 125-29.

5. Young, *Life and Letters,* 206, and Eldredge, "Connecticut Impressionists," 90.

6. Charles De Kay, "A Group of Colourists," *Magazine of Art,* Vol. 9 (1886), 389-90.

7. Blashfield, *A Commemorative Tribute to J. Alden Weir,* Duncan Phillips, "J. Alden Weir," *The American Magazine of Art,* Vol. 8, no. 6 (April, 1917), 213.

8. Royal Cortissoz, *Personalities in Art,* New York, Scribner's, 1925, 406.

9. Sadakichi Hartmann, *A History of American Art,* 2 vols., Boston, L. C. Page, 1901, Vol. 2, 232.

10. Eliot Clark, "J. Alden Weir," *Art in America,* Vol. 8, no. 5 (August, 1920), 232-42.

**Edward Henry Potthast**

*Manhattan Beach.* **n.d.**

Oil on canvas mounted on board
12 x 16 in. (30.6 x 40.6 cm)
The Merrill J. Gross Collection

*Madeline.* n.d.
Oil on canvas
22¼ x 19¼ in. (56.5 x 50.3 cm)
The Daniel J. Terra Collection

# 12 Other Impressionists and "The Ten"

The Ten American Painters held their first exhibition at Durand-Ruel
Galleries in New York in March of 1898. The group of ten artists had
withdrawn from the Society of American Artists at the end of the previous
year in protest against the traditionalism that had set into this once
revolutionary group and the size of the Society's exhibitions. Though the
press referred to the group as "The Holy Seceders," the painters themselves
did not espouse any radical aesthetic doctrines. Their aims, in fact, were
very simple and straightforward; they were a group of artists, all of them
mature and established by 1898, who felt that their paintings would better be
seen in smaller, more select company and that the work of the different
members of the group would harmonize well with the others'. Each painter
was at first allotted an equal amount of wall space and was permitted to hang
there as many works as they felt could be exhibited comfortably. The press,
in fact, pointed out that some of the artists withdrew paintings which they
felt were disharmonious with others shown by their fellows.[1]

The group did not assume the name of "The Ten American Painters"; that
appellation was assigned by the press when the exhibition was advertised
as a "show of ten American Painters"; it was then shortened to "The Ten."
In truth, there were eleven painters who "seceded" from the Society: Frank
Benson, Joseph De Camp, Thomas Dewing, Childe Hassam, Willard
Metcalf, Robert Reid, Edward Simmons, Edmund Tarbell, Abbott Thayer,
John Twachtman and J. Alden Weir, but Thayer later changed his mind,
deciding that his production was too inconsistent to ensure his annual
participation, and also that the Society was too much in need of him.
Originally the group thought of themselves as twelve in number, inviting
Winslow Homer to join them, but Homer was sympathetic but disinterested.

The group may have been bound by consonant artistic ends, but they
were not all Impressionists. Edward Simmons, in fact, was primarily
a muralist, though some of his rare easel painting displays a muted degree of
Impressionist technique, and Thomas Dewing was rather an extremely
sensitive Tonalist figure painter. Yet, the group maintained a cohesiveness,
continuing to show together in New York at Durand-Ruel Galleries annually
until 1905, when they moved to the Montross Galleries. The Ten also
exhibited as a group in Boston, Chicago, Cincinnati, Philadelphia, St. Louis
and Toledo. Not all the painters exhibited faithfully each year, but the group
continued to show together for twenty years. On Twachtman's death in 1902,
William Merritt Chase was elected to take his place, so that there were
actually eleven members of "The Ten." The final exhibition of The Ten
took place in the winter of 1918-19, not a regular show, but something of a
retrospective event held at the Corcoran Gallery in Washington. By then, of
course, the Impressionist aesthetic which dominated the group shows had
itself become established and even old-fashioned, and it is perhaps fitting
that the demise of The Ten coincided with the establishment of The
New Society of American Painters, Sculptors and Gravers in May of 1919,
which represented a new spirit of discontent with the National Academy.

Years later, Childe Hassam claimed to have been instrumental in
the founding of The Ten though Weir and Twachtman were the prime
movers of the organization and its exhibitions in the early years.[2] Theodore
Robinson almost certainly would have been among them, had he lived.
The artists were all either of New York or Boston; the latter group will be
discussed in a later portion of this essay. Abbott Thayer, who did not stay
with the group, may seem a surprising inclusion, as he is known today

The notes for this chapter will be
found on page 82.

*Poppies.* **1888**
Oil on canvas
13 x 18 in. (33 x 46 cm)
Indianapolis Museum of Art,
James E. Roberts Fund

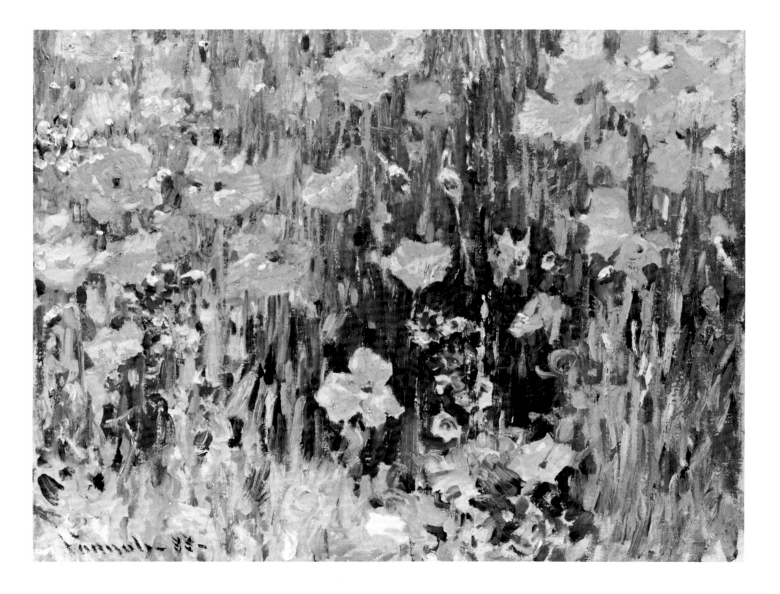

primarily for his beautiful images of idealized Womanhood, representing a kind of Aestheticism with moral purpose. Thayer was a warm and sympathetic colleague and a good friend of many artists of the period, including a number of The Ten. While his finest figure pictures display a rich, colorful and painterly technique, perhaps more pictorially harmonious with the Impressionist tendencies of the work of The Ten would have been his rarer diversions into landscape painting, his "holiday work." Among the most exciting of these are his views of Mount Monadnock painted from his home in Dublin, New Hampshire: broadly handled "impressions" of the great mountain seen at different times of day and seasons of the year, displaying a great freedom of brushwork and rich dark colorism.[3]

Among those active in The Ten, Willard Metcalf was the other leading landscape specialist (along with Hassam, Weir and Twachtman), and is an artist whose works have recently been studied and appreciated anew.[4] He came from Boston and studied with the interesting mid-century landscape painter George Loring Brown before going on to Paris and the Académie Julian, and remaining in France until 1889. He started his artistic career as a figure painter and illustrator, some of his best-known early works being illustrations for Frank H. Cushing's series of articles on the Zuni Indians which appeared in *Century* magazine in 1882-83, done before he went abroad. Metcalf was one of the first Americans to go to Giverny, staying there in 1887, but the first of his work done there and others of the same period are still very much in the Barbizon tradition. He also visited Tunis that year, and painted some especially fine canvases.

Metcalf himself attributed the change of his aesthetic direction to a period spent communing with nature and painting on the Damariscotta River in Maine in 1903. His paintings subsequent to that, mark his conversion to an uncomplicated and joyous interpretation of the New England landscape in an Impressionist manner. His works are not unlike Hassam's, though there is a greater insistence upon sure, pronounced draftsmanship and a careful delineation of space, often through emphasis upon a series of strong and clear diagonals pointing back into the distance. Royal Cortissoz wrote that draftsmanship was foremost in his art.[5] It is perhaps the combination of Impressionist brushwork and color with firm draftsmanship and careful spatial construction in a traditional manner that affords much of the later Impressionism of Metcalf and others the label of "academic Impressionism," but the work is appealing nevertheless.

Metcalf was especially concerned with seasonal aspects of nature, from rich fall foliage to warm spring light and color, but he was perhaps at his best and most distinctive in his winter scenes; Cortissoz felt that he caught the beauty of snow second only to Twachtman.[6] He was also one of the most frequent practitioners of the square format, though he employed it in a relatively traditional manner; he seldom combined it with the disappearing horizon and an interest in the flat picture plane. He painted throughout New England, but he was particularly regarded as a member of the Old Lyme art colony; critics stressed his Americanness, and Bernard Teevan called Metcalf the "finest American painter of New England Countryside."[7]

There were, of course, a great many American Impressionists who were not members of The Ten, the number increasing as time went on. It is neither possible nor relevant for an exhibition or essay of this scope to deal with all of them. A number of those omitted here, such as Theodore Butler, earlier mentioned, or William Horton, Walter Griffin and Edmund Greacen are artists of some originality, but several others have been chosen for inclusion because of their special contributions to the art of their time and for the quality of that contribution.

One such painter of considerable ability was Robert W. Vonnoh.[8] He was born in Hartford but grew up in Boston where, like many young New England artists, he began his career working in a lithographic shop. He went abroad in 1881 and returned to Boston to teach at the Cowles school and then at the Boston Museum school for two years before returning to France in 1887. It was at this time that Vonnoh began to work in a distinctly Impressionist mode, but one which critics viewed as relatively realistic, less aesthetic and Whistlerian than that of Twachtman.

As with so many American artists of the time, however, Vonnoh's painting consists of two quite distinct manners, separated not chronologically but thematically. He was an exceptionally gifted portrait painter, and in his figure paintings he displayed the strengths of the academic training he had received: dark and dramatic forms, solidly constructed. In his outdoor paintings, however, such as *November* of 1890, he displays the broken brushwork and varied hues of the new aesthetic, though here in a more muted palette. Critics emphasized the quality of "vibration" in his outdoor paintings. Like Hassam at much the same time, he was drawn to fields of flowers, particularly the poppy flowers favored by Monet and Hassam, which Vonnoh painted in the fields of Flanders. A prime example is his extremely large *Flanders, Poppy Field,* but his smaller studies of poppies also immerse the spectator directly into the fields, plunging the viewer into a maze of brilliant scarlets and chrome yellows; they are spatially disorienting as is the contemporaneous art of Maria Dewing, but without her naturalistic concerns. A teacher at the Pennsylvania Academy, Vonnoh was an extremely important influence on the younger generation of American artists, numbering among his students Edward Redfield, Elmer Schofield, Robert Henri, John Sloan, William Glackens and Maxfield Parrish.

Allen Tucker is another significant figure, not only as an artist but as a writer on art.[9] Among his books is one on Twachtman, with whom he studied at the Art Students' League. Not surprisingly, in his early landscape painting he was attracted to intimate portrayals of nature rendered in an Impressionist mode. His *Corn Shucks and Wind Mill* of 1909 displays a full commitment to Impressionism in its dissolution of form into light and color, applied to an American subject—a kind of native equivalent of Monet's haystacks—and a subject which Tucker painted a number of times. Gradually, however, during the early years of the 20th century, Tucker abandoned the tenets of Impressionism for a less naturalistic, more conceptual concern with larger design and expressive form. He became one of the most consciously imitative followers of Vincent Van Gogh, trading in an Impressionist style for a Post-Impressionist one.

Edward Henry Potthast is another painter in whose work interest has been rekindled in recent years.[10] He was born in Cincinnati, and like Twachtman and a great many other Midwestern painters, went to Europe to study in Munich in 1882, working under Ludwig Loefftz, after having begun at the McMicken School in his native city in 1870. He returned to this country in 1885 but was abroad again in 1888, this time in France, working at Barbizon and nearby Grez, and coming to know some of the American Impressionists such as Robert Vonnoh. He returned once more to Cincinnati, and was

**Willard Leroy Metcalf**

*The Cornish Hills.* 1911

Oil on canvas
35 x 40 in. (88.9 x 101.6 cm)

Collection of Mr. and Mrs.
Thomas W. Barwick

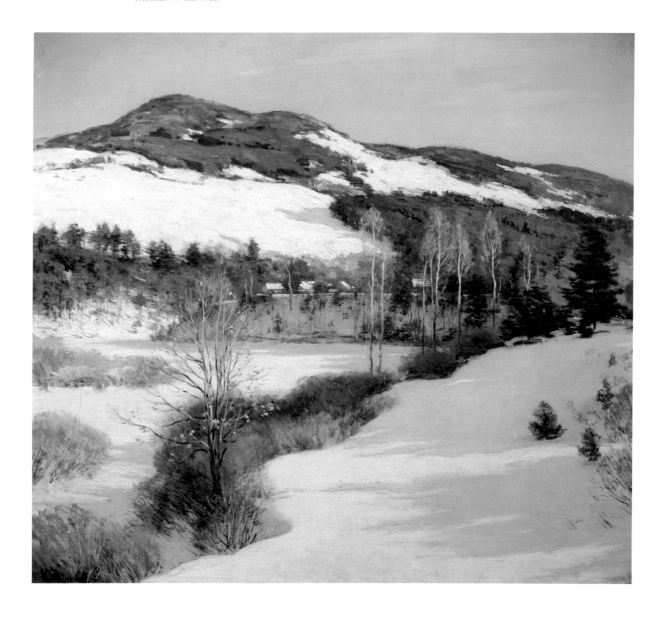

## Willard Leroy Metcalf

*The River.* 1919
Oil on canvas
26 x 29 in. (66 x 75.6 cm)
The Daniel J. Terra Collection

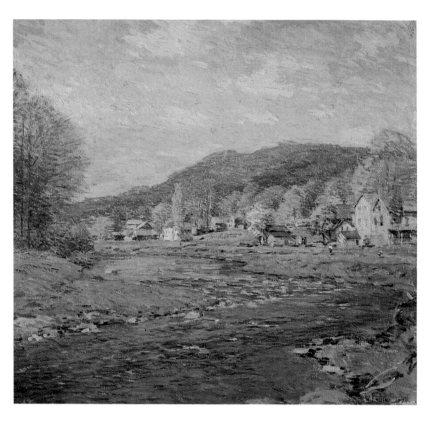

a friend of many of the more advanced, European-trained artists from that city: Robert Blum, Frank Duveneck, Joseph De Camp and Twachtman. In 1896 he moved to New York City where he remained for the rest of his career.

Potthast's early work is in the dark tonalities of Munich painting, but his most admired pictures today are later works different in style and subject. Though he painted pure landscapes and, late in life, in 1910, went out West and painted the Grand Canyon with Thomas Moran, Elliott Daingerfield, Frederick Ballard Williams and De Witt Parshall, he is best known for his beach scenes done outside of New York, populated with carefree bathers and active, happy children. Faces and forms are generalized into colorful patterns, often emphasizing circular compositions which utilize the activity of the figures, beach umbrellas and colorful round bathing caps, set against the splashing surf and the deep blue sea. The subject matter of Potthast's work recalls the beach scenes of William Glackens, but his generalized forms and thickly impastoed surfaces are closer to the work of Maurice Prendergast, as are also the free-flowing wet washes of his watercolors. But there may be another source for Potthast's pictures. They are, in some ways, a native equivalent of the extremely popular and much published work of Joaquin Sorolla, the Spanish painter whose "Sorollismo" was an artistic manner akin to Impressionism. Sorolla was the subject of the great exhibition at the Hispanic Society in New York City in 1909 where 356 works were shown, an exhibit which was much touted at the time and which had a great deal of impact. Potthast's adoption of a bright and colorful aesthetic and his turn to beach scenes often featuring children are usually dated earlier, with the suggestion that he began to paint in this manner in the first years of the new century, but his chronology is rather spotty and his works are usually undated. In any case, Sorolla's art was well-known and much written about even before his great exhibition and might well have influenced Potthast, the 1909 show only confirming his distinctive qualities and underscoring the validity of his influence.

Emil Carlsen is another painter whose representation in an exhibition of American Impressionism may seem surprising.[11] Danish-born, he came to this country in 1872 and taught in Chicago; in 1884 he returned to Europe, painting in Paris on commission from the New York dealer, Blakeslee, and studying the work of Chardin. He returned to New York City after two years, and established himself as one of this country's foremost still-life specialists and the artist to come closest to capturing the mood and spirit of Chardin. He had a studio in New York City but taught regularly at the Pennsylvania Academy. By the turn of the century, however, Carlsen was increasingly involved in landscape painting, though he never abandoned his interest in still life which had won him such acclaim. His landscapes were often written about as "lyrical" and "decorative," the forms of nature arranged and interpreted in a tapestry-like manner. The colors in his landscapes are light and bright, laid on uniformly and often quite thinly, rather than in the usual thick impasto of Impressionism. Forms diminish in size naturalistically, but color and light intensity remain even, so that one is aware of the two dimensional surface of the painting. As in the work of Twachtman earlier, Carlsen often utilizes a high horizon and some of his landscapes — often quite large canvases — are square or nearly-square. In his landscapes Carlsen eschews the dramatic, and though concerned with light and color, his scenes are static and serene, forms carrying limited color seen through an

*The White Veil.* 1909

Oil on canvas
36 x 36 in. (91.5 x 91.5 cm)
The Detroit Institute of Arts, Gift of
Charles Willis Ward, 1915

atmospheric veil. His technical aesthetic and his gentle attitude toward nature was most like the art of J. Alden Weir, whose close friend he was. Late in his career, Carlsen became deeply involved with a kind of personal mysticism and imbued his landscapes with spiritual overtones.

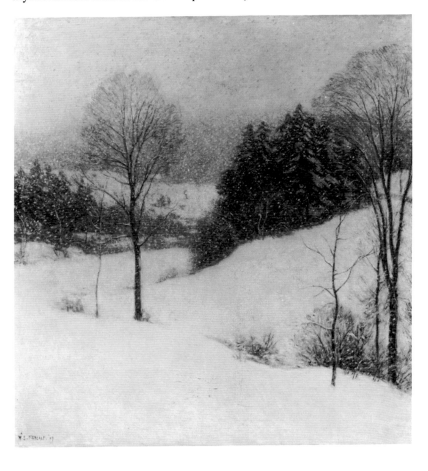

1. Studies by Pierce and Haley deal specifically with The Ten American Painters, but they are better treated in the general monographs by Boyle and Hoopes on American Impressionism. See also the reminiscences of one of them, Edward Simmons, *From Seven to Seventy: Memories of a Painter and a Yankee*, New York and London, Harper, 1922, 221-22. In addition, see Arthur Hoeber, "The Ten Americans," *International Studio*, Vol. 35, no. 137 (July, 1908), xxiv-xxix.

2. Hassam, "Twenty-Five Years of American Painting," 22.

3. Nelson C. White, *Abbott H. Thayer, Painter and Naturalist*, Hartford, Connecticut, privately published, 1951, is a perceptive and sympathetic study of Thayer; for Thayer's landscapes, see 215-18.

4. See the catalogue, Elizabeth De Veer, *Willard Leroy Metcalf: A Retrospective*, Museum of Fine Arts, Springfield, Massachusetts, 1976. Among previous studies there are articles on Metcalf by Christian Brinton, Royal Cortissoz, Catherine Beach Ely and Bernard Teevan, all listed in the bibliography.

5. Royal Cortissoz, "Willard L. Metcalf, An American Landscape Painter," *Appleton's Booklovers Magazine*, Vol. 6, no. 4 (October, 1905), 509.

6. In Cortissoz, "Willard L. Metcalf," American Academy of Arts and Letters, *Academy Publications*, No. 60 (1927), 1-8.

7. Bernard Teevan, "A Painter's Renaissance," *International Studio*, Vol. 82, no. 341 (October, 1925), 10.

8. Among the articles on Robert Vonnoh, the bibliography includes those by Eliot Clark and Harold Eberlein, plus two unsigned pieces that appeared in *International Studio*: "Vonnoh's Half Century," Vol. 77, no. 313 (June, 1923), 231-33, and "The Vonnohs," Vol. 54, no. 214 (December, 1914), xlviii-lii, the latter concerned with the art of both Robert Vonnoh and his wife, the sculptor, Bessie Potter Vonnoh.

9. See the article by Virgil Barker, "The Painting of Allen Tucker," *The Arts*, Vol. 13, no. 2 (February, 1928), 75-88, and the several studies of Tucker by his champion Forbes Watson which are cited in the bibliography. These writings, however, consider mainly his later, more expressionist painting.

10. The most significant study of Potthast is Arlene Jacobowitz, "Edward Henry Potthast," *The Brooklyn Museum Annual*, Vol. 9 (1967/68), 113-28.

11. Among those who have written on Carlsen are Arthur Edwin Bye, Eliot Clark, Duncan Phillips, Frederic Newlin Price and John Steele. Their articles were incorporated into the catalogue for a show devoted to Carlsen's painting, Wortsman Rowe Galleries, *The Art of Emil Carlsen, 1853-1932*, San Francisco, 1975.

**Allen Tucker**

*Corn Shucks and Wind Mill.* 1909
Oil on canvas
30 x 36 in. (76.2 x 91.5 cm)
The Newark Museum

## Robert Reid

*The Violet Kimono.* ca. 1910

Oil on canvas
29 x 26¾ in. (73.7 x 66.1 cm)
National Collection of Fine Arts,
Smithsonian Institution, Gift of John Gellatly

*Good Morning.* n.d.
Oil on canvas
32 x 26 in. (81.3 x 66 cm)
The Butler Institute of American Art,
Youngstown, Ohio

# 13 Impressionists of the Decorative Figure

Although Impressionist painters here and abroad explored many themes, the two subjects most often painted, and not surprisingly, were landscapes and the figure; still lifes, portraits and other themes appear only occasionally. It may be that there is a somewhat greater proportion of figure painting to landscape in American Impressionism as against French; there is certainly a great variation in the approach to the figure by the different American interpreters. In a sense, the demands and concerns of figure painting would seem inimicable to Impressionism, the former involving firm construction, anatomical consideration and a precise placement of the figure in an environment, and the latter implying dissolution of form and an emphasis upon changing conditions of perception. It is exactly the complications of effecting a balance —or perhaps a compromise— between these two opposing conceptions that demanded the attention of the Impressionist figure painter, particularly as most of them were academically trained in the ateliers of Paris and Munich. Some of the American Impressionists differentiated strongly between the aesthetic approaches they took to the figure and to the landscape; others attempted to achieve a balance that would satisfy both ends. The artists of the Boston School, to which we shall turn in the next chapter, never relinquished the sense of solid structure in their figure painting, but there were a number of other artists who allowed for a greater degree of dissolution of the figure in terms of light and color patterns, decoratively emphasizing more abstract concepts of design and harmonizing the figure with her environment. Such an approach did not differentiate the treatment of the human form from that of the surroundings as did Theodore Robinson, J. Alden Weir or Mary Cassatt. Beauty and decoration were the conscious artistic purposes of these artists and their figural subjects were, with few exceptions, lovely young ladies.

Among the artists of "The Ten," Robert Reid became a prominent specialist in depicting the decorative figure.[1] Like so many of his contemporaries, Reid studied at the Académie Julian in Paris, beginning in 1885, and won his first successes with several Normandy peasant scenes, *Death of the First Born* of 1888 and *Blessing the Boats* the following year. However, even by the time of his return to New York City in 1890, in such works as his small but brilliantly colored *Reverie* of that year, he had turned to the theme of the contemplative woman, broadly painted and brightly colored, turning his back on the more dramatic subject matter of his student years abroad.

Reid's artistic course was interrupted in a fortunate manner by his participation in the mural decoration at the Columbian Exposition in 1893, after which, for about a decade and a half, he was primarily occupied with large-scale mural decoration, and his easel work was, therefore, comparatively rare. Such canvases as he did paint, and those that followed his subsequent resumption of easel painting, consisted of close-up views of elegant women, sometimes in contemporary dress, often in robes which, though not exactly "period," lent the figure a timeless aura. Sometimes the garments were designated as kimonos in the titles, and with the additional inclusion of screens and fans, the depictions take on an air of the exotic and an Oriental conception of the decorative.

Reid's figures blend into their environment, a blending enhanced by repeated decorative motifs in curving arabesques, suggesting a kinship with contemporaneous Art Nouveau patterns. His colors tend toward the pale and the perfumed, usually with one dominant tone throughout, often identified

The notes for this chapter will be found on page 88.

**Richard Emil Miller**

*Reverie.* n.d.

Oil on canvas
45 x 58 in. (114.3 x 147.3 cm)
The St. Louis Art Museum

in the titles, such as *The Violet Kimono* or *The White Parasol*. Other titles such as *Azaleas* or *Fleur-de-Lys* identify his lovely women by floral attributes which blend with the figures in form, color and beauty — works which might by the titles alone be identified as still lifes. But Reid's canvases are never still; there is almost always a suggestion of sinuous movement, and what Sadakichi Hartmann identified as "barbaric pageantry."[2] Arthur Hoeber wrote of Reid's appreciation of the beauty of femininity, so it is therefore not surprising that his oeuvre includes paintings of the female nude, though these tend to be more naturalistic in the rendering of form and of outdoor light than his usual treatment of the clothed figure as a decorative element. Reid was a painter of young womanhood, flowers and sunlight, devoid of spiritual or philosophical intentions; his women are the antithesis of the austere Aestheticism of the subjects of his fellow member among The Ten, Thomas Dewing. Considering his dominant interest in color, it is not surprising that he designed the entire scheme of stained glass in the twenty windows of the Rogers Memorial Church at Fairhaven, Massachusetts. In addition to his work at Chicago, his major murals were painted for the New York Appellate Courthouse, the Library of Congress, the United States Pavilion at the Paris Exposition of 1900, and, the most noted of all, those in the Boston State House.

Christian Brinton referred to Reid as a "Decorative Impressionist" in the title of an article published in 1911. This term even more effectively describes several younger artists who were primarily expatriates, working much of their careers in France, and whose paintings exhibit some Post-Impressionist influences, akin to the art of Pierre Bonnard and Edouard Vuillard.

Of the two major figures involved here, the better-known today is Frederick Frieseke, a painter much written about in his own time, including a number of articles that appeared in French and, more surprisingly, Italian periodicals.[3] In fact, in 1932 Frieseke was called America's best known painter internationally — an example of the vagaries of artistic reputation. Frieseke was born in Michigan and studied in Chicago before going to Paris in 1898 to study at the Académie Julian, and he also profited from the advice of Whistler. In 1906 he took the house at Giverny formerly occupied by Theodore Robinson, and became one of the best known of the American expatriates. He summered in Giverny through about 1919, when he moved to Normandy, where he lived until his death.

Frieseke's subjects are invariably women, sometimes in interiors, more often outdoors. Though working in Giverny, his figures, their environment and his coloration owe a debt to Bonnard, yet his figural types are perhaps closest to Renoir, whose work he admired tremendously. Frieseke's compositions exhibit a strong sense of design, related to the Post-Impressionist reaction against the freedom of Impressionism. His interior scenes, which were often painted when the weather was inclement, suggest a strong sense of the domestic in their settings of breakfast rooms and boudoirs, and sometimes Frieseke introduces the theme of maternity into his paintings, though without either the sense of character or the figurative structure of Mary Cassatt. Frieseke loved to study the effects of sunlight, either in interiors with light pouring through windows, or on figures silhouetted in doorways against the outdoors. He stated his love of sunshine — flowers in sunshine, girls in sunshine, the nude in sunshine.[4] Many of his buxom women are placed in garden settings, where dappled

light falls equally upon luscious nature and her inhabitants. The women are often portrayed in colorful decorative costumes, so that patterns are set against patterns, textiles against foliage, and in some of his garden pictures, he included a multi-colored umbrella to add a further decorative note.

Frieseke's world was a very feminine one. His paintings are never profound, but they are, at their finest, extremely captivating in their description of the relaxed woman. He exhibits a fondness for certain colors, often pinks, violets and whites. Some of Frieseke's finest pictures are depictions of the nude in outdoor settings, the dappled colored lights playing on the soft bodies of the figures, posed in relaxed and inviting postures. Painted in France, they are free of the continued puritanical restrictions of his native land. As a decorator, Frieseke was called upon to do decorative series of paintings in America: for Wanamaker's store in New York City and for hotels such as the Shelbourne in Atlantic City, the latter a highly decorative scheme of women and children in casual clothes or bathing costumes juxtaposed to striped umbrellas on the beach.[5]

With his European residency, Frieseke's work was seen and admired early in both France and Italy. He showed in Paris, where one of his Salon exhibits was purchased by the state in 1904. There was a small one-man show at the Biennale in Venice in 1909, and he showed in Rome in 1911. Back home he won the grand prize at the Panama-Pacific Exposition in San Francisco in 1915. Even by the mid-1920s, however, Frieseke's paintings had begun to be viewed as old-fashioned, and in the following decade both his output and his sales had declined tremendously. His dealer, William Macbeth, urged him to return to America, which the artist did briefly, in 1937, but before the end of the year he went back to France, where he died two years later.

Frieseke had followers in his mode of colorful figure painting, the best known being Karl Anderson, also from the Midwest; he studied at the Académie Julian in 1902 and then with George Hitchcock in Holland before working with Frieseke in Giverny in 1910-11, after which he returned to New York City. Almost as well-known as Frieseke and likewise an expatriate in Giverny was Richard E. Miller from St. Louis.[6] Miller studied first in his native town and then went to the Académie Julian in Paris in 1898. The French government purchased several works by him from early showings at the Salon. These were dark, strong, multi-figured paintings, and with his success in Paris, the artist decided to remain in France. He taught at the Colarossi Academy in Paris, and held summer classes in Giverny, employing a distinctive method identified as "Millerism." His work and his career were early identified with those of Frieseke and the now-forgotten Robert Lee MacCameron. Miller, too, had a small one-man exhibit at the Venice Biennale in 1909, and his painting was subsequently published in Italian periodicals.

Miller's subject matter is quite similar to Frieseke's, though his inevitable female figures are more strongly modeled and more carefully drawn. Where line is almost obliterated in Frieseke's work, it remains more evident in Miller's. Miller was more interested than Frieseke in painting women in indoor settings, enjoying the depiction of luxurious environments and a sense of opulence in figures at their dressing tables, or surrounded with jewelry. If Frieseke preferred curvilinear compositions, Miller utilized more geometric ones, with figures and furniture set at oblique angles, the diagonals of which carry the eye sharply through the scene. An effective device often found in Miller's work are slatted Venetian blinds, the repeated

*Autumn*. 1914
Oil on canvas
37¾ x 51 in. (96 x 130 cm)
Museo D'Arte Moderna, Venice, Italy

parallels of which reinforce the geometric structure of his compositions and, at the same time, introduce a controlled, graded light into the sparkling interiors. Some of these interior scenes bear a resemblance to Hassam's contemporaneous "Window" series.

Miller also preferred a wider and darker range of tones than Frieseke. He preferred especially a juxtaposition of greens and purples, and glistening, reflective surfaces, which some critics referred to as a "candy-like style."[7] Like Frieseke, his was a feminine world, filled with women and their accoutrements. Like his compatriot also, he not infrequently depicted the nude, though they are stronger, more classically defined than Frieseke's. Occasionally, Miller painted figures in broad, expansive landscape settings, and he also painted a number of pure landscapes which are tapestry-like, with no atmospheric diminution. Miller visited America in 1906, and after World War I, in 1918, he returned to this country for good. He settled in Provincetown where he taught, and was invited to paint murals in the State Capitol building in Jefferson City, Missouri.

1. Reid's work was discussed by many writers, among them Christian Brinton, Royal Cortissoz, Henry W. Goodrich, Charles Henry Hart, Arthur Hoeber, James William Pattison, Irene Sargent, Evelyn Marie Stuart, and Helene Barbara Weinberg; there is also the short, chatty and personal monograph by Stanley Stoner. All of these are cited in the bibliography. Some of them deal primarily with Reid's activities as a mural painter, a designer of stained glass, and a portraitist. Perhaps the title of Brinton's article best sums up the contemporary aesthetic consensus: "Robert Reid, Decorative Impressionist."

2. Hartmann, *A History*, Vol. 2, 248.

3. Those who have written on Frieseke include Albert E. Gallatin, Tristan Leclere, Clara MacChesney, Pier Occhini, Vittorio Pica, E. A. Taylor, William Walton, and Allen S. Weller. The most significant essay is by Moussa Domit in the exhibition catalogue *Frederick Frieseke, 1874-1939*, Telfair Academy of Arts and Sciences, Savannah, Georgia, 1974. Christian Brinton also discussed Frieseke's art at some length in his *Impressions of the Art at the Panama-Pacific Exposition*.

4. Allen S. Weller, "Frederick Carl Frieseke: The Opinions of an American Impressionist," *Art Journal*, Vol. 28, no. 2 (Winter, 1968), 162, quoting an interview with Frieseke by Clara MacChesney which appeared in the *New York Times*, June 7, 1914, section 6, page 1. The interview may have previously served Ms. MacChesney for her article, "Frederick Carl Frieseke: His Work and Suggestions for Painting from Nature," *Arts and Decoration*, Vol. 3, no. 1 (November, 1912), 13-15.

5. See Tristan Leclere, "La Decoration d'un hôtel américain," *L'Art décoratif*, Vol. 8, part 2 (1906), 195-200.

6. See the monograph by Robert Ball and Max Gottschalk, *Richard E. Miller, N.A.: An Impression and Appreciation*, St. Louis, The Longmire Fund, 1968. Others who have written on Miller include Vittorio Pica, "Artisti Contemporanei: Richard Emile Miller," *Emporium*, Vol. 39, no. 231 (March, 1914), 162-77, and Wallace Thompson, "Richard Miller — A Parisian-American Artist," *Fine Arts Journal*, Vol. 27, no. 5 (November, 1912), 709-14.

7. Thompson, "Richard Miller," 711.

*Reverie.* n.d.

Oil on canvas
36 x 34 in. (91.4 x 86.4 cm)

Museum of Art, Rhode Island School of
Design, Providence, Rhode Island, Gift of
Mrs. William C. Baker

## Charles Courtney Curran

*Lotus Lilies.* 1888
Oil on canvas
18 x 32 in. (49.7 x 81.2 cm)
The Daniel J. Terra Collection

**Edmund Charles Tarbell**

*The Venetian Blind.* n.d.
Oil on canvas
51⅞ x 38⅜ in. (130 x 96.3 cm)
Worcester Art Museum

# 14 Boston and Pennsylvania Impressionists

A number of early 20th-century writers and critics described and analyzed regional distinctions among groups of Impressionist and Impressionist-related American artists. We have already spoken of several art colonies with at least some affinity to the Impressionist mode, artists working in such centers as Cos Cob and Old Lyme, Connecticut. A good many of the leading Impressionists, of course, were based in New York City, some living there and certain ones, such as Childe Hassam, often painting the New York urban scene; others at least kept a studio in New York, exhibited there and taught in art schools in the city.

Boston was another center for Impressionist painting, and it has been pointed out that the organization of The Ten American Painters was made up of artists from New York and Boston. The Boston painters, in fact, represented a more cohesive group than their New York counterparts, both stylistically and in terms of predominant subject matter, but by the early 20th century, the Bostonians' work was compared to and contrasted with not that of their contemporaries in New York City, but to the painters of the Pennsylvania School.

The comparison is an interesting one today, and actually gains in interest from the historical perspective which can be brought to bear upon the two groups now. The critic most involved in presenting this analysis and point of view was the influential writer and very able artist (though not an Impressionist one) Guy Pene Du Bois; the seminal articles on the two groups appeared in *Arts and Decoration* in July and October, 1915, on the Pennsylvania and the Boston artists respectively.[1] The second of these made clear Du Bois' concern with the validity of their contrast. Other writers such as Sadakichi Hartmann had already noted certain regional characteristics, as had the historian of Boston art of the period, William Howe Downes.[2]

The basic differences are clear enough. The Boston painters were figure artists, the Pennsylvania ones were landscapists, in fact, their very designation indicates this. The contrast is not made between Massachusetts and Pennsylvania, nor between Boston and Philadelphia, but between the urban center, Boston, and the region, Pennsylvania. The Boston painters were viewed as essentially aristocratic in their outlook, the Pennsylvania artists as democratic. The latter were viewed as virile painters, not concerned with aesthetic matters, while the Bostonians were concerned with beauty but were, perhaps, a trifle timid. Both groups were admired, but the Pennsylvania painters more, and they were also seen as "more American." Yet, perhaps because they were a more cohesive group, the Boston school were written about more, as a school and individually, in their own time, and have continued to draw more attention. Their work is better known, and more admired, today.[3]

The notes for this chapter will be found on page 101.

*The Sisters.* 1899
Oil on canvas
40 x 39½ in. (102 x 99 cm)
Collection of IBM Corporation,
Armonk, New York

Any discussion of the Boston School must begin with Edmund Charles Tarbell, for at the time he was acknowledged as the leader.[4] In fact, the others were grouped around him and frequently referred to as "Tarbellites," which is not an unfair appellation, though it naturally applied more completely to some artists than to others. Born in West Groton, Massachusetts, Tarbell began his artistic career working for the Forbes lithography firm in Boston and then began to attend the Boston Museum school under the influential teacher Otto Grundmann, who was trained in Belgium. Like almost all of the other painters discussed in this essay, he went to Paris and studied at the Académie Julian, along with his good friend, contemporary, and fellow Boston Museum student, Frank Benson. He also traveled in Germany and spent a winter in Venice, returning to Boston in 1885.

Tarbell's rise to prominence began soon after he settled back in Boston. He began to teach at the Boston Museum schools in 1889, continuing in a leading role there until 1912, and greatly influencing a whole generation of young Boston artists, including Lillian Westcott Hale and George Hallowell. He was one of the Boston members of The Ten American Painters, and his work was the subject of a one-man show at the prominent and progressive St. Botolph Club in Boston in 1898.

Paintings such as *Three Sisters — A Study in June Sunlight* of 1890, *In the Orchard* of the following year and *Mother and Child in a Boat* of 1892 are characteristic of Tarbell's early maturity in their depiction of figures in easy social and familiar relationship, solidly drawn, and yet subject to scintillating light broken into a wide spectrum of colors. Tarbell was always comfortable in the manipulation of groups of figures, drawn from the upper classes, often young society women dressed in the latest casual fashion. Sadakichi Hartmann perceptively identified the figures and their environment as akin to the writing of William Dean Howells.[5] The light is often reflected light, and Tarbell's treatment of it and the natural outdoor settings of such pictures descends directly from Sargent through Sargent's influence on Dennis Bunker, the most significant artist and teacher in Boston in the previous decade.

Tarbell's painting during the 1890s was among the most advanced in color and aesthetic of light of any American artist. However, in the early years of the 20th century, beginning about 1903, his work became more conservative, a direction noted by critics, though not with any displeasure. The emphasis upon color vibration, so striking in his earlier pictures, lessened, except for his increasingly fewer outdoor scenes. He focused instead on indoor figural arrangements, sometimes a single young woman reading or crocheting, or groups of young women casually placed. The interiors are inevitably sparsely furnished, but the appointments are elegant and costly — antique furniture and Oriental pottery. On the walls are old master paintings (or copies of them) much admired in Tarbell's time, and of course by the artist himself, works in great Boston collections such as Mrs. Jack Gardner's, pictures by artists such as Velasquez and Titian.

Tarbell primarily painted women at leisure, reflecting the hermetic existence of society women. They enjoy the beauty of material things, they become part of that environment, and, as Hartmann wrote, they show good taste. Serene and complacent, they are sometimes caught in negligees behind Venetian blinds, reflected in waxed floors. As Du Bois pointed out, they may sew but they do not sew shirts!

*Seamstress.* 1916
Oil on canvas
36¼ x 28 in. (91.5 x 71.1 cm)
Corcoran Gallery of Art

In these pictures Tarbell has reverted to a more tonal treatment, less coloristic emphasis, and a greater concern with a filtered atmosphere, in works that might suggest the influence of Whistler in their compositions as well. But the true source for this change, at once radical and yet conservative, is the rediscovery of and interest in the work of Jan Vermeer. This was recognized by Tarbell's champions and much approved. Tarbell was felt to have been inspired by Vermeer, but not to be imitating him or his art. Tarbell's environment was a modern one; he did not paint costume pieces. His color, too, was contemporary, laid on with a full brush rather than utilizing old master glazes, but he was, in the manner of Vermeer, attempting to catch the nuances of light and atmosphere in a total visual effect of the illumination of his interior spaces. Isolated American precedents for Tarbell's aesthetic can be found in such works as J. Alden Weir's *Idle Hours* of 1888, but the inspiration of Vermeer was direct and overwhelming.

Many of Tarbell's best-known interior scenes were painted circa 1903-08. He also painted a number of delicate and sensitive nudes, the most commented upon being *The Venetian Blind* of 1907, again, a discreet young woman illuminated by nuanced light passing through drawn blinds. His nudes are portrayed shyly, perhaps even puritanically, turning their back to the spectator, and are carefully, academically rendered, with muted Impressionist overtones. His occasional still lifes also emit a fragrance of loveliness, beautiful flowers placed in elegant containers. Increasingly, in the early years of this century, he turned to portraiture, and even here his sensitivity to light and concern with the nuances of both form and character enabled him to avoid the stereotypical.

The artist most closely identified with Tarbell, and for many good reasons, is Frank Weston Benson.[6] Born in Salem, he was a fellow student with Tarbell at the Museum school in Boston from 1880-83, traveled with Tarbell to Paris and joined the Académie Julian with him, while spending his summers in Brittany. They both returned in 1885, and both began teaching at the Museum's schools in 1889. Nine years later, both also became members of The Ten American Painters. They were paired together in a number of two or more artist exhibitions during their lifetimes, and their work was the subject of a major exhibition at the Boston Museum in 1938, which turned out to be a memorial exhibition for Tarbell.

Benson's and Tarbell's artistic careers did display a good many similarities, but their identification has been greatly overemphasized. Benson, for instance, was also involved in mural painting, providing for the Library of Congress allegories of the three Graces and the four Seasons, symbolized as attractive and healthy young women. More importantly, in their easel painting, there is surprising diversity and even opposite courses. The paintings of single figures in interiors, and of young women, singly or in groups, posed outdoors, are not dissimilar, but the relative development of the two artists is different. Without over-generalizing, one can say that Benson's earlier works, those done at the end of the 19th century, tend to be his more conservative paintings, more solidly structured figures of women, still tonal and often involving dark and neutral tones. The works for which he is best remembered today are his later pictures, done from about 1900 on. These display very attractive girls and young women, usually members of his family, golden haired and in flowing white dresses, portrayed in brilliant sunlight in verdant, colorful landscapes, often silhouetted against bright

**Edmund Charles Tarbell** (above)

*Three Sisters—A Study in June Sunlight.* 1890
Oil on canvas
35⅛ x 40⅛ in. (89 x 101.8 cm)
Milwaukee Art Center Collection, Gift of Mrs. Montgomery Sears

**William McGregor Paxton**

*Nude.* 1915
Oil on canvas
24 x 33 in. (61 x 84 cm)
Museum of Fine Arts, Boston, Hayden Collection

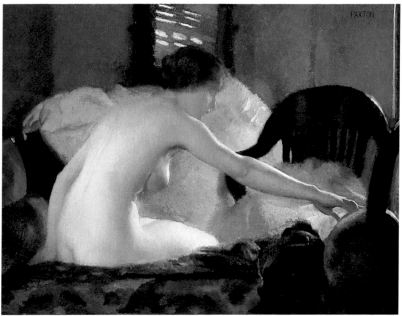

blue skies and fleecy clouds. Like Tarbell's earlier work, Benson's later pictures are concerned with sunshine, not with landscape. His figures tend to suggest greater activity: healthy and athletic young women, portrayed in very much of a holiday world. This is spontaneous but genteel painting, with nothing introduced that is harsh or ugly.

By the middle of the second decade of the present century, Benson's figure painting had turned back to more solid modeling, and his imagery became more monumental and more concerned with elegance and a sense of wealth. He was painting more portraits of upper-class members of society, many of women with their children, following the mode of 18th-century British aristocratic portraiture. His later excursions into still life painting are lavish both in size and in the richness of the properties depicted, and though concerned with lively brushwork and scintillating light, Benson in these displays is too involved with the materiality of objects to dissolve form Impressionistically. But, by this time, an almost new career had opened up to him, his involvement with sporting subjects, especially duck shooting, both in watercolor and particularly in etching and drypoint, where he achieved great renown. This later career began for Benson in 1912, substituting, as it were, for the teaching career which he renounced, along with Tarbell, after over two decades.

Among the "Tarbellites," the members of the Boston School, Joseph Rodefer De Camp had the most different background.[7] He grew up in Cincinnati and, meeting Duveneck there when the latter had returned from Munich, accompanied him to the Bavarian capital in 1875. He became a member of the "Duveneck Boys" and joined them in Florence and Venice in 1878. When he returned to this country in 1883, however, he settled in Boston; perhaps he chose that city because of Duveneck's previous success there five years earlier.

De Camp began winning his laurels in portraiture, establishing something of a rivalry with Sargent in the late 1880s, when the latter began to seek Boston clients on his return to America. The figure was, as with most of his Boston colleagues, De Camp's major interest. More solidly constructed than those of Benson and Tarbell, they display a sense of refinement and richness, though not without a concern with light and its effects. In pose and costume they are sometimes more consciously decorative, somewhat akin to the work of Robert Reid. His pictures of women silhouetted against light-filled windows are similar to Hassam's "Window" series of the 1910s. Like most of his fellow figure painters, he also occasionally essayed the nude. De Camp painted pure landscapes, too, particularly early in his post-European career. In some of these, including his best known, *The Little Hotel* of 1903, the influence of Impressionism is apparent in the soft colors, the liquidity of subject and surface, and the dissolution of form. De Camp, along with Tarbell and Benson, constituted the Boston contingent of The Ten.

The artist of the Boston School who has received the greatest amount of attention and reevaluation of late is William McGregor Paxton.[8] Born in Baltimore, he grew up outside of Boston and studied in the late 1880s at the Cowles School with Dennis Bunker. He went on from Boston to study in Paris with Gérôme, Bunker's own French master. Paxton, however, like many Americans at the time in France, was drawn more to the work of Jules Bastien-Lepage and Pascal Dagnan-Bouveret. When Paxton, in 1893, returned from Paris, his style academically reinforced with his study under Gérôme, he gravitated again to the Cowles School. His teacher, Bunker, was

## William McGregor Paxton

*The Yellow Jacket.* 1907
Oil on canvas
27 x 22⅛ in. (69 x 60 cm)
Collection of Mr. and Mrs. Richard Anawalt

## William McGregor Paxton

*The Front Parlor.* 1913
Oil on canvas
27 x 22⅛ in. (68.6 x 56.2 cm)
The St. Louis Art Museum, Cora E. Ludwig
Bequest by exchange and Edward
Mallinckrodt, Sr., Bequest by exchange

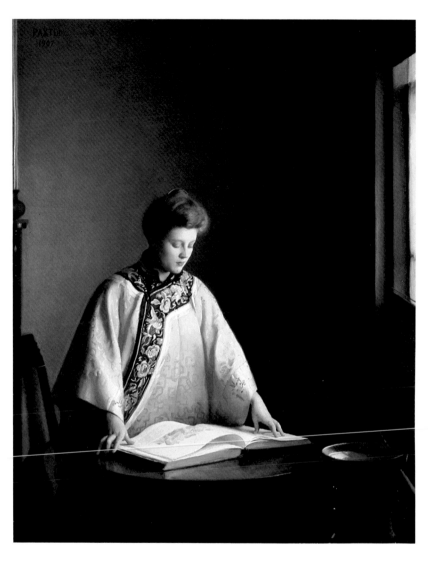

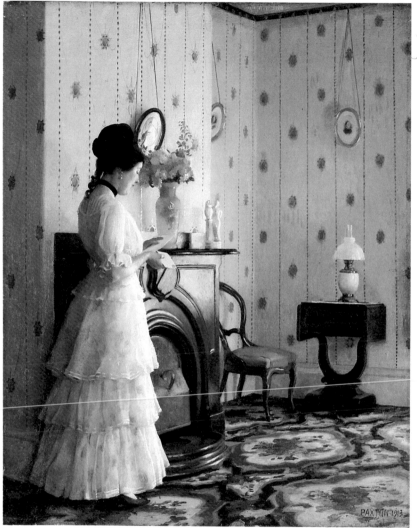

*In the Garden.* n.d.
Oil on canvas
30 x 25 in. (76.2 x 63 cm)
Collection of Messrs. James and
Timothy Keny

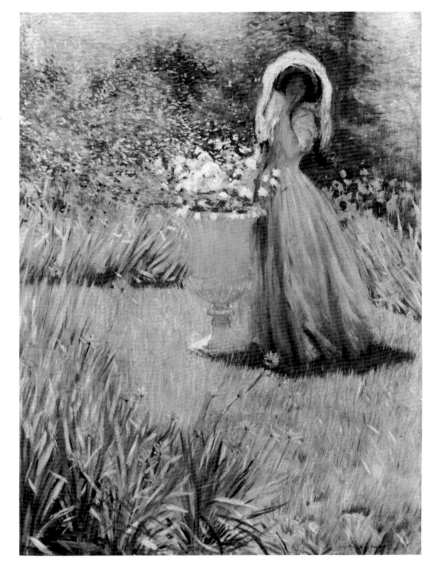

now dead, but instructing there was Joseph De Camp, who was abandoning the Munich manner for the higher key and broader vision of Impressionism. This, together with the example then being set by Tarbell and Benson, and perhaps the knowledge of Bunker's late flowering in his landscape style (under the influence of Sargent and toward an Impressionist outlook) may have influenced the subsequent direction of Paxton's art.

In November of 1904, a fire took place at the Harcourt Building in Boston where Paxton and De Camp had their studios. The loss of both artists' earlier work was enormous, especially for De Camp, but Paxton was then having a show at the St. Botolph Club, so that much of his immediate work was preserved. Perhaps this event, too, prevented him from depending too much upon the more traditional underpinings which had contributed to his own early accomplishments. In any case, by the early years of the 20th century, Paxton had begun to investigate successfully the effects of light and color in outdoor settings, while continuing to paint more traditionally and conservatively when interpreting the figure, and particularly the commissioned portrait indoors.

Although he made occasional excursions into landscape painting, the figure was preeminently Paxton's subject. Though he painted an occasional and usually very beautiful nude — including the present *Nude* of 1915, a beautiful figure bathed in soft and glowing Impressionist light — his primary subject was the woman in the domestic interior. These paintings divide into several groupings; there are close-up views of women intent on allurement, and the more poetic views of women incorporated into their environment. They are usually lovely women of leisure, at their ease, or servant-women attending to the care of attractive domiciles and precious objects. The harder, more polished surfaces of his paintings — as compared to those of Tarbell and Benson — coalesce with the wealth and elegance of the pristine, hermetic interiors in which his subjects reside. Again, Oriental accessories are often included to heighten the interpretation of the elegant woman as a *rara avis*. Within this fixation on a limited aspect of upper-class life, Paxton's range of color, light and atmosphere is great, from rather sombre and rather austere environments, as in *The Yellow Jacket* of 1907 — not unlike similar and quite contemporaneous paintings of Tarbell — to more sumptuous and more colorful ones. Like Tarbell, he was particularly attracted to and influenced by the painting of Vermeer, and his ideas on that great Dutch artist are incorporated into the critical study written by another of the Boston School, Philip Leslie Hale. Perhaps responding to criticism concerning a lack of overall harmoniousness in his pictures of figures and forms with porcelain-like surfaces, many of the paintings of the 1910s, for instance *The Front Parlor* of 1913, exhibit a softer diffusion of light and atmosphere. His lovely women, often more mature than those of Tarbell and Benson, usually concentrate upon their casual activities — reading particularly, or knitting, or putting on gloves; their eyes avoid the viewer, and their faces are often in soft half-shadows.

Writers in the early 20th century admired the technique, the clever brushwork, and the good taste of the "Tarbellites," but they deplored the emphasis upon elegant accessories, and the lack of laughter or tears, referring to the paintings as "parlor pictures." Above all, the critics felt the lack of individuality in their work. To so many of the writers, the works of Tarbell, Benson, De Camp and Paxton were only variants, often slight, of a single theme. Usually grouped with these artists in discussions of the time

was Philip Leslie Hale though, in fact, Hale's work was quite different and exhibited more breadth than that of the other Boston painters.[9] Hale was the son of a Boston clergyman and a collateral descendant of Nathan Hale. He studied in Paris at the École des Beaux-Arts and at the Académie Julian, and on his return established himself as a master of progressive aesthetic tendencies in Boston, a good friend of his fellows among the Boston School.

Hale's interiors with figures, whether studio scenes or commissioned portraits, exhibit a degree of painterliness and a fairly high key related to Impressionism, but the forms of the figures tend to be rather academically rendered, and a geometric structure is brought to the fore through the architecture of the interior space. But the situation is quite different when Hale moved to the outdoors. In his renderings of figures in gardens, fields and on verandas, Hale revealed himself as the most fully committed of the Boston painters to the tenets of Impressionism, and actually one of the most Impressionist of all American artists. In many of these canvases there is a total dissolution of figure and background in pure sunlight and broken brushwork, without any consideration of real space or form, and often with a dominating, high horizon. There is a preference for the juxtaposition of bright greens and yellows, not unlike some of the canvases of Bunker's last years, but rather than reflected light, Hale's is blazing sunshine, with a real sense of "vibration"; the figure merges into the landscape setting. Though the figure is at the center of Hale's art, there is more concern with the landscape itself than in the work of any of the other Boston Impressionists. Within his oeuvre, Hale displayed a variation from total dissolution to relatively harder and more precise painting closer to that of his Boston colleagues: the two examples in the present show, *In the Garden* and *The Crimson Rambler,* respectively, well illustrate this range, but whether or not this relates to chronological development must await a more thorough study of his highly engaging art. Hale was also an active writer on the contemporary art scene in local newspapers and in the periodicals of his day, often discussing, enthusiastically, the work of his Boston colleagues. He also wrote a number of books on art and art history, his most significant being a study of Vermeer that first appeared in 1913, and was republished in quite different form in 1937, six years after Hale's death.

One of the leading and most sensitive women artists working in Boston in the early 20th century was Philip Hale's wife, Lillian Westcott Hale, some of whose figural compositions are not unlike the mode of the Tarbellites, but perhaps a more significant woman painter was Lilla Cabot Perry of Boston, who studied with Bunker and Robert Vonnoh at the Cowles School before going on to the Academy Colarossi and Académie Julian in Paris.[10] In 1889 she went to Giverny, where she established a warm friendship with Monet and became a great admirer of his work. Earlier that year, in Boston, she had become aware of the Impressionist aesthetic through the paintings of John Breck, who had visited Giverny early and sent back Impressionist pictures to Boston, where they were shown to fellow artists and other friends in Lilla Perry's studio. Now Perry came under the spell of the master directly, and she and her husband, the writer Thomas Sergeant Perry, spent the next ten summers in Giverny, experiences about which she wrote a most enlightening article that was published in 1927.[11]

During the autumn of 1889, after her first summer there, she brought back to Boston a view of Etrétat by Monet — one of the first of his works seen in that city — which was admired by few, a notable exception being her brother-in-law, the artist John La Farge. A few years later, Lilla Perry lectured on Monet at the Boston Art Students Association.

Perry's work done in Giverny is attractive and very much in the Impressionist mode, if not especially original. Predictably, her figure paintings are darker and more solid, reflecting more the training she had received in Boston, and particularly in Paris. In 1898 her husband accepted the chair in English literature at a college in Tokyo, and the Perrys went to Japan, where they lived until 1901; Professor Perry was, in fact, the grand-nephew of Commodore Matthew Perry, who had opened up Japan to the world in 1853.

Lilla Perry was one of the most significant of the American painters who went to Japan in the late 19th century; beginning with Winckworth Allan Gay, the list of such American artists would include John La Farge, Robert Blum and Theodore Wores. During her residence in Japan, Perry painted over eighty pictures of Japanese life and scenery; of all the Americans to work there, Perry's work is the least traditional and is the most indebted to the Impressionist aesthetic, and some of her Japanese scenes are, in color and brushwork, extremely close to Monet. In 1901, the Perrys returned to Boston where she was one of the most active figures in the local art world and a close colleague of Tarbell, Benson, Hale and others. Though she and her husband acquired a second home in Hancock, New Hampshire, in 1903, they continued to make occasional summer visits back to Giverny until about 1909.

There were other Boston painters of ability and note whose works were influenced by Impressionism, or affected by the rediscovered art of Vermeer, that contributed to the dominant Boston aesthetic of the time, artists such as Edward Wilbur Dean Hamilton and William Worcester Churchill. The Boston School aesthetic was also shared by artists from other regions; Charles Courtney Curran was an artist from Kentucky who studied in Cincinnati and then in New York at the Art Students' League until going to Paris in 1888.[12] His early work, done in the late eighties, shows a concern with women in an outdoor environment, solidly drawn figures bathed in a silvery light. These are examples of the "gray movement," discussed by Otto Stark in his article in *Modern Art* in 1893, works inspired by the painting of the enormously influential Jules Bastien-Lepage. But after Curran returned to this country and settled in New York, he turned to a more colorful palette and more broken tones, though his figures, always of healthy young women and girls, are carefully drawn. He painted a great deal up the Hudson in the art colony which had been established by Edward Lamson Henry at Cragsmoor, near Ellenville, New York, after Henry visited there around 1879, and then built a home in Cragsmoor in 1884. In such an outdoor environment, Curran could position his figures — appealing American types — high up, silhouetted against the brilliant blue sky, isolated from all other concerns in unchanging, sun-drenched summertime.

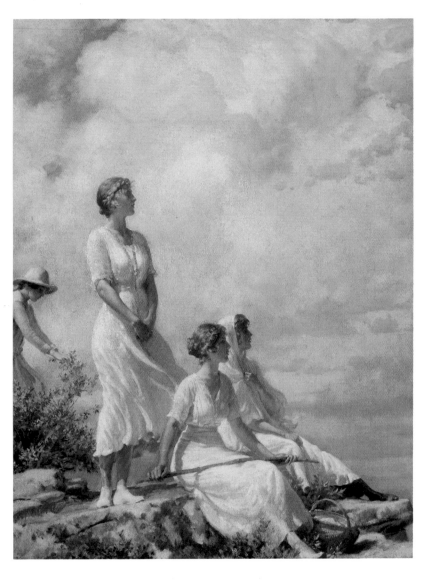

Guy Pene Du Bois, in his two articles of 1915, contrasted the Boston group strongly with that emanating out of the training at the Pennsylvania Academy of The Fine Arts, and which was characterized by a "concise expression of the simplicity of our language and of the prosaic nature of our sight. It is democratic painting — broad, without subtlety, vigorous in language..." Du Bois did not deny the "Americanness" of the Boston painters; rather he saw them as the aristocrats of American art, the Pennsylvania artists, the democrats. He saw the latter as the first truly national school, without soul and bare of sentiment. Today, their work, lesser known and appreciated than the Boston artists', seems less related to Impressionism; in technique it is more akin to the aesthetic of "The Eight" or the landscapes of George Bellows. But writers like Du Bois saw their approach as beginning with French Impressionism and applied to typical American scenery of tall trees and rolling country, often snowy winter scenes, bare of incident and filled with the clarity of cold, crisp air. The sense of nationality was important (perhaps more to the critics than to the artists themselves) for though Impressionism was undeniably of foreign origin, it was made to serve the American viewpoint and to embody American sentiments.

The leader of the Pennsylvania School was Edward Willis Redfield, who, after studying at the Pennsylvania Academy, went to Paris about 1886 and studied with the great academician William Bouguereau.[13] In Paris, Redfield became friendly with his fellow-Philadelphian Robert Henri, and both came under the influence of the Impressionists. In 1891, Redfield went with Henri to Venice where they became friendly with William Gedney Bunce, the local American expatriate there, who was then, though little remembered today, an influential figure.[14] Redfield returned home, and in 1898 acquired a home in Center Bridge, Pennsylvania, which became a focal point of the Pennsylvania School.

Redfield's broad and panoramic landscapes, with the paint applied in long, thick impastos, were viewed by the critics as virile and masculine — as opposed to the implied "femininity" or stated "timidity" of the work of the Boston artists. There was no antipathy among the artists of the two schools themselves, however; in fact, Redfield and Tarbell were good friends. Redfield's work was likened to the rigorousness of Winslow Homer's but praised for its joyful exuberance. Critics championed him, too, for his sense of locality — his were specifically "American" landscapes. He was especially a painter of the winter scene, and to Eliot Clark, his painting was the culmination of the tradition of American winter landscapes.[15] He did not paint the urban scene, and seldom painted the figure. Redfield's style and his aesthetic beliefs were perpetuated during his long years of instruction at the Pennsylvania Academy.

In some ways a more interesting, certainly a more sensitive painter, was Daniel Garber, whose painting is just now receiving new appreciation.[16] Garber came from Indiana, and studied with Frank Duveneck in Cincinnati before going to Philadelphia to study with Thomas Anshutz at the Pennsylvania Academy. Some of his earlier landscapes, such as those done in England about 1905, have an almost Whistlerian delicacy about them, and others suggest a relationship to the painting of J. Alden Weir, who taught briefly at the Academy, or perhaps the contemporaneous landscapes of Emil Carlsen, himself influenced by Weir. Many of these are broad, decorative and essentially two dimensional scenes, often depicting the area

## Daniel Garber

*Tanis.* 1915
Oil on canvas
60 x 46¼ in. (152.4 x 117 cm)
The Warner Collection of Gulf States Paper
Corporation, Tuscaloosa, Alabama

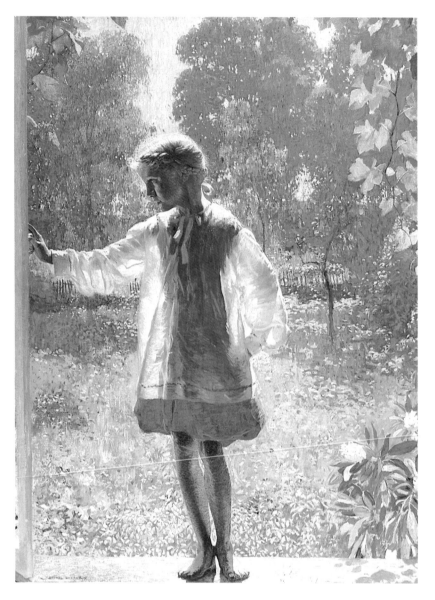

around Lumberville and New Hope.

Like so many artists discussed here, Garber essentially painted in two quite distinct manners, and, also like the others', they separate into his landscapes and his figure paintings. However, Garber is unique in that his most beautiful landscapes tend to be more solidly constructed, and more precisely drawn; it is the group of his finest figure paintings that revel in color and sunlight. His best-known landscapes are a series of paintings of the quarries at Byram in New Jersey on the Delaware River, done around 1917. The quarries' monumental rock formations fill the canvases; they are depicted with a muted but lyrical colorism, in which Garber has successfully rendered the poetry of a seemingly prosaic subject. The forms are not at all dissolved, but they are seen in splendid light. Garber's concern here is with "glow," the sparkle of the gilded edges of the giant quarry formation seen against the setting sun.

In contrast, his finest figure paintings, if not all of them, are awash with rich, bright color and warm sunlight. Forms are not dissolved, but reflections and transparency — of glass, fabrics and the like — are a major concern, and Garber's figures, too, are silhouetted against the bright outdoors. *Tanis* of 1915, a depiction of his daughter standing in full, bright light, is the best-known of these, but *The Orchard Window* was another one much admired when shown at the National Academy in 1921. In a number of his works of this period, Garber suggests some relationship with the contemporary "Window" series of Childe Hassam. Garber painted in and around New Hope for many years, and was an important teacher at the Pennsylvania Academy.

Though a year older than Garber, Robert Spencer was a student of the younger man in New Hope in 1909, after having left Nebraska and studying at the National Academy in New York between 1899 and 1901, and subsequently with William Merritt Chase and Robert Henri.[17] He had moved to Philadelphia in 1905, but later settled in New Hope. Spencer's paintings are unique among the Pennsylvania School artists in that they are not primarily landscape scenes but urban ones. His pictures inevitably emphasize large architectural structures, which, though monumental, are never grandiose buildings. Rather, they are invariably factories, mills or tenements: flat, prosaic walls, placed parallel to the picture plane and in front of which often teem a multitude of small figures. Spencer's is a world quite apart from that of his Boston contemporaries; he painted back yards, not front ones. Indeed, sometimes his pictures suggest a concern with social realism, with the lives and even the troubles of the working people. But his interpretation *is* Impressionist, actually more so than Redfield or most of the Pennsylvania artists. Spencer practiced a uniformly broken, flecked brushwork, and the quality of paint texture was important in his art, establishing an overall patterning which bears some similarity to the painting of Maurice Prendergast, however different is his subject matter.

An artist whose work is often quite close to that of Redfield was Walter Elmer Schofield, who was born in Philadelphia and studied at the Pennsylvania Academy under Anshutz from 1887-90, before going on to the Académie Julian under Bouguereau for about five years.[18] After his French studies, he went on to do much work in England, serving in the British Army during World War I and then establishing a studio in Cornwall after the war, so that he was, essentially, an expatriate. Many of Schofield's subjects are, not surprisingly, European ones, but he exhibited regularly at

**Edward Redfield**

*Pennsylvania Mills (in Bucks County).* n.d.

Oil on canvas
50 x 56 in. (127 x 148.2 cm)
Collection of Mr. Laurent Redfield

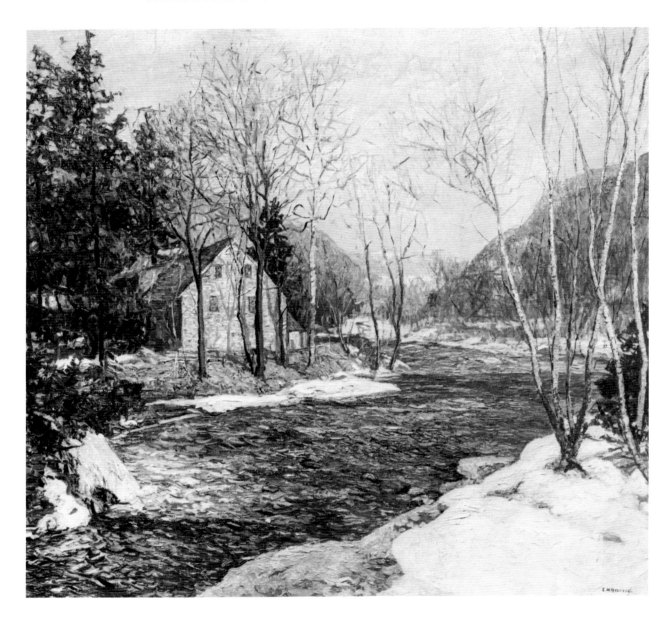

*The Rapids.* n.d.

Oil on canvas
50¼ x 60¼ in. (129 x 153 cm)
National Collection of Fine Arts,
Smithsonian Institution, Bequest of Henry
Ward Ranger through the National Academy
of Design

the Pennsylvania Academy and was associated in the minds of the critics and the public with Redfield and Garber. His work also was likened to that of Winslow Homer in its vigor; he painted out-of-doors in a broad and painterly style, in which the forms themselves seem to move in flowing compositions, often along strong diagonal axes. He preferred winter scenes, or, as critics wrote, winter, water and smoke. Schofield's landscape paintings are often enormous, consistently among the largest of the artists included herein.

Again, as with the Boston group, the interests, the techniques and the expression of the Pennsylvania School were not limited to artists of the area. George Gardner Symons was a significant painter whose work is quite similar to that of Redfield and Schofield particularly; this, in fact, was noted by writers of his time.[19] Symons was born in Chicago, and studied there before going on for further training in Paris, Munich and London. His work, all broadly-painted, expansive landscapes, was also noted for its virility and freedom, and he, too, was a specialist in snow scenes, exploiting the colors of shimmering shadows upon great areas of white. Referred to as an "Optimist in Art," he was considered both an Impressionist and a Realist, a Realist in his training but an Impressionist in his natural expression. Identified with his native city, his work was collected throughout the Midwest, though he lived much of his later life in New York City.

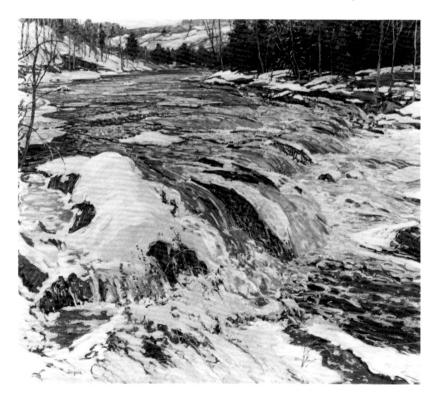

1. Guy Pene Du Bois, "The Pennsylvania Group of Landscape Painters," *Arts and Decoration*, Vol. 5, no. 9 (July, 1915), 351-54, and "The Boston Group of Painters: An Essay on Nationalism in Art," *Arts and Decoration*, Vol. 5, no. 12 (October, 1915), 457-60.

2. Hartmann, *A History*, Vol. 2, 237-39, and William Howe Downes, "Boston Art and Artists," in F. Hopkinson Smith, et al., *Essays on American Art and Artists*, Chicago, American Art League, 1896, 265-80.

3. See, for instance, Downes, "Boston Art and Artists," and R. H. Ives Gammell, "A Reintroduction to Boston Painters," *Classical America*, Vol. 3 (1973), 94-104.

4. Surprisingly, there is no monograph on Tarbell although there are many articles about him, including those by Frederick W. Coburn, Kenyon Cox, Philip Leslie Hale, Dora M. Morrell, Homer Saint-Gaudens, and John E.D. Trask.

5. Hartmann, *A History*, Vol. 2, 238. Hartmann writes perceptively on the Boston school, though not without some condescension.

6. Benson has been the subject of numerous articles and studies but some of them deal with his later excursion into printmaking and need not concern us here. Cited in the bibliography are articles by Charles H. Caffin, William Howe Downes, Anna Seaton-Schmidt, and Minna C. Smith.

7. For De Camp, see the articles by Rose V.S. Berry, William Howe Downes, and Arthur Hoeber.

8. See the excellent, detailed study of Paxton by his former pupil, R.H. Ives Gammell, in the exhibition catalogue, *William McGregor Paxton, N.A., 1869-1941*, Indianapolis Museum of Art, 1978. Also listed in the bibliography are articles by Frederick W. Coburn, Philip Leslie Hale, and Gardner Teall.

9. For Hale, see the several articles by Frederick W. Coburn cited in the bibliography, and the catalogue, Franklin P. Folts, *Paintings & Drawings by Philip Leslie Hale (1865-1931) from the Folts Collection*, Vose Galleries of Boston, Boston, 1966.

10. See Carolyn Hilman and Jean Nutting Oliver, "Lilla Cabot Perry — Painter and Poet," *American Magazine of Art*, Vol. 14, no. 11 (November, 1923), 601-04; and the

essay by Stuart P. Feld in the catalogue *Lilla Cabot Perry: A Retrospective Exhibition*, Hirschl & Adler Galleries, Inc., New York City, 1969.

11. Lilla Cabot Perry, "Reminiscences of Claude Monet from 1889 to 1909," *American Magazine of Art*, Vol. 18, no. 3 (March, 1927), 119-25.

12. The present bibliography lists articles on Curran by Clarence Cook and Homer Saint-Gaudens.

13. Redfield was the subject of articles by Benjamin Orange Flower, J. Nilsen Laurvik, and Frederic Newlin Price, and a number of studies by Charles V. Wheeler; these are cited in the bibliography.

14. For Bunce, see Frederic Fairchild Sherman, "William Gedney Bunce," *Art in America*, Vol. 14, no. 2 (February, 1926), 80-84; Royal Cortissoz, *American Artists*, New York, Scribner's, 1923, 126-31; and Charles Dudley Warner, "William Gedney Bunce," *Century*, Vol. 60, no. 4 (August, 1900), 635.

15. Eliot Clark, "American Painters of Winter Landscape," *Scribner's Magazine*, Vol. 72, no. 6 (December, 1922) 765-66.

16. See Bayard Breck, "Daniel Garber: A Modern American Master," *Art and Life*, Vol. 11, no. 9 (March, 1920), 493-97; Henry Pitz, "Daniel Garber," *Creative Art*, Vol. 2, no. 4 (April, 1928), 252-56; and Gardner Teall, "In True American Spirit, The Art of Daniel Garber," *Hearst's International*, Vol. 39, no. 6 (June, 1921), 28, 77.

17. See Frederic Newlin Price, "Spencer — and Romance," *International Studio*, Vol. 76, no. 310 (March, 1923), 485-91.

18. Two articles on Schofield are C. Lewis Hind, "An American Landscape Painter, W. Elmer Schofield," *International Studio*, Vol. 48, no. 192 (February, 1913), 280-89, and Arthur Hoeber, "W. Elmer Schofield," *Arts and Decoration*, Vol. 1, no. 12 (October, 1911), 473-75, 492.

19. See the articles by Thomas Shrewsbury Parkhurst, "Gardner Symons, Painter and Philosopher," *Fine Arts Journal*, Vol. 34, no. 11 (November, 1916), 556-65, and "Little Journeys to the Homes of Great Artists: Gardner Symons," *Fine Arts Journal*, Vol. 33, no. 4 (October, 1915), 7-9, supplement.

*Bloom of the Grape.* 1894

Oil on canvas
30⅛ x 40⅛ in. (77 x 102 cm)
Indianapolis Museum of Art,
Delavan Smith Fund

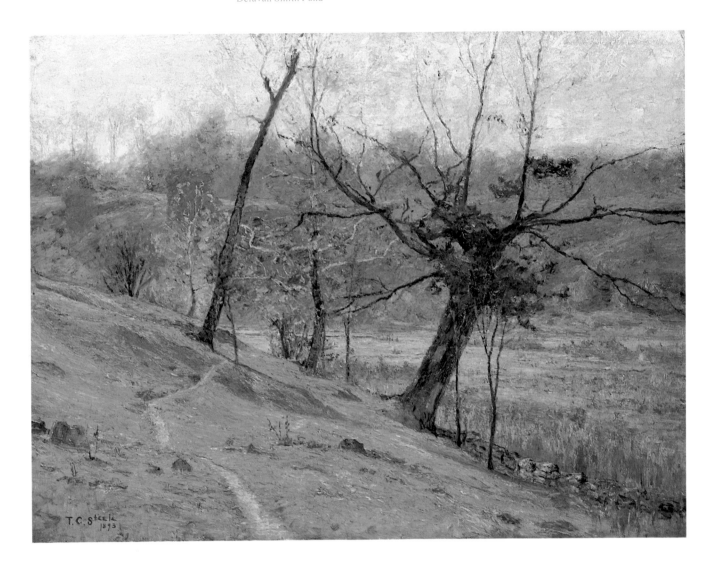

The notes for this chapter will be
found on page 109.

# 15 Regional Impressionism

By the 1890s, the Impressionist aesthetic had become a popular and dominant one in America, and it had penetrated to many regions and centers in the nation. There would seem little reason to pursue here the many manifestations of Impressionist painting throughout the country, even if local variations of approach or subject might be described. In connection with artistic developments in Indiana, however, and the emergence of The Hoosier School, a significant critical and artistic attitude toward Impressionism can be discerned, one that illuminates the directions that Impressionism was to take and the reasons for its continued popularity. The Indiana painters are here studied and presented not only because they constituted a united group of artists working together but also because their art produced a body of critical reaction and acclaim that enunciated a nationalistic aesthetic attitude; the Hoosier artists were seen as consciously attempting to create an *American* Impressionism.[1]

The artists of the Hoosier School were Theodore Clement Steele, Otto Stark, William J. Forsyth, John Ottis Adams and Richard Buckner Gruelle; a sixth painter, Samuel G. Richards, died before the group began to move in an Impressionist direction. The activity of the Hoosier School centered in Indianapolis, but, as a group of landscape painters, it was the Indiana countryside that attracted their attention, and their work was seen by a larger public and to greater critical acclaim particularly in Chicago and also in St. Louis.

There are three phases to the art of the Hoosier School: the pre-Impressionist work done by the painters up until approximately 1890; the years of the height of their significance, from *circa* 1890 until 1907; and the years from 1907 on, when the activity of the School attracted a second generation of painters all working in Indiana's Brown County where the leader of the School, Theodore Steele, lived in his famous "House of the Singing Winds." Steele, as the foremost Indiana artist of his time, is worthy of study in some detail.[2] He came from Waveland, Indiana, and began his professional art career as a portrait painter, though even early on he exhibited some interest in landscape. In 1873, Steele moved to Indianapolis, a much larger center though not one renowned for its art activity. He found there, however, a sincere artistic patron, Herman Lieber, who had come to America from the art center of Düsseldorf in 1852 and settled in Indianapolis the following year. Four years after Steele arrived in Indianapolis, he is said to have studied at the Indiana School of Art, which was founded then by John Love and James Gookins. Love, who was to die at the age of 30 in 1880, was just back from study in France under Gérôme, but he had worked at Barbizon, which was the direction his own art represented; Gookins had studied at Munich. Steele recognized the inadequacy of his own training, and in 1879 began to make plans to go abroad for study; Lieber raised the funds for Steele and his family.

Steele chose to go to Munich rather than Paris. Perhaps Gookins' own previous study there reinforced Steele's decision, and perhaps also the renown of Frank Duveneck's activities in the Bavarian capital, which had attracted so many young American art students from the Midwest. The common Midwestern Germanic heritage and his patron Lieber's own German background certainly were factors, but further reasons were defined years later by Steele's Hoosier colleague William Forsyth, in his *Art in Indiana*.[3] Munich was less expensive than Paris. Its Royal Academy was easier of access and it was a more liberal school. Steele studied there with Ludwig Loefftz, so sympathetic to young Americans in Munich, and also with the more traditional Hungarian artist, Julius Benczur. Much of the work Steele painted while in Munich was figural — he won a prize in 1884 for his *Boatman,* a strong, strangely backlit, silhouetted image, not at all idealized — but he also studied landscape painting, working with the American expatriate J. Frank Currier in Schleissheim.

Steele returned to Indianapolis in 1885, setting up an art school there with William Forsyth and joining the Art Association of Indianapolis, which had been formed in 1883 while he was away. Steele divided his own artistic efforts between portraiture and landscape painting. His portraits, such as that of Herman Lieber painted in 1887 or one of his mother from 1891, are strongly modeled, dark pictures, and his first landscapes done on his return, such as his 1885 *Pleasant Run,* continue the manner of his Schleissheim work. They are dark and dramatic, backlit with an overall greyish atmosphere, pastoral scenes with an emphasis upon scrubby foliage, and are extremely informal. Steele began already to voice nationalistic preferences however; he found more color and more contrast in America than in Germany, preferring the thicker atmospheric haze to the thin whiteness of Bavaria.

In 1886, Steele began to seek a national reputation, sending landscapes and his prize-winning *Boatman* to the Society of American Artists in New York City. That same year he began to explore the Indiana countryside for suitable subject matter, concentrating on Muscatatuck Valley and the area around Vernon — not to be confused with Monet's and Robinson's Vernon, near Giverny! About this time he began to abandon the dark underpainting he had previously practiced and the use of the palette knife. While he was to paint portraits throughout his career, he began a commitment to landscape painting, and for a significant reason. He felt that landscape was *the* modern art form, one that had had comparatively few great masters in the past. Portraiture, he believed, was universal, but landscape expressed a sense of particular place and it was that sense of place that Steele sought.[4]

In 1887, Steele made a trip to the village of Cavendish in Vermont, and his work done there shows a lighter palette, but it was still Barbizon in its pastoral expressivity, still solid and tonal and with a sense of depth. Gradually, however, his work changed, abandoning the Munich and Barbizon manner for one identifiable with Impressionism, and his 1892 *September* with its light tonality, bright colors, abandonment of the neutral tones, and broken brushwork represented Steele at the Columbian Exposition in 1893.

The recognition and acclaim of Steele and the Hoosier School are inseparably connected with the Chicago Exposition and the rise of a Midwestern cultural expression. That region found its critical proponent in the major writer and novelist, Hamlin Garland, who in his books championed a distinctive Middle Border expression and who sought no less in the art of the period. That search brought Garland to the art exhibit at the Chicago Exposition and to the aesthetic of Impressionism. Garland's famous essay on "Impressionism" which appeared in print in 1894 in *Crumbling Idols* reflects his impressions of the art seen at Chicago the previous year, and may have been substantially the same as the lecture he presented at the home of Franklin Head in Chicago. In it, Garland praised the dazzling sunlight effects, and the blue and purple shadows of the new landscape art. His analysis of the methodology of the Impressionists was quite perceptive

and correct. He identified the new art with French painters of Giverny, with the younger Scandanavian artists and, among the Americans, the artists of Boston: Frank Benson, Edmund Tarbell and particularly the already deceased Dennis Bunker, whose radiantly beautiful New England scenes he especially admired. Garland quoted a painter friend who "had grown out of the gray-black-and-brown method," who found the Barbizon artists too indefinite, too weak and too lifeless. And Garland echoed these sentiments when he found that "the work of a man like Enneking or Steele or Remington, striving to paint native scenes, and succeeding, is of more interest to me than Diaz."[5]

Steele was undoubtedly a new name to Garland then, but he was to become more familiar with Steele's art very soon, as his own involvement with the pictorial arts was to grow appreciably. The great Exposition in Chicago bore witness brilliantly to the rebirth of the Midwestern metropolis after the disastrous fire two decades earlier. But another purpose was to herald the coming of age of the culture of the area, and it is no coincidence that the very important periodical, significantly named *Modern Art,* began publication the year of the fair, 1893, in Indianapolis; this was the magazine where, in fact, the local artists Steele's and Otto Stark's several essays on Impressionism appeared. Immediately following the Columbian Exposition, the Central Art Association was founded in Chicago, in March of 1894. The Art Association soon had thousands of members from all over the Midwest, published an illustrated monthly journal, *Arts for America,* sponsored lecture series on all aspects of the pictorial arts, and held art exhibitions which traveled and where sales were actively promoted. Though the Association was founded by Mrs. T. Vernette Morse, Hamlin Garland was, for a while, its president.[6]

One of the most interesting publications to appear in this country on the subject of Impressionism was a pamphlet printed for the Central Art Association in autumn of 1894 entitled *Impressions on Impressionism.* It reproduced, or paraphrased, a discussion by persons who remained anonymous, but who were identified collectively as "The Critical Triumvirate," as they reviewed the "Seventh Annual Exhibition of American Paintings" at the Art Institute of Chicago, which opened on October 29 of that year. The Triumvirate were identified only as a Novelist, a Conservative Painter and a Sculptor; however, it has been ascertained that the Novelist is Garland, the Sculptor, Lorado Taft, and the Conservative Painter, the Barbizon-style landscapist, Charles F. Browne. Garland and Taft were respectively the president and vice-president of the Central Art Association, and we can also be certain that Garland was the author of the pamphlet.

The conversation among the three, with occasional comments on the exhibition scene made in passing by other visitors, makes a clear but balanced case for Impressionism. The Conservative Painter, of course, is shocked by the brilliant Impressionist color. Robert Vonnoh's work is much discussed, and likened to that of Mark Fisher who had shown at the Columbian Exposition the previous year. The Novelist—Garland—found Steele's work especially admirable, direct and natural, and spoke of the respect that Steele had garnered from his Eastern colleagues. But Garland went on to state that "What I miss in the whole Exhibition I miss in American art—and that is the drama of American life...We can't go on doing imitiations and taking notes abroad. What pleases me about the Exposition is that while the principle of impressionism is almost everywhere

it is finding individual expression. Henri and Herter, and Steele, and Tarbell, and Vonnoh, and Robinson all have a different touch—they are gaining mastery of an individual technique. This shows we're pulling out of the imitative stage. There are very few pictures here with Monet's brush-stroke imitated in them. The next step is to do interesting American themes and do it naturally—I don't want anybody dragooned into being American... The public will rise to meet the impressionist half-way; we never will return to the dead black shadow, nor to the affected grouping of the old."

The Conservative Painter—Browne—echoed Garland's sentiments, saying: "We will never have any home art with the real home flavor unless we are in close touch with what's around us here. What are Charles Sprague Pearce, Dannat, Walter Gay, Harrison, Howe, D. Ridgway Knight, Melchers, and hosts of our most talented American born doing for us? In one way, nothing and less than nothing, for they've educated the public into thinking that a picture isn't good for much unless dated and signed abroad. Is a Brittany peasant more to us than everything else? Haven't we out-door subjects in our fields, or our mountains, by our glorious lakes, on the shores of our loud sounding seas? We assuredly have... As an exhibit it does what it should, it gives one an idea of the tendency of things up to date. It's fresh and bright enough and interesting too, but it doesn't fan one into a red hot hope for the future of American art. Painting is more than paint, and sunlight is more than orange and purple, and a landscape as well as a figure means more than a symphony of color, a pang of grey, or a whoop of violet.'"[7]

Garland and his colleagues were calling for an Americanization of Modern art, and for the Novelist at least, preferably in the Impressionist mode. He restated this call and this preference in January of 1895, in the introduction to the catalogue of the Palette and Cosmopolitan Art Clubs exhibit in Chicago: "Monet makes Giverny, Giverny does not make Monet ...there must be keen sensitiveness to the beautiful and significant in nearby things. The Chicago artist, being denied certain picturesque aspects of seashore and mountain-side, has a rare chance to develop unhackneyed themes in sky and plain and in the life of the city itself. The light floods the Kankakee marshes as well as the meadows and willows of Giverny. The Muscatatuck has its subtleties of color as well as L'Oise, and a little young haymaker on the banks of the Fox River is certainly as admirable for art treatment in paint or clay as a clumsy Brittany peasant in wooden shoes."[8]

Yet the subtleties of the Muscatatuck had, in fact, already been rendered, and Garland knew that, for along with *September,* Steele had exhibited *On the Muscatatuck* at the Columbian Exposition. Soon, more of his work would be seen in Chicago. In 1894, Steele, with three fellow artists, participated in an important and historic exhibition sponsored by the Indianapolis Art Association at the Denison Hotel. His fellow exhibitors were William Forsyth, Otto Stark and Richard Buckner Gruelle. Gruelle was a self-trained painter who grew up in Illinois and went to Indianapolis in 1882. Forsyth's career was very similar to Steele's; he studied under Love and Gookins in their short-lived school in 1878 and then joined other Indianapolis artists in Munich, where he worked from 1883-1890. He returned to Indiana in 1890, first to Muncie where he worked with John Ottis Adams, a fellow student in the Munich Academy, and then moved to Indianapolis, painting at Vernon with Steele and teaching. Stark's background was somewhat different. Born in Indianapolis, he studied first at the Art Students' League in New York in

*November.* 1890
Oil on canvas
39⅜ x 32 in. (99.1 x 81.3 cm)
The Pennsylvania Academy of the Fine Arts,
Temple Fund Purchase, 1894

1882-83 under Chase, J. Carroll Beckwith and Walter Shirlaw, and then went to Paris in 1885 to study at the Académie Julian and also with Fernand Cormon. He returned to New York City in 1888, but after the death of his wife went back to Indianapolis in 1892, and two years later participated in the show of the summer work at the Denison Hotel.

So successful was the exhibition that Garland's Central Art Association brought it to Chicago, where it was presented during the winter at the Chicago Athenaeum Building. There were now five artists; the work of John Ottis Adams had been added to the show. It was this showing that earned the group their official designation as the "Hoosier Painters." Again, the Critical Triumvirate reviewed the exhibition and showered the artists with accolades, admiring their contentment at working out their own salvation in Indianapolis, unaided, undistracted by a brilliant society of painters. They were seen to represent the art consciousness of the West, in native canvases. Taft even voiced the opinion that crude works with local meaning appeal more than purely clever work. Garland felt that the show was one of the most unhackneyed and inspiring exhibitions ever made by an equal number of American landscape painters. The artists were identified as Impressionists, but they had selected the better parts of Impressionism. They were not "extreme impressionists" and did not slur everything, rather only the nonessentials. Their canvases focused upon prominent topographical features and large masses, utilizing plain skies and high horizons. Steele was recognized as the leader of the group, and particularly impressive was his most famous painting, the *Bloom of the Grape* of 1893, a scene in the Muscatatuck Valley. It was admired precisely because the artist was able to wring such beauty out of the apparently prosaic.

The critical success of their show in the larger city of Chicago, and Garland's endorsement of their work, helped the Hoosier School to coalesce. The group saw as their goal the rendering of the simple natural beauty of the Indiana woods and fields. As Otto Stark wrote in his essay on "The Evolution of Impressionism," the next step in art was embodiment of "Americanism." For Impressionism itself was a foreign artistic style and, as some critics had already pointed out, it was "soulless" and only "mechanical." American artists were to invest Impressionism with soul and with national spirit, and this could and should come about in the heartland of America rather than in the Europe-facing Eastern art establishment. This was American Regionalism and Nativism two generations before Thomas Hart Benton, John Steuart Curry and Grant Wood.

Steele emerged as not only the finest painter of the Hoosier School but their recognized leader, and he became a spokesman for the group and for Impressionism. He played this role when he lectured on "The Tendency of Modern Art" —a defense of Impressionism—about which he had written in *Modern Art* two years earlier. Steele's speech was given before the Convention of the Indiana Union of Literary Clubs in Huntington, Indiana, where Garland also was a speaker, and where an exhibition of the work of the Hoosier School was held. Garland's talk was on the "Indiana School of Landscape Painting," which he felt was a stronger group than the painters in Chicago. Garland also spoke to Steele of the admiration of Tarbell, Benson and Robinson for his work, and elsewhere the artist learned of Chase's high regard for his landscapes. In 1896, Steele advocated Modernism at the Art Institute of Chicago, the painter F. Hopkinson Smith being his "opponent," taking a negative stance.

That year, 1896, saw the creation of the Society of Western Artists, an attempt to create something in the pictorial arts distinctly Western, but catering to Impressionism and grounded in Modernism. The organization was centered in Chicago but its exhibitions were shown in six Midwestern cities: Cleveland, Cincinnati, Indianapolis, Chicago, St. Louis and Detroit. Frank Duveneck was the president of the group and Hamlin Garland its leading spokesman. The Indianapolis artists were recognized as the strongest, with Steele, Adams and Forsyth constituting the Indiana contingent of the new organization.

Through the Society, the work of Steele and his colleagues gained regional attention. In 1896, Adams and Steele showed in St. Louis, where Halsey Ives was the director of the Museum of Fine Arts. Ives lectured on Impressionism, declaring that the Indiana work was the equal of Monet's. Two years later, Steele and Adams bought a country home, The Hermitage, in Brookville, Indiana. In 1900, Steele's *Bloom of the Grape* won an honorable mention at the Paris Universal Exposition, where he was on the jury of selection, as he also was four years later for the Louisiana Purchase Exposition in St. Louis. Four of his canvases appeared there, including *The Old Mills*. By this time, Steele's work was totally committed to the Impressionist aesthetic.

In 1899 Steele's first wife had died, and in 1906 he married again. At about this time, he started to explore the little known region of Brown County in Indiana, and in 1907 built his "House of the Singing Winds" there. Perhaps this most unspoiled area of Indiana seemed even more fresh and native, more American. Steele's presence there became a magnet for many other artists: Adolph and Ada Shulz, Adam Emory Albright, John Hafen, Will Vawter, Fred Hetherington and Gustave Baumann, who became the Brown County School.[9] Steele, meanwhile, was recognized as the outstanding figure in Indiana art, his work shown with that of Adams, Forsyth and Stark in the International Exposition in Buenos Aires in 1910, and that same year he was honored by a one-man show at the John Herron Art Institute in Indianapolis.

When the Indiana artists were students in Munich, they had been struck by the national characteristics displayed in the art exhibitions at the Glaspalast there, and had determined to infuse such qualities into American art, or at least Indiana art, on their return. At the time of Steele's retrospective of 1910, one critic wrote that: "Mr. Steele learned in Europe only a better way of expressing Indiana."[10] The Hoosier artists appeared to have accomplished the artistic purposes set out by Hamlin Garland: to express in a Modern aesthetic those qualities unique to the American scene.

If a study of the Hoosier School reveals a consciously pursued nativist amalgamation of Impressionist principles with the exploration of the American scene, the present knowledge of the situation in California painting at the turn of the century suggests little systematic interest in or absorption of Impressionist aesthetic, although certain California artists do exhibit Impressionistic tendencies. By the end of the 19th century there were two major centers in the state, but the development of professional artistic trends in Los Angeles began only about 1910 or so, really postdating American involvement with Impressionism.

The situation in San Francisco, on the other hand, was very different, with a strong artistic tradition already established even as early as the 1860s. However, during the period of greatest creative exploration of Impressionism elsewhere in America—the last decade of the 19th century— San Francisco art was dominated by the California Decorative style, embodied in the work of Arthur Mathews, which affected all areas of visual culture, not only painting but furniture and the decorative arts as well. Mathews' style was primarily a figurative one, reflective of European Symbolism and related to the flat, decorative manner and muted tonal harmonies of Puvis de Chavannes and the rhythmic linearization of Art Nouveau.[11]

Mathews' domination of the pictorial arts almost completely precluded an extensive investigation of Impressionism. A group of French Impressionist pictures was first shown in San Francisco at the 1894 Mid-Winter Fair, including works by Pissarro, Renoir, Sisley and two by Monet which were greeted enthusiastically for their dazzling atmosphere and color.[12] Several younger San Francisco artists, Joseph Raphael and Euphemia Charlton Fortune, did, in the early 20th century, apply Impressionist techniques and a wide range of color to landscapes in a very free, really expressionist manner. Raphael's treatment of a *Rhododendron Field* owes as much to Post-Impressionist Divisionism as it does to the parent movement; a native of San Francisco, Raphael had studied with Mathews at the Mark Hopkins Institute of Art before going on to Paris to study at the École des Beaux-Arts and at the Académie Julian; much of his life was spent in Europe living at Uccle in Belgium.[13] Euphemia Fortune studied in England, at the St. John's Wood School of Art, in 1904. After further study in New York and several years back in Europe, she settled permanently in Monterey, California, in 1912.

The influence of these painters was, in turn, felt by Selden Gile, the central figure of the Oakland "Society of Six" which introduced a doctrine of greater Modernism and Fauvism into Bay area painting.

A special case can be made for regarding the well-known San Francisco painter Theodore Wores as an Impressionist.[14] Wores, a landscape and genre painter in whom interest has greatly increased during the last decade, was one of the first students of the School of Design of the San Francisco Art Association, entering there in 1874 and studying under Virgil Williams, himself a pupil of George Inness. Encouraged by Toby Rosenthal, one of the earliest Americans to study in Munich, Wores went to the Bavarian capital in 1875, studying privately with Rosenthal and at the Royal Academy under Ludwig Loefftz and Alexander von Wagner. He was a friend of Duveneck and Chase, a member of the American Art Students Club, and joined the "Duveneck Boys" in Venice in 1879. A meeting with Whistler led to a fervent enthusiasm for Japan which Wores was later to satisfy.

*Rhododendron Fields.* 1915
Oil on canvas
30 x 40 in. (76.2 x 101.6 cm)
The Oakland Museum, Gift of the Dr.
William Porter Collection

*Ancient Moorish Mill, Spain.* 1903
Oil on canvas
29 x 36 in. (73.7 x 91.4 cm)
Dr. Ben Shenson and Dr. A. Jess Shenson
Collection

In 1881, back in this country, Wores became the first artist to investigate the subject matter of San Francisco's Chinatown, a theme heralding a predilection for the exotic which was to characterize much of Wores' painting. His fluid brushwork and bright coloration in these pictures brought Wores the patronage of the leading families of the area: the Stanfords, the Crockers and the Hearsts. In 1885, Wores made the first of several visits to Japan. He met John La Farge there briefly, and was later to write on Japan as La Farge had previously. Wores, through his several visits to Japan, influenced the direction of Japanese artistic Westernization, but Japanese art had no influence on Wores' painting. However, his painting did develop an increasing fluidity. Wores remained in Japan for two years, returning in 1887. On the occasion of exhibiting his work back in this country and then in London, he renewed his friendships with Chase and Whistler. His London exhibition at the Dowdeswell Galleries in 1888 was a success, and his work was compared to that of Whistler's disciple, Mortimer Menpes, who had shown his own Japanese pictures the previous year. Some English critics at the time referred to Wores' work as Impressionist.

In 1892, Wores went to the East again, visiting Hawaii and then Japan. He stayed in Japan over a year, and many more pictures are known from this second trip, works that are descriptive of Japanese life and landscape done in a polished style, but with brighter color, an interest in patterned light and shade, and a preference for floral motifs. These and Wores' Hawaiian scenes —he was to return in 1901-02 to Hawaii and to Samoa — are probably his best-known pictures today. Perhaps the finest of all his work, in terms of a sensitivity to light and to color relationships, are the paintings he did in Spain in 1903; the coloristic direction of his work at the time may owe something to the shipboard friendship he formed on the way to Europe with Philip and Lillian Hale from Boston. His scenes in and around Granada and Arcala are less concerned with the consciously picturesque and exotic than his Eastern views, and his pure landscapes done in Spain, crumbling architecture and garden subjects, bear witness to a sensitivity to the strong, all-pervading South European light.

This was Wores' last trip abroad; in 1907 he succeeded Mathews at the Hopkins Art School and continued to exert a force in the art life of San Francisco.

1. Wilbur D. Peat, *Pioneer Painters of Indiana*, Art Association of Indianapolis, 1954, is the standard study of Indiana art but it stops just short of consideration of the Hoosier painters. Of prime significance, therefore, is Mary Quick Burnet, *Art and Artists of Indiana*, New York, The Century Company, 1921, and William Forsyth, *Art in Indiana*, Indianapolis, H. Lieber, 1916. Forsyth was one of the Hoosier group. See also Eva Draegert, "The Fine Arts in Indianapolis, 1880-1890," *Indiana Magazine of History*, Vol. 50, no. 4 (December, 1954), 321-348.

2. The standard monograph on Steele, and extremely significant for a study of the Hoosier School, is Selma N. Steele, Theodore L. Steele and Wilbur D. Peat, *The House of the Singing Winds: The Life and work of T.C. Steele*, Indianapolis, Indiana Historical Society, 1966. Our bibliography lists several articles on Steele: Mary Quick Burnet, "Indiana University and T.C. Steele," *American Magazine of Art*, Vol. 15, no. 11 (November, 1924), 587-91, and Alfred Mansfield Brooks, "The Art and Work of Theodore Steele," *American Magazine of Art*, Vol. 8, no. 10 (August, 1917), 401-06, and his "The House of the Singing Winds," *American Magazine of Art*, Vol. 11, no. 4 (February, 1920), 139-41.

3. Forsyth, *Art in Indiana*, 13.

4. Quoted in Selma N. Steele, et. al., *House of the Singing Winds*, 36, from an interview with Steele which appeared in the Indianapolis *News* for February 19, 1887.

5. Garland, *Crumbling Idols*, 97-110.

6. On the activities of the Association, see Russell Lynes, *The Tastemakers*, New York, Harper, 1954, 151-56.

7. "A Critical Triumvirate," *Impressions on Impressionism*, Chicago, printed for the Central Art Association, 1894, 22-24.

8. Quoted in John D. Kysela, S.J., "The Critical and Literary Background for a Study of the Development of Taste for 'Modern Art' in America, from 1880 to 1900," unpublished M.A. thesis, Loyola University, 1964, 100.

9. See Adolph Robert Schulz, "The Story of the Brown County Art Colony," *Indiana Magazine of History*, Vol. 31, no. 4 (December, 1935), 282-89, and Josephine A. Graf, "The Brown County Art Colony," *Indiana Magazine of History*, Vol. 35, no. 4 (December, 1939), 365-370.

10. Selma N. Steele, et al., *House of the Singing Winds*, 136.

11. See the essay by Harvey L. Jones in the exhibition catalogue *Mathews Masterpieces of the California Decorative Style*, The Oakland Museum, 1972.

12. Sonia Bryan, "Impressionism in California: The Impact of Nineteenth Century French Art," in Joseph Armstrong Baird, Jr., ed., *Theodore Wores and the Beginnings of Internationalism in Northern California Painting: 1874-1915*, Davis, California, Library Associates, University Library, University of California, Davis, 1978, 14-18.

13. See the catalogue with an introduction by Theodore M. Lilienthal, *An Exhibition of Rediscovery: Joseph Raphael, 1872-1950*, Judah L. Magnes Memorial Museum, Berkeley, 1975.

14. For Wores, see especially the several publications by Joseph Armstrong Baird, Jr. and Lewis Ferbraché which are listed in the bibliography.

*Spring Thaw.* n.d.
Oil on canvas
25 x 30 in. (63.5 x 76.2 cm)
The Daniel J. Terra Collection

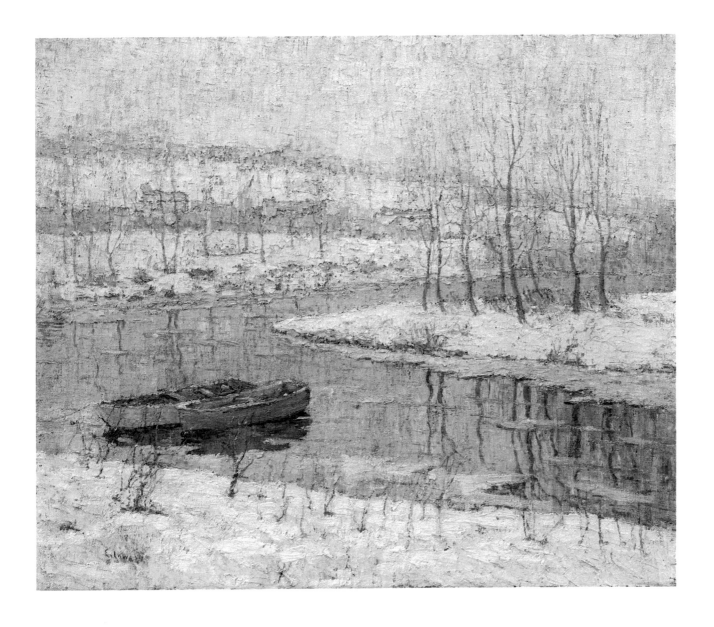

# 16 Impressionism and Early 20th-Century Movements in American Art

As we become more and more aware of the tremendous variety and vitality of art in this country at the turn of the century, we no longer disparage many of its manifestations — the exemplars of the genteel tradition, the painters of ideality, the expatriates in France working in Paris and among the peasants in the French countryside, and the practitioners of the newly revived mural tradition. The Impressionist aesthetic was related at least in part to some artists among these movements but certainly not to all: to Thayer to a degree but not to George de Forest Brush; to Frieseke and Miller but not to Charles Pearce or Frederick Bridgman; and while the Impressionist Robert Reid was an active mural painter, his fellow member of "The Ten," Edward Simmons, was a leading muralist yet little affected by Impressionism.

In the first decade of the 20th century, two new directions were taken up by younger American artists. In general, those who went to Europe and fell under the influence of the new Modernism are identified with increased formal and sometimes abstract concerns, and those who remained home for their inspiration were generally realists who painted the urban scene. Certainly all of the artists of both groups were aware of Impressionism, even if they regarded it as an either old-fashioned or superficial art form against which they reacted.

Among the European-inspired Americans, a number of Joseph Stella's still lifes from about 1909 — when he came into contact with Italian Futurism — appear to have been influenced by Impressionism in a scintillating, flecked brushwork and certainly in their bright, prismatic colorism, but by the time of the Armory Show in New York City in 1913, his work, though still with Impressionist overtones, was more animated and dynamic, with an underlying Cubist structure already breaking up into lines and areas of force and movement. A year later, as in his *Spring,* Stella had turned quite completely to a Futurist aesthetic, but that mode was not in itself formally inimicable to Impressionism, and indeed, many of the leading Italian Futurists had begun their professional careers working in an Impressionist manner. Likewise, the very complex early art of Alfred Maurer seems to have reached a maturity of Matisse-influenced Fauvism through a brief flirtation with Impressionism which took place around 1907, after a number of years of monumental figure painting which combines to varying degrees qualities of Whistler, the early Robert Henri, and a French turn of the century style, an admixture curiously reflected also in the very early — and pre-Impressionist — manner of the American expatriate Richard Miller.

Perhaps the most significant and certainly the most original use of Impressionism among the American Moderns was made by Marsden Hartley. Hartley was born in Lewiston, Maine, and studied in Cleveland under Cullen Yates after which, in 1898, he came to New York City to work with William Merritt Chase, but found Chase's aesthetic too superficial and left in 1900.

Hartley then started spending his summers in Maine, and around 1908 began to produce a series of Maine landscapes which first brought him to public attention.[1] They have, in fact, a curious relationship to Monet's serial approach, for they tend to repeat, if not exactly the same mountain configuration, the same general forms and settings over and over again with seasonal changes reflected in varying color harmonies, a mode he returned to in Maine later in his life with his paintings of Mount Katahdin, though these never embodied Impressionist qualities. Some of the early Maine landscapes did. Several of the first ones employ heavy, thick, dark paint in

jagged forms, with some breaking up of the surfaces, but others are more colorful, interpreting the autumnal appearance of the woods in the Maine hills and mountains in simplified, blocky areas overlaid with the texture of Impressionism. These are intense paintings, with strong entanglements of deep impasto, the paint laid side by side in long flecks — referred to at the time as the "Segantini stitch" after the peculiar method of the then famous Italian Impressionist, Giovanni Segantini, whose work was well known in America.

Hartley's works were seen in 1909 at an exhibition at Alfred Stieglitz' gallery, and were called decorative rather than realistic. For a while these landscape interpretations — often of Blue Mountain in Maine — became more vibrant, with a loosening of paint textures suggesting light in motion; they employ a basically flat picture plane which is emphasized by a high horizon and often by a square format. Hartley's aesthetic led critics to compare his work with that of Ryder, whom he much admired, as well as Adolphe Monticelli and Antonio Mancini. By 1912, however, there had occurred a gradual abandonment of the colorful stitch style for more forceful, severe and simplified Ryder-like shapes, and at the end of that year, Hartley himself went to Europe, where he became exposed to the diverse currents of Modernism. He remained sympathetic toward the American Impressionists, however, and he was later to write perceptively of several of the finest of them, such as Theodore Robinson and John Twachtman.[2]

If Impressionism appears at best to have served as only a passing phase for the American Modernists, the strong urban realism — often with social overtones — of the Ashcan School and "The Eight" might seem diametrically opposed to the light, joyous and carefree nature of Impressionism; certainly Robert Henri and his associates thought of themselves as adding a dramatic urgency missing in American art of their period. Yet, certain qualities and subjects which have already been pointed out as being among the concerns of the Impressionists are akin to the interests of The Eight: the emphasis on the city — especially in the art of Hassam, and even his occasional dealing with the working man — and the utilization by Redfield and other artists of the Pennsylvania School of a technique allied with The Eight suggest that the division is by no means so complete as we, or they, might like to project. Moreover, at least a few of The Eight themselves were even more closely allied with the Impressionists, at least for a period of time.

Perhaps the most surprising inclusion among these is the leader of the group, Robert Henri. Henri, too, studied at the Académie Julian in Paris, but in the early 1890s he gravitated increasingly toward Impressionism.[3] This was true particularly during the summers he spent working out-of-doors in the Forest at Fontainbleau, and he shared Theodore Robinson's dilemma: wishing at once to paint colorfully and spontaneously and yet preserve compositional order and precise drawing. He saw Monet's haystack series at the Durand-Ruel Galleries in 1891 and praised them unqualifiedly, voicing his own interest in capturing seasonal change.[4]

That summer he was in Venice with Redfield; thereafter he returned to this country, continuing his studies under Robert Vonnoh, who had just joined the faculty of the Pennsylvania Academy and who just recently had begun working in an Impressionist mode. When some of Henri's Venetian scenes were exhibited in the winter exhibition at the Academy — along with works by Tarbell and Benson — he was labeled an Impressionist in the manner of Monet.

Henri spent the summers of 1892 and 1893 on the coast of New Jersey, in the former year teaching a class for the Philadelphia School of Design for Women at Atlantic City and in the following year working at Avalon. The pictures done there catch the momentary breeziness of the coast, in a bright, light key, and several pictures of young women seated by the sea — women at one with nature — constitute some of the finest of all American Impressionist paintings. The treatment of the figure still shows a sense of draftsmanship, but displays the light and color and broken tones of orthodox Impressionism. Henri maintains the fidelity of the tangible figure in the manner of Vonnoh and Robinson, though she is formed with a loose brushwork, while the beach, water and sky are created from broad color areas.

Henri's involvement in Impressionism was of short duration however, and his defection by the mid-nineties constituted a great loss for the movement, followed as it was by the deaths of Robinson and then Twachtman. Gradually, as Impressionism became fashionable and, in a sense, academic in its manner of presentation and even in teaching — in the popular international work of Anders Zorn and Joaquin Sorolla, and the more pot-boiler paintings of Hassam, which concentrate primarily upon surface appearance and clever brushwork — Henri turned away from the aesthetic. He wrote: "I am not of the opinion that the spot-broken color, broken mass method is the best for presenting the idea of vibration — I think big flat, or practically flat, masses of form or color may render a sense of light and vibration — if the realization of value and color are right."[5] Yet, in the beautiful cityscapes that he painted in Paris and New York in the late nineties and the early years of this century, though they are dark and dramatic and without color, he still utilized the loose brushwork of Impressionism; and he continued to admire the paintings of Robinson and Twachtman. Years later, in a series of as yet unstudied pastels he drew on Monhegan Island in 1918, there was a partial return to the broken stroke and somewhat broader range of color in landscape that had marked his brief Impressionist period.

The most orthodox Impressionist painter among The Eight was Ernest Lawson, not only in technique but also in his thematic interest; although he was a "pure" landscape painter, the figure is included in a good many of them as accessory, and he did paint a small number of portraits.[6] He was born in Halifax, Nova Scotia, but he spent part of his youth with his family in Kansas City, and in 1889 went to Mexico to study art. In 1890 he continued his studies under John Twachtman at the Art Students' League in New York City, and then under Twachtman and J. Alden Weir at Cos Cob, Connecticut, working with them at just the time of heightened interest in Impressionism. Weir commented on Lawson's work when he first saw his youthful efforts, "By Jove, I've never seen as bad a painter,"[7] and even later, when Theodore Robinson viewed some of Lawson's work after the younger artist had gone to study at the Académie Julian in Paris in 1893, the older man found them crude and without character.

Yet, the influence of Weir and particularly of Twachtman upon Lawson's early work was profound. In some of his early landscapes, Lawson displayed a combination of Twachtman's refinement and Weir's Tonalism, and critics noted a disinterest in subject matter, similar to that of Twachtman. His refined aesthetic sense was sometimes likened to that of Dewing and of Dwight Tryon also. In France, Lawson painted at

Moret-sur-Loing, a popular center for Impressionist landscapists, where he met Alfred Sisley, who had a direct influence on the young American. Lawson also developed a friendship with the British writer, Somerset Maugham, in Paris, and in Maugham's novel *Of Human Bondage,* he is embodied in the character of the painter Frederick Lawson, who also painted at Moret.

Lawson returned to this country in 1894, and in 1898 settled in New York City at 155th Street in Washington Heights. He made this area in particular, and the landscape in and around New York more generally, the subject of his pictorial interpretation. The Harlem and East Rivers, the Hudson at Inwood, and the cliffs at Hoboken were his favorite painting grounds. Some of the work done in the early years of this century, particularly his many winter scenes, still suggest the limited palette and poetic nuances of Twachtman, but in general he adopted a wider color range and a greater concern with real, rather than suggested, space. The rugged scenery corresponded to the more "gutsy" paint qualities he adopted—landscapes with strong configurations and colors applied in a manner critics likened to "crushed jewels"; Duncan Phillips stressed his use of enamel paint.[8] The human figure frequently appeared, but often as squatters, living in old shacks, an unrefined way of life that relates Lawson's painting to that of many of the other members of The Eight, with whom he began to develop a close relationship around 1904-05. Some of Lawson's finest pictures depict his favorite landscape in relationship to the bridges and viaducts crossing them, the man-made structures—symbols of Modernism—reinforcing a sense of structured composition, and producing strong diagonal axes and often strong, but deeply colored, shadows. Lawson's occasional night scenes are beautiful Impressionistic renderings, a coloristic updating of Whistler's nocturnes.

Lawson occasionally painted outside of the New York environment, producing more pastoral visions in scenes among the Vermont hills. Even in these country scenes, however, there is a modern feeling in the strong palette and strong, simplified contours of the landscape: something of the structure of Cézanne and the emotionalism of Vincent Van Gogh. Albert Gallatin, in 1916, commented that Lawson's work was never sweet.[9] The artist's most publicized trip was taken that year to Spain, where he worked in Toledo and Segovia, producing strong work under the brilliant Southern light, more frankly picturesque scenes.[10] In 1931, Lawson (estranged from his wife) moved to Florida and produced a series of very expressionistic interpretations of the tropical landscape, more crudely painted than his earlier work, with overall, flame-like paint applied in a manner creating effects akin to tapestry. In a departure from his customary procedure, he produced a series of murals for the Post Office in Short Hills, New Jersey, completed the year of his death, 1939, which unfortunately were destroyed in 1963.

William Glackens was far more involved with the representation of the contemporary urban scene than was Lawson, but for much of his career he too shared the Impressionist aesthetic, though his style was less original than Lawson's.[11] Glackens was born in Philadelphia and grew up there, working for various Philadelphia papers such as the *Record,* the *Press* and the *Ledger.* He studied irregularly under Thomas Anshutz at the Pennsylvania Academy, and during these years formed close ties with Robert Henri, George Luks, Everett Shinn and John Sloan, all future members of The Eight. He went to

Paris for a year in 1895, though not to study formally, and on his return Luks helped him get a position with the *New York World*; he later did illustrations for the *Herald* and magazines such as *McClure's,* in addition to serving as a reporter for *Scribner's Magazine* and the *Post* during the Spanish-American War.

The basic problem with discussing Glackens' art is that it divides stylistically quite clearly, and seemingly abruptly, into two periods very unequal both in years and in quality. The pictures of the first decade of this century are the better known, the more published and admired, and yet far fewer in number; many of them are park and garden scenes painted in Paris and New York, exciting and dramatic in execution. They depend upon strong tonal contrast and vigorous brushwork, with broad areas of flat paint in a style akin to the early Manet or, contemporaneously, close to the early George Bellows.

Glackens' style is often said to have changed abruptly with the development of his close relationship with the wealthy collector, Albert Barnes, for whom Glackens acted as advisor in assembling the great collection now in the public domain in Merion Station, Pennsylvania. The first acquisition was a work by Pierre Renoir, and Glackens' own manner became quite similar to the style of Renoir, indeed the closest paraphrase of Renoir of any American. Glackens adopted the soft and feathery brushwork, and the hot and bright broken tones with an emphasis upon pinks and purples that characterize much of Renoir's work. Yet Glackens' relationship with the French Impressionists actually appears to have developed earlier; his *Chez Mouquin's,* an ambitious and successful café scene in the manner of Degas, is dated 1905, and his conversion to the style of Renoir may have begun to develop as early as 1906, on his second trip to Europe.

Many of Glackens colorful, Impressionist pictures depict the lively activity in New York's Washington Square; one parade scene of 1912 located there made extensive use of the colorful patterning of flags several years before Hassam turned to that theme. Another large group of Glackens' canvases depict beaches with figures swimming, many of them New York City beaches, and others in a similar style depict boating holidays. Glackens' background as an illustrator lends even his later works a frankly more illustrational air than displayed by Renoir's work; Glackens recorded specific activities. His color was often bolder than Renoir's, more in a 20th-century aesthetic. He was a friend of Alfred Maurer, and knew Matisse through Gertrude and Leo Stein. He painted a number of nudes, the earlier ones such as his well-known *Nude with Apple* of 1910, a modern Venus or Eve, which displays a very frank and modern sexuality, quite distinct from the timidity of the nudes of Edmund Tarbell, for instance. But his occasional later monumental figure paintings, done in the 1920s and 30s tend to be softer and the people's vacant expressions are somewhat reminiscent of the empty visages of Renoir. The colors of these later pictures tend to be paler and semi-transparent; one writer referred to his figures as having a kind of phosphorescence.[12] These big, rounded, warmer figures of his last several decades suggest a distant debt to Rubens, either through the intermediary of Renoir or through the popular studio imagery of Kenneth Hayes Miller and the "Fourteenth Street School." Among Glackens' most attractive later paintings are some of his still lifes, the majority of which seem to date from around 1925 and thereafter. Though occasionally these too are soft and unsubstantial, many of the fruit-and-flower still lifes display strong drawing

**William James Glackens**

*Breezy Day, Tugboats, New York Harbor.* ca. 1910

Oil on canvas
26 x 31¾ in. (66 x 80.7 cm)
Milwaukee Art Center Collection, Gift of Mr. and Mrs. Donald B. Albert and Mrs. Barbara Albert Tooman

**Ernest Lawson** (above)

*Spring Night, Harlem River.* 1913
Oil on canvas mounted on panel
25 x 30 in. (63.5 x 76.2 cm)
The Phillips Collection, Washington, D.C.

**Ernest Lawson**

*Melting Snow.* n.d.
Oil on canvas
26 x 36 in. (66 x 91.5 cm)
The Daniel J. Terra Collection

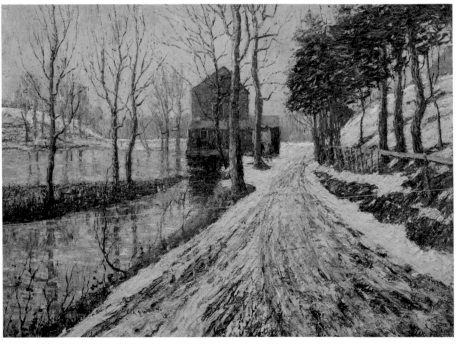

## Ernest Lawson

*Hoboken Heights.* n.d.

Oil on canvas mounted on panel
37½ x 47¼ in. (94 x 119.4 cm)
Norton Gallery and School of Art, West Palm
Beach, Florida

in their overall design, sometimes with bold decorative patterning in tablecloths and backgrounds, and a brilliance in the chromatic display uniting subject and setting.

Among the members of The Eight whose art was significantly related to Impressionism, the most original was undoubtedly Maurice Prendergast.[13] He was born in St. Johns, Newfoundland but grew up in Boston, and much of his career is associated with that city. He was in England and on the Continent in 1886, and was back in Paris during the winter of 1890-91, studying at the Colarossi Academy and the Académie Julian. This, with a relatively late exposure to some of the dominant trends of contemporary art, was the formative period in Prendergast's career. In addition to his academic training, he came under the influence of Whistler and of Post-Impressionist art in France. Furthermore, he sketched on the Parisian Boulevards, building up a repertory of gestures and movements which served him for life, though they were used with increasing simplification. The breezy, nonchalant figures in casual settings remained, too, the major thematic preoccupation of his art. Prendergast was particularly close to the Canadian artist James Wilson Morrice, with whom he sketched in Paris and who virtually introduced him to oil painting. Morrice's work is not unlike Prendergast's, and he maintained a position in Canadian Impressionism somewhat like that of Prendergast in this country's. Another friend was the Australian artist Charles Conder, who had arrived in Paris slightly earlier. Conder settled in England in 1894, about the same time that Prendergast returned to America, and their work done in Paris bears some similarity. However, Prendergast's art appears to owe a greater debt to Conder later in both their careers. The frieze-like arrangement of women and the heavily impastoed tapestry of flattened forms suggest Prendergast's continued interest in and awareness of Conder's work, seen either in American exhibitions or private collections.[14]

When Prendergast returned from Paris, he was a well-trained professional, and his watercolors of Revere Beach, with their light, gay shimmering effects, attracted the attention of such Boston collectors as Mrs. Mongomery Sears when they were exhibited at the Chase Gallery in 1897. He was to remain not only the leading American Impressionist painter in watercolor but one of the great practitioners of that medium. Not all of Prendergast's early watercolors are painted in a high key; some are dark and monochromatic, but all of them exploit the flowing wetness of the medium; his small oils of the period are also often rather dark, and their tonality and simplified form are still in a Whistlerian manner.

Prendergast's early success allowed him to return to Europe. The works painted in Venice in 1898 and 1899, primarily watercolors, are among the most colorful and brilliant of his entire career. He spent some time with the American expatriate William Gedney Bunce, and discovered the pageant art of the Renaissance master Vittorio Carpaccio in Venice. Prendergast's colors became warmer and richer under the Adriatic sun. Waving flags appear often in these works, many years before Hassam utilized the motif, and in Venice Prendergast established the ideographic formulation of figures as swirling circles of color that represent form, a treatment often repeated in brightly-hued parasols, one which became an important technique throughout his career. At this time space was treated in a relatively realistic manner, often with deep recession, though with a lack of atmospheric diminution; distance was suggested by compositional axes and diminution

**Ernest Lawson**

*Hudson River at Inwood.* n.d.
Oil on canvas
30 x 40 in. (76.2 x 102 cm)
Columbus Museum of Art, Ohio, Gift of
Ferdinand Howald

**Maurice Brazil Prendergast**

*Venetian Palaces on the Grand Canal.* 1898

Watercolor on paper
14 x 20¾ in. (35.6 x 62.7 cm)
Collection of Arthur G. Altschul

**Maurice Brazil Prendergast**

*The Grand Canal, Venice.* 1898-99

Watercolor on paper
17½ x 13¾ in. (45 x 34.9 cm)
The Daniel J. Terra Collection

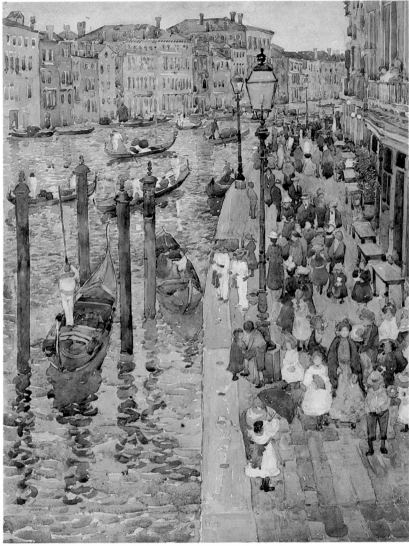

**Maurice Brazil Prendergast** (above)

*Opal Sea.* ca. 1903-06
Oil on canvas
22 x 34 in. (55.9 x 86.3 cm)
The Daniel J. Terra Collection

**Maurice Brazil Prendergast**

*Garden by the Sea.* 1916
Oil on canvas
21 x 33 in. (53.3 x 83.8 cm)
University of California, Los Angeles, Gift
of Mrs. Charles Prendergast

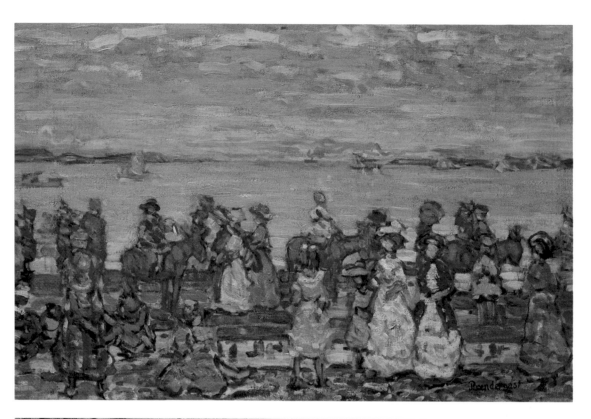

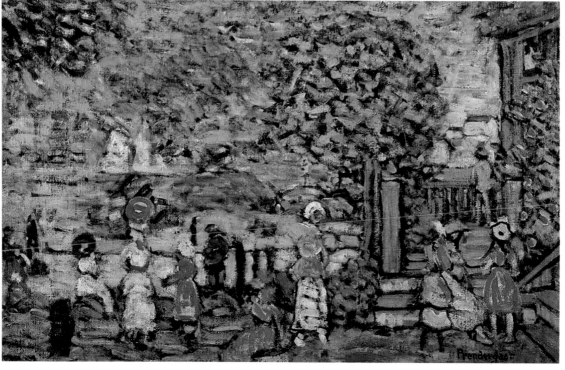

**Robert Henri**

*Girl Seated by the Sea.* **1893**

Oil on canvas
18 x 24 in. (45.7 x 61 cm)
Collection of Mr. and Mrs.
Raymond J. Horowitz

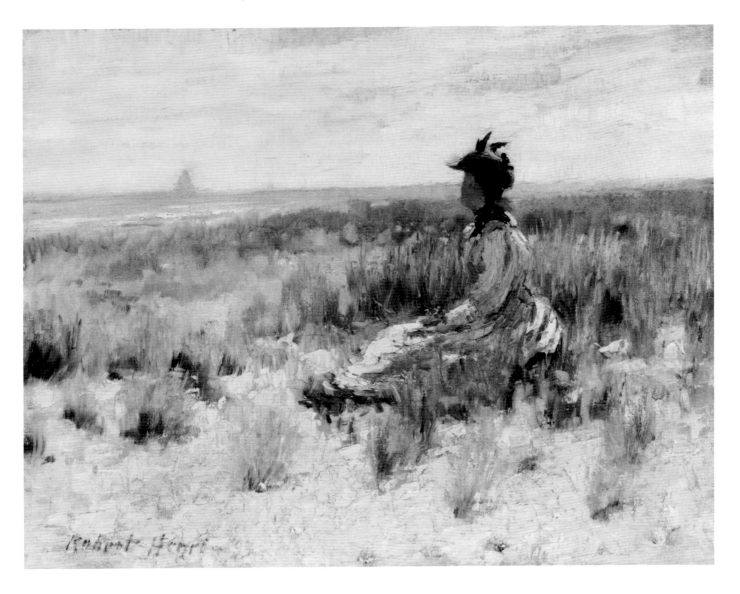

of formal size. Color and light were Impressionistic, but the lack of interest in atmosphere relates Prendergast's art more to the Post-Impressionists. Prendergast's Venetian watercolors also bear a curious similarity to the sun-drenched works painted in that city only a few years earlier by the Scottish master of the Glasgow School, Arthur Melville.

On his return home he spent much of his time in New York City, and became friendly with some of the other future members of The Eight through William Glackens. He had missed meeting Henri in Paris though Henri had himself established a friendship with Morrice. In the watercolors and oils that Prendergast painted in the very early years of this century, he established the basic design and format of most of his future work. He established an overall scheme for his compositions in nearly abstract rhythms, with figures, trees and other elements simplified and altered to conform to that design and to emanate a sense of joyous informality. These are basically two dimensional, and resemble tapestries. Some relationship with Divisionism is suggested, but more to the followers of Seurat than to the master himself; Prendergast eschewed both the spatial concerns and the chromatic science of the great Frenchman. Prendergast's watercolors were painted out-of-doors, the oils in the studio, and some of the oils are painted in a loose technique approaching that utilized in the watercolors, but there is more variety to Prendergast's technique than is usually credited. Subject matter, for the most part, remained constant: park, beach and holiday scenes, usually warm and summery, though occasional winter scenes are often strongly colored also.

In 1908, Prendergast had an exhibition in New York City which the critics decried as work of unadulterated slop. This was followed by more travel in Europe, in France in 1909-10 and Italy 1911-12. In 1914 Prendergast moved to New York City, having received some sympathetic treatment in the 1913 Armory Show and having found total incomprehension in Boston. He became closer to other members of The Eight, and had a studio in the same building on Washington Square South as William Glackens.

Prendergast's work after his 1909 trip to Paris was increasingly influenced by the decorative Post-Impressionism of such artists as Paul Signac and Ker-Xavier Roussel. His work became larger, and he painted more in oils than in watercolors than he had previously. While an abstract, decorative treatment appears to drive from Roussel, some of his painting displays a structural emphasis which relates to Cézanne; Prendergast was one of the first American artists to appreciate Cézanne, a regard which he helped to spread to some of his colleagues. The influence of Cézanne can be seen most directly in a series of still lifes that Prendergast seems to have painted immediately after the Armory Show, although his pictures are seldom dated and his chronology difficult to establish. Cézanne's example may also account for a series of large-scale paintings of bathers that Prendergast created at this time, though their rhythmic structure and often paler colors again suggests Roussel and perhaps Conder. Increasingly deaf in his later years, Prendergast became seriously ill in 1922 and two years later he died.

Prendergast's art was quite inimitable, despite the many signs of cross-currents with British and Continental developments. Perhaps some connection with and influence upon the work of Jane Peterson can be seen, both in the non-atmospheric, allover decorative patterning, in the preference for park and garden scenes, and even the use of flag motifs, but Peterson preferred tighter, wiry outlines drawn from the aesthetic of Art Nouveau to

designate her forms.[15]

A New England artist whose interest in the urban scene allies his work thematically with that of The Eight is Arthur Clifton Goodwin.[16] Goodwin was born in Portsmouth, New Hampshire, but much of his professional career was spent in Boston, where a friendship that he developed about 1903 with the artist Louis Kronberg furthered his art appreciably. Kronberg, somewhat forgotten today, was best known for his images of ballet dancers, themselves somewhat indebted to Degas. Kronberg encouraged Goodwin in the mastery of the pastel medium, and Goodwin's able practice of pastel painting attracted steady Boston patronage. It also gave Goodwin an increased freedom of touch which infused his Boston city scenes with vigor, and the influence of the artists of the Boston School encouraged a bright coloration. Given the nature of the medium, Goodwin's pastels are more Impressionist than his oils, but his work in both media is concerned with the life of the city: that of Boston until 1921 when he moved to New York, where he had occasionally painted earlier. His Liberty Loan Parade of 1918 is not unrelated to the contemporary "Flag" series of Childe Hassam in its subject, color and its high vantage point, but the vigorous application of paint and broader, less systematic methodology of painting is closer to the work of John Sloan and George Luks. In the 1920s, Goodwin acquired a farm in Old Chatham, New York, where Luks also lived, and a relationship between the two artists is highly probable.

**Arthur Clifton Goodwin**

*Liberty Loan Parade*. 1918

Oil on canvas
29⅛ x 36¼ in. (73.8 x 93 cm)
Indianapolis Museum of Art, Martha Delzell
Memorial Fund

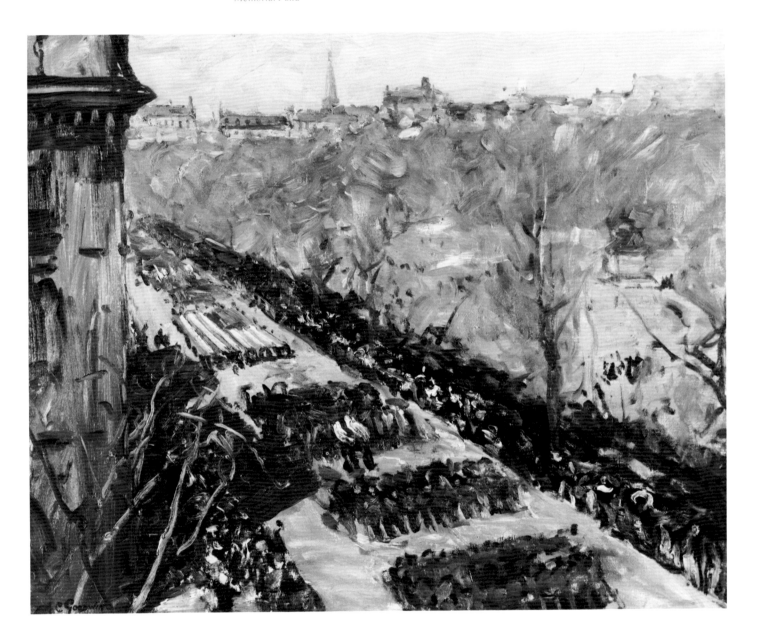

1. The most perceptive discussion of this early phase of Hartley's art is Charles H. Caffin, "Unphotographic Paint: The Texture of Impressionism," *Camera Work,* No. 28 (October, 1909), 20-23; for a general treatment of the artist, see Elizabeth McCausland, *Marsden Hartley,* Minneapolis, University of Minnesota Press, 1952.

2. Hartley, *Adventures,* especially 74-79.

3. The standard monograph on Henri is the very perceptive volume by William Innes Homer, *Robert Henri and His Circle,* Ithaca and London, Cornell University Press, 1969. Henri's Impressionist manner is given particular attention on pages 211-13; the later, Monhegan pastels are overlooked.

4. Homer, *Robert Henri,* 62.

5. Homer, *Robert Henri,* 232.

6. For Lawson, see the books by Henry and Sidney Berry-Hill, Guy Pene Du Bois, and Frederic Newlin Price; the articles by Jeanne Adeney, Catherine Beach Ely, Albert E. Gallatin, Duncan Phillips, Frederic Newlin Price, Ameen Rihani, Frederic Fairchild Sherman, and Arthur Strawn; and the exhibition catalogues: Dennis R. Anderson, *Ernest Lawson Exhibition,* A C A Galleries, New York City, 1976, Barbara O'Neal, *Ernest Lawson, 1873-1939,* National Gallery of Canada, Ottawa, Ontario, 1967, and Adeline Lee Karpiscak, *Ernest Lawson, 1873-1939,* University of Arizona Museum of Art, Tucson, 1979.

7. Frederic Newlin Price, "Lawson, of the 'Crushed Jewels,'" *International Studio,* Vol. 78, no. 321 (February, 1924), 367.

8. Duncan Phillips, "Ernest Lawson," *American Magazine of Art,* Vol. 8, no. 7 (May, 1917), 260.

9. Albert E. Gallatin, "Ernest Lawson," *International Studio,* Vol. 59, no. 233 (July, 1916), xv.

10. "Ernest Lawson's Spanish Pictures," *Fine Arts Journal,* Vol. 35, no. 3 (March, 1917), 225-27.

11. The primary works on Glackens are Vincent John De Gregorio, "The Life and Art of William J. Glackens," unpublished Ph.D. dissertation, The Ohio State University, 1955, and Ira Glackens, *William Glackens and the Ashcan Group,* New York, Crown Publishers, 1957. See also catalogue essays by Leslie Katz, *William Glackens in Retrospect,* City Art Museum of St. Louis, 1966, and Richard Wattenmaker, *The Art of William Glackens,* Rutgers, the State University, New Brunswick, New Jersey, 1967. The bibliography lists articles by Margaret Breuning, Guy Pene Du Bois, Catherine Beach Ely, Albert E. Gallatin, Everett Shinn, and Forbes Watson, and the unsigned piece, "W.J. Glackens: His Significance to the Art of His Day," *Touchstone,* Vol. 7, no. 3 (June, 1920), 191-99.

12. Wattenmaker, *Glackens,* 10.

13. The primary studies of Prendergast are the essays in the two exhibition catalogues, Hedley Howell Rhys, *Maurice Prendergast, 1859-1924,* Museum of Fine Arts, Boston, 1960, and Eleanor Green, *Maurice Prendergast,* University of Maryland Art Gallery, College Park, Maryland, 1976. See also the fine essay by Gwendolyn Owens in *Watercolors by Maurice Prendergast from New England Collections,* Sterling And Francine Clark Art Institute, Williamstown, Massachusetts, 1978. There is a book on Prendergast by Margaret Breuning, *Maurice Prendergast,* New York, Whitney Museum of American Art, 1931. See also the catalogues: Walter Pach, *Maurice Prendergast Memorial Exhibition,* Whitney Museum of American Art, New York City, 1934; Van Wyck Brooks' essay in Addison Gallery of American Art, *The Prendergasts: Retrospective Exhibition of the Work of Maurice and Charles Prendergast,* Phillips Academy, Andover, Massachusetts, 1938; and Charles H. Sawyer, *Maurice Prendergast,* M. Knoedler & Co., Inc., New York City, 1966. There is an article on the brothers Prendergast by Sawyer, "The Prendergasts," *Parnassus,* Vol. 10, no. 5 (October, 1939), 9-11, an article by William Milliken, "Maurice Prendergast, American Artist," *The Arts,* Vol. 9, no. 4 (April, 1926), 181-92, and Brooks' essay was separately reprinted. The reader should also consult the interesting article by Prendergast's friend and fellow-artist, Charles Hovey Pepper, "Is Drawing to Disappear in Artistic Individuality?" *The World Today,* Vol. 19, no. 1 (July, 1910), 716-19.

14. See the extremely perceptive essay by Cecily Langdale in the catalogue *Charles Conder, Robert Henri, James Morrice, Maurice Prendergast: The Formative Years, Paris 1890s,* Davis & Long Company, New York City, 1975.

15. For Peterson, see William Malcolm, "Jane Peterson, Artist," *Americana,* Vol. 37, no. 3 (July, 1943) 495-501, and Stuart P. Feld, *Jane Peterson: A Retrospective Exhibition,* Hirschl & Adler Galleries, Inc., New York City, 1970.

16. See the essays in two catalogues: Lionello Venturi, *Arthur Clifton Goodwin: A Selective Exhibition,* Addison Gallery of American Art, Phillips Academy, Andover, Massachusetts, 1946, and Sandra Emerson, Lucretia H. Giese, and Laura C. Luckey, *A.C. Goodwin, 1864-1929,* Museum of Fine Arts, Boston, 1974.

**Frederick Carl Frieseke**

*The Yellow Room.* ca. 1902

Oil on canvas
32¼ x 32 in. (82.6 x 81.3 cm)
Museum of Fine Arts, Boston, Bequest of
John T. Spaulding

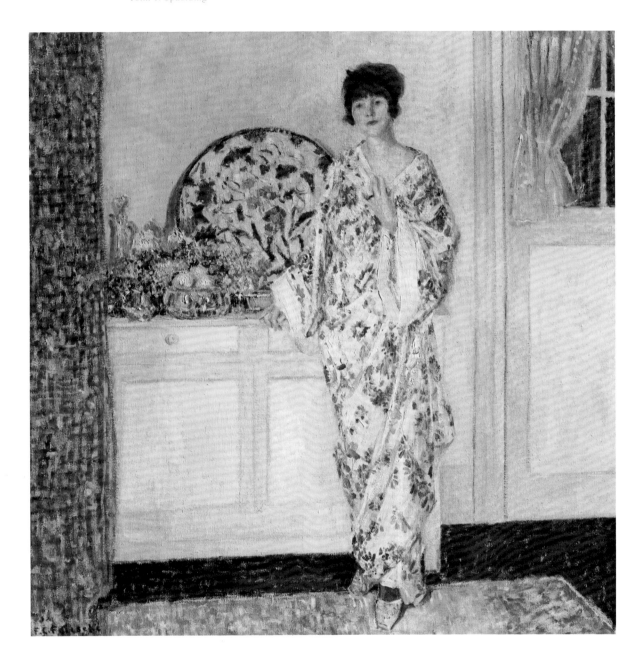

*Piazza di Spagna, Roma.* 1897
Oil on canvas
23 x 29½ in. (58 x 74 cm)
The Newark Museum

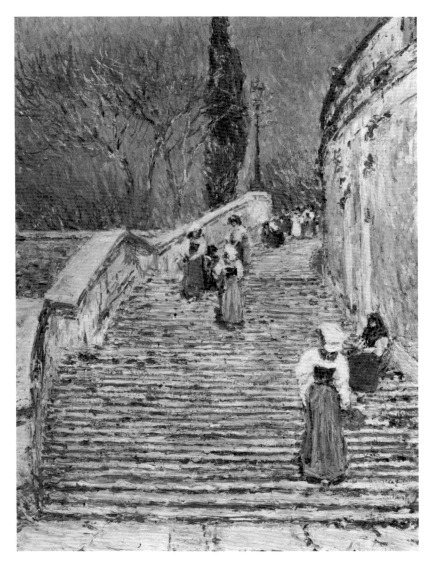

The notes for this chapter will be
found on page 127.

# 17 Conclusion: Impressionism at the Expositions

Impressionism as a vital aesthetic — practiced by some of the nation's leading artists, discussed by the major critics, collected by many of the significant art patrons and exhibited by many dealers and our nascent public art institutions — was a dominant factor in American art beginning in the late 1880s and continuing well into the 20th century. Its subsequent evaluation, as with almost all artistic movements, has been subject to the vicissitudes of its correspondence to later artistic and cultural developments. The initial reaction against it brought forth many adverse charges. To the artists and critics favoring the Ashcan School, it was too simpleminded and too unconcerned with the dynamics of contemporary life. To the European-oriented Modernists, Impressionism as it continued to be practiced and praised was too conservative and *retarditaire*. To the more traditional art lovers, the art of Hassam and his colleagues was too imitative, and to the lovers of ideal art it was without soul. To the more nationalistically minded, it was blatantly French-derived and seemingly uninvolved with the representation of purely and truly American values, whatever those might be.

Of course, cultural climates change continually, and the many practitioners of Impressionism in this country have begun to be reevaluated yet again, and upwards, sometimes indiscriminately so. Certainly they are valued today both for their aesthetic contribution and for the validity of their search for truth and beauty, as we traverse the history of their journey on the road that they chose among the many, all of which lead toward that common artistic goal.

The progress of American Impressionism, in both critical and popular esteem, may be traced in a simplified fashion in the representation of that aesthetic in the great international fairs held in this country, which, here as well as abroad, often serve as an accurate predictor if not a prescient bellwether of artistic developments. There was, of course, no Impressionism, American or European, in the great Centennial Exposition at Philadelphia in 1876, but we have seen in the comments of Hamlin Garland and others that the movement won the day at Chicago in the Columbian Exposition of 1893.[1] That Impressionist triumph would seem a strange one, for one searches in vain through the official catalogue of the Fine Arts exhibition for the names of Monet, Renoir, Pissarro or Sisley. The only French "Impressionist" officially represented was Jean-François Raffaelli, who was soon to become the darling of American critics and collectors when he followed up the success of his three works exhibited at the Exposition with several personal — and triumphant — trips to America, including Chicago. But this exclusion of the French Impressionists — as late as 1893! — is not surprising, since the president of the Jury of Admission was Gérôme, one of the vice-presidents Léon Bonnat, and the other members included Bouguereau, Lefebvre and Vibert. The most "Impressionist" French picture commissioned was the great mural of *Modern Woman* by Mary Cassatt — not a French artist, not an example of her more Impressionist manner, and not in the Fine Art exhibit!

But French Impressionist pictures *were* to be seen at the Chicago exhibition, sent not from France, but lent from American private collections such as the Cassatt, Spencer and Palmer collections which numbered works by Manet, Monet, Renoir, Sisley, Pissarro and Degas. Actually, at least tentative ventures toward Impressionism could be found in the work of some of the major artists sent officially from other European nations, such as

Max Liebermann from Germany or Philip Wilson Steer from England, and French influence could be found in the work of England's Henry La Thangue and George Clausen, as well as in some of the pictures of artists of the Newlyn School. And it was in the painting sent over from Scandinavia that many contemporary critics found their Impressionism; such artists as Fritz Thaulow from Norway and Anders Zorn and Bruno Liljefors of Sweden were extremely popular in this country, and were much written about.

The American Impressionists focused upon here were much in evidence in the Fine Arts display, and some of the pictures included here were exhibited at Chicago; some of the painters were involved in the mural decoration of the Manufactures and Liberal Arts Building also. Although Impressionism by no means dominated the American painting display, such works stood out, and included were pictures by such artists as Abbott Graves whom space does not permit us to include here. Furthermore, the American Impressionist work received official commendation with medals awarded to Childe Hassam, Willard Metcalf, Robert Reid, Theodore Robinson, John Singer Sargent, Edmund Tarbell, John Twachtman and Frederic Porter Vinton.

The International Universal Exposition of 1900 was held in Paris. Most of the then active Impressionists were shown, but the general profile of the movement was low in the American exhibit. The late Theodore Robinson was represented by a number of works; Twachtman was not represented. Robert Reid not only showed a painting, *Azaleas,* but provided one of the mural decorations, of *America Unveiling her Natural Strength.* Among the pictures included there was Edmund Tarbell's *Venetian Blind,* illustrated herein. One of the purposes of the American display, as set forth in the preface of the exhibition catalogue, was to prove that American art had emancipated itself to a large degree from the European domination that had marked the American exhibit in the previous Paris international show of 1889, where the Director General had been quoted as saying that "The United States Section was but a brilliant annex to the French Section . . ."

The Fine Arts Gallery of the Pan-American Exposition held in Buffalo in 1901 was limited to American artists only, but the Impressionists and Impressionist-related works were even more in evidence. There were large displays of the work of Hassam, Weir and Twachtman, and some of the younger artists were included, particularly those of the Pennsylvania School such as Redfield, Schofield and Symons. By 1901, the ranks of the American Impressionists were sustaining their losses; four works by Theodore Robinson were also included. Again, some of the paintings in the present exhibition were shown, such as Weir's *In the Sun,* and it is possible that Mary Cassatt's great *A Cup of Tea* was the work entitled *Tea,* one of three that represented her.

By 1904, in the Universal Exposition in St. Louis, Impressionism was no longer a controversial issue, and paintings by Monet and Renoir hung side by side with those of Bouguereau. In the American exhibit, the Impressionists still dominated and still represented the most advanced mode present; Theodore Robinson was one of the few deceased artists honored by inclusion. A special, "contemporary" feature was a display of mural painting (that both original works and photographs), and Frank Benson was among those showing in this display. Given the Midwestern location of the show, it is not surprising that the Hoosier school was much in evidence, including Theodore Steele's *The Old Mills,* and one of Wores' recent

Spanish paintings was displayed.

A fitting conclusion to this brief survey lies in a few observations concerning the art at the Panama-Pacific Exposition held in San Francisco in 1915.[2] Impressionism had traveled across the Continent in the thirty years since Durand-Ruel's New York show in 1886, through Chicago and St. Louis and, indeed, at San Francisco it had become officially "historicized." Single room displays were given to Chase, Hassam, Redfield, Sargent, Tarbell, Twachtman and Whistler among the artists here discussed, as well as to several painters whose work is at least related to the Impressionist movement, for example Duveneck and Gari Melchers; only the California artists chosen for such distinction — William Keith, Arthur Mathews and Francis McComas — were unrelated to Impressionism.

In the general United States display, the other Impressionists were present en masse: Cassatt, Schofield, Metcalf, Paxton, Hale, Spencer, Garber, Perry, Weir, Frieseke and Glackens. Frieseke won the grand prize for oil paintings; Metcalf received a medal of honor. Lawson, Vonnoh and Reid won gold medals, and Glackens and Perry won silver ones. Robert Reid painted the mural decorations in the dome of the Fine Arts Building; among the other muralists were the well-known painters William de Leftwitch Dodge; Frank Du Mond; the dean of San Francisco artists, Arthur Mathews; and Edward Simmons, a member of The Ten American Painters. The critical palm for mural contribution went to the influential English artist, Frank Brangwyn, however. The European Impressionists were well represented, with, for instance, a whole wall of works by Monet, but the critical appreciation of the foreign paintings was still highest in regard to the Swedish contingent, again including Zorn and Liljefors.

For writers attending the San Francisco fair, the exhibition proved not only that American art had come of age, but that California, more specifically, had begun to make valid artistic contributions. In addition to Keith, Mathews and McComas, a whole host of younger regional artists were represented, and among these, Joseph Raphael and Euphemia Charlton Fortune received silver medals. But there were new forces present too; critics discussed and disputed the merits of such painters as Robert Henri and George Bellows, though it was too soon to expect the shadow of the recent Armory Show to fall upon an official exposition.

By 1915, as the Exposition in San Francisco so concretely showed, Impressionism had become a piece of art history; it had occurred, and it was established. Although of the major figures of the movement only Twachtman had then been added to the roster of deceased masters, and the rest of the artists here discussed and illustrated were still active, and even though new painters were continuing to explore the aesthetics of Impressionism, most of the creative and innovative impulses had passed, along with the struggle for its critical acceptance.

Nevertheless, in a larger sense, Impressionism had not only entered into the mainstream of the nation's art history, it had become interwoven into the fabric of contemporary life. In a quite profound, short article that appeared in *The New Republic* at the same time as the San Francisco Exposition, Louis Weinberg put his finger on the overall, ultimate significance of Impressionism. Weinberg discussed the impact of Impressionism not only upon art, but upon literature, music, journalism and art criticism itself. Weinberg distinguished between the technique of Impressionism — which he succinctly analyzed according to its broken color, purer palette, luminous

shadows and vibrating light used as a means of recording the transitory nature of phenomena and the fluidity of motion — and Impressionism as a principle. He saw that principle as one reflecting a philosophy of change, of the ephemeral. "The railroad, the telephone, the telegraph, the linotype machine, the steamship, the phonograph and 'the movies,' all contribute to the rush of changing impressions, to the bewildering multiplicity of effects." He summed up the situation as follows: "We move in an age of impressionistic living. All is atmosphere and movement. There are relatively few hard contours, all is a matter of environment. There are few fundamental bed-rock traditions or deeply rooted faiths. Most things are enveloped in the vibrating atmosphere of doubt — light, the rationalists call it. In our social life, in our industrial life, in our political and in our very religious life, all is change."[3]

From the moral certainties and affirmations of David's *Oath of the Horatii* to the splintered, kaleidoscopic fragmentation of Duchamp's *Nude Descending a Staircase* lies a philosophic and cultural change of profound proportions. Impressionism, of all artistic movements, was the most important way station on that aesthetic road, and the contributions of the American artists were not unworthy.

1. The wealth of articles, pamphlets, catalogues and books published in connection with the international expositions was enormous; this was especially true of those of 1876, 1893 and 1915. The reader is directed to the official catalogues issued for the Fine Arts section of each Exposition. Not surprisingly, many of the leading writers and critics of the period, whose works have been mentioned here, wrote about the art at the 1893 "White City" — Mariana Van Rensselaer, John Van Dyke, William Howe Downes, Will Low and others — describing and praising the pictures by American painters, including many of the Impressionists.

2. For a study of American Impressionism, the major publications related to the Panama-Pacific Exposition are Christian Brinton's *Impressions of the Art at the Panama-Pacific Exposition*; Eugen Neuhaus, *The Galleries of the Exposition*, San Francisco, P. Elder & Co., 1915; and the monumental 2-volume *Catalogue De Luxe of the Department of Fine Arts*, by John E.D. Trask and John Nilsen Laurvik.

3. Louis Weinberg, "Current Impressionism," *The New Republic*, Vol. 2, no. 18 (March 6, 1915), 124-25.

**Robert Spencer**

*The White Tenement.* 1913

Oil on canvas
30 x 36⅛ in. (76.2 x 91.7 cm)
The Brooklyn Museum, John B. Woodward
Memorial Fund

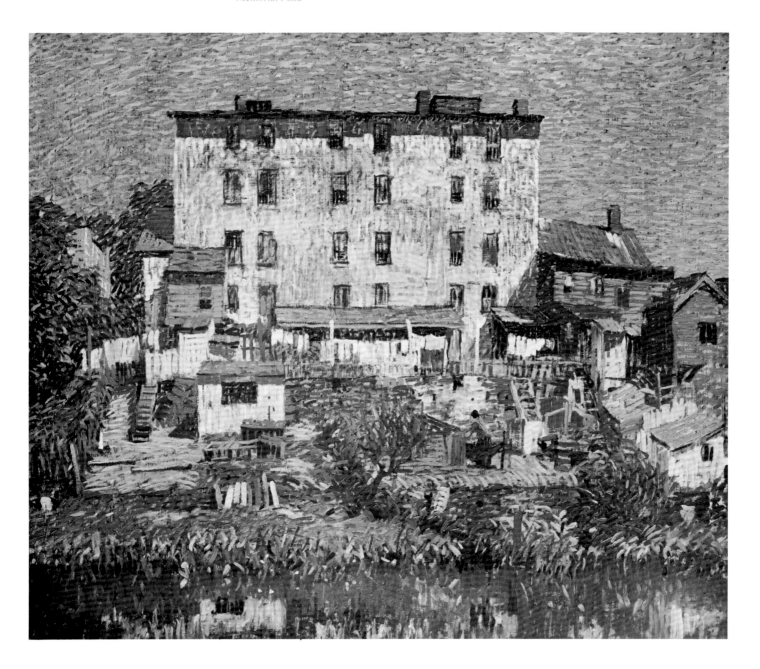

### John Ottis Adams (1851-1927)

•*The Bank*. n.d.

Oil on linen
33 x 48 in. (84 x 122 cm)
F. C. Ball Collection, on permanent loan to
the Ball State University Art Gallery from the
Ball Brothers Foundation

• indicates a work which is not
illustrated.

### Otto Henry Bacher (1856-1909)

*Nude Outdoors*. 1893

Oil on canvas
35½ x 22⅝ in. (89 x 57 cm)
Collection of The Cleveland Museum of Art,
Gift of Will Low Bacher

### Cecilia Beaux (1863-1942)

*New England Woman
(Mrs. Jedediah H. Richards)*. 1895

Oil on canvas
43 x 24 in. (109 x 61 cm)
The Pennsylvania Academy of the Fine Arts,
Temple Fund Purchase, 1896

### Frank Weston Benson (1862-1951)

*The Sisters*. 1899

Oil on canvas
40 x 39½ in. (102 x 99 cm)
Collection of IBM Corporation,
Armonk, New York

*Eleanor*. 1907

Oil on canvas
25 x 30 in. (63.5 x 76.2 cm)
Museum of Fine Arts, Boston,
Hayden Collection

*Summer*. 1909

Oil on canvas
36⅜ x 44⅜ in. (91.5 x 111.8 cm)
Museum of Art, Rhode Island School of
Design, Providence, Rhode Island, Bequest
of Isaac C. Bates

### John Leslie Breck (1860-1899)

*Garden at Giverny*. ca. 1887

Oil on canvas
18 x 22 in. (45.6 x 55.9 cm)
Private collection, courtesy
Berry-Hill Galleries

### John Appleton Brown (1844-1902)

*Apple Blossoms*. n.d.

Oil on canvas
31 x 40 in. (78.7 x 101.6 cm)
Bentley-Sellars Collection

### Dennis Miller Bunker (1861-1890)

*Wild Asters*. 1889

Oil on canvas
25 x 30 in. (63.5 x 76.2 cm)
Private Collection

### Soren Emil Carlsen (1853-1932)

*Summer Clouds*. 1913

Oil on canvas
39⅛ x 45 in. (99 x 114 cm)
The Pennsylvania Academy of the Fine Arts,
Temple Fund Purchase, 1913

### Mary Stevenson Cassatt
### (1844-1926)

*Lydia Cassatt, the Artist's Sister
(Lydia Reading the Morning
Paper #1)*. 1878

Oil on canvas
32 x 23½ in. (81.3 x 59.7 cm)
Joslyn Art Museum, Omaha, Nebraska

*A Cup of Tea*. ca. 1880

Oil on canvas
25⅝ x 36⅜ in. (63.5 x 91.4 cm)
Museum of Fine Arts, Boston, Maria
Hopkins Fund

*Smiling Sarah in a Hat Trimmed in
a Pansy (Bess with Dog)*. ca. 1901

Oil on canvas
26½ x 22½ in. (67 x 57 cm)
Scripps College, Claremont, California,
Gift of General and Mrs. Edward Clinton
Young, 1946

### William Merritt Chase (1849-1916)

*Bath Beach*. ca. 1887

Oil on canvas
27 x 49¾ in. (68.6 x 124.5 cm)
The Parrish Art Museum, Southampton, New
York, Littlejohn Collection

*Landscape (Over the Hills and Far
Away)*. ca. 1885-87

Oil on canvas
25¼ x 32¾ in. (65.3 x 83.2 cm)
Henry Art Gallery, University of Washington,
Seattle, Horace C. Henry Collection

*Sunset Glow*. ca. 1890-95

Oil on panel
16 x 14½ in. (40.6 x 36.8 cm)
Spencer Museum of Art, The University of
Kansas, Gift of Mr. and Mrs. Charles
Slawson and the Charles Z. Offin Art Fund

*Shinnecock Landscape*. ca. 1895

Oil on canvas
16 x 24 in. (40.6 x 61 cm)
The Parrish Art Museum, Southampton,
New York

*Lady with a Parasol*. ca. 1899

Oil on canvas
16 x 12 in. (40.6 x 30.1 cm)
Collection of Mr. and Mrs.
Thomas R. Gallander

*The Olive Grove*. ca. 1910

Oil on panel
23¼ x 33¼ in. (58.4 x 83.9 cm)
The Daniel J. Terra Collection

### Charles Courtney Curran
### (1861-1942)

*Lotus Lilies*. 1888

Oil on canvas
18 x 32 in. (49.7 x 81.2 cm)
The Daniel J. Terra Collection

*Summer Clouds*. 1917

Oil on canvas
50 x 40 in. (127 x 101.6 cm)
The Daniel J. Terra Collection

## John Appleton Brown

*Apple Blossoms.* n.d.
Oil on canvas
31 x 40 in. (78.7 x 101.6 cm)
Bentley-Sellars Collection

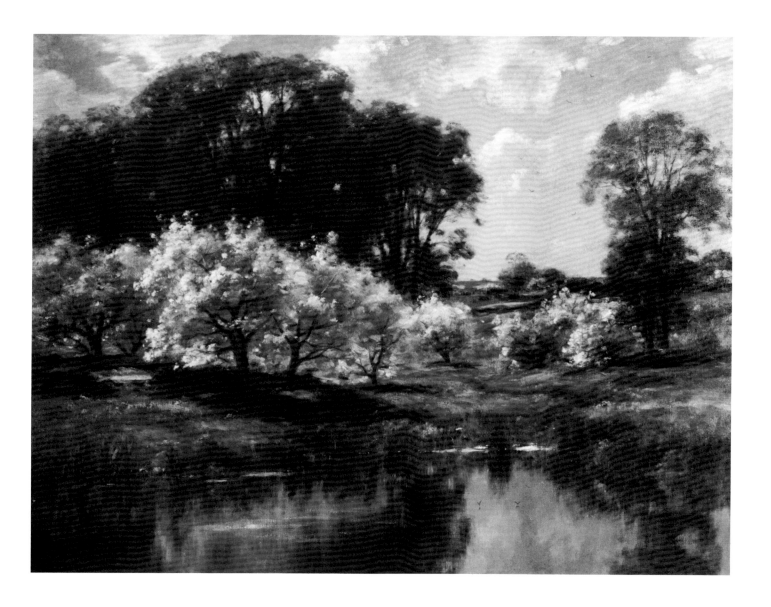

**Joseph Rodefer De Camp
(1858-1923)**

*The Little Hotel (at Rocky Neck,
Gloucester, Massachusetts).* 1903

Oil on canvas
20 x 24¼ in. (51 x 61 cm)
The Pennsylvania Academy of the Fine Arts,
Temple Fund Purchase, 1904

*Seamstress.* 1916

Oil on canvas
36¼ x 28 in. (91.5 x 71.1 cm)
Corcoran Gallery of Art

**Thomas Wilmer Dewing
(1851-1938)**

*Madeline.* n.d.

Oil on canvas
22¼ x 19¼ in. (56.5 x 50.3 cm)
The Daniel J. Terra Collection

*A Reading.* 1897

Oil on canvas
20¼ x 30¼ in. (50.8 x 76.3 cm)
National Collection of Fine Arts,
Smithsonian Institution, Bequest of Henry
Ward Ranger through the National Academy
of Design

*The Hermit Thrush.* ca. 1893

Oil on canvas
34¾ x 46⅛ in. (86.4 x 116.9 cm)
National Collection of Fine Arts,
Smithsonian Institution, Gift of John Gellatly

*The White Birch.* ca. 1896-1899

Oil on canvas
42½ x 54 in. (106.7 x 137.2 cm)
Washington University Gallery of Art,
St. Louis

**John Joseph Enneking (1841-1917)**

*Trout Brook, North Newry, Maine
(The Brook, Maine Woods).* n.d.

Oil on canvas
24⅛ x 30⅛ in. (61.4 x 76.5 cm)
Henry Art Gallery, University of Washington,
Seattle, Horace C. Henry Collection

**Mark Fisher (1841-1923)**

*The Duck Pond.* n.d.

Oil on canvas
14¼ x 20⅜ in. (37 x 52 cm)
De Ville Galleries, Los Angeles

**Frederick Carl Frieseke
(1874-1939)**

*Good Morning.* n.d.

Oil on canvas
32 x 26 in. (81.3 x 66 cm)
The Butler Institute of American Art,
Youngstown, Ohio

*The Yellow Room.* ca. 1902

Oil on canvas
32¼ x 32 in. (82.6 x 81.3 cm)
Museum of Fine Arts, Boston, Bequest of
John T. Spaulding

**Daniel Garber (1880-1958)**

*Tanis.* 1915

Oil on canvas
60 x 46¼ in. (152.4 x 117 cm)
The Warner Collection of Gulf States Paper
Corporation, Tuscaloosa, Alabama

*The Quarry (Across the Delaware
from Limeport, Pennsylvania).* 1917

Oil on canvas
50 x 60 in. (127 x 152.4 cm)
The Pennsylvania Academy of the Fine Arts,
Temple Fund Purchase, 1918

**William James Glackens
(1870-1938)**

*Still Life with Three Glasses.* n.d.

Oil on canvas
20 x 29 in. (50.8 x 73.7 cm)
The Butler Institute of American Art,
Youngstown, Ohio

*Breezy Day, Tugboats, New York
Harbor.* ca. 1910

Oil on canvas
26 x 31¾ in. (66 x 80.7 cm)
Milwaukee Art Center Collection, Gift of Mr.
and Mrs. Donald B. Albert and Mrs. Barbara
Albert Tooman

*Bathhouse, Bellport.* 1914

Oil on canvas
26 x 32 in. (66 x 81.3 cm)
Private Collection

**Arthur Clifton Goodwin
(1866-1933)**

*Liberty Loan Parade.* 1918

Oil on canvas
29⅛ x 36¼ in. (73.8 x 93 cm)
Indianapolis Museum of Art, Martha Delzell
Memorial Fund

**Philip Leslie Hale (1865-1931)**

*The Crimson Rambler.* n.d.

Oil on canvas
25 x 30 in. (63 x 76.2 cm)
The Pennsylvania Academy of the Fine Arts,
Temple Fund Purchase, 1909

*In the Garden.* n.d.

Oil on canvas
30 x 25 in. (76.2 x 63 cm)
Collection of Messrs. James and Timothy
Keny

**Marsden Hartley (1887-1943)**

• *Late Autumn.* 1908

Oil on academy board
12 x 14 in. (30.5 x 35.6 cm)
University Gallery, University of Minnesota,
Minneapolis, Bequest of Hudson Walker
from the Ione and Hudson Walker Collection

**Frederick Childe Hassam
(1859-1935)**

*Le Jour de Grand Prix.* 1887

Oil on canvas
24 x 31 in. (61 x 78.7 cm)
Museum of Fine Arts, Boston, Ernest
Wadsworth Longfellow Fund

*Geraniums.* 1888

Oil on canvas
18¼ x 12⅞ in. (46 x 30.5 cm)
The Hyde Collection

*Washington Arch, Spring.* 1890

Oil on canvas
26 x 21½ in. (66.1 x 53.3 cm)
The Phillips Collection, Washington, D.C.

*Commonwealth Avenue, Boston.*
ca. 1892

Oil on canvas
22¼ x 30½ in. (55.9 x 76.5 cm)
The Daniel J. Terra Collection

*Celia Thaxter in Her Garden.* 1892

Oil on canvas
22⅛ x 18⅛ in. (56 x 46 cm)
National Collection of Fine Arts,
Smithsonian Institution, Gift of John Gellatly

*Home of the Hummingbird.* 1893

Watercolor on paper
14 x 10 in. (35.6 x 25.4 cm)
Collection of Arthur G. Altschul

*The Stewart Mansion, New York
City.* 1893

Oil on canvas
18 x 22 in. (45.7 x 55.9 cm)
Collection of the Santa Barbara Museum of
Art, Preston Morton Collection

*Piazza di Spagna, Roma.* 1897

Oil on canvas
23 x 29½ in. (58 x 74 cm)
The Newark Museum

*The Hovel and the Skyscraper.* 1904

Oil on canvas
34¾ x 31 in. (88.3 x 78.7 cm)
Collection of Mr. and Mrs.
Meyer P. Potamkin

**Frank Weston Benson** (above)

*Eleanor.* 1907

Oil on canvas
25 x 30 in. (63.5 x 76.2 cm)
Museum of Fine Arts, Boston,
Hayden Collection

**Frank Weston Benson**

*Summer.* 1909

Oil on canvas
36⅜ x 44⅜ in. (91.5 x 111.8 cm)
Museum of Art, Rhode Island School of
Design, Providence, Rhode Island, Bequest
of Isaac C. Bates

*Still Life, Fruits.* **1904**

Oil on canvas
20 x 30¼ in. (63.5 x 76.8 cm)
Portland Art Museum, Portland, Oregon,
Gift of Col. C.E.F. Wood, in memory of his
wife, Nanny Moale Wood.

*Provincetown.* **1909**

Oil on canvas
24 x 23 in. (61 x 58.5 cm)
Canajoharie Library and Art Gallery,
Canajoharie, New York

*Sunset at Sea.* **1911**

Oil on burlap
34 x 34 in. (86.4 x 86.4 cm)
Brandeis University Art Collection, Rose Art
Museum, Gift of Mr. and Mrs. Monroe
Geller, New York

*The Union Jack, New York, April
Morn.* **1918**

Oil on canvas
36 x 30⅛ in. (91.3 x 76.5 cm)
Hirshhorn Museum and Sculpture Garden,
Smithsonian Institution

## Robert Henri (1865-1929)

*Girl Seated by the Sea.* **1893**

Oil on canvas
18 x 24 in. (45.7 x 61 cm)
Collection of Mr. and Mrs.
Raymond J. Horowitz

## Arthur Hoeber (1854-1915)

*Salt Marshes of Northern New
Jersey.* **n.d.**

Oil on canvas
20 x 24 in. (50.8 x 61 cm)
The Reading Public Museum and Art Gallery,
Reading, Pennsylvania

## Winslow Homer (1836-1910)

*An Adirondack Lake.* **1870**

Oil on canvas
24¼ x 38¼ in. (61.6 x 97.2 cm)
Henry Art Gallery, University of Washington,
Seattle, Horace C. Henry Collection

## George Inness (1825-1894)

*Morning, Catskill Valley.* **1894**

Oil on canvas
33⅜ x 54 in. (84 x 137.2 cm)
Santa Barbara Museum of Art, Preston
Morton Collection

## Ernest Lawson (1873-1939)

*Spring Night, Harlem River.* **1913**

Oil on canvas mounted on panel
25 x 30 in. (63.5 x 76.2 cm)
The Phillips Collection, Washington, D.C.

*Hudson River at Inwood.* **n.d.**

Oil on canvas
30 x 40 in. (76.2 x 102 cm)
Columbus Museum of Art, Ohio, Gift of
Ferdinand Howald

*Hoboken Heights.* **n.d.**

Oil on canvas mounted on panel
37½ x 47¼ in. (94 x 119.4 cm)
Norton Gallery and School of Art, West Palm
Beach, Florida

*Spring Thaw.* **n.d.**

Oil on canvas
25 x 30 in. (63.5 x 76.2 cm)
The Daniel J. Terra Collection

*Melting Snow.* **n.d.**

Oil on canvas
26 x 36 in. (66 x 91.5 cm)
The Daniel J. Terra Collection

*Smiling Sarah in a Hat Trimmed in a Pansy (Bess with Dog).* ca. 1901

Oil on canvas
26½ x 22½ in. (67 x 57 cm)
Scripps College, Claremont, California, Gift of General and Mrs. Edward Clinton Young, 1946

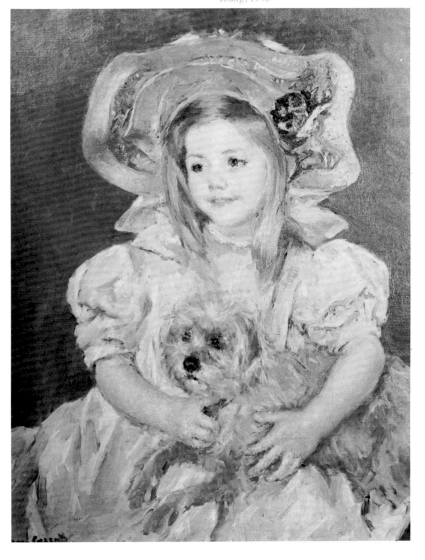

### Willard Leroy Metcalf (1853-1925)

*The White Veil.* 1909

Oil on canvas
36 x 36 in. (91.5 x 91.5 cm)
The Detroit Institute of Arts, Gift of Charles Willis Ward, 1915

*The Cornish Hills.* 1911

Oil on canvas
35 x 40 in. (88.9 x 101.6 cm)
Collection of Mr. and Mrs. Thomas W. Barwick

*The River.* 1919

Oil on canvas
26 x 29 in. (66 x 75.6 cm)
The Daniel J. Terra Collection

### Richard Emil Miller (1875-1943)

*Reverie.* n.d.

Oil on canvas
45 x 58 in. (114.3 x 147.3 cm)
The St. Louis Art Museum

*Reverie.* n.d.

Oil on canvas
36 x 34 in. (91.4 x 86.4 cm)
Museum of Art, Rhode Island School of Design, Providence, Rhode Island, Gift of Mrs. William C. Baker

### John Francis Murphy (1853-1921)

*Autumn Landscape.* n.d.

Oil on canvas
7⅛ x 9⅛ in. (17.8 x 22.9 cm)
Corcoran Gallery of Art

### William McGregor Paxton (1869-1941)

*The Croquet Players.* ca. 1898

Oil on canvas
32 x 21 in. (81.3 x 53.3 cm)
Collection of Mrs. Robert Douglas Hunter

*The Yellow Jacket.* 1907

Oil on canvas
27 x 22⅛ in. (69 x 60 cm)
Collection of Mr. and Mrs. Richard Anawalt

*The Front Parlor.* 1913

Oil on canvas
27 x 22⅛ in. (68.6 x 56.2 cm)
The St. Louis Art Museum, Cora E. Ludwig Bequest by exchange and Edward Mallinckrodt, Sr., Bequest by exchange

*Nude.* 1915

Oil on canvas
24 x 33 in. (61 x 84 cm)
Museum of Fine Arts, Boston, Hayden Collection

*The Other Room.* 1916

Oil on canvas
31½ x 17½ in. (80 x 44.5 cm)
El Paso Museum of Art

### Lilla Cabot Perry (1848-1933)

*Japan.* 1900

Oil on canvas
17¾ x 21¾ in. (45 x 55.3 cm)
Coggins Collection of American Art

### William Lamb Picknell (1853-1897)

*Road to Concarneau.* 1880

Oil on canvas
42⅜ x 79¾ in. (106.8 x 202 cm)
Corcoran Gallery of Art

### Edward Henry Potthast (1857-1927)

*Manhattan Beach.* n.d.

Oil on canvas mounted on board
12 x 16 in. (30.6 x 40.6 cm)
The Merrill J. Gross Collection

**William Merritt Chase** (above)

*Shinnecock Landscape.* ca. 1895

Oil on canvas
16 x 24 in. (40.6 x 61 cm)
The Parrish Art Museum, Southampton,
New York

**William Merritt Chase**

*Bath Beach.* ca. 1887

Oil on canvas
27 x 49¾ in. (68.6 x 124.5 cm)
The Parrish Art Museum, Southampton, New
York, Littlejohn Collection

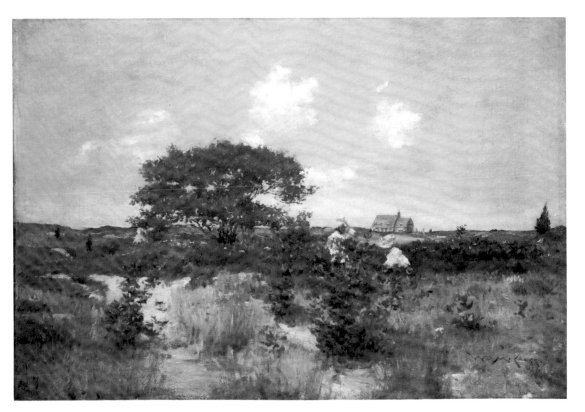

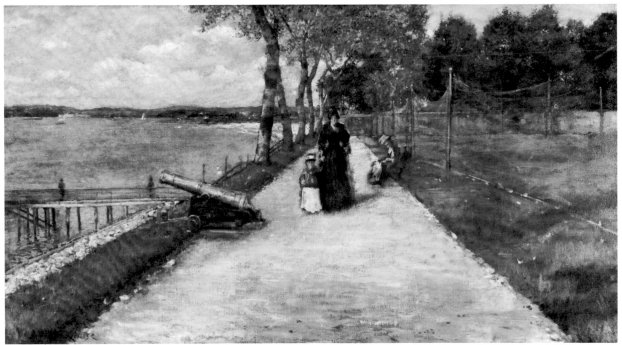

## William Merritt Chase

*Landscape (Over the Hills and Far Away).* ca. 1885-87
Oil on canvas
25¼ x 32¾ in. (65.3 x 83.2 cm)
Henry Art Gallery, University of Washington,
Seattle, Horace C. Henry Collection

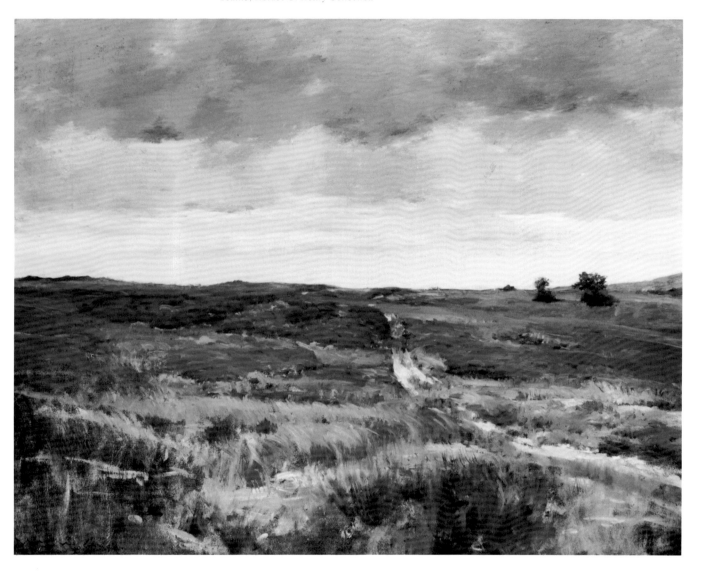

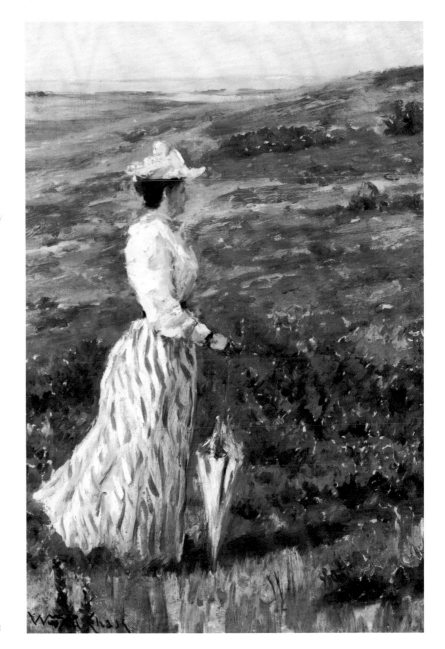

*Lady with a Parasol.* ca. 1899
Oil on canvas
16 x 12 in. (40.6 x 30.1 cm)
Collection of Mr. Thomas R. Gallander

### Maurice Brazil Prendergast (1859-1924)

*Revere Beach.* 1896
Watercolor and pencil on paper
13½ x 9⅞ in. (34.5 x 25.1 cm)
The St. Louis Art Museum

*Venetian Palaces on the Grand Canal.* 1898
Watercolor on paper
14 x 20¾ in. (35.6 x 62.7 cm)
Collection of Arthur G. Altschul

*The Grand Canal, Venice.* 1898
Watercolor on paper
17½ x 13¾ in. (45 x 34.9 cm)
The Daniel J. Terra Collection

*Opal Sea.* ca. 1903-06
Oil on canvas
22 x 34 in. (55.9 x 86.3 cm)
The Daniel J. Terra Collection

*Garden by the Sea.* 1916
Oil on canvas
21 x 33 in. (53.3 x 83.8 cm)
University of California, Los Angeles, Gift of Mrs. Charles Prendergast

*Autumn Festival.* ca. 1917-18
Oil on canvas
21½ x 32⅛ in. (52.3 x 81.3 cm)
The Phillips Collection, Washington, D.C.

*Crepuscule.* ca. 1920
Oil on canvas
18 x 22 in. (50.8 x 55.9 cm)
Scripps College, Claremont, California, Gift of General and Mrs. Edward Clinton Young, 1946

### Joseph Raphael (1872-1950)

*Rhododendron Fields.* 1915
Oil on canvas
30 x 40 in. (76.2 x 101.6 cm)
The Oakland Museum, Gift of the Dr. William Porter Collection

### Edward Redfield (1869-1965)

*Pennsylvania Mills (in Bucks County).* n.d.
Oil on canvas
50 x 56 in. (127 x 148.2 cm)
Collection of Mr. Laurent Redfield

### Robert Reid (1862-1929)

*The Violet Kimono.* ca. 1910
Oil on canvas
29 x 26¾ in. (73.7 x 66.1 cm)
National Collection of Fine Arts, Smithsonian Institution, Gift of John Gellatly

### Theodore Robinson (1852-1896)

*La Vachere ('The Cowherd').* ca. 1888
Oil on canvas
30¼ x 20⅛ in. (77 x 52 cm)
National Collection of Fine Arts, Smithsonian Institution, Gift of William T. Evans

*Winter Landscape.* 1889
Oil on canvas
18¼ x 22 in. (49.8 x 55.9 cm)
The Daniel J. Terra Collection

*Two in a Boat.* 1891
Oil on canvasboard
9¾ x 14 in. (23 x 35.5 cm)
The Phillips Collection, Washington, D.C.

*The Layette.* 1892
Oil on canvas
58⅛ x 36¼ in. (150 x 93 cm)
Corcoran Gallery of Art

*La Débâcle ('The Debacle').* 1892
Oil on canvas
18 x 22 in. (45.8 x 55.9 cm)
Scripps College, Claremont, California, Gift of General and Mrs. Edward Clinton Young, 1946

*The Wedding March.* 1892
Oil on canvas
22 x 26 in. (55.9 x 66.1 cm)
The Daniel J. Terra Collection

*Sunset Glow.* ca. 1890-95
Oil on panel
16 x 14½ in. (40.6 x 36.8 cm)
Spencer Museum of Art, The University of
Kansas, Gift of Mr. and Mrs. Charles
Slawson and the Charles Z. Offin Art Fund

*Valley of the Seine.* 1892
Oil on canvas
26 x 32 in. (66 x 81.2 cm)
Randolph-Macon Woman's College, Gift of
Francis M. Weld, 1945

*Valley of the Seine.* 1892
Oil on canvas
25 x 32½ in. (63.5 x 81.3 cm)
Addison Gallery of American Art, Phillips
Academy, Andover, Massachusetts

*Port Ben, Delaware and Hudson
Canal (Napanoch, New York).* 1893
Oil on canvas
28¼ x 32¼ in. (71.3 x 82 cm)
The Pennsylvania Academy of the Fine Arts,
Gift of the Society of American Artists, 1900

*Canal Scene.* 1893
Oil on canvas
16 x 22 in. (40.6 x 55.9 cm)
The Daniel J. Terra Collection

*White Bridge.* 1893
Oil on canvas
15 x 22 in. (38.1 x 55.9 cm)
Collection of Mr. and Mrs. Ralph Spencer

*Boats at a Landing.* 1894
Oil on canvas
18½ x 22 in. (47 x 55.9 cm)
Collection of Mr. and Mrs.
Meyer P. Potamkin

*Union Square.* 1895
Oil on canvas
20 x 17 in. (51.8 x 44.1 cm)
New Britain Museum of American Art, New
Britain, Connecticut, Alix W. Stanley Estate

## John Singer Sargent (1856-1925)

*Dennis Miller Bunker Painting at
Calcot.* 1888
Oil on canvas
26¾ x 25 in. (66.2 x 63.5 cm)
The Daniel J. Terra Collection

*Gourds.* n.d.
Watercolor on paper
13⅞ x 19¾ in. (33 x 48.4 cm)
The Brooklyn Museum, Purchased by special
subscription, 1909

*Pomegranates.* n.d.
Watercolor on paper
14⅛ x 21 in. (35.9 x 51 cm)
The Brooklyn Museum, Purchased by special
subscription, 1909

*Alpine Pool.* 1909
Oil on canvas
27½ x 42¾ in. (69.9 x 108.6 cm)
The Metropolitan Museum of Art,
George A. Hearn Fund, 1907

## Walter Elmer Schofield (1867-1944)

*The Rapids.* n.d.
Oil on canvas
50¼ x 60¼ in. (129 x 153 cm)
National Collection of Fine Arts,
Smithsonian Institution, Bequest of Henry
Ward Ranger through the National Academy
of Design

## Robert Spencer (1879-1931)

*The White Tenement.* 1913
Oil on canvas
30 x 36⅛ in. (76.2 x 91.7 cm)
The Brooklyn Museum, John B. Woodward
Memorial Fund

## Theodore Clement Steele
## (1847-1926)

*Bloom of the Grape.* 1894
Oil on canvas
30⅛ x 40⅛ in. (77 x 102 cm)
Indianapolis Museum of Art,
Delavan Smith Fund

*The Old Mills.* 1903
Oil on canvas
30 x 45 in. (76.2 x 114.3 cm)
Collection of Mr. and Mrs. Clarence W. Long

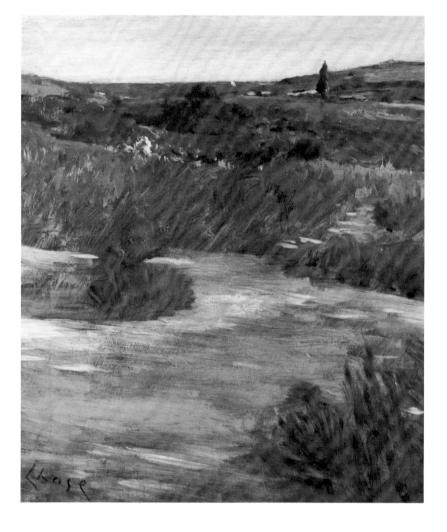

*The Little Hotel (at Rocky Neck, Gloucester, Massachusetts).* **1903**
Oil on canvas
20 x 24¼ in. (51 x 61 cm)
The Pennsylvania Academy of the Fine Arts,
Temple Fund Purchase, 1904

*The White Birch.* **ca. 1896-1899**
Oil on canvas
42½ x 54 in. (106.7 x 137.2 cm)
Washington University Gallery of Art,
St. Louis

## George Gardner Symons
## (1863-1930)

*Silence and Evening Light.* **n.d.**
Oil on canvas
50 x 60 in. (127 x 153 cm)
The Butler Institute of American Art,
Youngstown, Ohio

## Edmund Charles Tarbell
## (1862-1938)

*Three Sisters – A Study in June Sunlight.* **1890**
Oil on canvas
35⅛ x 40⅛ in. (89 x 101.8 cm)
Milwaukee Art Center Collection, Gift of
Mrs. Montgomery Sears

*Mother and Child in a Boat.* **1892**
Oil on canvas
30 x 35 in. (76.2 x 88.9 cm)
Museum of Fine Arts, Boston,
David P. Kimball in memory of his wife
Clara Bertram Kimball

*The Breakfast Room.* **1896**
Oil on canvas
25 x 30 in. (63.5 x 76.2 cm)
The Pennsylvania Academy of the Fine Arts,
Gift of Clement B. Newbold, 1973

*The Venetian Blind.* **n.d.**
Oil on canvas
51⅞ x 38⅜ in. (130 x 96.3 cm)
Worcester Art Museum

## Abbott Handerson Thayer
## (1849-1921)

*Mount Monadnock.* **n.d.**
Oil on canvas
22 x 24 in. (55.9 x 61 cm)
Corcoran Gallery of Art

## Allen Tucker (1866-1939)

*Corn Shucks and Wind Mill.* **1909**
Oil on canvas
30 x 36 in. (76.2 x 91.5 cm)
The Newark Museum

## John Henry Twachtman
## (1853-1902)

*View of the Seine, Neuilly.* **n.d.**
Oil on wood panel
13¼ x 15½ in. (33.1 x 38.2 cm)
University of Nebraska Art Galleries,
Howard S. Wilson Memorial Collection

*Old Holley House, Cos Cob.*
**ca. 1890-1900**
Oil on canvas
25 x 25⅛ in. (63.5 x 64.1 cm)
Cincinnati Art Museum, John J.
Emery Endowment

*Niagara in Winter.* **ca. 1893**
Oil on canvas
30 x 25 in. (76.2 x 63.5 cm)
New Britain Museum of American Art,
New Britain, Connecticut, Harriet Russell
Stanley Fund

*Snow.* **ca. 1895**
Oil on canvas
30 x 30 in. (76.2 x 76.2 cm)
Collection of Mr. and Mrs.
Meyer P. Potamkin

*Meadow Flowers.* **n.d.**
Oil on canvas
33¼ x 22¼ in. (83.9 x 55.9 cm)
The Brooklyn Museum, Polhemus Fund

*Emerald Pool, Yellowstone.* **ca. 1895**
Oil on canvas
24¼ x 30¼ in. (64.1 x 76.7 cm)
The Wadsworth Atheneum, Hartford,
Bequest of George A. Gay, by exchange, and
the Ella Gallup Sumner and Mary Catlin
Sumner Collection

*Yellowstone Falls.* **ca. 1895**
Oil on canvas
30 x 30 in. (76.2 x 76.2 cm)
Collection of Mr. and Mrs. William Marshall
Fuller, Courtesy Amon Carter Museum

*Bark and Schooner (Italian Salt Barks).* **ca. 1900**
Oil on canvas
25 x 25 in. (63.5 x 63.5 cm)
University of Nebraska Art Galleries,
F. M. Hall Collection

# John Joseph Enneking

*Trout Brook, North Newry, Maine
(The Brook, Maine Woods).* n.d.
Oil on canvas
24⅛ x 30⅛ in. (61.4 x 76.5 cm)
Henry Art Gallery, University of Washington,
Seattle, Horace C. Henry Collection

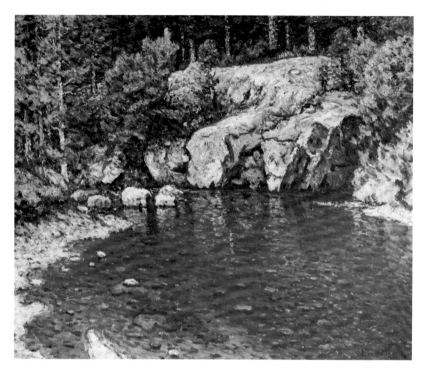

## Robert William Vonnoh
## (1858-1933)

*Poppies.* 1888
Oil on canvas
13 x 18 in. (33 x 46 cm)
Indianapolis Museum of Art,
James E. Roberts Fund

*November.* 1890
Oil on canvas
39⅜ x 32 in. (99.1 x 81.3 cm)
The Pennsylvania Academy of the Fine Arts,
Temple Fund Purchase, 1894

## Julian Alden Weir (1852-1919)

*The Factory Village.* 1897
Oil on canvas
29 x 38 in. (73.6 x 96.5 cm)
Collection of Mrs. Charles Burlingham

*In the Sun.* 1899
Oil on canvas
34 x 26⅞ in. (86.4 x 66.5 cm)
Brigham Young University

*The Plaza: Nocturne.* ca. 1911
Oil on canvas mounted on board
29 x 39½ in. (73.6 x 100.3 cm)
Hirshhorn Museum and Sculpture Garden,
Smithsonian Institution

*Fording the Stream.* ca. 1910-19
Oil on canvas
25⅛ x 30⅛ in. (63.5 x 76.5 cm)
The Newark Museum

*River Scene.* n.d.
Oil on canvas
22¾ x 29¾ in. (55.9 x 73.6 cm)
The Daniel J. Terra Collection

## Theodore Wendel (1859-1932)

*Bridge at Ipswich.* ca. 1908
Oil on canvas
24¼ x 30 in. (52 x 76.2 cm)
Museum of Fine Arts, Boston, Gift of Mr.
and Mrs. Daniel S. Wendel and Purchase,
Arthur Gordon Tomplins Fund

## James Abbott McNeill Whistler
## (1834-1903)

*Canal, San Canciano, Venice.*
ca. 1880
Pastel on brown paper
11¼ x 6½ in. (27.9 x 13.4 cm)
The Westmoreland County Museum of Art,
William A. Coulter Fund

## Theodore Wores (1860-1939)

*Girl with Rhododendrons.* 1899
Oil on canvas
44¾ x 33 in. (111.8 x 83.8 cm)
California Historical Society

*Ancient Moorish Mill, Spain.* 1903
Oil on canvas
29 x 36 in. (73.7 x 91.4 cm)
Dr. Ben Shenson and Dr. A Jess Shenson
Collection

*The Quarry (Across the Delaware*
*from Limeport, Pennsylvania).* **1917**

Oil on canvas
50 x 60 in. (127 x 152.4 cm)

The Pennsylvania Academy of the Fine Arts,
Temple Fund Purchase, 1918

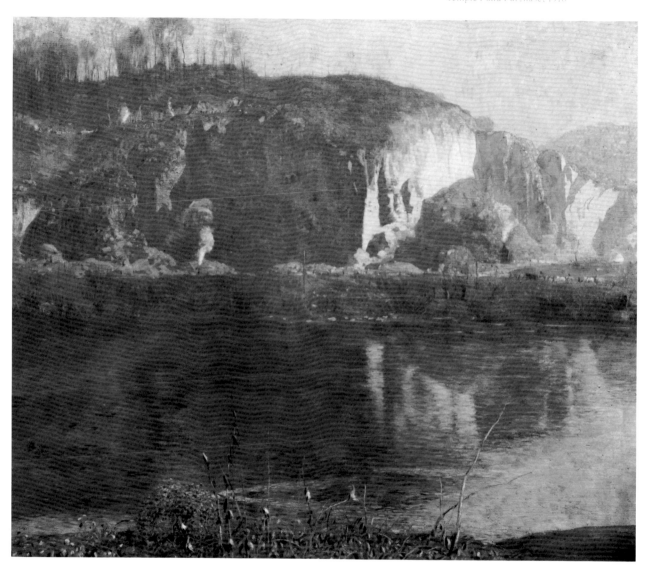

## William James Glackens

*Bathhouse, Bellport.* 1914

Oil on canvas
26 x 32 in. (66 x 81.3 cm)
Private Collection

**Philip Leslie Hale**

**Frederick Childe Hassam**

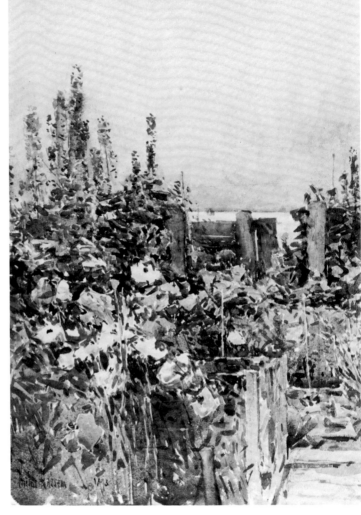

## Frederick Childe Hassam

*The Hovel and the Skyscraper.* 1904

Oil on canvas
34¾ x 31 in. (88.3 x 78.7 cm)
Collection of Mr. and Mrs.
Meyer P. Potamkin

## Frederick Childe Hassam

*Sunset at Sea.* 1911

Oil on burlap
34 x 34 in. (86.4 x 86.4 cm)
Brandeis University Art Collection, Rose Art
Museum, Gift of Mr. and Mrs. Monroe
Geller, New York

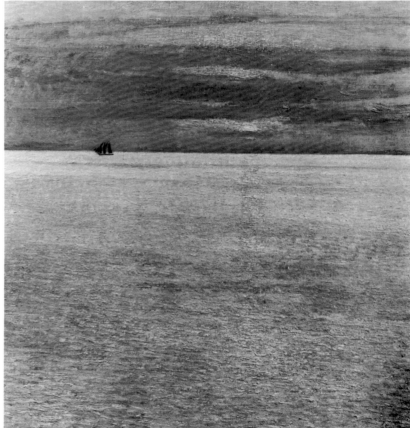

*The Stewart Mansion, New York City.* **1893**

Oil on canvas
18 x 22 in. (45.7 x 55.9 cm)
Collection of the Santa Barbara Museum of
Art, Preston Morton Collection

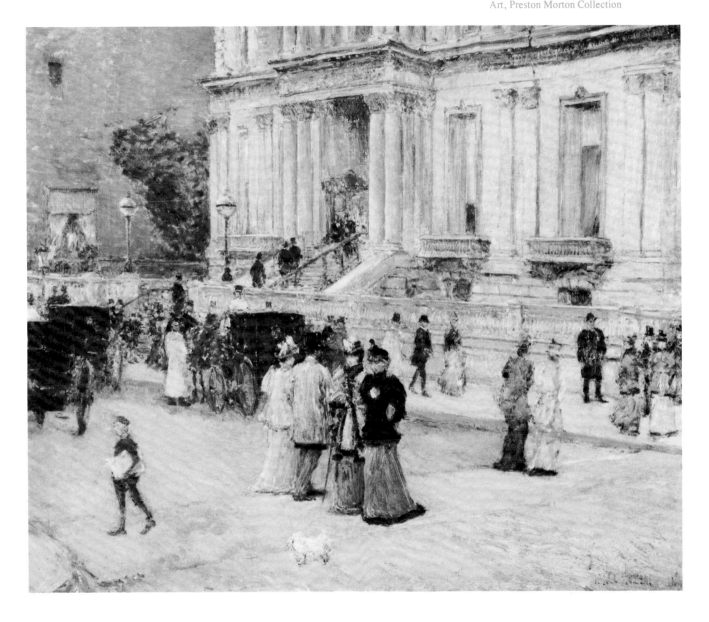

**Arthur Hoeber**

*Salt Marshes of Northern New Jersey.* n.d.

Oil on canvas
20 x 24 in. (50.8 x 61 cm)

The Reading Public Museum and Art Gallery, Reading, Pennsylvania

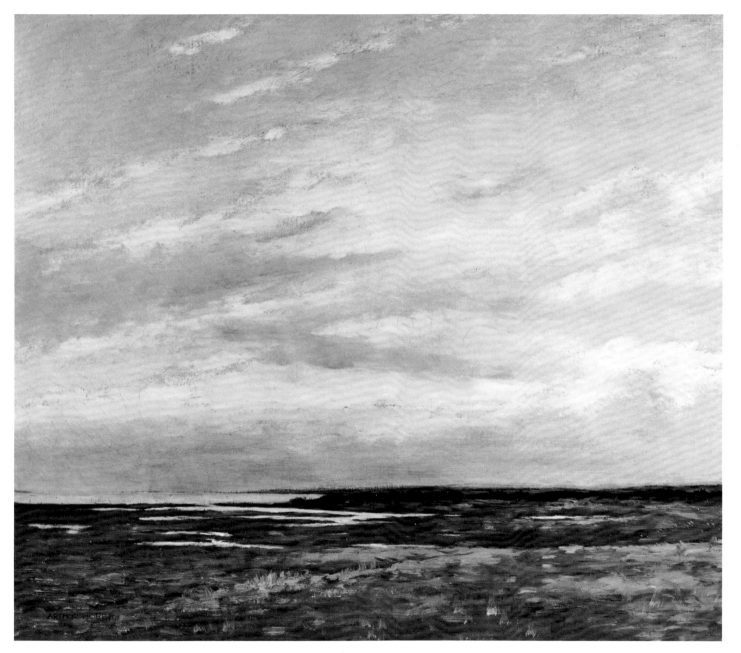

**John Francis Murphy**

*Autumn Landscape.* n.d.
Oil on canvas
7⅛ x 9⅛ in. (17.8 x 22.9 cm)
Corcoran Gallery of Art

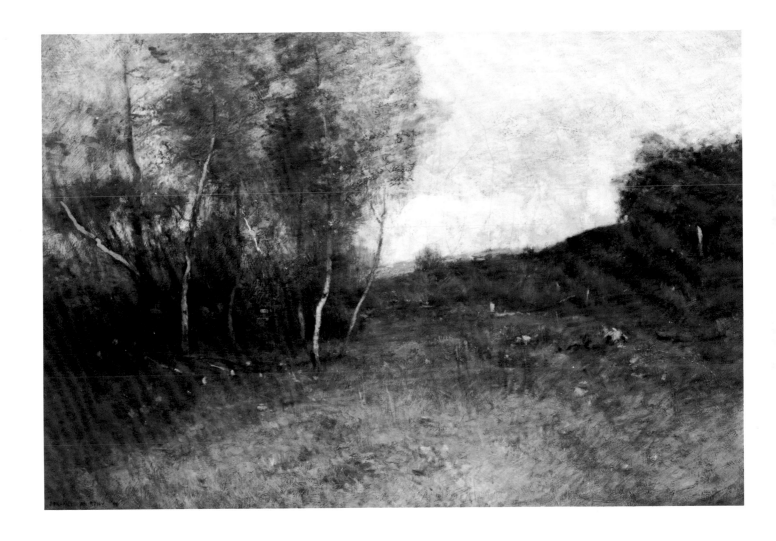

## William McGregor Paxton

*The Other Room.* 1916
Oil on canvas
31½ x 17½ in. (80 x 44.5 cm)
El Paso Museum of Art

*Japan.* 1900
Oil on canvas
17¾ x 21¾ in. (45 x 55.3 cm)
Coggins Collection of American Art

**Maurice Brazil Prendergast**

*Revere Beach.* 1896

Watercolor and pencil on paper
13½ x 9⅞ in. (34.5 x 25.1 cm)
The St. Louis Art Museum

**Maurice Brazil Prendergast**

*Crepuscule.* ca. 1920

Oil on canvas
18 x 22 in. (50.8 x 55.9 cm)
Scripps College, Claremont, California,
Gift of General and Mrs. Edward Clinton
Young, 1946

**Theodore Robinson** (above)

*Valley of the Seine.* 1892

Oil on canvas
26 x 32 in. (66 x 81.2 cm)
Randolph-Macon Woman's College, Gift of
Francis M. Weld, 1945

**Theodore Robinson**

*Valley of the Seine.* 1892

Oil on canvas
25 x 32½ in. (63.5 x 81.3 cm)
Addison Gallery of American Art, Phillips
Academy, Andover, Massachusetts

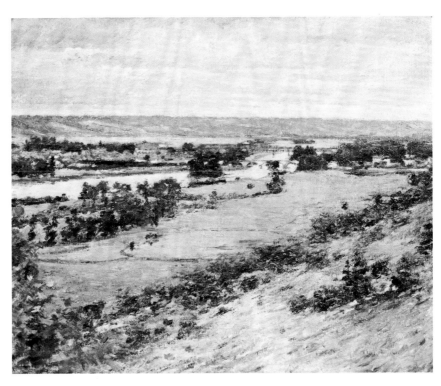

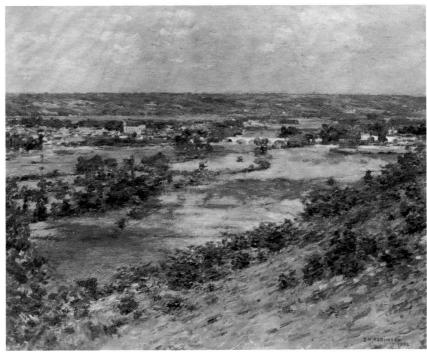

**Theodore Robinson** (above)

*White Bridge.* 1893

Oil on canvas
15 x 22 in. (38.1 x 55.9 cm)
Collection of Mr. and Mrs. Ralph Spencer

**Theodore Robinson**

*Port Ben, Delaware and Hudson Canal (Napanoch, New York).* 1893

Oil on canvas
28¼ x 32¼ in. (71.3 x 82 cm)
The Pennsylvania Academy of the Fine Arts,
Gift of the Society of American Artists, 1900

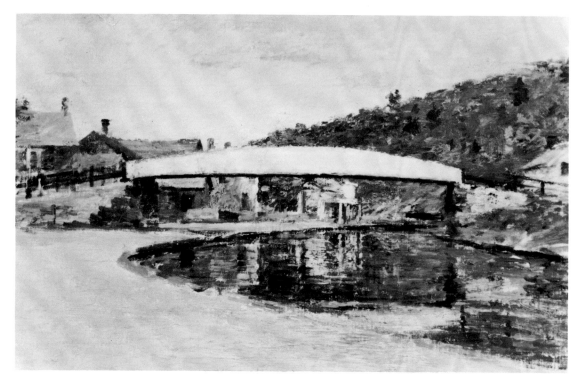

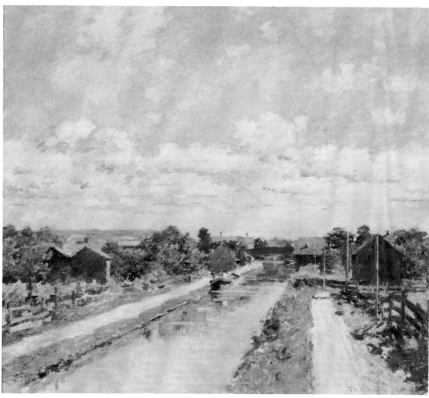

**Theodore Robinson**

*La Vachere ('The Cowherd').*
ca. 1888

Oil on canvas
30¼ x 20⅛ in. (77 x 52 cm)
National Collection of Fine Arts,
Smithsonian Institution, Gift of
William T. Evans

**Theodore Robinson**

*The Layette.* 1892

Oil on canvas
58⅛ x 36¼ in. (150 x 93 cm)
Corcoran Gallery of Art

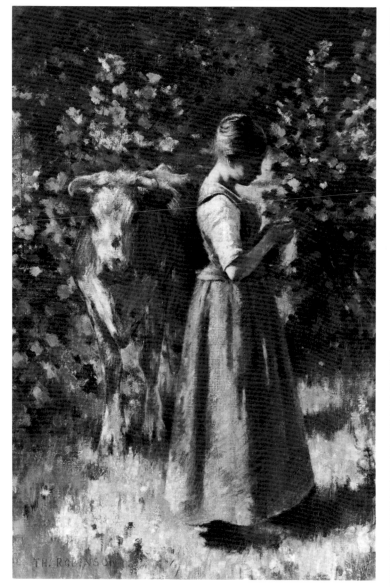

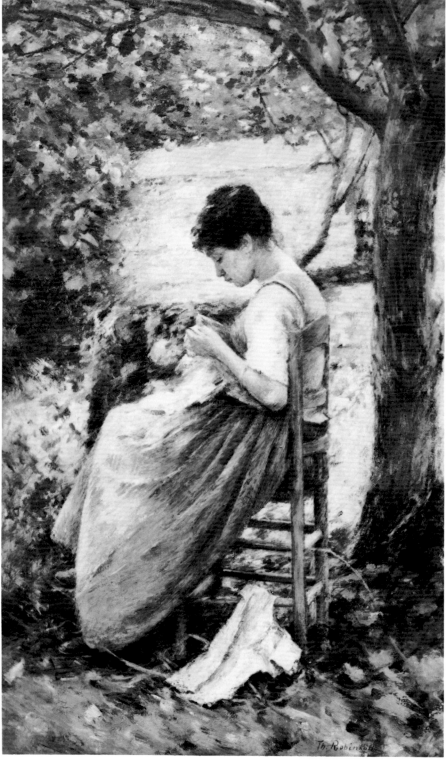

**Theodore Robinson**

*Two in a Boat.* 1891
Oil on canvasboard
9¾ x 14 in. (23 x 35.5 cm)
The Phillips Collection, Washington, D.C.

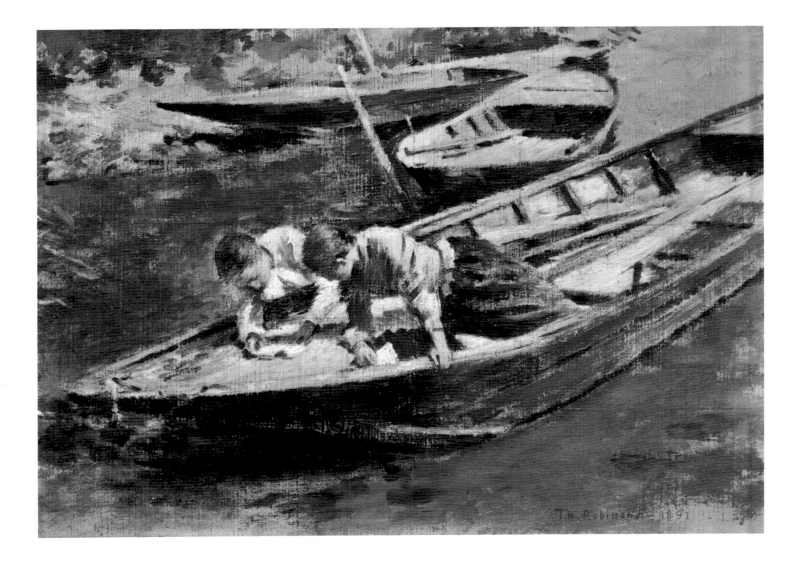

*The Old Mills.* 1903
Oil on canvas
30 x 45 in. (76.2 x 114.3 cm)
Collection of Mr. and Mrs. Clarence W. Long

## George Gardner Symons

*Silence and Evening Light.* n.d.

Oil on canvas
50 x 60 in. (127 x 153 cm)
The Butler Institute of American Art,
Youngstown, Ohio

## Edmund Charles Tarbell

*Mother and Child in a Boat.* 1892

Oil on canvas
30 x 35 in. (76.2 x 88.9 cm)
Museum of Fine Arts, Boston, David P.
Kimball in memory of his wife Clara
Bertram Kimball

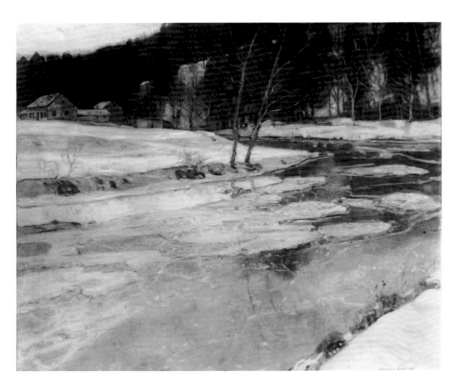

**Abbott Handerson Thayer**

*Mount Monadnock.* n.d.
Oil on canvas
22 x 24 in. (55.9 x 61 cm)
Corcoran Gallery of Art

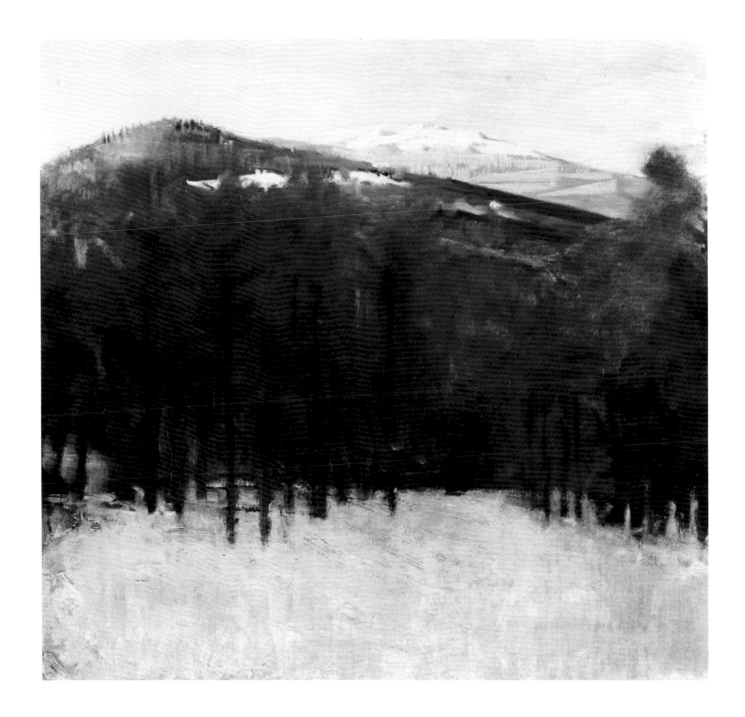

**John Henry Twachtman**

**John Henry Twachtman**

*Niagara in Winter.* ca. 1893

Oil on canvas
30 x 25 in. (76.2 x 63.5 cm)
New Britain Museum of American Art,
New Britain, Connecticut, Harriet Russell
Stanley Fund

*Snow.* ca. 1895

Oil on canvas
30 x 30 in. (76.2 x 76.2 cm)
Collection of Mr. and Mrs.
Meyer P. Potamkin

*Fording the Stream.* ca. 1910-19
Oil on canvas
25⅛ x 30⅛ in. (63.5 x 76.5 cm)
The Newark Museum

**Julian Alden Weir**

*In the Sun.* 1899

Oil on canvas
34 x 26⅞ (86.4 x 66.5 cm)
Brigham Young University

**Theodore Wendel**

*Bridge at Ipswich.* ca. 1908

Oil on canvas
24¼ x 30 in. (52 x 76.2 cm)
Museum of Fine Arts, Boston, Gift of Mr.
and Mrs. Daniel S. Wendel and Purchase,
Arthur Gordon Tomplins Fund

**Theodore Wores**

*Girl with Rhododendrons.* 1899
Oil on canvas
44¾ x 33 in. (111.8 x 83.8 cm)
California Historical Society

# Edmund Charles Tarbell

*The Breakfast Room.* 1896

Oil on canvas
25 x 30 in. (63.5 x 76.2 cm)
The Pennsylvania Academy of the Fine Arts,
Gift of Clement B. Newbold, 1973

# Bibliography

Prepared by William H. Gerdts and Chad Mandeles

This bibliography aims toward completeness on the subject of American Impressionism, with a number of qualifications and exceptions. Publications dealing with a single artist are confined to artists represented in the present exhibition or discussed in the text. Moreover, full bibliographies are not provided for those painters here represented whose work only partially falls into the scope of Impressionism; the art of painters such as Chase, Sargent and Whistler is of great complexity and has been the subject of numerous studies, many of which are irrelevant to the present bibliography. In general, newspaper articles have been omitted. Early exhibition catalogues and records have been included only when the shows were of special historic significance and/or contained essays pertinent to the present study; the proliferation of individual and group exhibitions in the late 19th and early 20th centuries in which the Impressionists figured was so great as to make impractical a complete listing here. An attempt has been made, however, to record all the exhibitions of the last four decades devoted to or substantially concerned with American Impressionism, coinciding with the renewed interest in and reevaluation of this artistic phenomenon.

Books and articles have been listed separately from exhibition catalogues, which have been divided further into individual, group and thematic exhibitions.

Adams, Adeline, *Childe Hassam*. New York: American Academy of Arts and Letters, 1938.

Adeney, Jeanne, "Art Notes (Ernest Lawson)," *Canadian Bookman*, Vol. 12, no. 2 (February, 1930), 39.

Alexandre, Arsene, "La Collection Havemeyer et Miss Cassatt," *La Renaissance*, Vol. 13, no. 2 (February, 1930), 51-56.

_____, "Miss Mary Cassatt, aquafortiste," *La Renaissance de l'art francais et des industries de luxe*, Vol. 7, no. 3 (March, 1924), 127-33.

"American Painters—J. Appleton Brown," *The Art Journal* (New York), Vol. 4 (1878), 198-99.

"An Almost Complete Exhibition of Childe Hassam," *Arts and Decoration*, Vol. 6, no. 3 (January, 1916), 136.

Anderson, Margaret Steele, *The Study of Modern Painting*. New York: The Century Company, 1914.

"Art in Boston: The Wave of Impressionism," *The Art Amateur*, Vol. 24, no. 6 (May, 1891), 141.

Andrew, William W., *Otto H. Bacher*. Madison: Education Industries, 1973.

Arms, John Taylor, "Childe Hassam, Etcher of Light," *Prints*, Vol. 4, no. 1 (November, 1933), 1-12.

Bacon, Henry, "Glimpses of Parisian Art," *Scribner's Monthly*, Vol. 21, no. 2 (December, 1880), 169-81; Vol. 21, no. 3 (January, 1881), 423-31; Vol. 21, no. 5 (March, 1881), 734-43.

Baird, Joseph Armstrong, Jr., ed., *Theodore Wores and the Beginnings of Internationalism in Northern California Painting: 1874-1915*. Davis, California: Library Associates, University Library, University of California, Davis, 1978.

Ball, Robert, and Max W. Gottschalk, *Richard E. Miller, N.A.: An Impression and Appreciation*. St. Louis: The Longmire Fund, 1968.

Barker, Virgil, "The Painting of Allen Tucker," *The Arts*, Vol. 13, no. 2 (February, 1928), 75-88.

Barnard, George Gray, "The Genius of Thayer," *The Arts*, Vol. 1, no. 6 (June-July, 1921), 6-7.

Baur, John I.H., "Introducing Theodore Wendel," *Art in America*, Vol. 64, no. 6 (November-December, 1976), 102-12.

_____, "J. Alden Weir's Partition of 'In the Park,'" *The Brooklyn Museum Quarterly*, Vol. 25, no. 4 (October, 1938), 125-29.

_____, "Photographic Studies by an Impressionist," *Gazette des Beaux-Arts*, Ser. 6, Vol. 30 (October-November, 1946), 319-30.

Beatty, Helen M., "Abbott H. Thayer, 1849-1921," *Scribner's Magazine*, Vol. 70, no. 10 (October, 1921), 379-84.

Beaux, Cecilia, *Background with Figures, Autobiography of Cecilia Beaux*. Boston and New York: Houghton Mifflin Company, 1930.

Bell, Mrs. Arthur, "The Work of Cecilia Beaux," *International Studio*, Vol. 8, no. 32 (October, 1899), 215-22.

Bell, Ralcy Husted, *Art-Talks with Ranger*. New York: G.P. Putnam's Sons, 1914.

Benjamin, Samuel, *Art in America*. New York: Harper & Brothers, Publishers, 1880.

Berry, Rose V.S., "Joseph DeCamp: Painter and Man," *American Magazine of Art*, Vol. 14, no. 4 (April, 1923), 182-89.

_____, "Lillian Westcott Hale—Her Art," *American Magazine of Art*, Vol. 18, no. 2 (February, 1927), 59-70.

Berry-Hill, Sidney, and Henry Berry-Hill, *Ernest Lawson, American Impressionist, 1873-1939*. Leigh-on-Sea, England: F. Lewis, 1968.

Beuf, Carlos, "The Etchings of Childe Hassam," *Scribner's Magazine,* Vol. 84, no. 4 (October, 1928), 415-22.

Beurdeley, Yveling Rambaud, "Miss Cassatt," *L'Art dans les deux mondes,* No. 1 (November 22, 1890).

Biddle, George, "Some Memories of Mary Cassatt," *The Arts,* Vol. 10, no. 2 (August, 1926), 107-11.

Bizardel, Yvon, *American Painters in Paris.* New York: Macmillan Co., 1960.

Blashfield, Edwin Howland, *A Commemorative Tribute to J. Alden Weir.* New York: American Academy of Arts and Letters, 1922.

\_\_\_\_\_, "John Singer Sargent—Recollections," *North American Review,* Vol. 221, no. 827 (June, 1925), 641-53.

Blumenschein, Ernest L., "The Painting of To-morrow," *Century,* Vol. 87, no. 6 (April, 1914), 844-50.

Bolles, J.M., "Messrs. Steele and Forsyth," *Modern Art,* Vol. 1, no. 2 (Spring, 1893), unpaginated.

Borgmeyer, Charles Louis, "Birge Harrison—Poet Painter," *Fine Arts Journal,* Vol. 29, no. 4 (October, 1913), 582-606.

Bouche, Louis and William Yarrow, eds., *Robert Henri, His Life and Works.* New York: Privately printed by Boni and Liveright, 1921.

Bowdoin, W.G., "In Summertime," *The Artist,* Vol. 28 (June, 1900), 44-47.

Boyle, Richard J. *American Impressionism.* Boston: New York Graphic Society, 1974.

\_\_\_\_\_, *John Twachtman.* New York: Watson-Guptill Publications, 1979.

Breck, Bayard, "Daniel Garber: A Modern American Master," *Art and Life,* Vol. 11, no. 9 (March, 1920), 493-97.

Breeskin, Adelyn D., *Mary Cassatt: A Catalogue Raisonné of the Oils, Pastels, Water-Colors, and Drawings.* Washington, D.C.: Smithsonian Institution Press, 1970.

\_\_\_\_\_, *The Graphic Work of Mary Cassatt, a Catalogue Raisonné.* New York: H. Bittner, 1948.

Breuning, Margaret, "Comprehensive View of William Glackens," *The Art Digest,* Vol. 23, no. 7 (January 1, 1949), 12.

\_\_\_\_\_, *Mary Cassatt.* New York: Hyperion Press, 1944.

\_\_\_\_\_, *Maurice Prendergast.* New York: Whitney Museum of American Art, 1931.

Brinton, Christian, "Concerning Miss Cassatt and Certain Etchings," *International Studio,* Vol. 27, no. 108 (February, 1906), i-vi.

\_\_\_\_\_, "The Conquest of Color," *Scribner's Magazine,* Vol. 62, no. 4 (October, 1919), 513-16.

\_\_\_\_\_, *Impressions of the Art at the Panama-Pacific Exposition, with a Chapter on the San Diego Exposition and an Introductory Essay on the Modern Spirit in Contemporary Painting.* New York: John Lane Company, 1916.

\_\_\_\_\_, *Modern Artists.* New York: The Baker and Taylor Company, 1908.

\_\_\_\_\_, "Robert Reid, Decorative Impressionist," *Arts and Decoration,* Vol. 2, no. 1 (November, 1911), 13-15, 34.

\_\_\_\_\_, "Willard L. Metcalf," *Century,* Vol. 77, no. 1 (November, 1908), 155.

Brooks, Alfred Mansfield, "The Art and Work of Theodore Steele," *American Magazine of Art,* Vol. 8, no. 10 (August, 1917), 401-06.

\_\_\_\_\_, "The House of the Singing Winds," *American Magazine of Art,* Vol. 11, no. 4 (February, 1920), 139-41.

Brooks, Van Wyck, "Anecdotes of Maurice Prendergast," *American Magazine of Art,* Vol. 31, no. 10 (October, 1938), 564-69, 604.

"The Brothers Prendergast in Review," *The Art News,* Vol. 37, no. 2 (October 8, 1938), 14-15, 19.

Brownell, William Crary, *French Art; Classic and Contemporary Painting and Sculpture.* New York: Charles Scribner's Sons, 1892.

\_\_\_\_\_, "French Art—III. Realistic Painting," *Scribner's Magazine,* Vol. 12, no. 5 (November, 1892), 604-27.

\_\_\_\_\_, "The Younger Painters of America," *Century,* Vol. 20, no. 1 (May, 1880), 1-15; Vol. 20, no. 3 (July, 1880), 321-35; Vol. 22, no. 3 (July, 1881), 321-34.

Bryant, Lorinda Munson, *American Pictures and Their Painters.* New York: John Lane Company, 1917.

Buchanan, Charles L., "The Ambidextrous Childe Hassam," *International Studio,* Vol. 67, no. 227 (January, 1916), lxxxiii-lxxxvi.

Bullard, E. John, *Mary Cassatt, Oils and Pastels.* New York: Watson-Guptill Publications, 1972.

Burnet, Mary Quick, *Art and Artists of Indiana.* New York: The Century Company, 1921.

\_\_\_\_\_, "Indiana University and T.C. Steele," *American Magazine of Art,* Vol. 15, no. 11 (November, 1924), 587-91.

Butler, Howard Russell, "J. Alden Weir," *Scribner's Magazine,* Vol. 59, no. 1 (January, 1916), 129-32.

Caffin, Charles H., "The Art of Frank W. Benson," *Harper's New Monthly Magazine,* Vol. 119, no. 709 (June, 1909), 105-14.

\_\_\_\_\_, "The Art of Thomas W. Dewing," *Harper's New Monthly Magazine,* Vol. 116, no. 695 (April, 1908), 714-24.

\_\_\_\_\_, "Arthur Hoeber—an Appreciation," *New England Magazine,* Vol. 28, no. 2 (April, 1903), 223-33.

\_\_\_\_\_, *How to Study Pictures.* New York and London: D. Appleton-Century Company, 1941.

\_\_\_\_\_, "Some New American Painters in Paris," *Harper's New Monthly Magazine,* Vol. 118, no. 704 (January, 1909), 284-93.

\_\_\_\_\_, *The Story of American Painting.* New York: Frederick A. Stokes Company, 1907.

\_\_\_\_\_, *The Story of French Painting.* New York: The Century Company, 1911.

\_\_\_\_\_, "Unphotographic Paint: The Texture of Impressionism," *Camera Work,* No. 28 (October, 1909), 20-23.

Campbell, Pearl H., "Theodore Robinson, A Brief Historical Sketch," *Brush and Pencil,* Vol. 4, no. 6 (September, 1899), 287-89.

Carson, Julia Margaret Hicks, *Mary Cassatt.* New York: D. McKay, 1966.

Cary, Elizabeth Luther, "The Art of Mary Cassatt," *The Scrip,* Vol. 1, no. 1 (October, 1905), 1-5.

\_\_\_\_\_, "The Etched Work of J. Alden Weir," *Scribner's Magazine,* Vol. 68, no. 4 (October, 1920), 507-12.

Chamberlain, Samuel, "Frank W. Benson the Etcher," *The Print Collector's Quarterly,* Vol. 25, no. 2 (April, 1938), 169-72.

Charteris, Evan, *John Sargent.* New York: Charles Scribner's Sons, 1927.

Cheney, Sheldon, *An Art-Lover's Guide to the Exposition.* Berkeley: At the Sign of the Berkeley Oak, 1915.

\_\_\_\_\_, *The Story of Modern Art.* New York: Viking Press, 1941.

Child, Theodore, "The King of the Impressionists," *The Art Amateur,* Vol. 14, no. 5 (April, 1886), 101-02.

_____, "A Note on Impressionist Painting," *Harper's New Monthly Magazine,* Vol. 74, no. 440 (January, 1887), 313-15.

"Childe Hassam and His Prints," *Prints,* Vol. 6, no. 1 (October, 1935), 2-14, 59.

Clark, Eliot, "American Painters of Winter Landscape," *Scribner's Magazine,* Vol. 72, no. 6 (December, 1922), 763-68.

_____, "The Art of John Twachtman," *International Studio,* Vol. 72, no. 286 (January, 1921), lxxvii-lxxxvi.

_____, "The Art of Robert Vonnoh," *Art in America,* Vol. 16, no. 5 (August, 1928), 223-32.

_____, "Childe Hassam," *Art in America,* Vol. 8, no. 4 (June, 1920), 172-80.

_____, "Emil Carlsen," *Scribner's Magazine,* Vol. 66, no. 6 (December, 1919), 767-70.

_____, "J. Alden Weir," *Art in America,* Vol. 8, no. 5 (August, 1920), 232-42.

_____, "John Henry Twachtman," *Art in America,* Vol. 7, no. 3 (April, 1919), 129-37.

_____, *John H. Twachtman.* New York: Privately printed, 1924.

_____, "Theodore Robinson," *Art in America,* Vol. 6, no. 6 (October, 1918), 286-94.

_____, "Theodore Robinson, A Pioneer Impressionist," *Scribner's Magazine,* Vol. 70, no. 6 (December, 1921), 763-68.

"Claude Monet," *Scribner's Magazine,* Vol. 19, no. 15 (January, 1896), 125.

Closson, William Baxter, "The Art of John J. Enneking," *International Studio,* Vol. 76, no. 305 (October, 1922), 3-6.

Coburn, Frederick W., "Edmund C. Tarbell," *International Studio,* Vol. 32, no. 127 (September, 1907), lxxv-lxxxvii.

_____, "Mr. Tarbell's 'New England Interior,'" *New England Magazine,* Vol. 38, no. 1 (March, 1908), 96-97.

_____, "Philip L. Hale, Artist and Critic," *The World Today,* Vol. 14, no. 1 (January, 1908), 59-67.

_____, "Philip L. Hale's 'The Art Students,'" *New England Magazine,* Vol. 38, no. 2 (April, 1908), 196-97.

_____, "Seeing Nature with Both Eyes," *The World Today,* Vol. 9, no. 5 (November, 1905), 1210-14.

Coffin, William A., "Robert Reid's Decorations in the Congressional Library, Washington, D.C.," *Harper's Weekly,* Vol. 40, no. 2078 (October 17, 1896), 1028-29.

"Colored Shadows," *Scribner's Magazine,* Vol. 19, no. 57 (April, 1896), 522.

Cook, Clarence, "The Impressionist Pictures," *The Studio,* Vol. 1 (April 17, 1886), 245-54.

_____, "A Representative American Artist," *The Monthly Illustrator,* Vol. 11, no. 4 (November, 1895), 289-92.

_____, "Some Present Aspects of Art in America," *The Chautauquan,* Vol. 23, no. 5 (August, 1896), 595-601.

Corn, Wanda M. "The New New York," *Art in America,* Vol. 61, no. 4 (July-August, 1973), 58-65.

Cortissoz, Royal, *American Artists.* New York: Charles Scribner's Sons, 1923.

_____, "An American Artist Canonized in the Freer Gallery," *Scribner's Magazine,* Vol. 74, no. 5 (November, 1923), 539-46.

_____, "Claude Monet," *Scribner's Magazine,* Vol. 81, no. 4 (April, 1927), 329-36.

_____, *In Summertime: Paintings by Robert Reid.* New York: R.H. Russell, 1900.

_____, Introduction to *The Etchings and Dry-Points of Childe Hassam, N.A.* New York: Charles Scribner's Sons, 1925.

_____, "Personal Memories," *The Arts,* Vol. 1, no. 6 (June-July, 1921), 8-24.

_____, *Personalities in Art.* New York and London: Charles Scribner's Sons, 1925.

_____, "Some Imaginative Types in American Art," *Harper's New Monthly Magazine,* Vol. 91, no. 542 (July, 1895), 164-79.

_____, "Willard L. Metcalf," American Academy of Arts and Letters, *Academy Publications,* No. 60 (1927), 1-8.

_____, "Willard L. Metcalf, An American Landscape Painter," *Appleton's Booklovers Magazine,* Vol. 6, no. 4 (October, 1905), 509-11.

_____, "The Work of Robert Reid," *Appleton's Booklovers Magazine,* Vol. 6, no. 6 (December, 1905), 738-48.

Cortissoz, Royal, and Frederic Newlin Price, *Walter Griffin.* New York: Ferargil, 1935.

Cournos, John, "John H. Twachtman," *The Forum,* Vol. 52 (August, 1914), 245-48.

Court, Lee W., comp. and ed., *Joseph DeCamp, An Appreciation.* Boston: State Normal Art School, Boston, 1924.

Cox, Kenyon, "The American School of Painting," *Scribner's Magazine,* Vol. 50, no. 3 (December, 1911), 265-68.

_____, "The Art of J. Alden Weir," *Burlington Magazine,* Vol. 15, no. 74 (May, 1909), 131-32.

_____, "Recent Works by Edmund C. Tarbell," *Burlington Magazine,* Vol. 14, no. 70 (January, 1909), 254-60.

"A Critical Triumvirate" [Charles F. Browne, Hamlin Garland, Lorado Taft], *Five Hoosier Painters.* Printed for the Central Art Association, 1894.

_____, *Impressions on Impressionism.* Chicago: Printed for the Central Art Association, 1894.

Curran, Charles C., "The Art of John H. Twachtman," *The Literary Miscellany,* Vol. 3, no. 4 (Winter, 1910), 72-78.

Cushing, Frank H., "My Adventures in Zuni," *Century,* Vol. 25, no. 2 (December, 1882), 191-207; Vol. 25, no. 4 (February, 1883), 500-11.

Czestochowski, Joseph S., "Childe Hassam Paintings from 1880 to 1900," *American Art Review,* Vol. 4, no. 4 (January, 1978), 40-51, 101.

Daingerfield, Elliott, "Color and Form—Their Relationship," *The Art World,* Vol. 3, no. 3 (December, 1917), 179-80.

Damigella, Anna Maria, *L'Impressionismo fuori di Francia.* Milan: Fratelli Fabbri, 1967.

Davidson, Carla, "Boston Painters, Boston Ladies," *American Heritage,* Vol. 23, no. 3 (April, 1972), 4-17.

Davol, Ralph, "The Work of John J. Enneking," *American Magazine of Art,* Vol. 8, no. 8 (June, 1917), 320-23.

De Gregorio, Vincent John, "The Life and Art of William J. Glackens," unpublished Ph.D. dissertation, Ohio State University, 1955.

De Kay, Charles, "French and American Impressionists," *The New York Times,* January 31, 1904, 23.

_____, "A Group of Colourists," *Magazine of Art,* Vol. 9 (1886), 389-90.

_____, "John H. Twachtman," *Arts and Decoration,* Vol. 9, no. 7 (June, 1918), 73-76, 112, 114.

_____, "Whistler, the Head of the Impressionists," *The Art Review,* Vol. 1, no. 1 (November, 1886), 1-3.

De Mazia, Violette, "The Case of Glackens vs. Renoir," The Barnes Foundation, Merion Station, Pennsylvania, *Journal of the Art Department,* Vol. 2, no. 2 (Autumn, 1971), 3-30.

Denoinville, Georges, "Mary Cassatt, peintre des enfants et des mères," *Byblis,* Vol. 7 (Winter, 1928), 121-23.

De Veer, Elizabeth, "Willard Metcalf's 'The Ten Cent Breakfast,'" *Nineteenth Century,* Vol. 3, no. 4 (Winter, 1977), 51-53.

Dewhurst, Wynford, *Impressionist Painting: Its Genesis and Development.* London: G. Newnes, 1904.

Dewing, Maria Oakey, "Abbott Thayer — A Portrait and an Appreciation," *International Studio,* Vol. 74, no. 293 (August, 1921), vi-xiv.

Dewing, Thomas Wilmer, "A Letter to Abbott Thayer," *The Arts,* Vol. 1, no. 6 (June-July, 1921), 24.

Dewing, Thomas W., Childe Hassam, Robert Reid, Edward Simmons, and J. Alden Weir, "John H. Twachtman: An Estimation," *North American Review,* Vol. 176, no. 557 (April, 1903), 554-62.

Downes, William Howe, "Boston Art and Artists," in Smith, F. Hopkinson, Alfred Trumble, Frank Fowler, et. al., *Essays on Art and Artists.* Chicago: American Art League, 1896, 265-80.

_____, "Frank W. Benson and His Work," *Brush and Pencil,* Vol. 6, no. 4 (July, 1900), 144-57.

_____, "Impressionism in Painting," *New England Magazine,* Vol. 6, no. 5 (July, 1892), 600-03.

_____, "John Appleton Brown, Landscapist," *American Magazine of Art,* Vol. 14, no. 8 (August, 1923), 436-39.

_____, *John S. Sargent: His Life and Work.* Boston: Little, Brown & Co., 1925.

_____, "Joseph DeCamp and His Work," *Art and Progress,* Vol. 4, no. 6 (April, 1913), 918-25.

_____, "Mr. Benson's Etchings," *American Magazine of Art,* Vol. 9, no. 8 (June, 1918), 309-13.

_____, "The Spontaneous Gaiety of Fránk Benson's Work," *Arts and Decoration,* Vol. 1, no. 5 (March, 1911), 195-97.

_____, "The Vinton Memorial Exhibition," *Art and Progress,* Vol. 3, no. 4 (February, 1912), 474-77.

Drinker, Henry S., *The Paintings and Drawings of Cecilia Beaux.* Philadelphia: Pennsylvania Academy of the Fine Arts, 1955.

Du Bois, Guy Pene, "The Boston Group of Painters: An Essay on Nationalism in Art," *Arts and Decoration,* Vol. 5, no. 12 (October, 1915), 457-60.

_____, *Ernest Lawson.* New York: Whitney Museum of American Art, 1932.

_____, "Ernest Lawson, Optimist," *Arts and Decoration,* Vol. 6, no. 11 (September, 1916), 505-07.

_____, "The French Impressionists and Their Place in Art," *Arts and Decoration,* Vol. 4, no. 4 (January, 1914), 101-05.

_____, "The Idyllic Optimism of J. Alden Weir," *Arts and Decoration,* Vol. 2, no. 2 (December, 1911), 55-57, 78.

_____, "The Pennsylvania Group of Landscape Painters," *Arts and Decoration,* Vol. 5, no. 9 (July, 1915), 351-54.

_____, *William Glackens.* New York: Whitney Museum of American Art, 1931.

_____, "William Glackens, Normal Man," *Arts and Decoration,* Vol. 4, no. 12 (September, 1914), 404-06.

Eberlein, Harold Donaldson, "Robert W. Vonnoh: Painter of Men," *Arts and Decoration,* Vol. 2, no. 11 (September, 1912), 381-83, 402, 404.

Edgerton, Giles, "Is America Selling Her Birthright in Art for a Mess of Pottage?" *The Craftsman,* Vol. 11, no. 6 (March, 1907), 657-70.

_____, "Pioneers of Modern American Art," *The Craftsman,* Vol. 14, no. 6 (September, 1908), 597-606.

_____, "The Younger American Painters: Are They Creating a National Art?" *The Craftsman,* Vol. 13, no. 5 (February, 1908), 512-32.

Eldredge, Charles, "Connecticut Impressionists: The Spirit of Place," *Art in America,* Vol. 62, no. 5 (September-October, 1974), 84-90.

Eliasoph, Paula, *Handbook of the Complete Set of Etchings and Drypoints of Childe Hassam, N.A.* New York: Leonard Clayton Gallery, 1933.

Ely, Catherine Beach, "Abbott Henderson Thayer," *Art in America,* Vol. 12, no. 2 (February, 1924), 85-93.

_____, "J. Alden Weir," *Art in America,* Vol. 12, no. 3 (April, 1924), 112-21.

_____, *The Modern Tendency in American Painting.* New York: F.F. Sherman, 1925.

_____, "The Modern Tendency in Lawson, Lever and Glackens," *Art in America,* Vol. 10, no. 1 (December, 1921), 31-37.

_____, "Thomas W. Dewing," *Art in America,* Vol. 10, no. 5 (August, 1922), 224-29.

_____, "Willard L. Metcalf," *Art in America,* Vol. 13, no. 6 (October, 1925), 332-36.

"Ernest Lawson," *Arts and Decoration,* Vol. 10, no. 5 (March, 1919), 257-59.

"Ernest Lawson's Spanish Pictures," *Fine Arts Journal,* Vol. 35, no. 3 (March, 1917), 225-27.

"The Etchings of Childe Hassam," *Nation,* Vol. 101, no. 2632 (December 9, 1915), 698-99.

F. W., "Notes on a Young 'Impressionist,'" *The Critic,* Vol. 1, no. 15 (July 30, 1881), 208-09.

Faulkner, Joseph W., "Painters at the Hall of Expositions, 1890," *Chicago History,* Vol. 2, no. 1 (Spring, 1972), 14-16.

Ferbraché, Lewis, *Theodore Wores, Artist in Search of the Picturesque.* San Francisco: David Printing Co., 1968.

Fitzgerald, Desmond, "Claude Monet — Master of Impressionism," *Brush and Pencil,* Vol. 15, no. 3 (March, 1905), 181-95.

Flower, Benjamin Orange, "Edward W. Redfield: An Artist of Winter-Locked Nature," *Arena,* Vol. 36, no. 1 (July, 1906), 20-26.

Forgey, Benjamin, "American Impressionism from the Vital to the Academic," *Art News,* Vol. 72, no. 8 (October, 1973), 24-27.

Forsyth, William, *Art in Indiana.* Indianapolis: H. Lieber Co., 1916.

_____, "Some Impressions of the Art Exhibit at the Fair — III . . . Impressionism . . .," *Modern Art,* Vol. 1, no. 3 (Summer, 1893), unpaginated.

Fowler, Frank, "The New Heritage of Painting of the Nineteenth Century," *Scribner's Magazine,* Vol. 30, no. 2 (August, 1901), 253-56.

_____, "The Value of Art Effort," *Scribner's Magazine,* Vol. 44, no. 2 (August, 1908), 253-56.

"French and American Impressionists," *The Art Amateur,* Vol. 29, no. 1 (June, 1893), 4.

"The French Impressionists," *The Critic,* Vol. 5, no. 120 (April 17, 1886), 195-96.

"Frieseke, at 68, Turns to Pure Landscape," *The Art Digest,* Vol. 6, no. 15 (March, 1932), 12.

Fuller, Sue, "Mary Cassatt's Use of Soft-Ground Etching," *American Magazine of Art,* Vol. 43, no. 2 (February, 1950), 54-57.

Gallatin, Albert E., *American Water Colourists.* New York: E.P. Dutton & Company, 1922.

_____, *Certain Contemporaries; A Set of Notes in Art Criticism.* New York: John Lane Company, 1916.

_____, "Ernest Lawson," *International Studio,* Vol. 59, no. 233 (July, 1916), xiii-xv.

_____, "The Paintings of Frederic C. Frieseke," *Art and Progress,* Vol. 3, no. 12 (October, 1912), 747-49.

_____, *Whistler: Notes and Footnotes.* New York: The Collector and Art Critic Co., 1907.

_____, *Whistler's Pastels and Other Modern Profiles.* New York: John Lane Company, 1913.

_____, "William Glackens," *American Magazine of Art,* Vol. 7, no. 7 (May, 1916), 261-63.

Gammell, R.H. Ives, *Dennis Miller Bunker.* New York: Coward McCann, 1953.

_____, "A Reintroduction to Boston Painters." *Classical America,* Vol. 3 (1973), 94-104.

_____, *Twilight of Painting: An Analysis of Recent Trends to Serve in a Period of Reconstruction.* New York: G.P. Putnam's Sons, 1946.

Garczanski, Edward Rudolf, "Jugglery in Art," *The Forum,* Vol. 1 (August, 1886), 592-602.

Garland, Hamlin, *Crumbling Idols; 12 Essays on Art.* 1894. New edition. Cambridge, Massachusetts: Harvard University Press, Belknap Press, 1960.

_____, *Roadside Meetings.* New York: The Macmillan Press, 1930.

_____, "Theodore Robinson," *Brush and Pencil,* Vol. 4, no. 6 (September, 1899), 285-86.

Geffroy, Gustave, "Femmes artistes: Un Peintre de l'enfance, Miss Mary Cassatt," *Les Modes,* Vol. 4 (February, 1904), 4-11.

Getscher, Robert Harold, "Whistler and Venice," unpublished Ph.D. dissertation, Case Western Reserve University, Cleveland, 1970.

Glackens, Ira, *William Glackens and the Ashcan Group; the Emergence of Realism in American Art.* New York: Crown Publishers, 1957.

Glackens, William J., "The American Section: The National Art," *Arts and Decoration,* Vol. 3, no. 5 (March, 1913), 159-64.

"W. J. Glackens: His Significance to the Art of His Day," *Touchstone,* Vol. 7, no. 3 (June, 1920), 191-99.

Goodrich, Henry W., "Robert Reid and His Work," *International Studio,* Vol. 36, no. 44 (February, 1909), ciii-cxxi.

Grafly, Dorothy, "In Retrospect — Mary Cassatt," *American Magazine of Art,* Vol. 18, no. 6 (June, 1927), 305-12.

Griffith, Fuller, *The Lithographs of Childe Hassam — A Catalogue.* United States National Museum Bulletin Number 232. Washington, D.C.: Smithsonian Institution, 1962.

Hale, John Douglas, "The Life and Creative Development of John H. Twachtman," 2 vols., unpublished Ph.D. dissertation, Ohio State University, 1957.

Hale, Nancy, *The Life in the Studio.* Boston: Little, Brown & Co., 1969.

_____, *Mary Cassatt, A Biography of the Great American Painter.* Garden City, New York: Doubleday & Company, 1975.

Hale, Philip L., "'The Coral Necklace,' by Edmund C. Tarbell," *Harper's New Monthly Magazine,* Vol. 129, no. 769 (June, 1914), 136-37.

_____, "Edmund C. Tarbell — Painter of Pictures," *Arts and Decoration,* Vol. 2, no. 4 (February, 1912), 129-31, 156.

_____, "William MacGregor Paxton," *International Studio,* Vol. 39, no. 153 (November, 1909), xlvi-xlviii.

Haley, Kenneth, "The Ten American Painters; Definition and Reassessment," unpublished Ph.D. dissertation, State University of New York at Binghamton, 1975.

Hamilton, Luther, "The Work of the Paris Impressionists in New York," *Cosmopolitan,* Vol. 1, no. 4 (June, 1886), 240-42.

Harrison, Birge, "Appeal of the Winter Landscape," *Fine Arts Journal,* Vol. 30, no. 3 (March, 1914), 191-96.

_____, *Landscape Painting.* New York: Charles Scribner's Sons, 1909.

_____, "The True Impressionism in Art," *Scribner's Magazine,* Vol. 46, no. 4 (October, 1909), 491-95.

_____, "With Stevenson at Grez," *Century,* Vol. 93, no. 2 (December, 1916), 306-14.

Hart, Charles Henry, "Robert Reid's Mural Decoration in the New State House at Boston," *The Era,* n.s. Vol. 9, no. 4 (April, 1902), 445-47.

Hartley, Marsden, *Adventures in the Arts.* New York: Boni and Liveright, 1921.

Hartmann, Sadakichi, *A History of American Art,* 2 vols. Boston: L.C. Page & Co., 1902.

_____, "Thomas W. Dewing," *The Art Critic,* Vol. 1, no. 2 (January 1894), 34-36. Hassam, Childe, *Three Cities.* New York: R.H. Russell, 1899.

_____, "Twenty-Five Years of American Painting," *The Art News,* Vol. 26, no. 28 (April 14, 1928), 22-28.

Havemeyer, Louisine W., "The Cassatt Exhibition," *The Pennsylvania Museum Bulletin,* Vol. 22, no. 113 (May, 1927), 373-82.

_____, *Sixteen to Sixty, Memoirs of a Collector.* New York: Privately printed for the family of Mrs. H.O. Havemeyer and The Metropolitan Museum of Art, 1961.

Heming, Arthur H.H., *Miss Florence and the Artists of Old Lyme.* Essex, Connecticut: Pequot Press, 1971.

Henderson, Helen W., "Centenary Exhibition of the Pennsylvania Academy of the Fine Arts," *Brush and Pencil,* Vol. 15, no. 3 (March, 1905), 145-55.

Hess, Thomas B., "Degas-Cassatt Story," *The Art News,* Vol. 46, no. 9 (November, 1947), 18-20, 52-53.

Hill, Frederick D., "Cecilia Beaux, the Grande Dame of American Portraiture," *Antiques,* Vol. 105, no. 1 (January, 1974), 160-68.

Hilman, Carolyn, and Jean Nutting Oliver, "Lilla Cabot Perry — Painter and Poet," *American Magazine of Art,* Vol. 14, no. 11 (November, 1923), 601-04.

Hind, C. Lewis, "An American Landscape Painter, W. Elmer Schofield," *International Studio,* Vol. 48, no. 192 (February, 1913), 280-89.

_____, "Mark Fisher," *The Art Journal,* Vol. 72 (January, 1910), 15-20.

Hoeber, Arthur, "Birge Harrison, N.A., Landscape Painter," *International Studio,* Vol. 44, no. 173 (July, 1911), iii-v.

_____, "DeCamp, A Master of Technique," *Arts and Decoration,* Vol. 1, no. 6 (April, 1911), 248-50.

_____, "Edward Emerson Simmons," *Brush and Pencil,* Vol. 5, no. 6 (March, 1900), 241-49.

_____, "Gari Melchers," *International Studio,* Vol. 31, no. 121 (March, 1907), xi-xviii.

_____, "Mary Cassatt," *Century,* Vol. 57, no. 5 (March, 1899), 740-41.

_____, "Robert Reid," *Century,* Vol. 77, no. 5 (March, 1909), 799.

_____, "The Ten Americans," *International Studio,* Vol. 35, no. 137 (July, 1908), xxiv-xxix.

_____, "W. Elmer Schofield," *Arts and Decoration,* Vol. 1, no. 12 (October, 1911), 473-75, 492.

Homer, William Innes, *Robert Henri and His Circle.* Ithaca: Cornell University Press, 1969.

Hooper, Lucy, "Art Notes from Paris," *The Art Journal* (New York), Vol. 6 (1880), 188-90.

Hoopes, Donelson F., *The American Impressionists.* New York: Watson-Guptill Publications, 1972.

_____, *Childe Hassam.* New York: Watson-Guptill Publications, 1979.

_____, "John S. Sargent: Worcestershire Interlude, 1885-89," *The Brooklyn Museum Annual,* Vol. 7 (1965/66), 74-89.

Howells, William Dean, *Venetian Life,* 2 vols. Cambridge, Massachusetts: Printed at the Riverside Press, 1892.

Huth, Hans, "Impressionism Comes to America," *Gazette des Beaux-Arts,* Ser. 6, Vol. 29 (April, 1946), 225-52.

Hyslop, Francis E., Jr., "Berthe Morisot and Mary Cassatt," *College Art Journal,* Vol. 13, no. 3 (Spring, 1954), 179-84.

"Impressionism and After," *Scribner's Magazine,* Vol. 21, no. 41 (March, 1897), 391-92.

"Impressionism in France," *American Art Review,* Vol. 1 (1880), 33-35.

"The Impressionist Exhibition," *The Art Amateur,* Vol. 14, no. 6 (May, 1886), 121.

"The Impressionists," *Art Age,* Vol. 3, no. 33 (April, 1886), 165-66.

"The Impressionists," *The Art Amateur,* Vol. 30, no. 4 (March, 1894), 99.

"The Impressionists," *The Art Interchange,* Vol. 29, no. 1 (July, 1892), 1-7.

"The Impressionists' Exhibition at the American Art Galleries," *The Art Interchange,* Vol. 16, no. 9 (April 24, 1886), 130-31.

Inness, George, Jr., *Life, Art, and Letters of George Inness.* New York: The Century Company, 1917.

"Mr. Inness on Art–Matters," *The Art Journal* (New York), Vol. 5 (1879), 374-77.

Isham, Samuel, *The History of American Painting.* New York: Macmillan Co., 1905.

Ives, A.E., "Mr. Childe Hassam on Painting Street Scenes," *The Art Amateur,* Vol. 27, no. 5 (October, 1892), 116-17.

Ivins, William M., Jr., "New Exhibition in the Print Galleries: Prints by Mary Cassatt," *Bulletin of the Metropolitan Museum of Art,* Vol. 22, no. 1 (January, 1927), 8-10.

Jackman, Rilla Evelyn, *American Arts.* Chicago and New York: Rand, McNally & Company, 1928.

Jacobowitz, Arlene, "Edward Henry Potthast," *The Brooklyn Museum Annual,* Vol. 9 (1967/68), 113-28.

James, Henry, "The Grosvenor Gallery and the Royal Academy," *The Nation,* Vol. 24, no. 622 (May 31, 1877), 320-21.

_____, "Our Artists in Europe," *Harper's New Monthly Magazine,* Vol. 79, no. 469 (June, 1889), 50-66.

"Jerome Myers, Ernest Lawson," *Arts and Decoration,* Vol. 10, no. 5 (March, 1919), 257-59.

"John J. Enneking," *Photo Era,* Vol. 38, no. 1 (January, 1917), 30.

Johnson, Una, "The Graphic Art of Mary Cassatt," *American Artist,* Vol. 9, no. 9 (November,1945), 18-21.

Johnson, Virginia C., "The School of Modern Impressionism," *The Art Interchange,* Vol. 42, no. 4 (April, 1899), 88.

Kelly, Florence Finch, "Painters of Sea and Shore," *Broadway Magazine,* Vol. 18, no. 5 (August, 1907), 580-86.

King, Pauline, *American Mural Painting.* Boston: Noyes, Platt & Company, 1902.

Kristiansen, Rolf, "John J. Enneking: An Artist Rediscovered," *American Artist,* Vol. 26, no. 8 (October, 1962), 45-47, 71-72.

Kysela, John D., S.J., "The Critical and Literary Background for a Study of the Development of Taste for 'Modern Art' in America, from 1880-1900," unpublished M.A. thesis, Loyola University, 1964.

_____, "Mary Cassatt's Mystery Mural and the World's Fair of 1893," *The Art Quarterly,* Vol. 29, no. 2 (1966), 129-45.

La Farge, John, *The Higher Life in Art.* New York: The McClure Company, 1908.

LaFollette, Suzanne, *Art in America.* New York: Harper, 1929.

Larkin, Oliver W., *Art and Life in America.* New York: Rinehart, 1949.

Laughton, Bruce, "British and American Contributions to Les XX, 1884-93," *Apollo,* Vol. 86, no. 69 (November, 1967), 372-79.

Laurvik, John Nilsen, "Edward Redfield," *International Studio,* Vol. 41, no. 162 (August, 1910), xxix-xxxvi.

Leclere, Tristan, "La Décoration d'un hôtel américain," *L'Art décoratif,* Vol. 8, part 2 (1906), 195-200.

Leeper, John P., "Mary Cassatt and Her Parisian Friends," *Bulletin of the Pasadena Art Institute,* No. 2 (October, 1951), 1-9.

Lejeune, L., "The Impressionist School of Painting," *Lippincott's Magazine,* Vol. 24 (December, 1879), 720-27.

Levy, Florence N., "Theodore Robinson," *Bulletin of the Metropolitan Museum of Art,* Vol. 1, no. 8 (July, 1906), 111-12.

Lewison, Florence, "Theodore Robinson, America's First Impressionist," *American Artist,* Vol. 27, no. 262 (February, 1963), 40-45, 72-73.

_____, "Theodore Robinson and Claude Monet," *Apollo,* Vol. 78, no. 19 (September, 1963), 208-11.

Lines, Vincent, *Mark Fisher and Margaret Fisher Prout.* London: Published privately on the occasion of the memorial exhibition of Margaret Fisher Prout at the R.W.S. Gallery, Conduit St., London, Skilton, 1966.

Lowe, David, "Mary Cassatt," *American Heritage,* Vol. 25, no. 1 (December, 1973), 10-21, 96-100.

Lucas, E.V., "John White Alexander and Frederick Carl Frieseke," *Ladies' Home Journal,* Vol. 43, no. 1 (July, 1926), 16-17, 126.

Lynes, Russell, *The Tastemakers.* New York: Harper, 1954.

McCausland, Elizabeth, *Marsden Hartley.* Minneapolis: University of Minnesota Press, 1952.

MacChesney, Clara, "Frederick Carl Frieseke — His Work and Suggestions for Painting from Nature," *Arts and Decoration,* Vol. 3, no. 1 (November, 1912), 13-15.

_____, "Mary Cassatt and Her Work," *Arts and Decoration,* Vol. 3, no. 8 (June, 1913), 265-67.

McGuire, James C., *Childe Hassam, N.A.* American Etchers, Vol. 3. New York: T. Spencer Hutson & Co., 1929.

McKown, Robin, *The World of Mary Cassatt.* New York: T.Y. Crowell, 1972.

McLaughlin, George, "Cincinnati Artists of the Munich School," *The American Art Review,* Vol. 2, part 1 (1881), 1-4, 45-50.

McSpadden, Joseph Walker, *Famous Painters of America.* New York: T.Y. Crowell & Co., 1907.

_____, *Famous Painters of America.* New York: Dodd, Mead & Company, 1923.

"Mary Cassatt's Achievement: Its Value to the World of Art," *The Craftsman,* Vol. 19, no. 6 (March, 1911), 540-46.

Mase, Carolyn C., "John H. Twachtman," *International Studio,* Vol. 72, no. 286 (January, 1921), lxxi-lxxv.

Mather, Frank Jewett, Jr., "The Luxembourg and American Painting," *Scribner's Magazine,* Vol. 47, no. 3 (March, 1910), 381-84.

_____, *Modern Painting.* New York: H. Holt and Company, 1927.

Mauclair, Camille (Camille Faust), *The French Impressionists (1860-1900).* P.G. Konody, tr. London: Duckworth & Co., 1911.

_____, "Un Peintre de l'enfance, Miss Mary Cassatt," *L'Art decoratif,* Vol. 8, no. 47 (August, 1902), 177-85.

Mechlin, Leila, "The Art of Cecilia Beaux," *International Studio,* Vol. 61, no. 161 (July, 1910), iii-x.

_____, "Contemporary American Landscape Painting," *International Studio,* Vol. 39, no. 153 (November, 1909), 3-14.

_____, "The Freer Collection of Art," *Century,* Vol. 73, no. 3 (January, 1907), 357-70.

Mellerio, Andre, "Mary Cassatt," *L'Art et les artistes,* Vol. 12 (November, 1910), 69-75.

Meyer, Annie Nathan, "A City Picture: Mr. Hassam's Latest Painting of New York," *Art and Progress,* Vol. 2, no. 5 (March, 1911), 137-39.

Milliken, William Mathewson, "Maurice Prendergast, American Artist," *The Arts,* Vol. 9, no. 4 (April, 1926), 181-92.

Moore, Charles Herbert, "Modern Art of Painting in France," *Atlantic Monthly,* Vol. 68, no. 410 (December, 1891), 805-16.

Moore, George, *Modern Painting.* London: W. Scott, 1900.

Morgan, Charles Lemon, *Frank W. Benson, N.A.* New York: The Crafton Collection; London: P. & D. Colnaghi & Company, 1931.

Morrell, Dora M., "A Boston Artist and His Work," *Brush and Pencil,* Vol. 3, no. 4 (January, 1899), 193-201.

Morris, Harrison Smith, *Confessions in Art.* New York: Sears Publishing Company, 1930.

Morton, Frederick W., "Childe Hassam, Impressionist," *Brush and Pencil,* Vol. 8, no. 3 (June, 1901), 141-50.

Mount, Charles Merrill, *John Singer Sargent; A Biography.* London: The Cresset Press, 1957.

Myers, Elizabeth P., *Mary Cassatt, A Portrait.* Chicago: Reilly & Lee, 1971.

"The National Note in Our Art — A Distinctive American Quality Dominant at the Pennsylvania Academy," *Craftsman,* Vol. 9, no. 6 (March, 1906), 753-73.

Neuhaus, Eugen, *The Galleries of the Exposition: A Critical Review of the Paintings, Statuary, and the Graphic Arts in the Palace of Fine Arts at the Panama-Pacific International Exposition.* San Francisco: P. Elder & Co., 1915.

_____, *The History and Ideals of American Art.* Stanford, California: Stanford University Press; London: H. Milford, Oxford University Press, 1931.

Newman, Gemma, "The Greatness of Mary Cassatt," *American Artist,* Vol. 30, no. 2 (February, 1966), 42-49.

Novak, Barbara, *American Painting of the Nineteenth Century.* New York: Praeger, 1969.

Oakley, Thornton, *Cecilia Beaux.* Philadelphia: Howard Biddle Printing Company, 1943.

Occhini, Pier Ludovico, "Karl Frédéric' Frieseke," *Vita d'arte,* Vol. 7 (February, 1911), 58-68.

O'Connor, John, Jr., "From Our Permanent Collection: 'River in Winter' by John H. Twachtman (1853-1902)," *Carnegie Magazine,* Vol. 25, no. 4 (April, 1951), 136-38.

"Oil-Paintings and Pastels by Mr. Twachtman," *The Critic,* Vol. 18, no. 376 (March 14, 1891), 146-47.

Ormond, Richard, *John Singer Sargent.* New York and Evanston: Harper & Row, 1970.

P.G.H., Jr., "Book Illustrators III. Willard L. Metcalf," *The Book Buyer,* Vol. II, no. 3 (April, 1894-1895), 120-22.

Pach, Walter, "At the Studio of Claude Monet," *Scribner's Magazine,* Vol. 43, no. 6 (June, 1908), 765-68.

_____, "Peintres-Graveurs contemporains M.J. Alden Weir," *Gazette des Beaux-Arts,* Ser. 4, Vol. 6 (September, 1911), 214-15.

Paff, Adam E.M., *Etchings and Drypoints by Frank W. Benson.* Boston and New York: Houghton Mifflin Company, 1917.

"A Painter on Painting," *Harper's New Monthly Magazine,* Vol. 56, no. 133 (February, 1878), 458-61.

"Painters' Motifs in New York City," *Scribner's Magazine,* Vol. 20, no. 13 (July, 1896), 127-28.

"Painting America: Childe Hassam's Way," *Touchstone,* Vol. 5, no. 4 (July, 1919), 272-80.

Parkhurst, Thomas Shrewsbury, "Gardner Symons, Painter and Philosopher," *Fine Arts Journal,* Vol. 34, no. 11 (November, 1916), 556-65.

_____, "Little Journeys to the Homes of Great Artists: Gardner Symons," *Fine Arts Journal,* Vol. 33, no. 4 (October, 1915), 7-9, supplement.

Pattison, James William, "The Art of Childe Hassam," *House Beautiful,* Vol. 23, no. 2 (January, 1908), 19-20.

_____, "Robert Reid, Painter," *House Beautiful,* Vol. 20, no. 2 (July, 1906), 18-20.

Peat, Wilbur David, *Pioneer Painters of Indiana.* Indianapolis Art Association of Indianapolis, Indiana, 1954.

Pepper, Charles Hovey, "Is Drawing to Disappear in Artistic Individuality?" *The World Today,* Vol. 19, no. 1 (July, 1910), 716-19.

Perlman, Bennard B., *The Immortal Eight: American Painting from Eakins to the Armory Show (1870-1913).* New York: Exposition Press, 1962.

Perry, Lilla Cabot, "Reminiscences of Claude Monet from 1889 to 1909," *American Magazine of Art,* Vol. 18, no. 3 (March, 1927), 119-25.

Phillips, Duncan, *A Collection in the Making.* New York: E. Weyhe; Washington, D.C.: Phillips Memorial Gallery, 1926.

_____, "Emil Carlsen," *International Studio,* Vol. 61, no. 244 (June, 1917), cv-cx.

_____, "Ernest Lawson," *American Magazine of Art,* Vol. 8, no. 7 (May, 1917), 257-63.

_____, "The Impressionistic Point of View," *Art and Progress,* Vol. 3, no. 5 (March, 1912), 505-11.

_____, "J. Alden Weir," *American Magazine of Art,* Vol. 8, no. 6 (April, 1917), 213-20.

_____, "J. Alden Weir," *Art Bulletin,* Vol. 2, no. 4 (June, 1920), 189-212.

_____, "Maurice Prendergast," *The Arts,* Vol. 5, no. 3 (March, 1924), 125-31.

_____, "Twachtman — An Appreciation," *International Studio,* Vol. 66, no. 265 (February, 1919), cvi-cvii.

_____, "What is Impressionism?" *Art and Progress,* Vol. 3, no. 2 (September, 1912), 702-07.

Phillips, Duncan, Emil Carlsen, Royal Cortissoz, Childe Hassam, J. B. Millet, H. De Rassloff, Augustus Vincent Tack, and Charles Erskine S. Wood, *Julian Alden Weir: An Appreciation of His Life and Works.* New York: E. P. Dutton & Company, 1922.

Pica, Vittorio, "Artisti Contemporanei: Berthe Morisot — Mary Cassatt," *Emporium,* Vol. 26, no. 151 (July, 1907), 3-16.

_____, "Artisti Contemporanei: Richard Emile Miller," *Emporium,* Vol. 39, no. 231 (March, 1914), 162-77.

Pierce, Patricia Jobe, *The Ten.* Concord, New Hampshire: Rumford Press; North Abington, Massachusetts: Distributed by Pierce Galleries, 1976.

Pierce, Patricia Jobe, and Rolf H. Kristiansen, *John Joseph Enneking: American Impressionist Painter.* North Abington, Massachusetts: Pierce Galleries, 1972.

Pilgrim, Dianne H., "The Revival of Pastels in Nineteenth-Century America: The Society of Painters in Pastel," *The American Art Journal,* Vol. 10, no. 2 (November, 1978), 43-62.

Pisano, Ronald G., *William Merritt Chase.* New York: Watson-Guptill Publications, 1979.

Pitz, Henry, "Daniel Garber," *Creative Art,* Vol. 2, no. 4 (April, 1928), 252-56.

"The Point of View," *Scribner's Magazine,* Vol. 9, no. 69 (May, 1891), 657-58.

Pomeroy, Ralph, "Yankee Impressionists: Impressive, Impressionable," *Art News,* Vol. 67, no. 7 (November, 1968), 51.

Pool, Phoebe, *Impressionism.* New York: F. A. Praeger, 1967.

Pousette-Dart, Nathaniel, comp., *Childe Hassam,* introduction by Ernest Haskell. New York: Frederick A. Stokes Company, 1922.

Price, Frederic Newlin, "Childe Hassam—Puritan," *International Studio,* Vol. 77, no. 311 (April, 1923), 3-7.

_____, "Emil Carlsen—Painter, Teacher," *International Studio,* Vol. 75, no. 302 (July, 1922), 300-08.

_____, *Ernest Lawson, Canadian American.* New York: Ferargil, 1930.

_____, "Lawson, of the 'Crushed Jewels,'" *International Studio,* Vol. 78, no. 321 (February, 1924), 367-70.

_____, "Redfield, Painter of Days," *International Studio,* Vol. 75, no. 303 (August, 1922), 402-10.

_____, "Spencer—and Romance," *International Studio,* Vol. 76, no. 310 (March, 1923), 485-91.

_____, "Weir—the Great Observer," *International Studio,* Vol. 75, no. 300 (April, 1922), 127-31.

Quimby, Ian M.G., "Mark Fisher: An American Impressionist," *Antiques,* Vol. 91, no. 6 (June, 1967), 780-83.

"R.R." [Riordan, Roger], "From Another Point of View," *The Art Amateur,* Vol. 27, no. 7 (December, 1892), 5.

Rand, Harry, "American Impressionism," *Arts Magazine,* Vol. 50, no. 9 (May, 1976), 13.

Reece, Claude, "Frank W. Benson," *Prints,* Vol. 4, no. 4 (March, 1934), 4-8.

Reutersvard, Oscar, "The Accentuated Brush Stroke of the Impressionists," *Journal of Aesthetics and Art Criticism,* Vol. 10, no. 3 (March, 1952), 273-78.

_____, "The 'Violettomania' of the Impressionists," *Journal of Aesthetics and Art Criticism,* Vol. 9, no. 2 (December, 1951), 106-10.

Rewald, John, *The History of Impressionism.* New York: The Museum of Modern Art, 1962.

_____, *Postimpressionism from Van Gogh to Gauguin.* New York: The Museum of Modern Art, 1956.

Reynolds, Gary A., "A San Francisco Painter, Theordore Wores," *American Art Review,* Vol. 3, no. 5 (September-October, 1976), 101-17.

Richardson, Edgar P., *Painting in America: The Story of 450 Years.* New York: T.Y. Crowell, 1956.

Rihani, Ameen, "Landscape Painting in America—Ernest Lawson," *International Studio,* Vol. 72, no. 287 (February, 1921), 114-17.

Riordan, Roger, "Miss Mary Cassatt," *The Art Amateur,* Vol. 38, no. 6 (May, 1898), 130.

_____, see also "R.R."

Rittenhouse, Jessie B., "The Art of John J. Enneking," *Brush and Pencil,* Vol. 10, no. 6 (September, 1902), 335-45.

Robinson, Frank Torrey, *Living New England Artists.* Boston: S.E. Cassino, 1888.

Robinson, Theodore, "Claude Monet," *Century,* Vol. 44, no. 5 (September, 1892), 696-701.

_____, "A Normandy Pastoral," *Scribner's Magazine,* Vol. 21, no. 6 (June, 1897), 757.

_____, Unpublished diaries, March, 1892-March, 1896. Copy at the Frick Art Reference Library, New York City.

Roof, Katherine Metcalf, *The Life and Art of William Merritt Chase.* New York: Charles Scribner's Sons, 1917.

_____, "William Merritt Chase: An American Master," *The Craftsman,* Vol. 18, no. 1 (April, 1910), 33-45.

_____, "The Work of John H. Twachtman," *Brush and Pencil,* Vol. 12, no. 4 (July, 1903), 243-46.

Rothenstein, William, *Men and Memories, Recollections of William Rothenstein, 1872-1900,* 3 vols. London: Faber & Faber, 1931.

Rowe, L.E., "Boudin, Vinton and Sargent," *Bulletin of the Rhode Island School of Design,* Vol. 25, no. 1 (January, 1937), 2-5.

Ruge, Clara, "The Tonal School of America," *International Studio,* Vol. 27, no. 107 (January, 1906), lvii-lxvi.

Rummell, John, and E.M. Berlin, *Aims and Ideals of Representative American Painters.* Buffalo, New York: n.p., 1901.

Ryerson, Margery Austen, "J. Alden Weir's Etchings," *Art in America,* Vol. 8, no. 5 (August, 1920), 243-48.

_____, "John H. Twachtman's Etchings," *Art in America,* Vol. 8, no. 2 (February, 1920), 92-96.

Saint-Gaudens, Homer, "Abbott H. Thayer," *International Studio,* Vol. 33, no. 131 (January, 1908), lxxxi-lxxxix.

_____, *The American Artist and His Times.* New York: Dodd, Mead & Company, 1941.

_____, "Charles Courtney Curran," *The Critic,* Vol. 48, no. 1 (January, 1906), 38-39.

_____, "Edmund C. Tarbell," *The Critic,* Vol. 48, no. 2 (February, 1906), 137.

_____, "Thomas W. Dewing," *The Critic,* Vol. 48, no. 5 (May, 1906), 418-19.

Salaman, Malcolm Charles, *Frank W. Benson.* London: The Studio, 1925.

Sargent, Irene, "The Mural Paintings by Robert Reid in the Massachusetts State House," *The Craftsman,* Vol. 7, no. 6 (March, 1905), 699-712.

Sawyer, Charles H., "The Prendergasts," *Parnassus,* Vol. 10, no. 5 (October, 1939), 9-11.

Seaton-Schmidt, Anna, "An Afternoon with Claude Monet," *Modern Art,* Vol. 5, no. 1 (January 1, 1897), 32-35.

_____, "Frank W. Benson," *American Magazine of Art,* Vol. 12, no. 11 (November, 1921), 365-72.

Ségard, Achille, *Un Peintre des enfants et des mères: Mary Cassatt.* Paris: Ollendorff, 1913.

Sherman, Frederic Fairchild, *American Painters of Yesterday and Today.* New York: Privately printed, 1919.

_____, *Landscape and Figure Painters of America*. New York: Privately printed, 1917.

_____, "The Landscape of Ernest Lawson," *Art in America,* Vol. 8, no. 1 (January, 1919), 32-39.

_____, "Theodore Robinson," unpublished article, n.d. (ca. 1928?) Copy at the Frick Art Reference Library, New York City.

_____, "William Gedney Bunce," *Art in America,* Vol. 14, no. 2 (February, 1926), 80-84.

Shinn, Everett, "William Glackens as an Illustrator," *American Artist,* Vol. 9, no. 9 (November, 1945), 22-27, 37.

Shulz, Adolph Robert, "The Story of the Brown County Art Colony," *Indiana Magazine of History,* Vol. 31, no. 4 (December, 1935), 282-89.

Simmons, Edward, *From Seven to Seventy: Memories of a Painter and a Yankee.* New York and London: Harper & Brothers, 1922.

Singleton, Esther, comp. and ed., *Modern Paintings, as Seen and Described by Great Writers.* New York: Dodd, Mead & Company, 1911.

Slocum, Grace L., "Old Lyme," *American Magazine of Art,* Vol. 15, no. 12 (December, 1924), 635-42.

Smith, David Loeffler, "Observations on a Few Celebrated Women Artists," *American Artist,* Vol. 26, no. 1 (January, 1962), 51-55.

Smith, Minna C., "The Work of Frank W. Benson," *International Studio,* Vol. 35, no. 140 (October, 1908), xcix-cvi.

Soissons, S.C. de, *Boston Artists—A Parisian Critic's Notes.* Boston: n.p., 1894.

Stark, Otto, "The Evolution of Impressionism," *Modern Art,* Vol. 3, no. 2 (Spring, 1895), 53-56.

Stebbins, Theodore, E., Jr., *American Master Drawings and Watercolors.* New York: Harper & Row, 1976.

Steele, John, "The Lyricism of Emil Carlsen," *International Studio,* Vol. 88, no. 365 (October, 1927), 53-60.

Steele, Selma N., Theodore L. Steele, and Wilbur D. Peat, *The House of the Singing Winds; The Life and Work of T.C. Steele.* Indianapolis: Indiana Historical Society, 1966.

Steele, Theodore C., "Impressionalism," *Modern Art,* Vol. 1, no. 1 (Winter, 1893), unpaginated.

Stephens, Henry G., "'Impressionism'—The Nineteenth Century's Distinctive Contribution to Art," *Brush and Pencil,* Vol. 11, no. 4 (January, 1903), 279-97.

Stewart, Jeffrey, "Soren Emil Carlsen," *Southwest Art,* Vol. 4, no. 10 (April, 1975), 34-37.

Stoner, Stanley, *Some Recollections of Robert Reid.* Colorado Springs: The Dentan Printing Co., 1934.

Stranahan, Mrs. C.H., *A History of French Painting.* New York: Charles Scribner's Sons, 1888.

Strawn, Arthur, "Ernest Lawson," *Outlook,* Vol. 157, no. 16 (April 22, 1931), 573.

Stuart, Evelyn Marie, "Finished Impressions of a Portrait Painter," *Fine Arts Journal,* Vol. 36, no. 1 (January, 1918), 32-40.

Sutton, Denys, *Nocturne: The Art of James McNeill Whistler.* London: Country Life, 1964.

Sweet, Frederick A., "America's Greatest Woman Painter: Mary Cassatt," *Vogue,* Vol. 123, no. 3 (February, 15, 1954), 102-03, 123.

_____, "A Chateau in the Country," *The Art Quarterly,* Vol. 21, no. 2 (Summer, 1958), 202-15.

_____, *Miss Mary Cassatt: Impressionist from Pennsylvania.* Norman, Oklahoma: University of Oklahoma Press, 1966.

Tabarant, Adolphe, "Les Disparus—Miss Mary Cassatt," *Bulletin de la vie artistique,* Vol. 7 (July, 1926), 205-06.

Taber, Edward Martin, *Stowe Notes, Letters, and Verses.* Boston and New York: Houghton Mifflin Company, 1913.

Taft, Lorado, *Painting and Sculpture in Our Time; Syllabus of a Course of Six Lecture Studies.* Chicago: University of Chicago Press, 1896.

Taylor, E.A., "The Paintings of F.C. Frieseke," *International Studio,* Vol. 53, no. 212 (October, 1914), 259-67.

Teall, Gardner, "In True American Spirit, The Art of Daniel Garber," *Hearst's International,* Vol. 39, no. 6 (June, 1921), 28, 77.

_____, "Mother and Child, The Theme as Developed in the Art of Mary Cassatt," *Good Housekeeping Magazine,* Vol. 50, no. 2 (February, 1910), 141.

_____, "Paxton: A Painter of Things Seen," *Hearst's Magazine,* Vol. 31, no. 6 (June, 1917), 457-58, 525.

Teevan, Bernard, "A Painter's Renaissance," *International Studio,* Vol. 82, no. 341 (October, 1925), 3-11.

"Ten American Painters," *The Art Amateur,* Vol. 38, no. 6 (May, 1898), 133-34.

Tharp, Ezra, "T.W. Dewing,"*Art and Progress,* Vol. 5, no. 5 (March, 1914), 155-61.

Thaxter, Celia, *An Island Garden.* Boston and New York: Houghton, Mifflin & Co., 1894.

Thayer, Gerald H., "The Last Rites," *The Arts,* Vol. 1, no. 6 (June-July, 1921), 24-27.

"Theodore Robinson," *Scribner's Magazine,* Vol. 19, no. 84 (June, 1896), 784-85.

"Theodore Robinson, Pioneer Impressionist," *Scribner's Magazine,* Vol. 70, no. 48 (December, 1921), 763-68.

Thompson, Wallace, "Richard Miller—A Parisian-American Artist," *Fine Arts Journal,* Vol. 27, no. 5 (November, 1912), 709-14.

Thorpe, Jonathan, "John H. Twachtman," *The Arts,* Vol. 2, no. 1 (October, 1921), 4-10.

"Three Paintings of the Nude by Frederick Carl Frieseke," *International Studio,* Vol. 76, no. 306 (November, 1922), 153-55.

Toulgouat, Pierre, "Peintres américains à Giverny," *Rapports: France—Etats-Unis,* No. 62 (May, 1952), 65-73.

Trask, John E.D., "About Tarbell," *American Magazine of Art,* Vol. 9, no. 6 (April, 1918), 218-28.

[Trumble, Alfred?], "Claude Monet," *The Collector,* Vol. 2, no. 8 (February 15, 1891), 91.

Trumble, Alfred, "Impressionism and Impressions," *The Collector,* Vol. 4, no. 14 (May 15, 1893), 213-14.

_____, "A Painter's Progress," *The Quarterly Illustrator,* Vol. 2, no. 5 (January-March, 1894), 48-50.

Tucker, Allen, *John H. Twachtman.* American Artists Series. New York: Whitney Museum of American Art, 1931.

"Two Paintings by J. Alden Weir," *The Brooklyn Museum Quarterly,* Vol. 13, no. 4 (October, 1926), 124-25.

Valerio, Edith, *Mary Cassatt.* Paris: Les Éditions G. Crès, 1930.

Van Dyke, John Charles, *American Painting and Its Tradition.* New York: Charles Scribner's Sons, 1919.

_____, *Art for Art's Sake.* New York: Charles Scribner's Sons, 1898.

_____, ed., *Modern French Masters.* New York: The Century Company, 1896.

Van Rensselaer, Mariana, "American Painters in Pastel," *Century,* Vol. 29, no. 2 (December, 1884), 204-10.

"Venice Pastels and Etchings," *The Art Journal* (London), Vol. 43 (1881), 93.

Von Mach, Edmund, *The Art of Painting in the Nineteenth Century.* Boston and London: Ginn and Company, 1908.

Vonnoh, Robert, "Increasing Values in American Paintings," *Arts and Decoration,* Vol. 2, no. 7 (May, 1912), 254-56.

"The Vonnohs," *International Studio,* Vol. 54, no. 214 (December, 1914), xlviii-lii.

"Vonnoh's Half Century," *International Studio,* Vol. 77, no. 313 (June, 1923), 231-33.

W.H.W., "What is Impressionism?" *The Art Amateur,* Vol. 27, no. 6 (November, 1892), 18.

_____, "What is Impressionism? Part II," *The Art Amateur,* Vol. 27, no. 7 (December, 1892), 5.

Waern, Cecilia, "Some Notes on French Impressionism," *Atlantic Monthly,* Vol. 69, no. 414 (April, 1892), 535-41.

Walton, William, "Cecilia Beaux," *Scribner's Magazine,* Vol. 22, no. 4 (October, 1897), 477-85.

_____, "Miss Mary Cassatt," *Scribner's Magazine,* Vol. 19, no. 3 (March, 1896), 353-61.

_____, "Two Schools of Art: Frank Duveneck, Frederick C. Frieseke," *Scribner's Magazine,* Vol. 58, no. 5 (November, 1915), 643-46.

Warner, Charles Dudley, "William Gedney Bunce," *Century,* Vol. 60, no. 4 (August, 1900), 635.

Watson, Forbes, *Allen Tucker.* American Artists Series. New York: Whitney Museum of American Art, 1932.

_____, "Allen Tucker," *Magazine of Art,* Vol. 32, no. 12 (December, 1939), 698-703.

_____, "Allen Tucker — A Painter with a Fresh Vision," *International Studio,* Vol. 52, no. 205 (March, 1914), xix-xxi.

_____, "Glackens," *Magazine of Art,* Vol. 32, no. 1 (January, 1939), 4-11.

_____, "John H. Twachtman — A Painter Pure and Simple," *Arts and Decoration,* Vol. 12, no. 6 (April 25, 1920), 395, 434.

_____, *Mary Cassatt.* American Artists Series. New York: Whitney Museum of American Art, 1932.

_____, "Mary Cassatt," *The Arts,* Vol. 10, no. 1 (July, 1926), 3-4.

_____, "Philadelphia Pays Tribute to Mary Cassatt," *The Arts,* Vol. 11, no. 6 (June, 1927), 289-97.

_____, *William Glackens.* New York: Duffield and Co., 1923.

_____, "William Glackens," *The Arts,* Vol. 3, no. 4 (April, 1923), 246-60.

_____, "William Glackens — An Artist Who Seizes the Colorful and Interesting Aspects of Life," *Arts and Decoration,* Vol. 14, no. 2 (December, 1920), 103, 152.

Weber, Nicholas Fox, "Rediscovered American Impressionists," *American Art Review,* Vol. 3, no. 1 (January-February, 1976), 100-15.

Webster, J. Carson, "Technique of Impressionism: A Reappraisal," *College Art Journal,* Vol. 4, no. 1 (November, 1944), 3-22.

Weinberg, Helene Barbara, "Robert Reid: Academic Impressionist," *Archives of American Art Journal,* Vol. 15, no. 1 (1975), 2-11.

Weinberg, Louis, "Current Impressionism," *The New Republic,* Vol. 2, no. 18 (March 6, 1915), 124-25.

Weitenkampf, Frank, *American Graphic Art.* New York: Macmillan Co., 1924.

_____, "Childe Hassam and Etching," *American Magazine of Art,* Vol. 10, no. 2 (December, 1918), 49-51.

_____, "The Drypoints of Mary Cassatt," *The Print Collector's Quarterly,* Vol. 6, no. 4 (December, 1916), 397-409.

_____, "Some Women Etchers," *Scribner's Magazine,* Vol. 46, no. 6 (December, 1909), 731-39.

_____, "Weir's Excursion into Print-Land," *Arts and Decoration,* Vol. 12, no. 3 (January 20, 1920), 208-09.

Weitzenhoffer, Frances, "Estampes Impressionnistes de peintres américains," *Nouvelles de l'estampe,* No. 28 (July-August, 1976), 7-15.

Welch, M.L., "Mary Cassatt," *American Society of the Legion of Honor Magazine,* Vol. 25 (Summer, 1954), 155-65.

Weller, Allen S., "Frederick Carl Frieseke: The Opinions of an American Impressionist," *Art Journal,* Vol. 28, no. 2 (Winter, 1968), 160-65.

_____, "The Impressionists," *Art in America,* Vol. 51, no. 3 (June, 1963), 86-91.

Wheeler, Charles V., "Redfield," *American Magazine of Art,* Vol. 16, no. 1 (January, 1925), 3-8.

_____, *Redfield.* Washington, D.C.: Privately printed, 1925.

_____, "Redfield's One-Man Show," *American Magazine of Art,* Vol. 21, no. 3 (March, 1930), 139-42.

White, Israel L., "Childe Hassam — A Puritan," *International Studio,* Vol. 45, no. 178 (December, 1911), xxix-xxxvi.

White, Nelson C., *Abbott H. Thayer, Painter and Naturalist.* Hartford, Connecticut: Privately published, 1951.

_____, "The Art of Thomas W. Dewing," *Art and Archeology,* Vol. 27, no. 6 (June, 1929), 253-61.

"Who's Who in American Art," *Arts and Decoration,* Vol. 6, no. 3 (January, 1916), 135.

Wick, Peter, *Maurice Prendergast Watercolor Sketchbook, 1899.* Boston and Cambridge, Massachusetts: Museum of Fine Arts and Harvard University Press, 1960.

Wickenden, Robert J., *The Art and Etchings of John Henry Twachtman.* New York: Frederick Keppel & Co., 1921.

Wilson, Ellen, *American Painter in Paris: A Life of Mary Cassatt.* New York: Farrar, Straus & Giroux, 1971.

Wright, Helen, "Etchings by Frank W. Benson," *Art and Archeology,* Vol. 15, no. 2 (February, 1923), 92-95.

Yarnell, James L., "John H. Twachtman's 'Icebound,'" *Bulletin of the Art Institute of Chicago,* Vol. 71, no. 1 (January-February, 1977), 2-5.

Yeh, Susan Fillin, "Mary Cassatt's Images of Women," *Art Journal,* Vol. 35, no. 4 (Summer, 1976), 359-63.

Young, Dorothy Weir, *The Life and Letters of J. Alden Weir.* New Haven: Yale University Press, 1960.

Young, Mahonri Sharp, "A Boston Painter," *Apollo,* Vol. 108, no. 201 (November, 1978), 344-45.

_____, *The Eight; the Realist Revolt in American Painting.* New York: Watson-Guptill Publications, 1973.

_____, "Purple Shadows in the West," *Apollo,* Vol. 98, no. 140 (October, 1973), 308-10.

_____, "A Quiet American," *Apollo,* Vol. 79, no. 27 (May, 1964), 401-02.

Zigrosser, Carl, *Childe Hassam.* New York: Frederick Keppel & Co., 1916.

Zimmerman, Agnes Saumarez, "An Essay Toward a Catalogue Raisonné of the Etchings, Drypoints and Lithographs of J. Alden Weir," *The Metropolitan Museum of Art Papers,* Vol. 1, part 2, 1923.

――――, "Julian Alden Weir――His Etchings," *The Print Collector's Quarterly,* Vol. 10, no. 3 (October, 1923), 288-308.

Zug, George Breed, "The Story of American Painting――IX. Contemporary Landscape Painting," *The Chautauquan,* Vol. 50, no. 3 (May, 1908), 369-402.

## Individual Exhibitions

A C A Heritage Gallery, Inc., *Childe Hassam, 1859-1935.* New York City, 1965.

American Academy of Arts and Letters, *A Catalogue of an Exhibition of the Works of Childe Hassam,* New York City, 1927.

Anderson, Dennis R., *Ernest Lawson Exhibition.* A C A Galleries, New York City, 1976.

Baird, Joseph A., Jr., *Theodore Wores: The Japanese Years.* The Oakland Museum, Oakland, California, 1976.

Bates, Arlo, *Memorial Exhibition of the Works of Frederic Porter Vinton.* Museum of Fine Arts, Boston, 1911.

Baur, John I.H., *Theodore Robinson, 1852-1896.* The Brooklyn Museum, Brooklyn, 1946.

Baur, John T.H., *Theodore Wendel, An American Impressionist, 1859-1932.* Whitney Museum of American Art, New York City, 1976.

[Beatty, Helen M.] "H.M.B.," *Exhibition of Paintings by Abbott H. Thayer.* Carnegie Institute, Pittsburgh, 1919.

Boyle, Richard J., *John Henry Twachtman, 1853-1902.* Ira Spanierman, New York City, 1966.

Boyle, Richard J., and Mary Welsh Baskett, *John Henry Twachtman.* Cincinnati Art Museum, Cincinnati, 1966.

Breeskin, Adelyn D., *Mary Cassatt, 1844-1926.* National Gallery of Art, Washington, D.C., 1970.

――――, *Mary Cassatt, Pastels and Color Prints.* National Collection of Fine Arts, Washington, D.C., 1978.

――――, *The Paintings of Mary Cassatt.* M. Knoedler & Co., Inc., New York City, 1966.

Buckley, Charles E., *Childe Hassam: A Retrospective Exhibition.* Corcoran Gallery of Art, Washington, D.C., 1965.

Burke, Doreen Bolger, and David W. Kiehl, *Childe Hassam as Printmaker.* The Metropolitan Museum of Art, New York City, 1977.

The Butler Institute of American Art, *Edward Henry Potthast From the Collection of Mr. and Mrs. Merrill Gross.* Youngstown, Ohio, 1965.

Buxton, Frank W., and R.H. Ives Gammell, *William McGregor Paxton.* Museum of Fine Arts, Boston, 1941.

Byrd, D. Gibson, *Paintings and Drawings by Theodore Robinson.* University of Wisconsin, Madison, 1964.

Cleveland Museum of Art, *Maurice Prendergast Memorial Exhibition.* Cleveland, 1926.

Coffin, William A., *Memorial Exhibition of the Works of Julian Alden Weir.* The Metropolitan Museum of Art, New York City, 1924.

Cortissoz, Royal, *Memorial Exhibition of the Works of Abbott Henderson Thayer.* The Metropolitan Museum of Art, New York City, 1922.

Crowninshield, Frank, *Exhibition of Paintings by Robert Reid, N.A., NIAC.* Grand Central Art Galleries, New York City, 1927.

Czestochowski, Joseph, S., *Childe Hassam Impressions.* Brooks Memorial Art Gallery, Memphis, Tennessee, n.d.

Bernard Danenberg Galleries, Inc., *Childe Hassam: An Exhibition of His "Flag Series" Commemorating the Fiftieth Anniversary of Armistice Day.* New York City, 1968.

De Veer, Elizabeth, *Willard Leroy Metcalf: A Retrospective.* Museum of Fine Arts, Springfield, Massachusetts, 1976.

Dodge, Ernest S., *Frank W. Benson, 1862-1951.* William A. Farnsworth Library and Art Museum, Rockland, Maine, 1973.

Domit, Moussa M., *Frederick Frieseke, 1874-1939*. Telfair Academy of Arts and Sciences, Savannah, Georgia, 1974.

Du Bois, Guy Pene, *Ernest Lawson*. Babcock Galleries, New York City, 1943.

_____, *William J. Glackens*. Whitney Museum of American Art, New York City, 1931.

Duncan, Walter Jack, *Paintings by Willard L. Metcalf*. Corcoran Gallery of Art, Washington, D.C., 1925.

Ely, Catherine Weir, *Catalogue of an Exhibition by J. Alden Weir*. Frederick Keppel & Co., New York City, 1927.

Emerson, Sandra, Lucretia H. Giese, and Laura C. Luckey, *A.C. Goodwin, 1864-1929*. Museum of Fine Arts, Boston, 1974.

Feld, Stuart P., *Lilla Cabot Perry: A Retrospective Exhibition*. Hirschl & Adler Galleries, Inc., New York City, 1969.

Ferguson, Charles B., *Dennis Miller Bunker (1861-1890) Rediscovered*. The New Britain Museum of American Art, New Britain, Connecticut, 1978.

Findsen, Owen, *The Merrill J. Gross Collection: Edward Potthast, 1857-1927*. Corcoran Gallery of Art, Washington, D.C., 1973.

_____, *Paintings by Edward H. Potthast (1857-1927) from the Collection of Mr. and Mrs. Merrill Gross*. The Taft Museum, Cincinnati, 1968.

Flint, Janet A., *J. Alden Weir, An American Printmaker, 1852-1919*. National Collection of Fine Arts, Washington, D.C., 1972.

Folts, Franklin P., *Paintings & Drawings by Philip Leslie Hale (1865-1931) from the Folts Collection*. Vose Galleries of Boston, Boston, 1966.

Gammell, R.H. Ives, *Dennis Miller Bunker*. Museum of Fine Arts, Boston, 1943.

_____, *William McGregor Paxton, N.A., 1869-1941*. Indianapolis Museum of Art, Indianapolis, Indiana, 1978.

Goodyear, Frank H., Jr., *Cecilia Beaux: Portrait of an Artist*. Pennsylvania Academy of the Fine Arts, Philadelphia, 1974-75.

Green, Eleanor, *Maurice Prendergast*. University of Maryland Art Gallery, College Park, Maryland, 1976.

"H.M.B.," see Beatty, Helen M.

Hammer Galleries, *Childe Hassam*. New York City, 1969.

Haskell, Ernest, *Exhibition of a Retrospective Group of Paintings Representative of the Life Work of Childe Hassam, N.A.* The Buffalo Fine Arts Academy Albright Art Gallery, Buffalo, 1929.

Hirschl & Adler Galleries, Inc., *Childe Hassam*. New York City, 1974.

Holicong Junior High School, *An Exhibition of Paintings by Edward W. Redfield*. Holicong, Pennsylvania, 1975.

Howard, Leland G., *Otto Stark, 1859-1926*. Indianapolis Museum of Art, Indianapolis, Indiana, 1977.

The J.L. Hudson Gallery, *Childe Hassam*. Detroit, 1968.

Jacobowitz, Arlene, *Edward Henry Potthast, 1857 to 1927*. Chapellier Galleries, New York City, 1969.

Johnston, Sona, *Theodore Robinson, 1852-1896*. The Baltimore Museum of Art, Baltimore, 1973.

Karpiscak, Adeline Lee, *Ernest Lawson, 1873-1939*. University of Arizona Museum of Art, Tucson, 1979.

Katz, Leslie, *William Glackens in Retrospect*. City Art Museum of St. Louis, St. Louis, 1966.

Kennedy Galleries, *Theodore Robinson, American Impressionist (1852-1896)*. New York City, 1966.

Knudsen, Elizabeth Greacen, *Edmund W. Greacen, N.A., American Impressionist, 1876-1949*. Cummer Gallery of Art, Jacksonville, Florida, 1972.

Langdale, Cecily, *The Monotypes of Maurice Prendergast*. Davis & Long Company, New York City, 1979.

Larcada Gallery, *J. Alden Weir (1852-1919)*. New York City, 1966.

Lewison, Florence, *Theodore Robinson, the 19th Century Vermont Impressionist*. Southern Vermont Artists, Inc., Manchester, Vermont, 1971.

Florence Lewison Gallery, *Theodore Robinson*. New York City, 1962.

_____, *Theodore Robinson, America's First Impressionist*. New York City, 1963.

Lilienthal, Theodore M., *An Exhibition of Rediscovery: Joseph Raphael, 1872-1950*. Judah L. Magnes Memorial Museum, Berkeley, 1975.

Mastai, M.L. D'Otrange, *Mark Fisher, 1841-1923, the Impressionist*. Vose Galleries of Boston, Boston, 1962.

Maxwell Galleries Ltd., *Theodore Earl Butler (1860-1936), American Impressionist*. San Francisco, n.d.

Mellerio, Andre. *L'Exposition des oeuvres de Mary Cassat*. Galeries Durand-Ruel, Paris, 1893.

The Milch Galleries, *Allen Tucker, 1966-1939, Centennial Exhibition*. New York City, 1966.

Moehl, Karl J., *Exhibition of Paintings: Edward Henry Potthast*. The Peoria Guild of Lakeview Center, Peoria, Illinois, 1967.

The Museum of Modern Art, *Marsden Hartley*. New York City, 1944.

O'Neal, Barbara, *Ernest Lawson, 1873-1939*. National Gallery of Canada, Ottawa, Ontario, 1967.

Owens, Gwendolyn, *Watercolors by Maurice Prendergast from New England Collections*. Sterling And Francine Clark Art Institute, Williamstown, Massachusetts, 1978.

Pach, Walter, *Maurice Prendergast Memorial Exhibition*. Whitney Museum of American Art, New York City, 1934.

Pisano, Ronald G., *William Merritt Chase (1849-1916)*. M. Knoedler & Co., Inc., New York City, 1976.

Price, Lucien, *Frank W. Benson, 1862-1951*. Essex Institute and the Peabody Museum of Salem, Salem, Massachusetts, 1956.

Rhys, Hedley Howell, *Maurice Prendergast, 1859-1924*. Museum of Fine Arts, Boston, 1960.

Sawyer, Charles H., *Maurice Prendergast*. M. Knoedler & Co., Inc., New York City, 1966.

Shapiro, Barbara Stern, *Mary Cassatt at Home*. Museum of Fine Arts, Boston, 1978.

Spence, Robert, and Jon Nelson, *The Etchings of J. Alden Weir*. University of Nebraska Art Galleries, Lincoln, 1967.

Staley, Allen, and Theodore Reff, *From Realism to Symbolism: Whistler and His World*. Wildenstein & Co., New York City, 1971.

Tananbaum, Dorothy, *The Art of Emil Carlsen*. Hammer Galleries, New York City, 1977.

Thurlow, Fearn C., *J. Alden Weir*. Montclair Art Museum, Montclair, New Jersey, 1972.

Tyler Museum of Art, *Emil Carlsen*. Tyler, Texas, 1973.

University of Arizona Museum of Art, *Childe Hassam, 1859-1935*. Tucson, 1972.

University of New Mexico, *Impressionism in America*. Albuquerque, 1965.

Valente, Alfredo, *Robert Henri, Painter-Teacher-Prophet*. New York Cultural Center, New York City, 1969.

Venturi, Lionello, *Arthur Clifton Goodwin: A Selective Exhibition*. Addison Gallery of American Art, Phillips Academy, Andover, Massachusetts, 1946.

Watson, Forbes, *William Glackens Memorial Exhibition*. San Francisco Museum of Art, San Francisco, 1939.

Wattenmaker, Richard J., *The Art of William Glackens*. Rutgers, the State University, New Brunswick, New Jersey, 1967.

Weller, Allen S., *Frederick Frieseke, 1874-1939*. Hirschl & Adler Galleries, Inc., New York City, 1966.

White, Nelson C., *Abbott H. Thayer, 1849-1921*. Lyman Allyn Museum, New London, Connecticut, 1961.

_____, *Thomas W. Dewing*. Durlacher Brothers, New York City, 1963.

Winer, Donald A., *A Retrospective Exhibition of the Work of the Great American Impressionist Edward Willis Redfield of Pennsylvania*. William Penn Memorial Museum, Harrisburg, Pennsylvania, 1973.

Wortsman Rowe Galleries, *The Art of Emil Carlsen, 1853-1932*. San Francisco, 1975.

Young, Mahonri Sharp, *J. Alden Weir, 1852-1919, Centennial Exhibition*. American Academy of Arts and Letters, New York City, 1952.

_____, *Paintings by Julian Alden Weir*. The Phillips Collection, Washington, D.C., 1972.

## Group Exhibitions

Addison Gallery of American Art, *The Prendergasts: Retrospective Exhibition of the Work of Maurice and Charles Prendergast*. Phillips Academy, Andover, Massachusetts, 1938.

Fifth Avenue Galleries, *Catalogue of Paintings in Oil and Pastel by J. Alden Weir and J.H. Twachtman*. New York City, 1889.

The Fine Arts Society Limited, *Mark Fisher and His Anglo-American Contemporaries*. London, 1967.

Jewett Arts Center, *Four Boston Masters: Copley, Allston, Prendergast, Bloom*. Wellesley College, Wellesley, Massachusetts, 1959.

Johnson, Lincoln, *Paintings, Drawings and Graphic Works by Manet, Degas, Berthe Morisot and Mary Cassatt*. The Baltimore Museum of Art, Baltimore, 1962.

Joslyn Art Museum, *Mary Cassatt Among the Impressionists*. Omaha, Nebraska, 1969.

Langdale, Cecily, *Charles Conder, Robert Henri, James Morrice, Maurice Prendergast: The Formative Years, Paris 1890s*. Davis & Long Company, New York City, 1975.

Milkovich, Michael, *Mary Cassatt and the American Impressionists*. The Dixon Gallery and Gardens, Memphis, Tennessee, 1976.

Pisano, Ronald G., *William Merritt Chase in the Company of Friends*. Parrish Art Museum, Southampton, New York, 1979.

_____, *The Students of William Merritt Chase*. Heckscher Museum, Huntington, New York, 1973.

Price, Lucien, and Frederick W. Coburn, *Frank W. Benson, Edmund C. Tarbell*. Museum of Fine Arts, Boston, 1938.

Charles E. Slatkin Galleries, *Claude Monet and the Giverny Artists*. New York City, 1960.

Sweet, Frederick A., *Sargent, Whistler and Mary Cassatt*. The Art Institute of Chicago, Chicago, 1954.

## Thematic Exhibitions

American Academy of Arts and Letters, *Impressionist Mood in American Painting*. New York City, 1959.

The Brooklyn Museum, *American Impressionists and Others, 1880-1900*. Brooklyn, 1932.

_____, *Leaders of American Impressionism*. Brooklyn, 1937.

Clark, Carol, *American Impressionist and Realist Paintings and Drawings from the William Marshall Fuller Collection*. Amon Carter Museum of Western Art, Fort Worth, Texas, 1978.

Coe Kerr Gallery, Inc., *Masters of American Impressionism*. New York City, 1976.

Colby College, *American Painters of the Impressionist Period Rediscovered*. Waterville, Maine, 1975.

Corn, Wanda M., *The Color of Mood, American Tonalism 1880-1910*. M.H. de Young Museum, San Francisco, 1972.

Dayton Art Institute, *America and Impressionism*. Dayton, Ohio, 1951.

Faxon, Susan, Alice Downey, and Peter Bermingham, *A Stern and Lovely Scene: A Visual History of the Isles of Shoals*. University Art Galleries, University of New Hampshire, Durham, 1978.

Grand Central Art Galleries, Inc., *Memories of Old Lyme Art Colony 1900-1935*. New York City, 1967.

Hills, Patricia, *Turn of the Century America*. Whitney Museum of American Art, New York City, 1977.

Hirschl & Adler Galleries, Inc., *The American Impressionists*. New York City, 1968.

Lowe Art Museum, *French Impressionists Influence American Artists*. University of Miami, Coral Gables, Florida, 1971.

Mount Holyoke College, *French and American Impressionism*. South Hadley, Massachusetts, 1956.

National Gallery of Art, *American Impressionist Painting*. Washington, D.C., 1973.

Philadelphia Museum of Art, *Three Centuries of American Art*. Philadelphia, 1976.

Pilgrim, Dianne H., *American Impressionist and Realist Paintings and Drawings, from the Collection of Mr. and Mrs. Raymond J. Horowitz*. The Metropolitan Museum of Art, New York City, 1973.

Preato, Robert R., *Impressionist Moods: An American Interpretation; American Painters Rediscovered 1880-1930*. Grand Central Art Galleries, Inc., New York City, 1979.

Rathbone, Perry T., *Boston Painters*. Museum of Fine Arts, Boston, 1971.

The Santa Barbara Museum of Art, *Impressionism and Its Influence in American Art*. Santa Barbara, California, 1954.

Seavey, Kent L., *A Century of California Painting 1870-1970*. Crocker-Citizens National Bank, Los Angeles, 1970.

Siegfried, Joan C., *Some Quietist Painters: A Trend Toward Minimalism in Late Nineteenth-Century American Painting*. Skidmore College, Saratoga Springs, New York, 1970.

Trask, John E.D., and John Nilsen Laurvik, *Catalogue De Luxe of the Department of Fine Arts, Panama-Pacific International Exposition*, 2 vols. San Francisco, 1915.

University of Iowa, *Impressionism and Its Roots*. Iowa City, 1964.

Wickersham Gallery, *Quietist Moments in American Painting 1870-1920*. New York City, n.d.

Wood, Carolyn H., *American Impressionist Painters*. Huntsville Museum of Art, Huntsville, Alabama, 1978-79.

# Index

Designed by Douglas Wadden.

**Staff of the Henry Art Gallery**

Harvey West, Director
Frederick W. Dunagan, Curator of Collections
Joseph N. Newland, Editor of Publications
Vickie L. Ross, Project Administrator
Carole Sabatini, Accountant
Gail E. Creager, Secretary to the Director
Michael Fitzgerald, Chief of Security
Mona Nagai, Editorial Assistant

**Photograph credits:**

Armen Photographers, 83, 125, 159; E. Irving Blomstrann, 50, 67, 158; Brenwasser, 32; Noble Bretzman, 122; Lee Brian, 116; Barney Burstein, 144; Geoffrey Clements, 142; Tom Feist, 29; Images, 8, 21, 52, 57, 70, 77, 81, 115; Instructional Media Services, University of Washington, 136, 140; John Leckie, 133; Joseph Levy, 62; Al Monner, 62; Johsel Namkung, 16, 90, 98, 110, 119; Phillips Studio, 45, 105, 134, 139, 141, 143, 152, 158, 162; David Preston, 135; Nathan Rabin, 118; Steven and Barbara Schenk, 53, 150; Taylor & Dull, Inc., 143; John Tennant, 63; F. J. Thomas, 119; Malcom Varon, 120; Herbert P. Vose, 12, 85, 95, 96; Robert Wallace, 13, 78, 94, 102, 155; Steven Young, 36, 118

Set in various sizes and weights of Times Roman by Paul O. Giesey/Adcrafters. Separations and lithography by Graphic Arts Center, Portland, Oregon. Printed on Vintage Velvet 80 lb. text, with Kromkote cover and jacket. Case binding by Lincoln and Allen, Portland, Oregon.